Cinema Today

To Shamim Sarif
with much gratitude!

Cinema Today

A Conversation with Thirty-nine Filmmakers from around the World

ELENA OUMANO

RUTGERS UNIVERSITY PRESS

NEW BRUNSWICK, NEW JERSEY, AND LONDON

LIBRARY OF CONGRESS CATALOGING-IN-PUBLICATION DATA

Elena Oumano

Cinema today : a conversation with thirty-nine filmmakers from around the world /
Elena Oumano.
 p. cm.

Filmmakers interviewed: Tomas Alfredson, Özcan Alper, Olivier Assayas, Serge Bozon,
Catherine Breillat, Andrew Bujalski, Charles Burnett, Pedro Costa, Constantino Costa-
Gravas, Claire Denis, Sergei Dvortsevoy, Jihan El-Tahri, Ari Folman, Matteo Garrone,
Bette Gordon, Eric Guirado, Lance Hammer, Mia Hansen-Love, Mary Harron, Scott
Hicks, Courtney Hunt, Agnès Jaoui, Kyoshi Kurosawa, Pablo Larrain, Anne Le Ny,
Lucrecia Martel, Brillante Mendoza, Teona Strugar Mitevska, Gerardo Naranjo, Lucia
Puenzo, Shamim Sarif, Paul Schrader, Céline Sciamma, Jerzy Skolimowski, Jean-Marie
Téno, Ivo Trajkov, Melvin Van Peebles, Gary Winick, Jia Zhangke.

ISBN 978–0–8135–4876–0 (hardcover : alk. paper)—ISBN 978–0–8135–4877–7
(pbk. : alk. paper)

1. Motion picture producers and directors—Interviews. 2. Motion pictures—
Production and direction. 3. Screenwriters—Interviews. 4. Motion pictures
authorship. I. Oumano, Elena.

PN1998.2.C5675 2010

791.4302'320922—dc22 2009052307

A British Cataloging-in-Publication record for this book is
available from the British Library.

Visit our Web site: http://rutgerspress.rutgers.edu

Manufactured in the United States of America

For Lukas Alexander Roth and Sela Grace Roth

CONTENTS

*Tomas Alfredson, Özcan Alper, Olivier Assayas, Serge Bozon,
Catherine Breillat, Andrew Bujalski, Charles Burnett, Pedro Costa,
Constantin Costa-Gavras, Claire Denis, Sergei Dvortsevoy,
Jihan El-Tahri, Ari Folman, Matteo Garrone, Bette Gordon,
Eric Guirado, Lance Hammer, Mia Hansen-Love, Mary Harron,
Scott Hicks, Courtney Hunt, Agnès Jaoui, Kiyoshi Kurosawa,
Pablo Larrain, Anne Le Ny, Lucrecia Martel, Brillante Mendoza,
Teona Strugar Mitevska, Gerardo Naranjo, Lucia Puenzo,
Shamim Sarif, Paul Schrader, Céline Sciamma, Jerzy Skolimowski,
Jean-Marie Téno, Ivo Trajkov, Melvin Van Peebles, Gary Winick,
Jia Zhangke*

INTRODUCTION

When the far-flung bits and pieces borrowed from older, more established arts are shaped into a smooth, composite whole to make great cinema, something entirely new, powerful, and exciting results—moving images and sounds that follow their own rules of movement, space, and story to reveal a livelier, more passionately intense reflection of the world as we experience it. This metamorphosis begs the perennial question, what is cinema? Famously posed by seminal French film theorist André Bazin, the question has never been answered to everyone's complete satisfaction, so we continue to explore it today, even while recognizing that cinema's unique magic eludes description through mere words and that it may not always be wise to deconstruct the illusion. Yet, when thirty-nine international filmmakers share various and sometimes oppositional views on their art, perhaps we can piece together their ideas and approach a more comprehensive understanding of what cinema can be and how it can work. After all, who is better qualified than filmmakers themselves to describe cinema's collision of various art forms, textures, images, sounds, rhythms, and other expressive elements, as well as to dissect the frustrating, exhausting, and exhilarating process by which a filmmaker's vision finds its way onto the screen?

The usual way we receive information about an art from its makers is via the interview's choppy question-and-answer format. But reading an interview can be tedious, and plowing through a collection of interviews in which the same topics, issues, and questions are directed to each subject in turn, over and over, can be even worse, like being trapped in a revolving door. *Cinema Today* attempts to spring the catch on that revolving door with a symposium-in-print format created by editing my interviews with thirty-nine independent and personal filmmakers. My questions have been removed and their answers grouped together under the various key cinema topics that form this book's chapters.

Cinema Today opens with the evergreen question, what is cinema? A similar question could be posed regarding independent and personal cinema. What do those terms mean when they are commonly used to describe everything from mainstream genre fare made independently of major film studios, to truly personal art films made by those same studios, to any series of continuous images, however brief, that can be viewed over the Internet, via computer, or on the screens of handheld devices?

Unlike mainstream or commercial film directors, the filmmakers interviewed here are involved in almost every phase of creating the film—from its writing to its final edit and sometimes even its distribution. Some are the authors of their works in the sense that their films are stamped with a unique cinematic signature despite the collaborative nature of the medium. Other personal and art filmmakers are equally involved in the entire filmmaking process, but try to avoid displaying a consistent style as they adapt to the differing contents, concepts, and genres of their film projects.

The nationalities of these filmmakers—who come from countries including Kazakhstan, Turkey, Macedonia, Portugal, Chile, Argentina, Egypt, Cameroon, Australia, the Philippines, South Africa, Greece, Portugal, Sweden, Japan, the People's Republic of China, Mexico, and Poland, in addition to the United States, Italy, the United Kingdom, and France—reflect the fact that films are being made virtually everywhere in the world, thanks to a wider playing field created by dramatically lowered filmmaking costs and light-weight equipment. Significantly, many of the newcomers are women. And finally, more films are being seen by more viewers in more places than ever before. A little more than thirty years ago, VHS videotape emerged as a popular viewing platform; it was speedily relegated to dinosaur status by the emergence of the DVD, which, in turn, is now threatened with extinction, as more and more films are being broadcast by pay-per-view and free cable television stations or downloaded from Web sites to be viewed on computer and handheld devices. These additional viewing platforms, along with digital video recorders, which can store a wealth of television entertainment, and large flat-screen televisions and home theater setups offer viewers numerous options. However, the emergence of these technologies also raises the issue of what will lure audiences into theaters to see films when an abundance of entertainment, often of high quality, awaits them at home.

On the one hand, more good work is being created than ever. On the other, exhibition is a growing problem for art filmmakers. Dwindling foreign and DVD sales have eaten into two major sources of independent film's profits and financing. Although small-scale, local film scenes have emerged almost everywhere in the world, commercial Hollywood blockbusters continue to dominate international screens, casting an increasingly large shadow under which little else in the way of personal and independent filmmaking is able to thrive, particularly in America. As of this writing, the future for independent filmmakers is uncertain, particularly given the current global financial crisis and especially in America, where filmmakers receive almost no government support.

Until recently, studios such as Warner Bros. and Paramount Pictures, attracted by the unexpected critical and financial successes of such independent films as writer/director/actor Billy Bob Thornton's *Sling Blade* (1996), bought out independent studios, hired key independent film figures, and formed their own independent film divisions. A-list Hollywood stars are still willing to forgo enormous salaries in order to participate in these films, but virtually every major studio has stopped making medium-budget ($10–15 million) art films, despite enthusiastic critical notice and Academy Awards. In the end, these films wind up losing money, in part because their marketing costs often far outstrip their production budgets. As of this writing, Sony Pictures Classics is the only studio-owned entity still committed to independent art films.

Independent film distributors are also struggling and some are failing, so fewer are willing to take chances on a film that seems difficult to market or may not readily find its audience. As extravagantly budgeted studio movies continue to crowd the limited pool of movie screens, art house cinemas are also closing their doors and independent films increasingly debut at film festivals that attract film journalists and film devotees, in hopes of garnering enough media attention and word of mouth to win a television and DVD audience, even without a theatrical release. Yet the goal is always theatrical distribution because it drives other platform sales. As film festivals serve increasingly as alternative exhibition sites and as competition to land a distributor grows ever more cutthroat, more filmmakers are opting to distribute their films themselves.

Despite these challenges, the filmmakers interviewed here—a group that includes acknowledged masters as well as prize-winning new talents—believe

that an individual driven by the passion to express him or herself through cinema will somehow be able to make a film and that people will somehow be able see it. In this spirit, *Cinema Today* provides a forum for these artists to recount how they arrived at the creative and practical choices that brought their film projects to life and to address their relationships to their art—to explain why, for instance, cinema is their chosen medium, the one that allows them to express something they could not say as powerfully or vividly through any other means.

ACKNOWLEDGMENTS

Heartfelt thanks go to my colleague Philip Weisman, who first suggested I embark on this book project. *Cinema Today* would also not have been possible without the encouragement, support, guidance, and faith of my terrific editor, Leslie Mitchner.

I am endlessly grateful to the many people who support cinema by creating and running film festivals and art house cinemas and by working as publicists to help worthy films reach their audiences. They had little to gain by arranging the interviews I conducted with the filmmakers in this book, but they did it anyway. They include Lucius Barre, Martin Marquet, Gabriele Caroti, Jeanne R. Berney, Steve Grunyo, Denise Lulo, John de Natale, Johanna Ney, Oleg Dubson, Suzanne Fedak, Susan Norget, Charlie Olsky, Sophie Gluck, Rebeca Conget, Mike Maggiore, Heter Myers, John Murphy, Jessica Edwards, Jessica Uzzan, Sasha Berman, Donna Dickman, Cheryl Duncan, Keleigh Thomas, Jenny Scheubeck, Mathieu Fournet, Gary Springer, Claire Weingarten of Film Movement, Wendy Lidell of International Film Circuit, Jessica Beiler, Jason Ishikawa, everyone at 42West, everyone at the Cinema Guild offices in New York City, Mike Maggiore and Adam Walker at Film Forum, and John Kochman, Aurelie Godot, Caroline Aymar, and everyone else at Unifrance.

Special thanks as well to everyone working at the New York Film Festival, the New Directors/New Films Festival, the Tribeca Film Festival, the Rendez-vous with French Cinema Today festival, the New York African Film Festival, and the African Diaspora Film Festival. Your dedication to this art form has ensured that New York City remains a world mecca for filmmakers and film lovers. If I've left out anyone, please forgive me.

I would like to express my appreciation to the brilliant translators who helped out whenever necessary, especially Robert Gray and another

excellent colleague, Vincent Cheng. Copyeditor Gretchen Oberfranc brought a sharp eye to the manuscript.

To the immensely gifted photographer, David Godlis, words cannot express my gratitude for your generosity in allowing me to reproduce so many of your images.

Finally, *Cinema Today* relies most of all on the kindness of the wonderful filmmakers who gave so freely of their time in order to speak within these pages.

Cinema Today

1

Cinematography

Ideally, the cinematographer (aka director of photography, or DP) is the director's greatest ally, but the relationship between director and DP varies. Some independent directors, such as Lance Hammer and Andrew Bujalski, welcome the DP's input during pre-production and the shooting phase on virtually every decision relating to the film's visuals and sometimes even on other matters. Some directors plan all the camera shots themselves, often in tandem with blocking the actors' movements, so the DP's responsibility is limited to lighting the sets or locations. At times, directors like Brillante Mendoza, Scott Hicks, and Sergei Dvortsevoy even take up the camera themselves.

Unless the director writes the script, as do many of the filmmakers interviewed here, his or her vision of the film usually begins to take on life during pre-production, when the words of the script start to evolve into images that will eventually be cut together in the editing room. Camera angles, exterior and interior sets, lighting, and the actors' movements (blocking) all work together to create the film's mise-en-scène—the sum total of the film's visual look and feel. Even if a director approaches the shoot improvisationally—deciding on the spur of the moment how close or far to place the camera from the subject and how the camera will move—he or she has already made many decisions during the film's pre-production phase, often in collaboration with all the heads of the technical crew.

The basic language of cinema has barely altered, but the means by which images and sounds are captured and edited together has been transformed radically in less than two decades. Many independent filmmakers

are using digital video cameras that store images on hard drives. Almost everyone edits digitally, even when their movies have been shot on film stock, because they believe the aesthetic considerations will affect a viewer's sense of a film, even if the average filmgoer cannot detect the differences, at least consciously.

So one key decision often made jointly by director and DP during pre-production regards format, that is, whether to shoot digitally or on film stock, as well as what type of camera(s) and lenses to use. Shooting on film requires purchasing stock, paying for its development, and risking the possibility of running out of film and breaking the mood during the take of a scene. Shooting digitally requires only sufficient memory storage to hold the captured images. The money saved by shooting a feature on digital video is usually in the low six-figure range—an insignificant amount for some film budgets, but not for many independent filmmakers, whose budgets may range from less than $100,000 to $15 million. However, attempting to approximate the nuanced textures and colors of film stock during post-production is expensive in itself. In any case, it is now common practice to edit digitally by transferring film footage to a digital intermediary (DI), where changes such as the color of a shirt can be accomplished with the click of an icon. The DI is then usually transferred back to film for the final exhibition print. Still, some contemporary filmmakers cling to the visceral, hands-on experience of cutting film on a Steenbeck editing table, and Andrew Bujalski boasts a scar on his hand to prove it.

Ideally, the choice should be based on esthetic considerations, because a character delivering the same line in a particular shooting style, lighting scheme, or format will be perceived by viewers differently if shot and lit for a different format. Unfortunately, the cold hard truth is that esthetic discussions over format are often trumped by far more arduous discussions over budget.

Once decisions about format are reached, the filmmaker's choices become primarily issues of lighting and framing. Whatever is shown within the camera frame has a great deal to do with how the area is lit and viewed by adjusting the position and orientation of the camera and choosing a lens in relation to the subject. The camera frame is essentially a device to organize the elements of a film and isolate those elements from their context in order to create a film's diegetic reality through composition, movement, and light. Every framing choice excludes a part of the world and

therefore must be committed, because the filmmaker is driving the viewer's eye, forcing that viewer to look at something for a number of moments. Putting a frame around something should help the viewer to see better and to reflect on whatever he or she sees, so the frame should function as a key to reading the film. Of course, this assumption presumes that a filmmaker knows what he or she thinks about whatever is being filmed and has decided how much information to reveal to the viewer. Otherwise, choices of what to frame become meaningless.

So most filmmakers appreciate the camera frame for the very fact of its restrictions, which inspire and even force creative choices—what to include, what to leave out, and why. These choices also relate to a film's aural elements, because additional information can be conveyed solely through sound, whether recorded at the same time as the images or added later in the sound design.

Whatever was actually outside the frame when a scene was filmed doesn't matter, because part of a film's special reality comes from whatever the viewer believes lies outside the frame—from the fantasies created in that viewer's mind. The frame presents a world unto itself at the same time that it opens the film to other worlds, and so framing must be dynamic to bring viewers into the entire imagined space. In effect, the camera frame can be limitless, a film's space can be infinite, and a filmmaker can make the camera frame do whatever he or she wants.

If there is a language of cinema, one could say that the camera's various shots—including long shots, close-ups, medium shots, as well as the scenes and sequences they build—form film's visual grammar, which is often unique to a personal filmmaker's style. That grammar or language grows out of whoever the filmmaker is as a person and an artist, as well as the need to serve the story and concept he or she is trying to relate.

Although no hard and fast rules equate various camera angles and distances with different types and intensities of emotions, certain shots generally perform specific functions in terms of the information they give and the emotions they evoke. Shots can simply result from the dialogue. For example, if a dialogue passage is lengthy, the shot can be just as long. Conventionally, a lengthy shot gives the viewer a lot of information, almost like building a sentence or paragraph, so determining the length of a shot can be simply a matter of giving the viewer enough time to see. Or the filmmaker can use a shot from one angle and then intercut it with a shot of

the same dialogue sequence from a different angle, all the while maintaining continuity of dialogue, action, and emotion. The key is not to cut away too soon or too late, interrupting the viewer's curve of perception and comprehension. A filmmaker will usually cut a shot once it has made its statement or because he or she wants to give the viewer another viewpoint. Shots are then alternated in the edit to create desired effects.

In essence, each edit tells the viewer, "Look at this, now look at that." Of course, the filmmaker can work only with the material he or she has shot, so the choice comes down to creating framing changes after the shoot, by making cuts during the edit, or by moving the camera within a single shot during the shoot to ensure that this shot cannot be cut into later on, in the edit.

The montage theory of formalist Sergei Eisenstein dictates that each edit should direct the viewer's attention by underscoring a change in mood or emotion. Therefore, any change of feeling or content that occurs within the same shot is a mistake, because that change in the image's meaning must be underlined with a cut. More naturalistic filmmakers tend to move the camera in order to create shot changes that present a fuller context without overmanipulating the viewer's reading. They also tend to use lengthy takes with deep focus, not only to give viewers enough time to gather information but also to provide choices of where to look and, therefore, what to think, which offers a more active experience of the film. However, unless done artfully and for clear reasons, this type of shot can produce a muddled rather than ambiguous composition that confuses viewers and makes them unsure of where to look. Finally, although shot choices should serve story and concept, they often result from challenges that arise moment-to-moment during the film's shoot.

Of course, any theory is prone to absolutism, and the filmmakers here work in whatever ways best suit their purpose toward deepening the viewer's experience. As always, there are no rules, only cautions against common mistakes, such as diffusing the viewer's attention with too much depth of field or using so many close-ups that they lose their emphatic ability, much like a person who screams so often that no one pays attention anymore. Overuse of close-ups can also trap a director during the edit, when he or she will be forced to use a close-up that's too tight on the subject because there are no alternative shots. On the other hand, compensating for the frame's so-called limits by shooting from as many angles, distances,

and focal lengths as possible is like fishing by bombing the lake and then scooping up the carcasses as they float to the surface. All this information leaves nothing to the viewer's imagination, and it can overwhelm the filmmaker during the edit to the point where he or she loses track of the story and its informing concept.

The filmmakers here approach their craft more sportingly. For them, filmmaking balances somewhere on the spectrum between committing to previous decisions while remaining open to impromptu discoveries. Perhaps more to the point, overshooting takes time, time is money, and so directors are often forced to commit to camera decisions beforehand. In the end, whatever a filmmaker does technically doesn't matter, so long as he or she is understood.

Constantin Costa-Gavras

I work closely with the DP, but of course I act as my own cinematographer. In France the cinematographer just places the lights and the director makes the camera decisions. The director participates in writing the script, and then he does the other writing, which is most important—the way the movie is shot. I'm always amazed at the idea that planning shots is the cinematographer's work. The first time I did a movie in the United States everybody was asking, "What is your DP doing?" I said, "The DP does the lighting and then I tell him the exact camera movements and he or the camera operator does them." Some American directors also plan the shots, and I've always done it because it's part of the writing.

The frame is like writing on paper and using certain words. You use an adjective or a verb or three adjectives, one after another, and with the frame you go in close or very large or go with the movement. It's difficult to explain because it's something that comes from inside, like choosing words. Why do you go to a close shot? I don't have an explanation; it's completely intuitive. There's no logical explanation for how I use the camera, just like writing sentences. You have to show something and why you show it from a distance or move the camera or do not move it is completely instinctive. You develop that instinct but you're not always sure that it's right.

Every story, every scene ends up imposing how you shoot the movie, unless you're Carl Dreyer and shoot only in close-ups, but that's a particular style. You have to know exactly what you want, even when you go to the set

and don't find the same elements you had when you were sitting at your desk. But you know exactly what you want, so you find solutions.

Sometimes you go to the editing room and wonder why you did this or that, but you had to make a decision in the moment, even if you prepared. There's a story I like to tell about preparation. A Chinese emperor asked a painter to make a painting for him. One year later, the painter hadn't come. So he sent someone to ask why he didn't do the painting. The painter said, "Okay, I will do it." He got everything he needed and he did the painting in half an hour. The man asked how much, and the painter told him. He protested, "That much for half an hour of work?" The painter said, "No, one year of work." I think a director works like this.

Mia Hansen-Love

Writing is everywhere. When you shoot the film, the choice of whether to make the frame wide or use a close-up really has to do with some kind of language. Even the edit is like writing. I wanted to find a simple style that didn't show itself. I didn't want to say, "Oh, look, that's my style!" The most discrete style possible means the most transparent style possible—no effects and not calling attention to itself with too many cuts or close-ups.

Many good first films, especially in France, use very long shots, with long lenses, and very few cuts, because the filmmakers think that's more pure. I didn't want to do that, because I can see that they want to show how radical or pure they are. The artistic style that touches me most—in painting or film—looks transparent. It just concentrates on the action and the story, and tries to be free. I was finding my own way of styling the scenes by trying to discover the necessary way to film it.

Eric Guirado

Some filmmakers say we always make the same film, but in *Grocer's Son* (2007) I wanted to be very realistic and stick to the main character and the story. My first feature film, *Quand tu descendras du ciel* (2003), was different; there was more poetry in the editing, and I allowed myself more abstract and poetic images with emotional, rather than just story content. I wanted to be spare in this film, so the shots played out without many cuts, and I had several close-ups of the lead character's hands.

I'm concerned in every film not to show but to make the viewer feel. It's very easy to show something to the viewer, but to make the viewer feel is

more difficult. You can show an actor playing fear or happiness, but you go to another level when you make others feel what that character is feeling. For example, at one point in the film Antoine is finally happy to be in the countryside. He could say, "Oh, I'm so happy today," as he watches the countryside. But I wanted this moment to take place on a feeling level, so I didn't show his face—that would be too easy. Instead, I showed his hand just outside the window of his truck, feeling the wind as he drives through the countryside. We don't see his face, but we feel that he's happy to be here; we feel what he feels.

Bette Gordon

I always shoot a lot of coverage because so much happens in the editing room. So many things draw my attention every millisecond of the day when I'm shooting that I'll often see a performance in the editing that I was not 100 percent conscious of while watching on set. Then I'm glad that I have coverage because it allows me to move back and forth and capture those incredible moments. Maybe younger directors are bolder in the idea that "I'm going to shoot it like this and this is how it's going to be," but I want to get those mini-moments. Sometimes, a gesture, a look, a sigh is important.

I spend a lot of time thinking about the frame, and the cinematographer and I decide together where the camera will be. When I shot *Variety* (1983), we used 16 mm because we could get a camera from somebody. It was all about the neon in Times Square. We needed just a little lighting because Times Square and the Fulton Fish Market were like Las Vegas. I'd take my little wind-up Bolex [camera] and go out into Times Square myself to get a lot of the porn stuff. From 16 mm we blew up to 35 mm. It was really expensive, and we had to beg, borrow, and steal to do that, but we had been invited to Cannes and they don't show 16 mm films.

If I were shooting *Variety* today, I absolutely would shoot on film. It was about the framing, the color, and the light—a story about cinema in a way because it's about the pleasure in looking. You can't shoot that any other way but with the rich color and texture that film affords. That film has been compared to *The Killing of a Chinese Bookie* (John Cassavetes, 1976) or *Taxi Driver* (Martin Scorsese, 1976), and there's no other way to get that certain grittiness but on film. It needed that grittiness to tell the story. Other films don't need that quality to tell the story.

I was able to use longer takes on *Handsome Harry* (2009) because I shot it on digital and I didn't worry about spending money on more film stock. Also, this is a character-driven story, about the unfolding nature of all the characters, so I understood that as in a Cassavetes film, I needed to allow the characters to drive the camera, not the camera to drive the action. I set that out in my director's notes early on, when I discussed looking for a raw, emotional feeling in the film, both visually and also in allowing the camera to run and not giving actors marks that state, "You can only move to 'here,'" but sometimes that freedom is not possible. I've always been so concerned about saying "cut" when I want to go again. So there was freedom on the set that I didn't always have when I shot on film. In fact, they'd have to remind me that I didn't have to yell "cut" so quickly. Even for $74 million Hollywood movies there's never enough time or film or light or any number of things. So I was free in that sense, and I also shot all my rehearsals, which really helps.

It was the first time that I shot HD (high definition) digital and, of course, we had gone through the range of possibilities during pre-production. As a filmmaker who's always worked in the low-budget indie world, as much as I love film—and I do, as well as the collective experience of being in a cinema with the big screen—when I have a passion to tell a story, in the end, I would shoot on HD. It turned out that we could save a lot of money shooting on HD and we didn't have to cater to cameras. We ended up using a D-21 ARRI Film Style Digital camera with anamorphic lenses, and it was interesting because its logarithms mimic that of film. Of course, how much it would look like film was still a consideration, and maybe that was more important to my DP than to me.

The video image doesn't have the sense of texture and feel of film, and video can be too sharp. We wanted intimacy for *Handsome Harry* and, fortunately, we got good deals, and that was another reason for choosing digital. Because it was character-driven, I let my characters set the world and stepped back a little with the camera. At first I thought I'd follow them around because the camera is very mobile, but that's not what I did in the end. We used a still, non-invasive camera style, and it works very well for the film. It's a conundrum of course, because even when it's on video, we're still talking about "film."

Focus was absolutely critical, and sometimes I did have to take again and again, even though time was of the essence; but the anamorphic lenses

made the focus so critical. It was so important for the image to be the way I wanted it, and anamorphic was the only way to achieve that. We had not done our other low-budget films in wide-screen format. Maybe we started out with that ambition for one or two, but as the pressure mounted to meet a certain bottom line, there were other priorities. Is it the number of shooting days? Is it a particular location? Is it massaging your art department? What is the thing that you can't live without—that you feel the path of the story will ride on? It has to boil down to that single element being the highest on the list. A wide-screen format costs more in the post-production, so we've often jettisoned it.

The only problem with HD was in terms of projection, because we're showing it on HD still. We will go to film mainly because HD has not figured that out yet. In a few screening rooms the projection is fantastic, but I can't say that for all screening rooms. In many screening situations, where there are so many choices as to the calibration of the projectors—which are not exact, at least when you get to that final step in film and you have your release print—you can have the same projection, relatively speaking, depending, of course, on the bulb and other things.

Let's face it. I just want to tell the story. If all I had was a pixel vision camera, I would use it. At this point, I am happy if I can make something I feel passionate about and committed to. I can only say that whatever you can afford is right. If money had not been an issue for *Handsome Harry* I might have gone with shooting on film, but I'm happy for the experience of shooting digitally and freeing myself from worrying about takes and the cost, the cost, the cost.

Serge Bozon

I don't storyboard or do camera preparation before shooting a film. Where I'm going to put the camera, how many shots I'm going to take for a scene, where the actors are going to be—everything is improvised—and I do my own framing whenever I can. But there is no single method. I adore some directors who storyboard. I'm just bored when it's planned, and I'm much more excited when I have to do everything from scratch.

There's this false idea in contemporary cinema that to be close to an actor's emotions, you have to be close to the face, so there are just too many close-ups. Like John Ford said, "I don't want to see nasal hairs over twenty-five meters."

La France (2007) was almost always shot outside in the landscape, so what would be the right angle to shoot a scene in any given landscape? Otto Preminger's River of No Return (1954) is shot outside, but there's also something theatrical about it. The frontality of how it was shot creates a leveling and flattening-out aspect, as in theater. I noticed afterward that whenever there's a landscape shot in my film, it's from only one angle. Sometimes the camera gets closer within that angle, but we never see it from the side, only from the front, just like in the theater. That angle is called la rampe, because the theater audience is in one place, seeing from one angle. Yet what we call theatrical in that sense also opens the possibility to capture something distinctive to cinema. In La France the first long monologue in which a soldier tells the story of another soldier is shot from that frontal angle and in a single take, so the actor had no room to maneuver. He had to trust himself, and that intensified the tension in his performance. The wind started to blow very strongly, so the actor had to really go for it. There was even a moment where he interrupted himself and looked around. The theatricality of la rampe gave way to something that doesn't exist in theater—the interaction of the dialogue, a simple way of shooting, and the landscape—which resulted in something powerful.

Gerardo Naranjo

I shot I'm Gonna Explode (2009) completely differently from Drama/Mex (2006). I felt I shot Explode statically, but people tell me it still moves a lot. I didn't hold the camera still, but I felt it was more contained and precise. With Drama/Mex I tried to be chaotic, and I wanted the film's language to show the imperfection of human behavior and the chaos of feelings. Explode portrays the need to release angst. Although everything was also handheld and I used available lighting, what makes this film different is the subjective point of view in the beginning that is eventually erased so that, by at the film's end, we see the crude consequences of that subjectivity.

The biggest danger of this improvisation would be to tell too much, which is the biggest problem with directors who are not clear about what they are saying. Roman Polanski said there is just one precise way to shoot something, not two good ways to shoot it. If you are saying something, you have to say it a certain way. That's why films take so much energy and effort, because you never know the circumstances in which you will be shooting. You get there, and if you're conscious of what you are saying, there is a

precise way of relating that scene and you'll find it. A movie that uses just full shots and close-ups doesn't say anything. The audience can perceive there is no truth in it. But when a filmmaker takes a creative approach to cinema, the level of communication is much higher. That's why there are good movies and bad movies.

Mary Harron

All my films have been shot on film. This new one will be on film, but the project after it will be shot digitally. Everything goes to digital anyway in the edit, so there's not a vast difference.

Mise-en-scène is about the setting, the camera work, and the placement of the actors in that world. So you can rehearse the actors, but you have to see them in that world before you make final decisions about the shots and lighting. You also have to see them in their setting to know what the background of the shot is. It's about people and their relationship to the space. Roman Polanski is brilliant about where he puts the camera in terms of the people in a room or on a boat. It's a very careful arrangement of figures in a landscape and a room.

I usually look through the viewfinder or on the monitor. These days you always have a monitor, although it's probably good to look through the lens. Some people don't look through the lens and are more focused on standing by the actors. I'm in between because I like to be close to the actors and talk to them, but I do like to look at the frame. If you're on the same page with your DP, you don't have to adjust the frame much, because somehow they get it. I also was reading that Roman Polanski said he likes to get the actors into the location and have them run the scene. Then he blocks it and shoots it. But it's hard to do that with most film schedules because you have to pre-light.

How you frame depends on what kind of film you're making. When we did *American Psycho* (2000), we used a very wide angle and Super 35 mm film so we could have it wider, because it was about the characters within their setting as much as the characters. The set design was very important—the things, the objects, the apartments—they were all part of the story. So it was important to use them like Stanley Kubrick or Polanski—shooting with a wide-angle lens and deep focus, so you could see everything clearly.

That wasn't true of *The Notorious Bettie Page* (2005), where the most important thing was a sense of period, so we hardly used any modern lenses.

We had no long lenses, no telephoto lenses, nothing closer than a 50 mm lens. Basically we used the range of lenses you had in the fifties. A lot of *I Shot Andy Warhol* (1996) was handheld or on sticks, no Steadicam, no stuff on tracks, but some dolly shots—mostly handheld and simple, because of money, and it felt right. So the story dictates shooting style.

I shoot a lot of coverage. You're not usually allowed a lot of takes, only in the big scenes, like in *American Psycho* when he's confessing on the phone, and we did fifteen, sixteen takes. If the actor wants to do more takes and it's a crucial scene, I will do that, but mostly I try to move on after four takes.

Teona Strugar Mitevska

I always storyboard, and we follow it. When I write the script, I know exactly how I want to shoot it because there's only one way for me to deliver what I'm trying to tell, so the storyboard is just a tool to make sure everyone knows exactly where we are, they don't ask me too many questions, and it's quiet on the set. Sometimes miracles happen during the shoot, and you get an opportunity to shoot something differently from your original thought. I'm a slow thinker, so to be open to changing because of these miracles, I must be 100 percent prepared.

I have friends who shoot on HD and say it also gets a good quality, but we're not there yet. What's missing, for example, is that the black is too black and the different shades of gray that the eye detects and can be seen on film are missing, so film comes closest to the reality that I see. I know when the time comes, I will go to HD, but for now I love film.

For every scene there is one place for the camera, just one, and it's important to find it. I tried to stay still for *I Am from Titov Veles* (2007), and when I did move the camera, I kept that still feeling because I needed that to tell the story. I had no other rules. I used to be a graphic designer, so I have an obsession with harmony and balance within the frame, and when I work with the DP, he or she does the lighting and the framing is shared between us. The frame is also emotion, so you frame a particular way to serve the emotion or experience. You can't frame mechanically; that choice is a tool to add to the entire emotional experience of the film. Each frame is part of the dynamic or line of emotion the film follows. For example, if you stay in a wide shot for a scene, for the next scene you have to make a transition by framing in a certain manner that will intensify the emotion of the previous scene and continue that emotion within the next. Everything

is so connected within the form, every single element. It is about technique but it's also about intuition, which, again, is connected to emotion, but it's also very much about mathematics, because behind the emotion is also mathematics.

Özcan Alper

I had been told to shoot *Autumn* (2008) on digital because I didn't have enough money, but this film wasn't meant to be shot on digital. Actually, the next film has a different feel. HD has its own advantages, but if you really want to come up with a good result, you have to spend a lot of money in either medium. If you want quality HD, you still have to put a lot of money and effort into it in order to get a filmic quality.

I knew exactly what was being framed for every single shot of *Autumn*. I knew exactly what and how I wanted to shoot before we even started shooting. I planned everything ahead of time, but I don't use storyboards. I wrote everything on paper—how the actors would move, how the frame would be set—and I used my notes from when I had scouted locations. Writing and looking for locations took four years. I would find locations and then go back to the script and rewrite. First of all, I knew the Black Sea region, because it's where I'm from. I went there and examined the seasons thoroughly. Since I knew what would happen in the landscape and when, I set the timing of the film to follow the seasons. Also, I photographed everything, not professionally, just as a document to look at when I wanted to work on particular shots. Then I went to all the locations with my DP and art director, way before we started shooting the film. I told them about what kind of light I wanted, and I tried to work with natural daylight as much as possible. Even interior shots stuck to the daily cycles of the natural light. So if there was a particular light coming in the window in the morning for half an hour, I shot within that half hour. Of course, I used reflectors, mirrors to fill in, but it was important not to rely on that. I also told my DP about paintings that inspired me. For example, when we filmed on the Turkish coast, I told him I wanted the kind of light that was in a particular landscape painting. In the beginning, it was more about executing what I had in mind, but, over the course of time, the production designer and DP started to collaborate and bring their own ideas.

When I was making *Autumn*, I wanted to form my own sentence that would contribute to cinema's language. Although the film talks about a

region in Turkey, it's basically a story about love, death, and immortality, and the final shot represents that immortality. In the final scene, although Yusef is having trouble breathing, he plays a wind folk instrument called a *tulum* that's like Scottish bagpipes. I was trying to play with that image to signify the search for immortality. Yusef is composing a requiem for his own death throughout the film, so we see that finally he's playing that instrument, and although the song is about his death, it's also about bringing something back to life. I played with this idea, then I wrote it on paper, and I started thinking about how to visualize that sentence. Finally, I came up with this image where he starts playing and then the camera moves past him and out the window to show the procession for his funeral below. So time shifts to the future within a single, continuous shot without cuts to suggest that transition. That shot was indeed the most laborious for me. I gave it so much thought. Maybe a few people miss that, but I wasn't worried. A couple of friends who saw the first edit suggested that we zoom into the funeral and show the mother. But to me, that felt like writing a poem and then interpreting it afterward.

Anne Le Ny

For the particular topic of *Those Who Remain* (2007), I was inspired by British cinema, like the films of Ken Loach, because the risk with this theme is to become melodramatic. I wanted the camera work to be simple with absolutely no effects. I didn't want too many close-ups so the audience would be taken hostage, as one could say, forcing them to feel something. I wanted them to have the possibility to be with the characters or to withdraw. That's also why there's not much music in the film.

There are a few deviations, but when you follow a shooting style, you cannot suddenly change it, except for an opening shot that is a little different, in another tone. And as I wanted everything to be realistic, it also means that the film is not beautiful. The light in the hospital is not beautiful; he lives in a suburb and takes buses, which is also not glamorous.

Another decision was not to allow the viewer to see the sick partners, and that choice comes from my experience as an audience member. The most interesting theatrical productions of *Hamlet* don't deal with everything in it, only with one aspect of the play, say the psychology, and they take everything from this small angle. Yet all the rest still exists because it's within the play. When directors try to highlight everything, it doesn't

work well. My story deals with death and eroticism, and I'm well aware that I'm not Shakespeare, so if I didn't want to be superficial, I had to keep to a narrower angle and trust that whatever was out of the frame would also exist.

Charles Burnett

You can't have good photography without locations, because everything in the background is so much a part of the visuals and everything else. I work together with the production designer intensely. I started out wanting to be a cameraman, so the camera person and I talk about how I see it and specific images I want. You start off by looking through the camera, and then you see the dailies, so once you realize you're all in the same boat, you don't necessarily look through the viewfinder every time. I can pretty much visualize what the camera person is seeing by looking at the lenses he's using. I don't look at the monitor because it looks like something else altogether.

When I was doing a television film, *Nightjohn* (1996), I used the monitor for the first time for a little girl's long scene. All of a sudden, I realized the scene had been over for a while but she had kept repeating it. It was like watching television for me, so I'd forgotten I was the director and needed to call "cut."

When you imagine something or you get to a location and see something, the frame never really fits properly because your eye still has peripheral information. But film doesn't work that way—you cut out so much that it defines the area you're looking at—and you have to accept that. I see the shot in my mind, but I can never get it in the film because I can see higher and lower and more to each side. So I look at something without looking through the viewfinder and think, "This would be nice," and then try to do the best I can with framing. And I always shoot coverage so I don't have to end up chopping the film to make it work. I know time is going to be an issue, so I have to cover myself.

I've worked with high-definition digital video. There are differences in texture and how you shoot it technically. If you're doing something really big and professional on digital, you need a monitor, and the bigger the monitor, the better the lighting, so you drag that thing around. You see some nice stuff on digital, but I'd rather use 35 mm film. I like the way it looks; digital hasn't got there yet. There's more information to exploit on film,

and if you're doing special effects and blow-ups, you really see film's values, because you don't get the pixilation of digital video. If stuff is in focus, you get a clear-cut image with film, and there's a lot more to play with for the timer, the person who grades the film.

I'm also a fan of the old format, the full aperture where you see an almost square frame like the old 35 mm. I thought that was one of the best formats for film, composition-wise. One, because it's like the 35 mm still camera, and two, because I feel an affinity to the way older movies composed shots in 35 mm.

Agnès Jaoui

Sometimes you think you have the perfect location, but what you see in the frame is not what your eyes see. I always look through the viewfinder, but, of course, what you don't see is more important, and this is what is so joyful in shooting. Often you see a movie; you remember it and want to show it to your best friend or lover. You wait for the big scene, and it arrives—but it actually doesn't exist as you remembered it. Either there is nothing or just a little shot, and this is wonderful! In Ingmar Bergman's movies and Woody Allen's movies inspired by Bergman, you often don't see the main character, or they put the main action in the background, as in theater. They do that so you can imagine. Of course, whatever you imagine is most important.

Claire Denis

Of course I look through the viewfinder, and I know where to place the camera, and I share that with the DP. What I don't like is the monitor. I like to stand by the camera while shooting. I don't like to watch the image on the monitor because I feel away from the set, I feel alone. When I'm next to the camera and I move, I think I can physically direct the scene.

I know no framing that does not suggest what is not in the frame. There is no other way. But to say that whatever is framed out is more important than what is framed, this is, excuse me, bullshitting. It's really too sophisticated for me to say that what's out of frame is more important than what's inside. Cinema is simple, you know. You don't have to pretend things like that because it's not true. If it was true that what is outside the frame is more important, some people would be more interested in what is outside the frame. Why frame then? It's words; it's not real.

Until now, I've used film stock for my feature films. Honestly, for me, it's an economic reason. For a film like *White Material* (2009), film was cheaper and better qualified than digital for the kind of light we had, day and night. Digital would have meant spending much more on the timing of the film and much more on the lighting. We made *White Material* with almost no artificial light. So, economically, it was a better choice.

And it depends on what kind of image you do. If you make an image of a room in the winter in Paris, then digital needs less light to capture that image; but if you go in the white light, in a huge landscape, as in Africa, film is better. I think it was cheaper to make it on Kodak, absolutely.

I edited digitally on the Avid. This also changes a lot of things, and you have to pay for printing the takes onto film and everything, but, of course, digital editing saves a lot.

Jia Zhangke

The visual esthetic I choose has to do with the subject matter. For example, when I shot *Pickpocket* (1997), I wanted to capture the chaotic street scene. So I wanted a handheld camera to showcase people running through the frame and present that sense of reality, not only with the visual images, but also with the sound. Films I had seen in the past were superficial and so similar in their realities that I wanted my film to represent realism.

My second film, *Platform* (2000), was set in 1979 to 1989 and told the story of a touring performance group. I shot this film in 1999 and decided I could capture this story at a distance, being objective. Therefore I chose a quiet way to deal with the cameras so it was more about the characters, almost as if we were observing them.

To me, the four corners of the frame open it. So it's not limited, and the other important component is the interaction you create with the shots and the frames you put together. For example, the portrait shots in *24 Hour City* (2009)—those long takes with individuals standing before the camera for a long period of time—captured the subtle movements and emotional changes in these individuals. And it's almost as if, suddenly, these individuals are not the ones being observed. They are actually involved in an interaction with the camera. By extension, when the audience looks at that, the audience interacts with the camera at the same time. This sense of an interactive dynamic is important in the shots and frames that I design.

Kiyoshi Kurosawa

Experience has taught me that I can't film everything; there's a limited amount of space you can get on camera. But when you get to a location or set, you're confronted with 360 degrees of possibilities, so the question becomes, what do you cut off, what do you eliminate? Once I decided what I won't show, over the years I've figured out ways to use what I won't be showing in order to shape what's happening on-screen.

My guiding principle is always to be aware of the appropriate distance and appropriate angle of the camera. Maybe because I write my own screenplays I have the luxury of satisfying my storytelling desires and influences during the writing, so when it's time to film that script, I'm almost like a documentary filmmaker who records the story. It's certainly about tone and feel, and I guess it's neither intellectual nor emotional. It's the combined effect of the event and what it generates.

Jerzy Skolimowsky

I am experienced enough not to need to look through the viewfinder. If I know what lens is on the camera, I know what's in the frame and as I see the camera move, I know what's being framed. Rarely am I surprised by accidental framing. I know exactly what's going on, and I can always correct it in the right moment. I was happy with what I got from my DP for *Four Nights with Anna* (2008). I chose him because he's a painter, so we had this common knowledge of aesthetics and framing. The way we got together was funny. I called him and said, "I'm considering you for my film. Would you like to come to my place and talk?" So he came but we didn't talk. I told him, "I think it would be best if I played you a piece of music, and either you'll understand what I mean or you won't." I played him John Coltrane's "Olé," that wonderful twenty-minute piece with rhythm and emotional drive. Something is going on but it's discrete, and, at the same time, it's suppressed. The guy got it immediately. "This is how I see the film," I told him, and he said, "I understand."

Anna wasn't an aesthetical setting, but I wanted aesthetical framing, so that was a conflict of interest. I told the DP, "You have to make it aesthetical. I don't want any dirty frames." I hate overcrowded frames or something hanging from the frame. I wanted it to be clear in the nicest possible way but not static, so the camera is always on the move.

Brillante Mendoza

Digital technology plays a big role when you're doing a lot of films and these kinds of stories. *Serbis* (2008) was shot on film, but we made it look like a video, like a documentary, because when we viewed it, one of my actors said, "I don't see the dirt the way we saw it when we were filming." Shooting on film and then making it look like video made it look more worn-out. I was also making a statement—you're watching an old film that eventually will play in the kind of cinema house that is at the center of the story. And I had the actual film burn at the end of the movie because it's possible that this type of film would burn in an old cinema house.

Shooting in HD gives the filmmaker a lot of freedom in terms of special effects and movement, whereas shooting on celluloid gives you an instant depth of field that HD doesn't have. There are stories and concepts that should be shot on video and others that should be shot on film. Technical or fantasy films like the *Star Wars* series or the *Harry Potter* series should be shot on video, whereas panoramic films like *Out of Africa* (Sydney Pollack, 1985) or Wong Kar Wai's films should be on celluloid because of their grandeur and the overflowing of deep emotions.

I think digital filmmaking will push itself to the limit and maximize its high-definition potential. Advancements will be made to the point where you can use available light, which will be to the advantage of realist film-makers like me. But film shot on celluloid will always bring the audience into a different time, space, and perspective.

Courtney Hunt

It's all about serving the story. If it's a story about a nineteenth-century restaurant, then you shoot and light differently than what you'd use for a gritty, upstate New York trailer. When we meet Ray in the early part of *Frozen River* (2008), everything is so off kilter in the way it's shot that you feel her frenzy of "What am I going to do?!" I wanted Reed Morano Walker, *Frozen*'s cinematographer, holding the camera. It was wobbly and unsure because I want the audience to feel the character's loss of footing. And when Melissa Leo, who plays Ray, goes to Leila's (Misty Upham) camper and shoots it with her gun, Leila comes out, and then they decide to go on a smuggling run. It's the setup scene, so I also wanted that to feel like you're thrown a curve.

There's an action component to this film as well, which was guided by those John Ford movies with a feel of the frontier's open emptiness, and we framed the action scenes that way. So it was a matter of "This is civilization, this is a door frame, but the rest of the film is the frontier, lawless, crazy, and you don't know what can happen." When the son and mother were outside having an argument, I kept reframing it for Reed. I wanted the single-wide trailer to be a character in that situation, so if Ray was at its side, I wanted that frame half filled up with trailer. I wanted that single-wide to be in your face all the time, so the audience feels stuck—"I've got to get out of here!"

I looked through the viewfinder all the time. Reed set up beautiful things that she brought to the table, but when I say beautiful, I don't mean pretty. For example, we couldn't afford that device where you put a car up on a trailer and the actor pretends to drive and you can place the camera anywhere. That limited the number of angles we could have in the car scenes. *Thelma and Louise* (Ridley Scott, 1991) has all these grand angles, wind in their hair and two-shots. We didn't have those bells and whistles. We had Reed and me in the back seat, or Reed would take Misty's seat and shoot a side shot of Melissa and vice versa. We had to keep doing this to avoid the risk of visual boredom. We had a car mount for only one day to get a two-shot from the front. It becomes a technical thing, but if you have a camera and you are committed to telling the story, you can tell that story with that camera, and you don't have to have so many gizmos.

Lance Hammer

I had a clear idea of what needed to be accomplished visually and compositionally for *Ballast* (2008). I'd never met [English cinematographer] Lol Crawley, but I'd seen a DVD of his work on a short film, and it was precisely the aesthetic I was looking for. We talked extensively over the phone because I didn't have money to fly him out. I gave him the script first—a lot of it is implicit in that script—and we exchanged photographs and fumbled through language. Since we fumbled in the same way, we connected. I picked him up at the Jackson, Mississippi, airport, we got in a car, drove out to the Delta, and looked at everything and photographed. We never separated, and he became my collaborator. It was pure luck. Ultimately he was producing, directing, and casting with me because I had to have control over what I wanted to do photographically, and the best way to have control over that

is when the cinematographer completely understands what you're trying to do and does it.

Ballast was balanced between composed shots and improvised shots. The formal shots dealt with composing a frame in a more static way, even though it's a handheld camera. Lol would stop, hold it and compose a frame, and it usually had to do with something happening in the sky. There's a shot of Lawrence standing as the sun is setting through the clouds. That was happening as we were shooting, so we stopped everything to compose that static frame. It was more like painting, where you have formal arrangements. The dynamic shots were all about the rhythms of humans and things moving in three-dimensional space against each other, including Lol, who operated the camera and is basically the other actor in the scenes. He had to anticipate the motions of where someone would go, and the actors always did something different in each take. They were encouraged to improvise, so Lol had to respond intuitively by anticipating what they were going to do. This style becomes more about space and time than a two-dimensional flat image.

Catherine Breillat

It's an abomination when the DP decides on the shots instead of the director, especially in *Bluebeard* (2009). I set out the framing to be precise down to the inch. It depends on the sets, the locations, and how the bodies fit in with those locations. For example, the scene where the big sister appears over the head of the younger sister when the father is lying dead in the bed was set up with an extremely precise movement of the camera in order to frame the bed in a specific way. While we're shooting, I'm often talking, giving instructions to make the actors move in the precise manner that I want. When you see the girl, Bluebeard's wife, in the small room and he appears, then I would use different sounds. When I wanted him to move into the room, I would say, "Eee." And when I wanted her to appear, I would say, "Ahh." That was a very difficult scene to frame because of the tiny room and doorway. Bluebeard was supposed to be so huge where she appears in a tiny frame.

Andrew Bujalski

Matthias Grunsky, who was the cinematographer on all three of my films, has an unusual amount of influence, particularly because we trust each

other more with each film. We'll often talk through how we'll shoot a scene and what kind of shots we're going to get. He's meticulous and prepared, much more than I am. He'll have made out a secret preliminary shot list that he hides from me, but we've never storyboarded. On the first film, I thought, "I don't want to storyboard. I don't want a shot list. I just want to show up and figure it out organically." But on *Beeswax* (2009) I thought about storyboarding for the first time because I could always throw it out. I didn't do one, but I wouldn't rule it out in the future, partially because the nature of my films has changed a little. *Funny Ha Ha* (2002) ran on nothing but that organic quality, but *Beeswax* has a legal structure in the story, so its overall structure is different. I don't know if that's evolution or just particular to this film.

On a technical level, we've also gotten ever so slightly more ambitious. We had nicer prime lenses on this film and this is the first film where Matthias had a full-time camera assistant (AC). He always operates; he operated on this film too, but he had an AC with him. The poor guy didn't have any help on the first two movies, but whenever there was a need, we'd bring someone in on a day-to-day basis. It's a tradeoff. We set out to make a prettier film with *Beeswax* than we've made in the past, and the cost of that is having a full-time AC, which means another person. We had a full-time crew, including myself, of eight people, and for more complex days, we had a ninth person. The challenge with these films is they are all so small and intimate, and we often shoot in cramped apartments, so you don't have many places to fit people and the camera. Again, I credit Matthias for finding so many frames, because there aren't that many places to go. I try to keep things moving around, and I love a frame where, if I'm shooting someone, someone else's hand creeps into the frame, and Matthias knows that. It's so useful in editing because a shot comes to life when something creeps in.

Holding a shot focuses the mind a little bit, so sometimes using film stock is inconvenient, especially when a take isn't quite in the zone and you want to go again real quick. You wish you had video and could keep going. I'd always wanted to make the DVDs of my films special, so I did way too much work on esoteric special features for the *Mutual Appreciation* (2006) DVD, like the eight-minute short we shot on video. In a way, it was my opportunity to experiment with what it feels like to shoot in video, and you could sense the difference on set in terms of all the ritual around starting a film camera rolling. The air in the room felt a bit different with

video, and everybody kind of knew, which was surprising. You still have the same ritual of "Okay, everybody, quiet and action." Maybe it was just in my head, but I think the room felt different with video because there was less stuff around.

Melvin Van Peebles

I remember a French film I shot that won at some festival where they were talking about digital and will it come. Some people were saying, "This will never work," and I said, "By the way, guys, I shot this film digitally." Digital media takes light faster so you don't have to use as much lighting. But there are two components of lighting. Hollywood is in Southern California because back when movies started, they needed the sun, so the stages had no roofs, and actors talked with exaggerated expressions, not because they were stupid, but to make sure everything registered on the film stock. When they started shooting digitally, even on early television tape, they didn't need as much light, and you started getting that flat look. So one component is light, but the other component is modeling through lighting, which gives the images shape. That's why I use the same lighting setup for digital as I would for film. You can't light digital with just two lights, even though it will shoot anything and so many registers. People say, "Gee, golly, I could do away with the extra lens and lights," but then it won't have the texture and modeling.

Ivo Trajkov

Creating a strategy is most important. For *The Great Water* (2004), we chose wide-open landscape shots, but there is no landscape in the backgrounds. There is a wall, so those shots point to the characters' lack of freedom. We chose close-ups for the landscapes that we found in the human faces. So this was one of the framing strategies for the film. We found we hated medium shots, because they didn't go close enough to see the emotions in the eyes of the characters, and they also weren't far enough away to express that these characters are in an enclosed space.

Given the history of Eastern European cinema, the first choice to express what we needed to say about this tough and brutal childhood would be black and white, grainy, with a handheld camera. But when you recall your childhood, it doesn't matter how many problematic moments you remember, you always feel sentimental, so we decided not to go with

the cold colors and shaky camera that you expect from this story. We went with the opposite—nice, almost sepia coloring, a nice remembering of bad things. We tried to find this contrast inside the film—shooting beautifully a subject that is ugly.

I hate storyboards. I feel they trap me in the first idea. Sometimes you have the storyboard without even knowing the location or how the actors will express that location when you place them there. The actors are influenced by the space, so I'm always afraid of being trapped in my first idea. You have that storyboard, that frame, and you use it because you are under pressure. I'm afraid of not listening to the reality, of not being open to the moment, so I always throw away the script, because it becomes about "show me the scene." We've already had rehearsals and the assistants have the script, so I want to stay as open as possible to catch that surprise. If that doesn't work, you can always go back to the script. The point is not to be affected in the moment by what you were thinking two months ago.

I just finished a film we shot on the old-fashioned Panavision Cinemascope, with optical post-production, and it took double the time to shoot it. I read the script and had a strong feeling that it was a period film. I thought, "How can we bring out this feeling visually? What if we do this an old-fashioned way?" Of course, we suffered, because we didn't have the budget.

With Panavision Cinemascope, changing lenses took ten minutes. Panavision Cinemascope will probably be among the first old-fashioned cinema forms to die. You can have that same aspect ratio in Super 35 mm film, but it was about shooting with anamorphic lenses that belong to a different era of cinema and creating a whole different space. Just changing the focus is almost like zooming in and zooming out because these different lenses move inside of one lens. So suddenly the whole image is pumping, as when you watch John Ford films shot in Cinemascope, another format that is gone because no one wants to shoot that way these days.

I have worked with HD, but not for a feature. I did some tests because my next film probably will shoot on a Red One digital camera. There is definitely a different aesthetic with a digital image, as well as differences in the equipment and technical parameters. It's almost close to what we have in 35 mm, not aesthetically, but it's equal in the matter of quality. Of course, you work in post-production to get the digital image closer to the film image these days, at least for nonprofessional viewers.

It's hard to describe the aesthetic differences. Digital is sharper, but you can correct the depth of field by using film lenses on a digital camera. So suddenly, you have the feeling of film because of the depth of field you get with film lenses. Again, that's one step closer to film. Also, shooting digitally might fit the form of your story, and for some stories it's even better to shoot on webcam or cell phone. If you are able to do something that fits the story, subject, and expression, then it's is the right choice. We are richer now because we have more tools.

2

Cinema and Sound

As the last major element to be added to the language of cinema, sound was its final artistic frontier, and, in some respects, it still is. When sound was first added to moving images, it was widely regarded as an aesthetic tragedy and a business threat. Before, a good love story could be seen all over the world. No one cared who played the parts—Czech, Russian, English, American, French, or Japanese actors. Language wasn't a barrier.

A few contemporary purists still contend that cinematic art ended with the advent of sound, but most people believe that the addition of sound was a new beginning, one that offered possibilities of more realism and expression in a more complex medium. Sound can work powerfully in a film and speak to audiences in a poetic and emotional way.

Cinematic sound basically consists of voice-over narrative, lip-synch dialogue, dubbed dialogue, music, special effects, ambient sound, and silence—the absence of sound. Diegetic sound is part of the film's internal narrative space and includes dialogue and environmental noise that affect our sensibilities and sense of a film's time and place. Nondiegetic sound does not belong to the film's internal world. It includes sound effects and music intended to set rhythms, deepen understanding and empathy for a character, and influence mood and emotion. Even a single nondiegetic sound—for example, a song playing softly on the sound track—can totally transform the way a viewer relates to the images.

At times, direct sound, which is recorded at the same time as the images, is not deemed sufficiently expressive to render the full load of the reality being represented, so certain sounds are emphasized or new

sounds are added during the edit. "Looping" (aka additional or automated dialogue recording, or ADR) is the process of recording new voices or re-recording voices, that is, when an actor must re-record lines he or she spoke during filming in order to improve audio quality or make dialogue changes. "Dubbing" refers to the recording of voices not belonging to the actors because the film will be viewed in another language without subtitles. Sound effects, as opposed to dialogue or music, are artificially created sounds or sound processes used to emphasize the film's content. "Hard" sound effects—doors slamming, guns firing—synchronize with visual images. Background sound effects—street noises, waves washing ashore—do not synchronize with the images but can impact powerfully on the reality and atmosphere of a setting. All these sound effects must be recorded and processed during sound editing. The sound designer gathers all the film's sound tracks and puts each sound in its place, thereby re-creating the film through sound; then the sound mixer's job is to control the dynamics of each individual sound.

Generally, sound is used to identify and underscore an image or to juxtapose and even contradict that image. For example, a close-up on a face can be paired with a sound relating to an off-screen action. A film's visuals may appear real, even hyper-real, but its sounds can be abstract. Some filmmakers elide real-life direct sounds into music, playing off the contradiction between visual reality and aural abstraction.

Music conventionally has less reference than a film's images to the natural physical world, so many critics consider music to be more pure than cinema and other visual arts. Yet both cinema and music manipulate time and space, create rhythms, and convey powerful emotion. Filmmakers may even find inspiration for a film in the emotions evoked by a piece of music, rather than in literature, painting, theater, or photography, which cinema more apparently resembles. And many observers believe that the most deeply involving films often make the most creative use of sound's expressive possibilities.

Most art filmmakers regard image and sound as equals, with some, like Lucrecia Martel, even giving sound precedence by allowing it to shape a film's action and emotion and lead the images. Unfortunately, cinematic sound's full potential is infrequently explored and often abused—for example, when dialogue is used without discretion, simply to deliver exposition, or when loud music is used to shore up a scene that doesn't

stand on its own, or when ambient noise and sound effects are overdone. And although silence can be effective, too many directors shy away from it, as if a "dead" sound track will alienate viewers.

As many filmmakers note in the following pages, a film expands in scope and power whenever its sound is released from the role of slave to the image, as Jean-Luc Godard once described it, and becomes an equal partner.

Catherine Breillat

When I shoot on location, I use location sound and dialogue from the shoot almost exclusively. And except for the music present in the scenes, I almost never add it on later. What I do have are very low bass frequencies that are barely audible because these frequencies calm and arouse the audience's imagination. It takes the audience out of the realm of realism and into the subjective realm.

Mia Hansen-Love

When directors talk about their films, they often discuss the different aspects—editing, shooting, camera work, directing—as if each one were separate from the others. They talk about sound that way too, whereas for me, all those aspects form a homogenous unit, so music has to be an organic part of my film. There has to be an organic necessity for using music in a scene, and in every scene of *All Is Forgiven* (2007), with only two exceptions, the music is being listened to by a character; so in a sense, the music comes from within him or her.

I knew I didn't want to work with a film composer, because I'm allergic in general to film music. Conventional film music underscores emotions and explains the film, but to me, a film has its own music. I like the idea of music that opens doors to the film instead of merely explaining things, music that adds additional nuance and becomes another character.

Lucia Puenzo

Sound is absolutely fundamental in cinema, yet many times, especially when you're running against time, image tends to be given more importance. That is often an error. Even when we were running against time on *XXY* (2007), whenever we stopped filming a scene, we recorded the ambient sound thoroughly before I'd move on to the next scene. When we reached

the sound mix and editing stages, we had a lot of sound material, and it was pure gold. It makes a huge difference when you don't have to insert all these fake elements in the sound. Lucrecia Martel once told me, "If I could give you one piece of advice it's to be very careful with sound, because it can change your film for better or worse."

Many films don't seem to have a big universe around them because their sound is flat. If you have richly textured sound, even in a film that is not perfect, that film can become interesting because something is going on with the other senses. So we worked hard on the sound, even though it seemed ridiculous that our sound budget was too large for such a small film, but we had an exceptional sound mix.

On the other hand, I didn't want too much music on the sound track. Sometimes real life has no music, so I like when there's little music in a film. I had music only at the end of XXY, an Argentine singer who I felt represented Alex. I told the musicians that I didn't want to remember the music after the film was over, but I wanted an emotion to arise from the music, so we worked with it that way, as invisible music.

Anne Le Ny

I used the song "Where or When," sung in English by Bryan Ferry, as a little trick in Those Who Remain (2007). I didn't allow myself many tricks; there are three in that film, and this was one of them, not visual but aural. When you give yourself a rule, you can break it because you shouldn't respect your rules too much; otherwise your film becomes theoretical. Ferry sings it elegantly, without embellishment. The song begins on the sound track before the scene where Emmanuelle Devos's character is listening to the car radio, in order to join that scene to the one before. I also wanted a certain length to the song, so I had to start it in the shot before, and it becomes a moment as well.

Eric Guirado

When you are raised in the countryside, as I was, you develop an acute sensibility toward the light and the four seasons. In the town where Grocer's Son (2007) is set, it's possible even to distinguish the seasons by their different sounds, almost to the point of different months of the year, so we worked a lot on ambient sound. Some people say there are daytime ambient sounds and nighttime ambient sounds. I go even further. There's a different ambient

sound for each hour—for example, different crickets at eleven o'clock, three o'clock, and five o'clock. We worked a lot on that, and, of course, nobody hears, but I think it works for the unconscious level of the film, which is important to me. You work with what's visible and audible and also to get what is invisible and what others don't hear, so I work with elements no one will see or hear but of which they're aware on another level.

Scott Hicks

I'm always conscious and meticulous about sound, even in the documentary sphere. When *Glass: A Portrait of Philip in Twelve Parts* (2007) is viewed with its full Dolby surround-sound mix, it's colossal. From the outset, I said this film has to have a fabulous sound track because it's about a composer. One of the huge pleasures of editing the film was to have that vast garden of music to romp through. I could choose almost anything from the Philip Glass catalog, but I tried, in conjunction with the editor, to choose elements that resonated with the parts of the story that were being told instead of just having a gratuitous collection of Philip's hits.

I couldn't rely on the sound I would get on the camera. I had to have a sound recordist on the set with me all the time to get the voices and the ambient sounds. After we'd done something, I'd ask, "Did you get the room atmosphere, did you get the sound of those grasses in the wind, the sound of the ocean? Make sure you get those sounds." I'm always collecting sound, because when you work in the amazing soundscape of the Dolby world, all these things come into play in any film.

I used to sit through every stage of a sound mix of my films, and then I realized that some parts are best left to the technicians, so long as they leave me choices. They do all the pre-mixing, and then I review the material and say, "We need to do more of this or less of that." Now I check it in stages, but when I started out, I thought I needed to do everything.

You get what you pay for, no doubt. Also, if you work with people who know you, you have a relationship of understanding. The picture editor for *Glass*, who takes enormous pride in the end result, was also enormously involved in the sound, because by the end he'd imagined this world as much as I had. I did radio interviews last week, and one outlet played sections of the film on air. They didn't even play performance footage. They played Philip making pizza, talking about composing, Philip on the roller coaster—screams, rattles, and rolls—and some of the *Koyaanisqatsi*

(Godrey Reggio, 1982) music—all different bits and pieces that were mostly interactions with the camera. It made really good radio and made me wonder if there's a version of this film that I could condense down to a radio story.

Serge Bozon

All the sound in *La France* (2007) is natural, except for the bombs you hear when the raft crosses the frontline. Everything else was taken live, and I try to avoid too much specialization of sounds during the mixing process, that is, using different tracks for each element of sound. I mix everything at the same time so one sound doesn't come from one place and another sound in the mix comes from a different place.

It was important to record the singing and playing live, because my movie is not a musical. My musical tastes are often linked to amateurish, nonprofessional inspiration, so that's why it amused me to use extremely commercial pop songs. I wrote the lyrics and someone else wrote the melodies.

The singers are just ordinary soldiers, not professionals, so they sing out of tune sometimes, and it's fresh and amateurish, even more naked. At the same time, they're striving for something ambitious, because the songs have multilayered harmonies, and it was difficult for the actors. It's like a well-made action scene, where the viewer wonders, "Is he going to succeed?" In my film it was, "Are the chords going to break?"

Constantin Costa-Gavras

For a few years, we've been using sound in a dramatic way to dramatize some scenes or during most of the movie, like an earthquake or a tempest about to explode. Sound can be used that way for a moment where it's necessary, but it often becomes a trick. Silence is sometimes best. Some filmmakers have music all the time—boom, boom. But the more music you put in, the more you destroy the film, because the music is another character and it has to take the same road with the other characters. If you overdo it, it kills the other characters. Music in cinema is instinctive, and you decide on that during the editing. Even during the writing of a scene, I can think, "The music comes in here," and during the editing, I'll put music in the scene to see how the image reacts in front of that music. Sometimes the image kicks it away; sometimes the image loves it.

Teona Strugar Mitevska

Ambient and direct sounds are most important, and I write all the sound
indications in my script. Since I have already been on location, I know what's
there, so I try to get as much original sound as conditions permit. Of course,
sometimes it's not possible, but for *I Am from Titov Veles* (2007), I worked with
a French sound recordist who would go back on our free days to re-record
ambient sounds and silences. We used so much ambient and direct sound,
so many atmospheric sounds from the town of Veles, and it was beautiful
work. This film's sound is a symphony. There is actual music as well, but
sound can be treated like music with its connection to emotions.

Afrodita, the lead character in *Veles*, doesn't speak, but she has a voice-
over narrative. I had this crazy idea to record it on location, which didn't
work, of course, because her words are very internal. I re-recorded her
internal dialogue many, many times, and in the end we put the micro-
phone so close to her that you could hear every little sound one produces
between words. This created an internal and intimate effect, but it took
time to find it.

I was there for the sound mix. I'm present during every phase, and
also, because the film is so personal, so much connected to who I am,
usually the people who work with me insist that I'm there.

Bette Gordon

I love how sound can shape image. Directors like Jacques Tati understood
sound more than anyone. For example, you can use sound to get people to
look at a certain area of the image. Tati reversed perspective in one scene
where the dialogue took place in the foreground and a ping-pong game was
in the background, but you actually listen to the ping-pong sound and can't
hear the dialogue, so this directs your eye to the back of the frame.

Sound and off-screen sound are very important, and I've had the great
fortune of working with a brilliant sound designer, Skip Lievsay. He's taught
me so much about how to think about sound. It's surprising how little you
use of what you recorded during the shoot and how much of the sound you
reconstruct later in the sound design; and Eugene Gearty, Skip's partner, is
brilliant at re-creating things to suggest a certain presence. Most of what
you hear in movies is not what was recorded when the film was shot, but
they create post-production sounds beautifully. Of course, I try to use as
much of the natural sound as we need, but many times we reconstruct and

re-record. Everything's on computer now; it's amazing where we've been and where we are now.

Andrew Bujalski

My films have been pretty straightforward in their conception. I went to Harvard as an undergraduate, where they have this tremendous backbone of observational documentary. So we've always approached sound that way, and I've always wanted to get as much live sound as possible into the films. I've never looped a line of dialogue, ever. There are some sound effects where we needed them, and sometimes it seems useful to sweeten something or work in sounds that weren't recorded in the room, and work goes into that. Probably each film has been slightly more designed and elaborate, but in any of my films, 85 percent is the live sound of the room at that moment because that sound has character.

I get asked, "Why is there no score in your film?" I am a pretty auditorally oriented thinker and editor, and one thing weird and interesting about film is that you can do all kinds of crazy shit with the picture and cut all over the place, and people will comprehend it, but only if the sound stays consistent. The sound becomes the world you're describing, and so when I'm editing, I can play with sound—push the things I want to push and vice versa. That's what the sound mix is about: "Let's turn this up and turn that down." But as I spend time in the editing room, I get to know everything we recorded intimately, and I do fall in love with how it sounded in the scene when "the ring hit the table." It really becomes part of the texture of the screen.

Charles Burnett

Little pieces of sound can create a reality that the viewer may be unaware of but somehow senses. It makes the scene work. You can have a script, shoot it, edit it, and when you put the sound together, it becomes real. It's amazing how film works that way, in that these things give a film more depth and life. You really appreciate it when you see a film without sound. Some pieces work better without a lot of sound effects, just a minimum. But others need a little bit of presence, noise.

The sound doesn't have to be from the actual set, and this is really specific, because unless it's some unique sound, usually that stuff is re-created in the mix. There are always cars and stuff on location, and sound

people like it as clean as possible where they can isolate all that noise. If it's good, fine, but a bone I always pick with the sound people is that Foley sound of shoes walking. They make the sound of footsteps so distinct, as if everyone were walking with heels on a hardwood floor. I was doing the sound mix on a film and I said, "We can't have that Foley there because he's walking on a rug!" So you know it's Foley when you hear all these extra footsteps that are totally unneeded.

Music is important, and I don't have a problem with it. I don't like heavy-handed scores, but it depends. You have to use anything to keep the viewer in the film, to make it work. But you must do that during the shoot and edit, before you come to a situation where music saves a scene.

Olivier Assayas

I use little music, much less than most filmmakers, and I use it at specific moments, in order to add something to the film. I never use it to underline this or that. I use it at certain points to carry the narrative a bit further, when I feel it can lift the film. I am not a musician, but I listen to a lot of music. I love it and I react to it. I even need the energy of music at times to survive. It can keep you alive, so that's how I use music in my films, only at moments where it's vital.

This is connected to the way I use sound in general. I also rarely use scores. I did in my early films, and gradually I became annoyed with them, including a point during the making of my first film, *Paris Awakens* (1991). I thought the solution could be to use the music of someone I really admire, John Cale, and he wrote a beautiful score. But it felt like a score, so I used the music only here and there. I was happy with what he did, but I can't say it was a fully satisfying experience because in my next film, I had zero score, not one note of music, and I was perfectly happy with that. For the first film I did in Dolby stereo I suddenly had a much bigger space in terms of sound. I could experiment and go a bit further in terms of sound design and structuring the space through sound. I could become my own musician with the noises. It didn't involve music, but it involved sculpting the sound of the film.

The sound space obviously depends on the film. For a movie like *Demonlover* (2002), it's essential. In that film I worked with Sonic Youth, because they are halfway between sound design and scoring the film; some of the stuff they did is noise and some of it is musical. It's about scoring the

film but somehow having a seamless circulation between the background noises, the ambience of the film, and the score. I also wanted something that dealt with the modern world and the strange way I wanted to depict it in that film. So for that movie, the sound design is essential.

Paul Schrader

Different films have different musical needs and a number of films lately have done well with no music. *I Am Legend* (Francis Lawrence, 2007) has about thirty-five seconds of music at the very end. Walter Murch, who did the sound design for *Apocalypse Now* (Francis Ford Coppola, 1979), created a new world of sound design and did terrific work. In fact, he created the concept of sound design, and Leslie Shatz, who did *Mishima: A Life in Four Chapters* (1985), was Walter's assistant. So that concept of sound design came out of San Francisco and became very important. Take a film like *There Will Be Blood* (Paul Thomas Anderson, 2007)—an original use of sound. But I don't think you can be prescriptive. Like everything else about a film, I see deciding how to use sound as a matter of problem-solving.

Matteo Garrone

During the shoot for *Gomorrah* (2008), I worked with the sound carefully on set, and we also went back to locations to record the voices of drug dealers and all the other sounds. Then I went to Los Angeles for one month to work with Leslie Schatz, an extraordinary sound designer who worked on Gus Van Sant's *Elephant* (2003) and on *Apocalypse Now* when he was eighteen. I wanted that work to be invisible, impossible to detect. We tried to work with Robert Del Naja from Massive Attack, but when he saw the movie, he said, "You don't need music." So the film's only music is inside it, used like other sounds, like music coming out of a house, but never in the foreground. Of course, because it's Naples and they talk a lot, I did thousands of cuts in the sound and just a few on images.

The old way in Italy was not to use direct sound and to dub in the dialogue during post-production. There are a lot of funny stories about that, like actors just saying numbers instead of dialogue. I met an old man who owned a restaurant where Frederico Fellini used to go. He had worked in a Fellini movie, probably *Satyricon* (1969), because he had the face of an old Roman. He said that Fellini told him to recite his entire menu, and then Fellini replaced it with dialogue in the dubbing.

For me, imitating reality is not interesting, but interpreting reality is. That also applies to sound because a film's sound is very important. It's always the same: expression is more important than information. That starts with image because I'm visual. In the case of *Gomorrah*, it's subtle. It may appear to be realistic in its look and sound, but from my point of view it's all a transfiguration of reality.

Sergei Dvortsevoy

Sound was very important for *Tulpan* (2008), and from the beginning I wanted to record direct sound properly. We used a very good French recordist, and he had all the equipment we needed because the problem with the steppe is that it's always windy. We recorded a lot of sound while shooting the images, and whenever we stopped shooting for a break, we recorded more sound from the location. The production took four years from start to finish for everything, mostly because I changed the script and the location was so difficult. He recorded very well while he was there, but then I had to get two guys, one from the Czech Republic and a Kazakh guy, who were different but not bad. It wasn't a problem until post-production. First, I used a guy from Switzerland who was the wrong choice. He was a good sound engineer, but not for my film because he didn't understand what I wanted. He was in a hurry and wanted to create something different. He said, "Grass cannot sound like this," but I said, "Listen, grass is different in Kazakhstan from grass in Switzerland." He insisted on many things about which he wasn't right. I said, "Listen, we have to make the sound how I want it." In the end, I was forced to change him. So we redid the entire sound design and mix with the French recordist.

Jia Zhangke

For *Pickpocket* (1997), I wanted to capture the sounds of the street as well as the visual chaos—the pop music, street vendors, and people walking in and out of the frame—really capture the life of this town. When I listened to the sound recording during post-production, I wasn't satisfied because it wasn't chaotic enough. I forced the sound engineer to mix in other street noises, and she kept complaining, "You can't do that, you can't even make out what this is anymore." Therefore she had to quit her job, and I had to hire another engineer to put it together.

For *24 Hour City* (2009), there were three musical components. The

first was the top part, contemporary songs these workers recalled that reflected the memories of the time. As I did with my second movie, *Platform* (2000), I used the music of the time to echo the sense of an era and history. The second component of the music was in the beginning of the film, classical music by Japanese composer Yoshihiro Hanno. The third part, at the end, is electronic music by Lim Giong. I mixed these three components of the music from different nations to reflect that Chinese society has slowly opened and that a sense of individuality is on the rise.

Brillante Mendoza

When you are recording live sound, you normally ask everyone on the set to keep quiet so the recordist hears what the characters are talking about, and then you mix everything in post-production. I don't stop everyone from talking or making noise, so long as they talk in the way people would in that environment, because for me the background actor is very important. If you've been to Asia, you know it's chaotic and you cannot hear people talk. People are noisy, and it's part of the environment's pollution. I want to show the chaos and noise that are a part of our culture you can't avoid. If I made the sound too clean, the way a traditional film would present it, the film won't be at all true.

There's music only in the last part of *Serbis* (2008), and even in *Foster Child* (2007) and *Slingshot* (2007), my favorite of my films, there's little music. Music in films usually enhances a scene. But for me, so long as there's no need for it, if the story is there, presented well, and articulated the right way, I don't need this support to enhance it, to make it realistic or emotional.

Gerardo Naranjo

I'm Gonna Explode (2009) has much more music than my other films. I love Georges Delerue, who composed for Jean-Luc Godard and François Truffaut, particularly a song he wrote for Andrzej Zulawski's *L'important c'est d'aimer* (*That Most Important Thing: Love*, 1974) that Zulawski didn't use, so his widow let me use it. *Explode* also has a lot of contemporary music—a bolero and a love song my parents used to sing to each other called "Saborame" (My Taste), with lyrics like "my taste will be in your mouth for eternity." This is a romantic movie in which the kids stay together for seven days, and it starts from her romantic point of view and then moves above that. We also used

a score. I tried to create a meta-cinema through different sound layers, so two different songs play at the same time to signify two different realities. This is also the first time I used 5.1 Surround Sound. I'd never separated the sounds before, so it's very ambitious. The best thing about the sound in *Explode* is it's naturalistic as well as subjective, with a score and a voice-over that stops and becomes a diary, so there are different levels of narration. I think the value of the film, if there is any, is that it's an imaginary trip that looks real.

Courtney Hunt

We had a wonderful sound recordist for *Frozen River* who worked hard to get lots of ambient sound. We had a car engine, rustling coats, the sound of breathing and noses sniffling, so that was tricky, but he managed to do it. There was a lot of panic about the sound because we used the cheaper version of a sound system. In the scenes where the two women were in the car, they were miked right on their clothing and they were wearing layers of coats and shifting around, so you heard a "shhhh, shhhh, shhhh" noise. After we got back preliminary dailies around the middle of the shoot, everybody panicked that the sound was ruined, and a pall fell over the entire shoot. But we just kept shooting and it turned out to be okay because the cheap house that we'd used to do the "dupes" [formatting the sound track onto the strip of film images] was so cheap that they'd done a sloppy job. There wasn't a problem with our sound at all, but we didn't know that until much later. That's indie filmmaking; it's all about soldiering on. We just cleaned it up in the mix, and it was okay. My editor was very worried; she said, "We're going to have to do a lot of ADR [additional dialogue recording]." That's so expensive; all post-production is extremely expensive, but we ended up doing almost no ADR.

I think many filmmakers undervalue silence. I like the way Lucrecia Martel plays with this water sound, then no sound, and then this funny sound of this crazy instrument, whatever it's called, in *The Holy Girl* (2004). I also like to experiment with silence and stillness. Sometimes the music in movies drives me crazy because it's over the top. I'd assumed that my film's distributor, SONY Classics, would want to redo the score, but I really liked that they didn't. The score is an eclectic mix of three different people I brought in, two guys who shared the composer credit and a woman who sings a song softly at the end. I didn't use all this until we'd finished our

rough cut, because deciding where to use the music was really hard. I said, "Let's put singing lyrics over the dialogue," but my editor said, "You can't do that." I said, "But it's a really good song and if people don't want to listen they won't." But she said, "No." She was right. That film's music was the noise of the car or the burning of cigarettes, which you actually hear at one point. We tried music in different places, like the way a novel describes people thinking. But you can't really show that stream of consciousness in a movie, and that's what music is—the movie's stream of consciousness.

Lucrecia Martel

I find it strange that sound is given superficial treatment in cinema because sound is the first thing that comes to us as humans. For me, sound and touch are really intertwined, because we feel sounds all over our bodies, and it's our first experience when we're in our mother's womb. Sound is all around us, up until we die, and the sound environment we grew up in determines us and shapes us, mostly in terms of the way we narrate. I'm not saying the visual aspects are not important, but they definitely come second.

I take a lot of ambient sound on the set, which makes shooting that more difficult, because we use a lot of time shooting just for sound. But I believe people's ability to distinguish between intertwined sounds is much greater than their ability to distinguish between intertwined images. So sound allows us to convey an enormous amount of information. If we needed to convey that amount of information through scenes, through images, we would have to take a lot more shots and a lot more frames and create more scenes to set it up. Sound allows you to do that more concisely.

Ivo Trajkov

Some define film as a visual art and that's wrong, because sound so much affects the interpretation and impression the audience takes from a film. That's natural because our main communication channel is audio, not video. Sound affects us a great deal, but on an unconscious level, so we don't expect it to affect us as much as it does. If you don't use sound to support your idea, message, and storytelling, you miss out on a powerful tool.

Of course, I'm talking about re-creating the sound in post-production, because microphones often do not capture the sounds of reality but re-create that world instead. I frequently re-create a film's entire sound. I hate dialogue, so I throw away every possible dialogue, even those in the script,

and in the editing process more than 50 percent goes. Dialogue doesn't always matter. It operates on that informational level and indicates that the viewer needs to use his brain and audio channel, but the moment the viewer uses his brain, he isn't using his emotions as much as he can. The brain focuses on dialogue, so I always find it dangerous when the characters speak. Isak, the second character in *The Great Water* (2004), barely talks at all. He had lines in the script, and a few stayed in the shoot, but we erased them completely in the edit, and I believe we created a much more interesting character.

I kept the voice-over because I wanted the feeling of the novel behind the film. In the novel the author talks about the past in the first person, so I thought it was fair to keep that feeling of literature. However, if you use voice-over narration to save your ass, then, of course, it stinks.

The other level of sound involves re-creating a scene through sound. I shoot and edit a film in a particular way because of the theme, what I want to say. So you do the same with the sound. I go by what I want out of the scene, and I'm not attached to its reality. I will use any sounds, so long as they fit emotionally and support what I want to do. In a way, when I work with the sound in the editing, I'm re-creating the entire film.

Claire Denis

Jean-Luc Godard said sound is the slave of the image a long time ago, and he's probably the most inventive director in terms of sound. I have no theory about that. I work with direct sound. I don't need much added. I do all I need before, in the shoot, and I don't like sound that you buy. I like my own, so I get it with my sound engineer, especially when I shoot so far away, in Cameroon, as I did for *White Material* (2009). There is no sound you can make in France like that. Of course, I'm there for the sound mix. It's like a band, and you have to direct the band. It's one of the parts I like most. It's not re-creating the film, but it's the last part of the film's creation.

Kiyoshi Kurosawa

I think it's much the same with sounds as with visuals—there are always 360 degrees of possibilities. There are so many different sounds, whether it's the sound of a train going by or neighbors talking or cars racing by outside. So I try to represent the invisible world, whatever is happening off-

screen, within the context of the visible world through sound, by monitoring sound levels.

Music is such a powerful weapon that it can have a devastating impact on the audience's emotions and control them. People tend to trust a little too much in music, and they use it randomly in contemporary films. If you want to make the image moving, you can do it through sound or you can make whatever is on the screen scary through sound. So I try to use music as little as possible and only when I really want to have a devastating impact.

Jerzy Skolimowksi

Four Nights with Anna (2008) uses silence daringly. Modern films are so over-packed with everything—visual goodies, MTV cutting, and shocking sounds—that I just cannot watch them anymore. Sound in modern movies is used in a volatile way. It's obvious that the only intention of the directors and sound engineers is to shock, to get to the next cut, the next cut. This is not really the sound that more sophisticated people want to hear in a film. Creating the sounds of a film is like composing music—you have to have breaks, lighter parts, and then make it more intense. You have to play it, and the film doesn't need to have that many sounds. It's enough if you get your sound on a certain level, low rather than high, and then everything you put there works because it will be registered. Otherwise, you miss practically everything in a mess of sounds. You just hear noise.

I planned the silent scenes for *Anna* and that's why I decided on camera moves that would show image after image after image in long takes. It wouldn't be a static camera, which I don't like at all. I prefer a moving camera. Since I knew there was mostly going to be silence, I looked on the sets for anything that could be on the sound track, every squeak of the floor, every breeze, every little snore from Anna—and it always worked. I was also aware of what could happen outside the window of her room—dogs barking, cars passing, the helicopter in the distance—so all that was carefully planned. There's also a little musical noise played by a symphonic orchestra, not a computer or synthesizer. Forty people played string instruments, creating a strange vibrating noise that makes viewers aware that something strange is going on.

I believe in quality of sound. I can always hear cheap sound, and that is too easy. Fortunately, we were able to afford that orchestra for three nights,

and we played it at really critical points, but at an unusually low level. Usually it's played so you can hear it, but in this film the music is almost in the distance, almost subliminal.

The most important thing is to underline emotions. For example, I carefully chose the moments when the dog barks. The dog barks rarely and at certain moments, like when the lead character is stretching out his hand to touch her naked breast, so he moves his hand away, and that happens a few more times. It's always a strategy designed to combine image and sound in the right rhythm.

Pedro Costa

My connection to music and film is personal. It's probably not the same as with my colleagues. When they think of music and film, they think of other things that I don't do in most of my films. I don't use much music; I tend to stay with the direct sound, the voices. So I'm really prudent with that kind of "soup," as Jean-Marie Straub would say. Today sound is becoming a bit impossible, but there are hundreds of films that I love and admire that are made with music, even Hollywood musicals, and they exist because of music.

Pablo Larrain

We have a lot more cinematic tools today, and David Lynch has done interesting work with sound because film is audio-visual. Fifty percent of a film is the sound. I didn't want to use music that wasn't related to the situation in *Tony Manero* (2008), that kind of music you add later in the edit. All the film's music is part of the scenes. I don't like when you support a scene's emotion with music, so that when it's a sad situation, you put sad music on the sound track. That's a little like treating the audience as if it's stupid. I did it in my first film, and I will never do it again. If I do use music, I will always use it as a parallel element that takes the image to another place. The combination of image and sound should not be the same. The music should add something, so you end up with an interesting contrast.

Shamim Sarif

Sound is huge in suggesting what lies outside the frame, and that was a big learning curve for me in terms of the crazy freedom it gave us with *I Can't Think Straight* (2007). What do we want to hear here? What's the

background? What's going on? Does the sound of that water flowing in the background help? Does the sound of the duck enhance the awkward silence when they face each other in the park? A lot of the work on *Straight* involved putting sounds back into the film because the first financier never returned the sound track. So we had to re-create the sound for the entire movie. We struggled to pay for doing it at Pinewood Studios so it wouldn't be noticeable, and virtually all the cast performed better.

For *The World Unseen* (2007), we had a lot of ambient sound and a great sound recordist. The crickets and other stuff that's normally added later to a hot nighttime country scene came from real coverage of the location, and I think it made a lot of difference.

I'm not contemptuous of using music to shore up weak moments in a film because it's easy to say that shouldn't happen. But if you end up with a section that isn't quite there yet, music can help convey an emotion. You have access to all these pieces, and, yes, in an ideal world every piece should enhance every other piece. But in reality, it may be that you didn't get the shot you wanted that day or the actor wasn't on par. If music can help move that up to where it should be, then why not?

Lance Hammer

For *Ballast* (2008), I wanted to convey the Delta accurately in the winter, and it's about silence. But it's not really silence. I went out there to record all this and then returned to Los Angeles, closed my eyes, and listened. It's full of sound—the animals, distant highway noises, wind, and rain—all reverberating across space. It's like lots of muted reverb, and it's haunting. It's essential to hear all those nuances to understand the sense of the place, and if you put music on the film, it just contaminates it. And I love music.

On the other hand, Godard's *In Praise of Love* (2001) and *Notre musique* (2004) use music brilliantly. So music is an important, powerful, and dangerous tool that can be handled only by the very best filmmakers. I don't feel I know how to do that yet, and I'm offended when music manipulates emotion. My rule with *Ballast* was that the scene had to exist by itself. If it didn't work, it couldn't use music to salvage it, and it was cut from the film. There was a moment when I lost my nerve during the edit and explored the possibility of music in this film. I suffered serious doubts that I would not convey the experience of being there accurately or completely. I thought, "What am I doing? This is stupid, suicidal. You have to put music in." I'm a

musician, so I started writing a minimalist piano score. Adding the music totally changed the way I cut the film. It became very much about driving through the Delta in cars. In the end, though, I cut all that out and didn't use the music.

I just read in Sergei Eisenstein that we haven't yet fully used sound's expressive abilities, and I completely agree. They were saying that when sound was first introduced to pictures. Why haven't we learned the lesson yet? Theorists talk about sound as more primal and located deeper in our spinal cords and that it's a more meaningful and appropriate way of interpreting our environments. Sound mostly goes to the emotions and in an inarticulable way, so it's at least as important as picture and arguably even more so.

Tomas Alfredson

There's too much sound on sound tracks in films today. It doesn't take any courage to add a lot of sound because it smears out all the details. If you surround sound with silence—that really is about framing out certain things. You can make people think with sound without knowing that they are thinking. For instance, if you have a big panoramic shot of a city, and then you take away all the sounds of the cars, industry, and ambience so that you just have the sounds of a bird, the audience's eyes will immediately scan the screen for the bird—where is the bird? Why is that sound there? Maybe the bird appears in close-up in the next shot, which is another scene, or maybe somebody is looking at a television show that contains a bird, or whatever. Yet this type of sound is seldom used as a storytelling device.

We set *Let the Right One In* (2008) in a very cold winter where everything becomes silent. All you hear is your breathing and heartbeat, so I tried to make the sound as close as possible to the lead character's experience of this silent winter. We had to go up north in Sweden to get all the snow and darkness, and it's a very strange soundscape. We tried to get as close to the children as possible, so we did a lot of sound takes of their bodies—their tongues moving—and in one scene we even miked their eyes so you actually hear their eyelids opening and shutting. All those sounds give so much life to the film. Even the vampire sounds are all real, no synthesizers whatsoever. They were made with different animal sounds—frogs, wolves, rodents—and they affect you as nothing else ever could.

We used music in an old-fashioned, analogue way. The composer found

a strange instrument called a waterphon that was built by a crazy Austrian guy. It's an empty steel jar that turns into a pipe. You fill it with as much water as you want, depending on what sound you want, use a bow to play brass, pencil-like structures that surround this strange jar, and it gives a cold, wintry, glassy sound—very crisp and analogue. You can also hear each string when the bow touches the brass "keys."

Ari Folman

One of the most enjoyable parts of filmmaking for me is playing with the sound, and animation is a gift for sound designers because they can experiment freely. For the sound of the dogs in the opening nightmare sequence of *Waltz with Bashir* (2008) we used ninety-eight different tracks, just for effects, no music—everything you could think of, from lions to wolves to I don't know what else.

I found composer Max Richter through his Web site and e-mailed asking if he'd be interested in scoring the film. He was born to make music for films, and he had all the music completed before the animation was begun. We had the music while we worked on the video board. Eight animators worked on a scene at the same time that they listened to its music, so they had the mood. Usually you complete a film and you're rushed for time when you start working on the music. You get the film—in this case, the video board—and you put a score you choose underneath to underline it. But this time it was the other way around, and it went really well for the animators.

We used a lot of Brian Eno and a hype Icelandic band for the temporary score that the composer uses as a guide to the film's moods, but Max created a more professional score. "Okay, this is my taste," he said. "Do whatever you want." He was right. *Bashir* has the most scored sound of my films. In some places it's a strong experience, maybe too strong, as in the scene where the guy is swimming, but I decided to go for it. Maybe the composer drove me there, but I think this film needed the support of what we call in Hebrew "a big American film," because everything was about making it a film and not defining it as a cartoon. It's animation for adults, and Max was the guy who convinced me to go for it.

Jean-Marie Téno

Every individual word, every single thing has its own movement, its own dynamic. For me, cinema is image and sound, so, for instance, I used my own

voice to narrate *Sacred Places* (2009). People kept saying, "You should use a nice radiophonic voice." I use my own voice for a particular reason, and when I create the whole atmosphere with sound, I have people create some sound effects. People ask, "Why go through all that for a documentary?" But it's important to create those emotions. You won't see those effects, only hear them. I always laugh about the scene where the cine club owner goes to buy a big television and he says, "I would love to have this flat screen TV in my video club." I chose a romantic piece of Hollywood-style music to put under that, and people asked if that music was in the shot or added on. The guy was walking toward the cinema, dreaming of a big screen, and I had to indicate that he was dreaming of something he couldn't get, so, of course, I added that music to describe his dream. It was important to have that sound. I work in documentary just as I would in fiction film, except maybe I don't have the same means.

Özcan Alper

Hunger (Steve McQueen, 2009) is similar to *Autumn* (2008) in theme, and I liked *Hunger* so much that I distributed it in Turkey, even though I'm not a distributor. As in McQueen's film, sound was important for *Autumn*. I thought about the sensory deprivation so many prisoners go through when they are locked up for years and become overly sensitive to sound, so that's how I constructed the sound track of my film. I always had in mind how Yusef would feel about certain sounds, how he would hear things. I was also lucky in that I worked with people I had worked with before. My sound person was a man from Iran. I told him what I wanted and needed, and I emphasized that the sound should be natural. We recorded ten different types of wind, and we wanted on tape everything that we heard on set.

I worked on the sound design and mix with an editor in Turkey, and that was the most unfortunate part of the film. I wasn't happy with the sound editing and mix because I had something else in mind. I made some changes in the film's sound, but I'm still not fully happy. It's good, especially given the standards in Turkey, but I wanted to take it to the next level. After I said during a press interview, "I don't think there's a good sound editor in Turkey," that editor actually tried to sue me.

Sound lets the visuals breathe; otherwise, the visuals are hollow and there's no meaning. If you use sound in the right way, it makes you feel

what you see, it makes the visuals more tangible in a way, so that you almost smell and touch the film. It's really all about the sound because sound has that kind of depth, and if you manage to use the sound as an organic part of the film, it makes a difference. When things go wrong, it's usually because people design the sound as a completely different and separate element. To me, the film is a whole, and I always think of it that way.

3

Working with Actors

The process through which an actor transforms a character that exists on paper into a fully realized, complex, and persuasive being is elusive and variable. At the very least, an actor should possess enough emotional intelligence to comprehend the complexities of the character and enough intellectual intelligence to understand how that character fits into the canvas of an entire film. Aside from those minimal requirements, though, acting talent and the acting process are difficult to define, so filmmakers can be confused as to the best way to work with their actors.

Generally, a filmmaker's approach to directing actors reflects his or her overall working style. Some directors want no input at all from the creative team and expect every person working on the film to apply his or her professional expertise toward fulfilling the director's intentions, to take direction and carry it out. These directors may trust in the actors' professionalism, believing that they can develop their characters on their own and draw whatever guidance they need from the script. The director may lack time or inclination to hold discussions and rehearse. It can also be the case that the director does not know how to work with actors in order to get the best possible results. At the opposite end of the spectrum are directors who not only instruct actors on blocking—exactly how and where to move before the camera—but also give precisely inflected line readings that dictate every nuance of the performance.

The actor/directors among the filmmakers interviewed here, those most qualified to speak on this most vulnerable of a film's relationships,

argue that neither extreme is ideal. They prefer a collaborative relationship that allows actors creative freedom balanced with guidance and positive reinforcement that only the director can provide.

Filmmakers often try to cast actors in roles that reflect their real personalities, not only to ensure that the actors merge with the characters emotionally and intellectually, but also to engage the actors in helping the director explore the truths of the character more fully. A single weak performance can bring down an entire film, so many filmmakers describe the ideal casting as a marriage between actor and character.

Yet the greatest actors are often chameleons who assume different personalities as easily as most of us change clothes. A fine film actor should be able to play any character that suits his or her physicality, not just those similar to his or her real-life persona. And many wonderful actors are terrible auditioners because their techniques may involve working internally over time to absorb all the facets of a character before they are performance-ready.

Judging actors on how well they read a scene from the script in an audition may not provide as much information as a director would want. Asking an actor to improvise a scene from the script in character can be helpful, not necessarily to judge how well the actor improvises, but to reveal his or her interpretation of the role. However, an actor may have more to offer than the director was able to grasp in the improvisation, so even that casting process can result in missed opportunities. A few filmmakers insist on viewing an actor's reading, improvisation, or initial interview on film or video, because the camera lens is transformational. Many actors who appear small and drab on first impression in real life become powerful and charismatic figures on-screen.

All these considerations lead some directors to avoid auditions and rely more on viewing previous performances on film clips or entire films. Yet casting an actor based on past performances also presents pitfalls. The actor may be capable of playing many different characters, but his or her body of work thus far may not yet demonstrate that full range. Unless the filmmaker senses some quality in the actor that has not been exploited yet, that actor may not be cast. That's why some filmmakers work with the same actors in film after film. They know these actors' capabilities, have established smooth working relationships, and can rely on them to deliver what each film needs.

Like directors, actors differ in their preferred working styles. Some want to discuss their character interpretations; others keep the process private and seek direction only in regard to blocking out action and dialogue moves in front of the camera. Some want to rehearse, others do not. However, most actors and directors prefer to discuss the characters and how they contribute to the film's theme. Many directors like to improvise scenes from the film with the actors during rehearsals in order to decide what to accept and what to rule out. Improvisation during rehearsals can also loosen up the actors and help them get into their characters; but once the camera is rolling, most directors do not want to depart from the script, unless it's for changes agreed upon beforehand. One exception is when a film uses nonprofessional actors, because improvisation can help them understand what a scene is supposed to convey and express their characters' feelings more effectively through language closer to their own experiences.

Finally, just like anyone else, some film actors are comfortable and confident in their work, while others are chronically uncertain and therefore distrust the director. A film actor knows that effectiveness does not depend entirely upon the performance, hence the clichéd actor's complaint that the film failed because his or her best work was left on the cutting room floor. Unlike a theatrical situation, in which the actor can modulate his or her performance differently each night, the film director controls the actor's final performance through the ways in which it's shot and edited. The director selects whichever shots he or she prefers, arranges them in order, and may even drop whole sequences. A film is always an experiment, and no one knows exactly how it will turn out. So the actor has to find a way to trust that the director will not allow him or her to look like a fool, and the director needs to reassure the actors that they are safe.

In the end, because there is no agreed-upon "best" way for directors and actors to work together, the ideal collaboration takes into account each actor's needs, experience level, and personality. In the discussion that follows, the filmmakers offer examples of how they have collaborated with their actors, sometimes even discovering the key to a character in unexpected ways.

Anne Le Ny

I've had the experience of working with over-controlling directors, but I only remember the good ones, and the good ones do not tell you too much. I've

worked with Claude Miller and Agnès Jaoui, who trust you completely for each take and give you confidence and love. They can be demanding, but you feel this trust. There is nothing worse for an actor than somebody who distrusts you; you can lose your self-confidence very quickly.

The funny thing with both Vincent Lindon and Emmanuelle Devos in *Those Who Remain* (2007) was that they had to contradict their own biological rhythms in order to play their characters. Vincent is extremely speedy, full of energy, and always moving. We had acted together in several films, and because his character in my film is so silent, so internal, I thought I needed someone with lots of energy to play that role so the viewer believes and feels something is happening inside him, even if it doesn't show too much.

I just told Vincent to slow down, and we gave him a heavy coat and heavy shoes. The right shoes give you a relationship to the ground and dictate how you move, even how you feel. Most of acting is having the right shoes.

Vincent also had this heavy briefcase he hated because he had to carry it all the time, but it gave him the weight of five years of moral and physical exhaustion that his character had gone through as his wife battled cancer. I was also attached to Emmanuelle Devos's boots, although the noise they made drove the sound engineer crazy. Emmanuelle told me that since her character had lots of questions, she practiced asking questions in her normal life before the shoot, because she is also different from the character she played. She's not at all outspoken, always thinks before speaking, and is discreet, so she liked playing this character because it gave her some freedom. I was amazed that when we started shooting, she was already in character.

I felt a little guilty because I had been thinking of casting another kind of actress—someone more rock-and-roll, even a little younger, but I couldn't find the right one. My producer said wisely, "Maybe you should approach it another way—don't think of the character, think of actresses you like." Of course, I said, "Emmanuelle Devos." She's always inventing, and that's rare. She takes risks, like someone on a trapeze without a net. It's fascinating, and, yes, sometimes she's on the edge and you have to say, "No, this was not right." But it also means that she can do things nobody else would dare to.

After a while, when the actors become involved in the shoot, they know more about the characters than you do. You know more as the

director when it comes to the film's overall meaning, because you have a global point of view. But for instance, if a good actor has a problem saying a line, ninety-nine times out of one hundred, the line is badly written and he's right.

I think it's mainly a question of trust and of collaboration. Okay, I wrote the screenplay, I'm doing the shooting, I will do the editing. The film is in my hands, so I don't need to play boss on the set. Yet it's also collaborative, so I don't pretend that I know everything and that they can't have better ideas than mine. Sometimes the actors brought elements I would not have thought of, so it's about working together on the same level. In part, that's because of my own experience as an actor, and I'm not afraid of actors. I think a lot of directors are afraid of the actors. But I don't believe they will steal anything from me or take over the film, especially a first film with not much money. They agreed to do the film because they liked it, so I trusted they wouldn't try to hijack it.

Jerzy Skolimowski

I saw Artur Steranko and knew what he could offer me for *Four Nights with Anna* (2008). My most important directorial strategy was putting four or five pounds in each of his boots so his legs were heavy and his walk changed. That gave him the body language. Also, I kept him down: "Don't do too much. Just be yourself, that's it." Of course, I did a little more directing, but not that much discussion of what was going on. I don't think I have to inform the actors that much about what's in their characters because I am not sure about that myself. I see what's going on, and I know this is good and that is not good, so when they are going the wrong way, I stop them. When it goes along with my thoughts, I let them do whatever they want, and I make my selection on the set. I don't have any preconceived ideas that "you have to do this." No, I'm ready to accept what they can offer and select what is good. I'm an actor myself, so it's much easier to know what they deal with.

Céline Sciamma

I had more problems casting the boy than the girls in *Water Lilies* (2007) despite the much more radical behavior the girls' roles demanded. All the girls said, "Yeah, I'll do it," but the boys said, "No, I'm not going to pretend to sleep with a chubby and I'm not going to let anyone spit in my

mouth." I wanted the boy to be a nonprofessional, but the part was too small for a nonprofessional to commit to strongly, especially because of that spitting scene. The actor I cast has acted in several projects, but he was very good.

I worked with a mix of young professional actors and non-actors, so I used simple, sharp dialogue—brief and clear—and the girls don't speak that much anyway, because I wanted the movie to be mentally active. Movies in France tend to be talkative, especially ones with teenagers. They talk a lot and say whatever comes into their minds, but I don't think that's true to life. They may talk a lot, but I wanted each word to have meaning, weight. For example, everyone talks in the same clever way in *Juno* (Jason Reitman, 2007), and I didn't believe that this girl was sixteen. She was more like twenty-six.

Bette Gordon

For the most part, I know the actors I want, so I don't read them. Jamie Sheridan, the lead in *Handsome Harry* (2009), and I had worked together on *Luminous Motion* (1998), so we worked on the character of Harry together for two years, a rare and great experience. He had worked with Campbell Scott onstage on *Long Day's Journey into Night,* and Campbell had directed him in *Hamlet.* We cast friends and people we could get for a reading of *Handsome Harry* and Campbell came along to read Cagan and blew everybody away. Jamie said, "Campbell, you've got to come on board," and Campbell said yes.

Sometimes it is about relationships. I didn't call Steve Buscemi, who's a friend, until I knew that I was shooting because I wanted to make sure his schedule allowed him to work with me. I didn't know Aiden Quinn and others; we went out to them just because I respected their work. Todd Baylor, my casting director, brought the younger guys.

Casting *Handsome Harry* was a joy. I was thinking a lot about male sexuality and how, since the end of the Vietnam War, male sexuality is represented on the screen. I grew up loving actors like Steve McQueen, Lee Marvin, John Garfield, and Ben Gazzara, who represented strong, raw, sometimes inarticulate men, and I thought of being inundated today with metrosexual and Judd Apatow guys who are uninteresting to me but not to the young generation. I was mourning the loss of those other guys and intent on re-creating the sense of camaraderie that existed among them.

I admire what an actor can bring; often words on a page are only that. A script is just a blueprint for something else. Although I follow the script pretty carefully, I bring out a heart and soul that's underneath. I love getting underneath things and thinking, what is this person really saying? What am I really saying? What is the underneath story here? In *Handsome Harry* I worked with the actors on delving deeper, finding the characters' vulnerability, and breaking them down so they weren't just black-and-white portraits.

Kiyoshi Kurosawa

The same thing is true of my actors as my crew, in that once I cast a person, I trust him or her 100 percent, and I even think of my character as having been born into the actor's body and spirit. I don't do any rehearsals, barely any run-throughs, and I basically trust in that first take. We just get the camera rolling, and I believe that you get the truth in that first take.

The dialogue in *Tokyo Sonata* (2008) is 80 percent reflective of the original screenplay dialogue. I always provide my actors with the opportunity to make the language a little easier for them to deliver, but it's pretty much always 80 percent. What they do while they speak and the timing of it—none of that is in the screenplay. That's something I make up on the spot.

Mia Hansen-Love

When I made my first short film, I had been writing alone in my room all the time, so making the film was like an escape from writing. The big revelation was experiencing someone saying the truth of a dialogue, something written that was now coming through someone's body. I realized that getting to the truth of a text is possible only through the body of a real person. When you write, it's only words. You're also looking for truth, but in cinema you're not just looking for truth in the story, because you can't get truth in cinema without the actors. It really has something to do with their interpretations. I don't know why, but this relationship, this dependence on truth and incarnation, which is to me the essence of cinema, was very exciting when I experienced it in my first film. I have this text I've written, and I've dreamed about someone playing it. I know if I find the right person and the right way of working with this person, I'll get to the truth in this thing I've written, and I'd never get to that truth without this person.

Few of the actors in *All Is Forgiven* (2007) had previous professional experience. Paul Blain, who played Victor, is a great actor who'd performed in two or three films by his father, Gerard Blain, a great French director. Marie-Christine Friedrich, who plays his wife, is a Viennese actress, and this was her first time acting in France. I met Constance Rousseau, who plays their teenage daughter Pamela, on the street. Constance led us to her little sister, Victoire, who played Pamela as a child, and the young girl who approaches Pamela in the last scene of the film is another of Constance's sisters.

My work with the actors was extremely intuitive, especially since this was my first film and I hadn't any training. I had to sense it as I went along, so the second day on set I worked in a different way than I did on the first. I had a little experience as an actress, and I also went to acting school; but there was a great deal of complicity, between the actors and me. I wasn't directing them; I wasn't intimidating them on set. I worked with them almost as if I were one of the actresses.

My work with Constance, who was sixteen, was especially intuitive. Many young girls try to appear much older, but Constance allows herself to be fragile and have this sense of nakedness about her. I could see on-screen that she was true to how she is in real life—a very intelligent young girl whose every emotion is visible on her face—so my work involved bringing that out, as well as preserving, respecting, and capturing it. She'd quickly sense what I was getting at, and I constantly told her not to act. I gave her little direction or even character motivation. The lines themselves were clear enough, so she just had to read them naturally, and she had the intelligence and grace to do that. The depth and interiority came from the lines.

The actors and I read through the script a great deal before the shoot, and through that an understanding developed. We didn't rehearse because I didn't want to take away from the emotional impact of the scenes and have a sense of things being warmed over once the cameras started rolling. But read-throughs of the script were absolutely essential. Obviously, we could read through only scenes with dialogue, but since we did that a number of times, it allowed me to adjust the dialogue ever so slightly whenever I sensed the words weren't natural in an actor's mouth. So when we were shooting, the actors spoke their lines naturally with a great deal of precision.

That doesn't mean I didn't allow for improvisation and freedom. I would almost say that precision in certain scenes allowed me moments of what I could call digression, of improvisation. The film's structure seems to be built on this dialectic, a balance of moments that held strictly to what was written with moments of improvisation. The scenes in the river at the end of film, before Pamela reads her father's letter, were improvised with the children. With children it's almost an ethical point that they have to be lively, the way they are in real life. I don't want to put words in their mouths if those are my adult words. In most films with children you feel that someone put words in their mouths and that they are like little machines repeating what they are told to say. I wanted them to be free.

We filmed that scene at the end of the shoot with a small crew because we were out of money. The group of children was real, they were by themselves, and we were discreet. I related to them as if I were a child, and, as I was twenty-five, they treated me like an older sister and didn't feel I was a director making a film. I hope in the future, when I'm older, I can make other films with children and find a way not to intimidate children, so they stay natural.

Lucia Puenzo

For XXY (2007), the camera held the body of Inés Efron, who played Alex, within the frame a great deal, so we worked a lot with how her body would look on camera and how to make her body seem sexually ambiguous. Inés's body is not androgynous in real life; she's fragile and curvy, so she had to lose ten kilograms to do the film. She also had to discover how to redo everything—especially how to walk as Alex, even how to seduce a man—because at first she was too intense.

I experimented a lot with the young actors. With the adult actors, it was more orthodox. We met, read the script, and discussed it rationally. With the kids, we went on the street searching for people who had something of the characters of Alex or Alvaro. We'd follow them, studying their walks, and then go back and rehearse those walks or the way the person stood, spoke, or drank. Both Inés and Martin Piroyansky, who played Alvaro, rehearsed a lot, and they even improvised scenes that weren't in the script.

There was a lot of respect on everyone's part. If the actors had a suggestion, they gave it to me in private, and if I thought it wasn't a good idea, they dropped it. Ricardo Darin, who played Inés's father, watched not only

his work but also the work of every other actor and even the technicians. But he would never make comments out loud because he's respectful.

Eric Guirado

I like to work with an actor for a long time before filming—it's essential. But it was impossible with *Grocer's Son* (2007). Neither of the leads had the time, so I had just one read-through of the script. I was angry and had a lot of arguments with my producers. I wanted those actors, but because I couldn't rehearse with them, I had to direct them a lot during the shoot. You don't make friends that way; you just work. I was making a film, not trying to make a family, but it was difficult to maintain that collaborative spirit. You have to be precise about exactly what you want long before the shoot, and if the actor cannot rehearse, maybe it's better to change the actor. It's a shame if you really want him, but for me, if they can't rehearse, it's an enormous problem.

The performances are good, but I wouldn't say I was amazed by them, and it was too much work for what I got. I believe in work, and although I believe a little in grace, something that comes suddenly, you can't count on that. Some people have that grace, but when I say to myself every day, "I don't know what he's going to give me, let's wait for the shoot," it's too much.

I don't have a blind love for actors, but I love workers, people who like to work and play. There's a French saying that some actors spend more time focused on *je* (I) than on *joue* (playing the role). At first, I was afraid of Daniel Duval, who played the father, and confident in the two younger actors. He's known to have fits of temper, but he was nice with me, gentle, sweet, and accommodating. He tried to think about the character, but that wasn't the way it was with the younger actors. Duval likes to be concentrated, but young actors on the set like to play and shout. I like that too, but on independent French films, you have a short time because you have a small budget, so I'm always watching the time. I would like to play, but I can't.

Teona Strugar Mitevska

I could never be a good actress because I'm too external. My sister Labina is the opposite—she's internal, like silk, and lets her eyes speak. The moment you put her in front of the camera, it's incredible. But you can't always

tell. That's why when you cast, it's important to put people in front of the camera and see the transformation. Nikolina Kujaca, who played Sapho in *I Am from Titov Veles* (2007), also has this amazing presence in front of the camera. But Anna Kostovska, who plays the third sister, Slavica, has this monumental presence in real life, on-screen, and onstage. It's interesting what the camera does to each actor.

There are actors who base everything on themselves and who are best when they do a role like that. There are actors who do the opposite; so your job is to understand their methods and then work with them. For my first film, *How I Killed a Saint* (2003), I worked with a non-actor, a boy who could only act himself. He was amazing, but he was acting himself, and for me as a director, it was important to use him to act my character.

I cast by having actors read from the script and improvise, because it's important to see all their abilities—what they can do with improvisation and with the given text. I do an extensive casting process in order to find the right people. It's my film, my script; I have written the character, and I am quite detailed in my indications for each moment, even what the characters do when they don't speak. But actors are creative, so you must give them space to find their characters and freedom to be in control of their characters. These are personal relationships, like love relationships. Every time I make a film I have an emotional love relationship with each of my characters, in terms of understanding and creating this character. So it's not about control, although, in the end, you do control how you make the actors deliver exactly what you want. The process is really about guiding them toward finding the character, almost like psychoanalysis, and the depths of emotion actors can reach are amazing.

Ivo Trajkov

Casting is an important director's tool, as important as how you establish the mise-en-scène, how you work with your creative team, and how you do the sound. If you cast well, you've done more than half the job on the film. The casting for *The Great Water* (2004) was unusual because we worked with such a huge number of kids—two kids in the main roles and a whole bunch of kids behind them from their class, saying lines and doing things from time to time. Then we had 250 kids for school scenes. Finding and casting them was a project inside of the film project, and we worked with child casting director/acting coach Mykola Hejko, a genius. He doesn't speak

Macedonian, but he quickly found a way to communicate with the kids. I thought we could actually see every kid in Macedonia, so if there was a "Lem," we'd find the best one. So Mykola, his assistant, and the production manager drove from school to school, and every evening he brought me videotapes and we'd discuss them. Then we brought in the kids we'd selected to rehearse and tried to find the right ones. We improvised a lot because that freedom gets the best performances. The best way to do it is to involve them in the world of the story and allow them somehow to live their lives in front of the camera.

One problem was that Lem is the main character, but we needed the character of Isak to be unusual and charismatic; so if we found the best possible Isak, we would overshadow Lem, and that wouldn't be good for the film. I came up with the idea of casting a girl for that role, but the casting director laughed at me: "How will we find a girl who looks like a boy, fits the role, and can act? It's too many ifs." So we forgot that idea until one day he said, "I need to show you something." He ran the tape, the camera went to a boy in the classroom, and he said, "Hey, boy, can you please stand up and tell us your name?" The boy stood up and said, "I'm not a boy." So we knew we had Isak.

I work a lot with the actors in the preparation, and we rehearse a lot. We call them rehearsals, but it's more about creating the characters. We don't rehearse the mise-en-scène or the shots; we talk a lot about who the characters are so the actors create part of their personalities and become very familiar with them. Then, while we're shooting, I can say, "Okay, forget about everything. Let's try something else." And they will try as the characters, not as actors, which is a big difference. If there's no preparation like that, they can offer you a lot, but as actors. I want them, even the kids, to offer it to me as the characters. If this system works, I may ask them to do something, and they may answer, "No, I would never do this as my character." Because we created the characters together, I believe them. We find a way to express what we need without breaking character or using the character as a tool just because the author needs to do "this," so the character has to do "this," but it's not true. That's why I love the preparation part.

Sometimes explaining the background story allows kids to empathize. Kids are able to imagine what's happening to their characters. They can imagine emotionally, but you have to keep them in a halfway world

between reality and the film; you can't push them inside that brutal world. They can't truly believe it because you might hurt them. So everything was based on psychological tricks, even with the adult actors.

The most problematic scene was with the 250 kids. I expected Mykola to say, "We'll do it like this and this, and so on," based on his experience. But he said, "I never did it, nobody ever did." We were filming in an empty field, with nothing behind, and we couldn't afford twenty or eighty assistants, so I positioned some young actors and actresses as corporals of groups of younger actors. These young actors were acting their roles at the same time that they were being assistant directors.

Tomas Alfredson

I try to be picky when I cast. The casting directors make test films, and I don't meet actors for first impressions if I don't already know them. First impressions in real life can destroy the first impression from a two-dimensional filmed scene. If you haven't met an actor before, you should do the first meeting via a scene that the casting director has shot. Then I'll have the personal meeting because how a person is in private and how he or she is in front of a camera can differ a lot.

We don't have professional child actors in Sweden; we are too small a country. So we have to do open casting for children. I thought that the two lead characters of *Let the Right One In* (2008), Oskar and Elie, were actually two sides of the same person. She's everything he's not: she's strong, he's weak; she's brave, he's cowardly; she never lies, he has to lie to survive; she's old, he's young; she's dark, he's pale. They had to mirror each other in every aspect and, at the same time, be the same person. I tried to look for people with those specifications, which are hard to put on paper, so it took over a year to find them. I think we found Oskar first. Elie is androgynous; the character is a castrated boy—that's more outspoken in the book—so we cast a girl with a boyish look. Twice she says to Oskar, "If I were not a girl would you love me anyway?" which makes the story even more un-erotic. There is also a very brief glimpse of "his" castrated organ. We tried to have that scene twice as long, but it wasn't fair to the actress. And in the end, I decided to change her voice, so you hear another child actor with a deeper vocal pitch.

The main thing to keep in mind when working with child actors is the same regarding directing in general—deconstruction. You don't give a kid

responsibility for the entire character because an entire characterization is too heavy for a kid that age. You deconstruct it into small pieces. For example, if you have a sequence that gives the idea that this kid is disturbed in some way, you communicate that by breaking the sequence into ten or so pieces and do each one, piece by piece, so it won't be too heavy for him or her to make it happen. In *Right One,* one scene consists of Oskar walking down the road, looking sad. He looks into a shop window and sees candy. In the third scene he's inside the shop, but he realizes he has no money in his pocket. For the fourth scene, inside his room, he's eating a lot of candy. In the fifth scene, you see him puking in the bathroom while his mother stands outside, knocking on the door. When it's all put together, this communicates the impression that this boy is lonely, he's broke, he's stealing, he has an eating disorder, and maybe he's not bringing this up to his mother. When you shoot this, for the first scene, you just say to the boy, "You're walking on the street, and when you come to the car, stop for a moment and think of something sad." For the bathroom scene, you say, "You're standing in front of this loo and you feel sick. Do this as well as possible." So you've deconstructed it all into simple scenes a kid can relate to; but if you tried to communicate the whole sequence to him, it would be too much. I didn't give the kids the script for this film, so it was also easier for them to get into each scene without thinking of the whole film.

I don't believe this idea that a director can bring out things in people that they didn't know they had. That's mumbo jumbo. But if you choose the right actors and have a good relationship, you can have a professional and grown-up dialogue. If you give a lot of trust, you get a lot of trust, and people do well in a trustful environment.

Charles Burnett

Casting is so important. When I was doing *Killer of Sheep* (1977), I picked people long in advance who I thought had screen presence and looked the part. Part of the idea of doing *Killer* was to demystify filmmaking for the community. Kids, some in grade school, were involved, and at times it was just me and a kid and the other actors working as crew. It was a sort of training. When they weren't in front of the camera, they turned on the Nagra [portable audio recorder], helped with lights, held the mic. I wasn't concerned about doing a perfect film; it was about the process to a large extent, and I wanted to get the story out. I wasn't too worried about

the acting; if it was credible, it was okay. The actors were friends of mine, and that was difficult because I was monopolizing their weekend time; so I felt honored when they came, and I understood when they didn't. It was a casual shoot, and a lot of them didn't understand the process. One guy asked, "Can't so-and-so take my place?" But we'd already shot some footage of him, so I said, "We can't do that. It's not like a football game where the quarterback falls down and you bring in the second string and it keeps going." I learned a lot on that film about actors, particularly kid actors.

I never thought that little kids could understand things, so I usually demonstrated whatever they were going to do. When the little girl was at the sink getting water, I bent down to her level in order to tell her, "You go to the sink, get water, turn around, and drink." But she did the same thing I did: she crouched down. So I kept going lower to talk to her, and she kept going lower, until, finally, I realized she was doing what I was doing. I don't know why other filmmakers let kids improvise, because the kids remembered everything and they did their lines.

The adults were a different problem. It was a community where people drank on the weekends, so that was an issue. I also had friends with histories with each other, and I tried to keep them separated so old problems wouldn't arise. I had this notion, like Robert Bresson and others, that non-actors are the best. I was naïve, and when I started using actors because of expedience for *My Brother's Wedding* (1983), I was trying to move up a bit. There were problems with hours and so forth, things you don't run into with nonprofessional actors, but you can get a performance quicker—not necessarily better—from professional actors without working with them for a long time. They understand the filmmaking process.

There are special actors who extend themselves and go into areas you didn't imagine. For example, Sean Penn deserves a lot of credit for *Milk* (Gus Van Sant, 2008). But there are so many other good actors that don't get that opportunity. You find them in casting and ask, "Man, why don't I see you in more roles?" It's a dumb question because they aren't getting the roles.

Each actor is an individual, so you work with each one differently. Some want a lot of rehearsals; others don't want a lot of rehearsals. That's why I'm always confused, because there's no clear-cut method. The best thing is to provide space and have them trust you, so you can tell them where to

go and where not to go. I was lucky enough to work with Lynn Redgrave. She'd do a scene and then ask, "Did I gild the lily?" I'd nod to signify "Yes, a little bit." At first, we had this conversation, then it came down to just a look. You develop a language, you find a method. I remember reading about Joseph L. Mankiewicz directing *All about Eve* (1950). Bette Davis was struggling to get the character of Margo Channing, so Mankiewicz said, "Look, she has this mink stole. You come in and throw it on the floor like it was a poncho." All of a sudden, it clicked, and she knew what her character was. Something as nearly meaningless as an action can help an actor get the character.

Olivier Assayas

A film character is born from your imagination, plus whoever the actor is; and ultimately, who the actor is matters more than whatever you wrote. I like to work with actors who contradict whatever I wrote in the screenplay. Obviously I write a screenplay and have an idea for this or that part, but I have no certainty. I start working on the character, going for the obvious, and then I meet actors and discuss, and I realize, "Yeah, it's the obvious choice, but is it the exciting choice? Is it not going to be too dull and flat if the actor resembles the character too much?" At some point, I'm going to meet someone who is both what I wrote plus something else. You tell a story, and what happens on the actor's face is much more important in terms of the narrative—in terms of who that character is and how he or she relates to the audience—than whatever you've written. What you have written is superficial or it's a specific note; but ultimately, the wrinkles on your actor's face, the way that actor looks, what happens in his or her eyes will say more to the audience than whatever you've been trying to express in your film.

I hate auditioning actors with line readings. We talk. I don't feel I direct actors. I work with actors. So it's a collaboration, and I need to like them and be interested in them as individuals, because if I'm curious about them as individuals, hopefully the audience will be as well. Also, I want to be curious about what their take will be on what I've written. I need to work with people who are smart, fast, and capable of understanding not only how to act the scenes but also how to absorb and transcend the scenes. I need that level of understanding of what's going on. It's not so much about actors as it is about individuals.

Agnès Jaoui

As an actor, the worst thing I've been told is "Have fun." It's impossible after you've just done a scene and the director says, "Do it again and have fun." Or "Be funny," as one director said to me. "It was good but now, be funny."

The actors play scenes from the movie during auditions, and I take time because I remember as an actress how hard it is to wait and not meet the director. Casting is one of the hardest moments of the film for me because, with each actor, I feel how painful it is to audition. It's always important to have the right character, and I can't change actors when it isn't working, like some directors do. I don't have the money, and I would feel too bad. I like actors and theater, so I know a lot of them.

After they're cast, I try to see the actors as much as possible. I give them the finished script, and then I meet with each of them, one by one, to involve them and see if there are possible misunderstandings. Sometimes they don't get the meaning of a line, so we will speak about that. I want them to feel that I love them, because the better an actor is, the more self-doubting he or she is, and my job is to give them confidence. And then we rehearse almost all the scenes whenever it's possible, in a rehearsal space and on set, and also with the DP, sound engineer, costume designer, and makeup person. Some want to improvise and others don't. They're all different, but the most important thing I create for them is confidence.

Matteo Garrone

I always start from the face, so it was important to find the right faces for *Gomorrah* (2008). As [Roberto] Saviano said in the book, it's not cinema that takes inspiration from reality but reality that takes inspiration from cinema. So it was important to show that these people love Mafia movies that glamorize certain characters and how different their real lives actually are from those Mafia screen characters. They pretend to be like the movie Mafia, but their real lives look completely different.

I cast very specifically. My father is a theater critic, and I used to go to theater a lot, so I have a lot of theater director friends. Some had been doing theater with prison inmates for twenty years, and these prisoners are sometimes so good. I asked them if there were prisoners who had been released, and they gave me very good actors. That was the first casting. Another good director friend had been working in a local theater company in Campania, where I shot the story of Toto and Don Ciro, so I found all the

guys there. They were happy to be on-stage but they also lived there, so they had the background. I always mixed the character in the screenplay with the actual person who played that character. That's close to documentary, so it's like a marriage between the person and the character, as Jean Renoir described it. Toni Servillo, who plays Franco, and Gianfelice Imparato, who plays Don Ciro, are famous theater actors. I found a few other actors on the street, and I mixed all of them.

How I direct depends on the actor. With some actors, like Servillo, who is incredible, I worked more on the dialogue. But I wanted the two young guys playing the guys who pretended they were in a movie to think that they were so clever that their characters wouldn't die. I showed them the script page by page, or sometimes just told them the development of the dramaturgy without the ending. And I always shot in sequence—from scene one to scene forty—following the dramaturgical development of each character. That was also an important test for me, because the actors lived that journey and could tell me if the role actually corresponded to reality. But it was difficult at the end of the shoot to convince the two guys to die in character because they didn't want to look silly to their friends who would see the film. They wanted to kill at the end instead.

I don't believe in having real people act themselves because sometimes they are false, but there are exceptions, and the man with the red beard, the one who says, "If you do this again, I will kill you," was actually the real boss of the town. After he'd said that in his first scene, he came to me behind the camera and said, "Okay. These two guys have to die at the end. A real story close to here happened like that, and they died." He didn't know that I knew they would die because Saviano's book described that real situation. But the two guys were also standing there, so I didn't want to reveal the ending. I just said, "Okay, we'll see if they die or not; maybe they are so clever they won't die." So when we arrived at that last scene on the beach and were waiting for the sun to set, I thought that using the real boss to kill them would be offensive to him, just like a real boss wouldn't do it himself. But the actor/boss wanted to kill them. Someone called him at home and said, "They are on the beach and they are going to shoot the last scene without you." He jumped into his car and arrived on set, completely mad. He said, "Okay, nobody will shoot here. I don't want to be in this movie!" His nickname was "Bambino," and he acted just like a child. Everyone tried to calm him. "We wanted to call you but we didn't

know they didn't call you." I just waited, because the director is like a boss and he gets respect as a boss. So after all this show, he came to me, and I said to him, "Bambino, okay, you will kill them, but it's important that we make this a very good scene." He started to laugh, he was so happy, and he did it. And I convinced the two guys by saying, "Think of Leonardo DeCaprio in *Titanic* [James Cameron, 1997]. He died and became a hero. Think of how your mothers will cry." Filming this episode was a lot of fun. I can't forget the faces of the two guys while they were waiting, as all these animals fought each other over who would kill them. They were terrified, it was amazing. There's a close-up of the face of the thinner one, so scared. It's hard to explain how infantile and brutal these men are. This is the Camorra.

Sergei Dvortsevoy

The main character in *Tulpan* (2008) is played by a student at the Film Academy, a future director. The sister is a professional actor. The tractor driver is also a professional. The shepherd is an opera singer. Tulpan's parents were local people. It is difficult with amateurs, and you have to find some key for everyone—sometimes a very little thing, but it's important. I found it, but it was difficult—even for the professionals—once I realized that the animals offered such a high level of truth and organic existence onscreen. So I told the actors, "You have to be very organic—as good as the animals."

Of course, animals and children are the most difficult actors to work with. With animals, you cannot rehearse; you just create the situation and then observe. The same with the little boy; it was impossible to rehearse. I could never say to him, "Do this" or "Go there." You couldn't push him, so we just created situations. We played with him, and then we shot what we observed. The little girl wasn't in the script. I had two children in the script, but when I met the three children, all from one family in the village, I saw her in real life, singing all the time, and I decided to change the story and create her story line. Now I see that it's a powerful and important line.

The scene with the veterinarian complaining about the mother camel was also not in the script; it came from real life. I saw this camel, and I didn't understand why she was crying. Then I realized she was afraid we would steal her baby, so I decided to create the scene with the vet and the camel. It was a spontaneous decision. I decided to change everything that

morning, just before we started to shoot. Even now I can't imagine how we caught that, because the camera's movements and the camel's movements are so precise. It was very lucky.

Pedro Costa

I've worked with professional actors, but because I've been working mostly with people in their real situations within a community, it would be wrong, almost cheating them, if I imposed this machinery of the usual way films are made today. The people I work with on most of my films are exploited by everything—society, police, unemployment. So there's no sense in bringing in another big machine that's going to exploit them, perhaps rape them. So I had to rethink that before I shot them—what's the dialogue? I had to do all that work before; I had to prepare that and also show them, tell them. It was important they know that cinema can still exist in that kind of world. It can be part of their world, and with luck and work, it can produce interesting things. But you have to stay there; you have to be there. You can't go in like the shoots today that I see all the time. It's like they have police patrolling, and you cannot cross the line; you have to be silent. The silence thing always annoys me because it's like, "World! Shut up! Stop! We have to create something."

Claire Denis

I cast by knowing an actor's work, and sometimes, as with the young woman in *35 Shots of Rum* (2008), I met her and I knew immediately. I do tests because it's a sort of rehearsal but not to choose someone. When I see someone, I know already that I want to work with that person. I can see that he or she is exactly what I need, and I look and I want. And if I do tests, it's just to rehearse working with that person but not to test him or her. What is important is not a marriage between the character and the actor but the marriage with me. The connection is with me.

We discuss shoes, clothes, and hair, and we go to restaurants together. We avoid talking about the film; we speak about a million things, and we go to see films. We listen to music. I'm so afraid to rehearse too much and lose the film. Not the freshness. Actors can do things a million times and still be fresh, but I can't. Me, I lose my shyness, my emotion, and I need to be shy.

Sometimes we do run-throughs before the camera, and sometimes I don't need that so much. And sometimes we block scenes but not do

run-throughs, because I'm afraid that something might happen during the run-through that I would like so much and I wouldn't have it on film. I block because I know the framing. And I don't do a lot of takes, no. It's rare and happens only when there's a technical problem or when something unexpected happens, like thunder or wind or some sound thing, but it's rarely for acting.

Jia Zhangke

I don't understand how a lot of directors make films in the United States. Most of the time directors focus on the monitors, and usually the communication happens between the assistant directors and the actors. That's not how I make films. It's important that the actors not only perform for the camera but also have interaction with the director. You can't be glued to the monitors and leave the communication to others.

The difficulty and the challenges are the same with actors and non-actors, but the way you communicate with actors and non-actors is different. In my first three movies I used a lot of nonprofessional actors. The official language in China is Mandarin, but the actors' mother tongues are usually dialects from different provinces. And when they use their mother tongues, they come alive and are so much freer with expression and emotions. An unwritten rule states that movies must be in Mandarin for the government to promote them, but most actors in my movies speak dialects. Also, the location and story are familiar to them, and it's most important to make sure these nonprofessional actors feel comfortable with the crew because the sense of mystery about filmmaking can be intimidating. Once they're comfortable, their personal experience and imagination come through and enrich the screenplay. There are a lot of things I can't imagine, and their experience can fill in gaps caused by the limitations of my screenplay. So I use them not because they look like local people, have the accent, or act naturally, but for this sensibility, experience, and imagination they have beyond my screenplay that somehow complement the whole film. I give them freedom and license to play a huge role in bringing their own experiences and feelings to my film.

I've learned from nonprofessional actors that when they are having a hard time performing or saying a line, something's wrong with my script. Maybe it's not authentic, and that's why they feel so uneasy with the lines. For example, in *Still Life* (2006) the man playing the miner is a real mine

worker, and there's a scene in which he's reunited with his former wife. His wife asks, "Why, after sixteen years, do you suddenly show up?" In the script, it's because he was trapped in a mine shaft and he made a promise that if he survived he would visit his kids and former wife. But when we were shooting, the actor felt uneasy. I asked why, and he told me there's no need to say this; it was almost as if we were giving the punch line. If he doesn't say this, maybe the audience will have room and freedom to use their own imaginations about why he showed up. I was really taken aback, and I realized that this is more my style and that this indirect, subtle way is better than spelling everything out.

When it comes to professional actors, I trust their imaginations and performances. Of course, there's a reason we have the auditioning and casting processes, to find the connection that allows actors to relate to the characters they have to play. In *24 Hour City* (2009) Joan Chen's character refers to *Little Flower* (Zheng Zhang, 1980), a movie Joan Chen actually played in that made her famous and is part of her youth. This sense of reaching one's prime during a certain era and then having to deal with the aging process is similar to the situation of the character she plays in my movie. Through her character I wanted to show not only how society has changed individuals but also how individuals have changed through the process of aging. I give the actors and actresses this counterpoint so they have freedom to bring their own experiences and imaginations.

Gerardo Naranjo

We Mexicans have a strange emotional, let's say, sentimental education, because we are so used to a dramatic soap-operaish style of acting. We are used to being ridiculously sublime, and our nature is so excessive, so kitsch. That's precisely why I try not to work with actors who have those vices and why I don't do too many takes, so they start to know what they are doing, become self-conscious, and offer their best angles to the camera.

The two young leads in *I'm Gonna Explode* (2009) aren't actors. They were fifteen-year-olds we found in the street that we selected precisely because they are that, incomplete persons, but not in a pejorative way. They are fifteen, not sure of their concepts, but they take risks, walk in, and make decisions, and it's beautiful to see them take big steps in life, knowing the dangers and being unsure but being brave enough to go ahead.

We see the adults from the perspective of the kids, so professionals play the adults for precise reasons. They are well-known, great actors who used a theatrical acting style to portray their characters in a ridiculous fashion. The kids appreciate and live life fully, whereas the adult characters are fools, ridiculously shallow and completely lost. So I used the actors' knowledge of the medium and their intention to give their best angles.

Lucrecia Martel

The first thing I do when I'm casting is to call people whose work I like, who have great talent and work well. Actually casting takes me a huge amount of time. Thank god I've been working with the same casting director, Natalia Smirnoff, since my first film. I also devote a lot of time to casting secondary and tertiary characters, even extras. I select and know all of them personally, and I actually have conversations with everybody I film in any single scene in the movie. Nobody goes into my film that I haven't spoken with.

I write scenes for casting that are not going to be in the movie. For *The Headless Woman* (2008), I wrote a terror audition scene for the lead character in which she was in a public place and had the feeling that she'd walked by a corpse that was alive. Some of that scene's lines were scripted, but a lot was improvised. It's important to film those casting scenes directly, and I'm the one with the camera. It helps me to understand deeply what the actor is about.

It was Maria Onetto's first lead role in film. I saw a huge number of actresses for the role, and when they were doing improvs, Maria seemed mysterious. Even just talking to her in a restaurant, her way of dealing with people is so different from what we're used to. She doesn't worry about whether or not she looks good or what people think of her. That's her personally, not even as an actor. I was so impressed over how she doesn't care if people find her good-looking, ugly, or ridiculous. I also cast her because of her physical features—she's very tall, very white—and that was important because I was trying to find somebody who may or may not have committed a crime and is trying to hide from that. Because people in that part of Argentina are short and dark, with her type of body it would be hard to hide.

I believe the secret to dealing with anybody in your crew, especially the actors, is to have open conversations, to listen and take in what they

have to say. I try to avoid that sadistic/masochistic attitude that can take place on a set. There are so many horror stories about that in the film industry, and I think it's such a small, bourgeois, and unnecessary attitude. So I make a point to keep the conversation kind, and I could count on Maria's incredible sensitivity and memory. Whenever we were getting ready to shoot, Maria always remembered what we'd just filmed or what was coming later, to the point where she'd remind me on the continuity, and that helped a lot.

Brillante Mendoza

Sometimes I cast the actors before the script is finished, because I work with the same people, so they're involved in the preparation, which is a long process. I've worked with the same actors over and over again in my films because I treat actors completely differently than other directors. I befriend my actors. Most of the time, I talk with them much prior to the shooting. We go out and talk a lot about anything under the sun, not necessarily about the film or their characters, because I want their confidence and trust. I also reveal myself to the actors. It's a long process, but we develop a certain relationship, involvement, and a total environment when we are on the set. That's why the shooting period is short, because 50 percent of my work is already done. I also talk with my writer all the time, and we go out a lot, even if we don't talk about the film. But the mere fact that we all know each other very well adds a lot and is important because it means we're following the same line.

I don't rehearse on set with the actors because I don't want to tire them, and I'm a first-take director. I don't do several takes because I believe in the spontaneity of the shot and the actors delivering their characters. When they do it the first time, they really feel their characters, but if you keep rehearsing and doing it several times, they can lose the authenticity of the scene and whatever they're trying to portray. We don't have to discuss when we're on the set, even if I give minimal instruction. We know each other so well that I can work very fast on set.

Courtney Hunt

I went to the Film Columbia festival in upstate New York, where James Schamus brought *21 Grams* (Alejandro González Iñárritu, 2003), featuring

Melissa Leo, and she liked the script for the *Frozen River* short. I was very shy, had a one-year-old baby, and was all about breastfeeding. She's also a mom, so we talked about this and that and made friends. I could tell from *21 Grams* that she could carry a feature. You don't see that kind of energy with every actress. There's a lot of flatness in the acting world. A lot of people acting in these big movies seem afraid to squinch up their faces because it might look ugly, and this fear of any type of ugliness is not unique to women. I don't know anyone who cries without moving their face, but you see it all the time in movies. It's one of those false realities that cinema sets up, and we all go along with it. But it's just not true, and there are actors who can do it, like Melissa. She's alive, a dynamo, and I knew that if you helped that kind of energy a little, it could carry the movie.

Misty Upham counterbalanced her energy. I found Misty on the Native American Celebrities Web site. I think she and Melissa were wondering during the making of the short, "What is this girl doing?" But they stuck with me for the next three years until we made the feature. What helped keep them involved with the project was that when they'd ask, "Now, why would she do this?" and other motivational questions, I'd go on for an hour and a half with the back story. Then they'd say, "When were you going to tell us these back stories?" I had written the complete back stories for the characters because I had the feature-length version of the film in my head, but I didn't want to discuss that with them because I felt the short had to stand on its own.

My writing is action-based. I don't have long moments of people thinking and dramatic, long-held moments. I'm not crazy about those shots in close-ups, when the music has to come up—come on. *Frozen River* is about people doing stuff, so we'd talk about what people were doing. "She does this, she does that." "No, no, I think she does that and then this and this." "Okay, she can do it that way." We switched around the order of various actions so the motivation could stay fresh for the actors. "No, I really think she'd have her coffee and then she'd light a cigarette." And they had certain character things they'd bring to it, especially Melissa. Misty was more like, "Do you want it angrier? Okay." And she'd do it. They were easy to work with and balanced each other well.

Other than them, I didn't have the luxury of auditioning people for other parts. I picked people, they came, and they brought me what they had. I accepted what they had and worked with it as best I could.

Lance Hammer

In servitude to conveying the Delta accurately in *Ballast* (2008), it was obvious I had to cast people who lived in the actual town where I was shooting. They couldn't have acting experience, and they had to bring their own experiences and language to the roles. I wrote a script with dialogue, but it was always provisional, and I knew I wasn't going to show it to the actors. This is the great benefit of working with nonprofessionals—you don't have to give them a script.

I found Mike Smith in a Baptist church, and I had open calls, visited churches and Boys and Girls Clubs, and looked on the street for people with the physical characteristics I wanted for the parts. I saw a lot of people, but I didn't have much time, so I narrowed the auditions down to three or four people for each role. And through the auditioning process, I auditioned the directing technique. "Okay, I respond to your physical, energetic presence; it feels close to the character I've written. Let's try a scene together." So I'd bring in two actors I was auditioning for two different roles and say, "Here's what's happening in this scene. This person is doing this and that person is going to say something more or less like that to the other person, and they'll respond. How would you respond to that? Tell me your response." We'd talk it over, and I'd say, "Okay, let's try it." They understood right away. "Imagine this was happening in your life. How would you respond?" Children role-play naturally, and they bring their own emotions to being a soldier, an astronaut, whatever.

Özcan Alper

When I'm working on the characters' psychological states, I also think about their physical features. For example, Yusef, the lead character of *Autumn* (2008), is from the Black Sea region, so I knew what his bone structure should be like. And when I was thinking about this Georgian prostitute, I wanted her to look sexy but, at the same time, look innocent. I contacted theater companies, casting agencies, and film schools. First, I looked at their physicalities, then their acting styles, and I was also interested in sensing if we would become friends. The process of auditions and rehearsals took a lot of time; the pre-production in general took one year. If you don't have much money, you don't have much to risk, so instead of taking risks while shooting, I'd rather take time in pre-production. Also, since the lead character speaks Hemshinli, an Armenian dialect, with his mother, Turkish

with others, and Georgian with the Georgian girl, it took six months for the lead actor to learn these new languages.

I let the actors improvise when the camera was off, before shooting, and we went over the script. I explained everything in advance, talked with them about the characters' psychologies and motivations. But while shooting, I was more rigid, I wouldn't give them that much freedom. We did have a sort of coach, a friend who had recently been released from prison and had a story similar to Yusef's, so he came to the set and helped out the lead actor by explaining certain psychological issues. There were some difficulties with the woman who played the Georgian prostitute, probably due to language constraints and differing backgrounds. When I talked to my lead actor, I used references ranging from Dostoyevsky to Brecht, and we became friends, whereas the lead actress didn't have that experience. So I had different styles of directing different actors. You have to accommodate their differences. I gave the lead actor a lot of room, whereas I would even tell the Georgian actor where to place her glass. The mother was a completely different story. She was not a professional actor; she was playing her real life, and I followed her daily routines. I let her pray, light the stove, and I followed her around. Sometimes I would say, "Why don't you prepare breakfast for all of us?" So she would do her thing, and we'd film it.

Andrew Bujalski

In all three pictures I've done, the strategy was the same—I began with the leads in mind. For *Beeswax* (2009), it was the Hatcher sisters, maybe because they bring so much specificity as twins and in terms of Tilly's disability. The other films were equally reliant on the specific people I wrote for. I couldn't have done *Beeswax* without the twins or *Funny Ha Ha* (2002) without Kate Dollenmayer. All these people are friends I found charismatic and compelling.

I had a fantasy about how I could translate what I thought was so interesting about them into a screen performance. Even though none was a professional actor, you still have an idea of how somebody performs in daily life. But one thing you don't know until you try it is what will happen when you pull out a video camera and do a little screen test. Some people absolutely freeze up. But once I have a sense of how I might work with them within those confines, I start writing. Of course, I can't tailor every part for

every person, but I build around my idea of how the leads are going feel to the viewer on-screen. So I start with an idea of a feeling and then build an imaginary story around that.

My knowledge of their lives bleeds into the story, but I've never written anything biographical related to the people who play the characters. In *Mutual Appreciation* (2006) Justin Rice was a musician, and that was a huge part of building the story. But it's more to do with the sense of what I find funny about them or what I think will play on the screen, which doesn't really go to the depths of their personalities or their life experiences. It's completely personal to me and, in a way, personal to my sense of them, but it's never factual. In the case of *Beeswax*, I was probably pushing these characters furthest into a story that didn't necessarily come directly from them. I was mashing together this vibration I had about the actors and the characters I could build with them and my external concerns.

The drama takes place on such a low frequency in my films that it will not work if the performances don't feel organic, as if they're coming from a real place. If the actors convey the information too efficiently, which is what I think professional actors try to do—convey information efficiently—then the story won't make any sense. It needs that level of confusion because the story is about that level of confusion. So I try to create an environment where they can do their best work, but they're still doing the work.

Much like any movie with professional actors, casting is 90, 95 percent of my job—getting the right people with the right instincts and then making a space wherein things can work with me, not against me.

Mary Harron

I'm casting right now for a vampire film, and I guess the film wouldn't have gotten very far if it wasn't sort of a horror genre, although it's an art version. I take casting seriously. It's almost the most important part of what I do, and it's certainly the most important part of pre-production. I spend a long time doing it, and I'm not particularly interested in stars. I'm casting sixteen-year-old girls right now, and how many sixteen-year-old girls are well known? To me, casting isn't about creating building blocks to financing the movie. Obviously, stars help finance a film, but it's really about the person's appropriateness for the role. There's been pressure over casting since the early nineties, when stars started wanting to be in independent movies. Distributors then wanted big stars in every film, even for a $3 million

movie—"Get Brad Pitt playing this." The expectations got very high. So one reason I wanted to do a horror movie was that for horror you don't usually have to get a big cast of stars.

These days they put the auditions online when you can't be there or if they're vetting a lot of people. They were casting my new film in Los Angeles for a couple of weeks before I could get out there, so they put a lot of people online so I could look at them. But sometimes that's a shame. For *The Notorious Bettie Page* (2005), I was at endless audition sessions. We saw many people for the lead role. Gretchen Mol was great, and after she read, no one else was right, but HBO was a bit hesitant and wanted me to see other people.

I like great character actors and up-and-coming actors because some-times—it depends on the actor—a star persona can get in the way. And I will fight for someone if he or she is right for a part. They have to embody the character, and film casting is very specific. It's not enough that they look right; it's not enough that they be good actors. They have to have something of that character in them or they have to have an inner quality that is right on-screen for that character. When Christian Bale came in for *American Psycho* (2000), he didn't do a great audition. Someone else actually did a better audition, technically. Christian had just been playing a British character, and he had trouble holding his American accent, which interfered with his timing, and I had trouble getting him to the right pace and energy. But I cast him based on the range of work he'd already done, where he'd been very different in different movies, and because he had a quality that was compelling and seemed right. I felt that he's a great actor, he'll get it right.

I always prefer that people read, but some people won't read if they're famous or have done a huge amount of work. You don't have to get David Strathairn to read for you. He's done many varied roles, so you know what he does. But in the case of *The Notorious Bettie Page,* he wanted to check out what I thought of the film and his character. If the actor is well known, sometimes he or she is kind of interviewing you during your meeting.

I want everyone in the cast to be right, even the day players, so I spend a lot of time. Very few people are good at casting, so I talk with my casting director and my husband, who is also my writing partner now. Sometimes at the end of pre-production, there might be one or two parts you have to

cast quickly, before you've found quite the right person. But in an ideal world, everyone blows you away, even if they're on-screen for just three minutes.

Constantin Costa-Gavras

The most important thing about actors is casting them correctly. But before you cast, you must have the right writing—the situations and dialogue for an actor to play in the story. If the dialogue and situation are not good, the actors will not be good. Then you have to have good actors. I see all the actors, decide who's right, then discuss the roles with them for a long time and see how they accept the characters or don't accept them. Essentially, I'm trying to be sure that they want to serve the roles rather than have the role serve their personalities, and this is a delicate moment.

I never do line readings. Those readings they do in Hollywood are bullshit. You cannot get something good from an actor who is reading two pages in fifteen minutes—it's ridiculous. It's a way of showing your power and making people feel obligated to you, making them submissive.

Once actors are cast, we talk together for a long time before shooting and also before difficult scenes. Sometimes we spend a weekend before the shoot to establish the scenes in a general way, then we go into detail on the day we shoot—blocking and explaining the psychological state of the character in that moment.

I'm open to feedback from actors, but it depends on how intelligent they are. I could say that actors are a little like musical instruments. You touch a violin a little, and it has a nice sound, but with a big tuba, you have to work harder.

Catherine Breillat

I invent my actors. In France, no one wanted to work with me. There were no men who were willing to act in *Sex Is Comedy* (2002), and no French actresses would accept either. But I went to a stage première and was waiting to congratulate the stage actress, when a woman stood up and stared at me. It was the actress Anne Parillaud. We'd never met, but I realized that she was going to do the film. My producer and first assistant thought I was crazy: "Well, you at least have to ask her if she wants to." I said, "No, she doesn't know it, but she's going to do the film. She wants to do the film." I first

saw Asia Argento in Toronto. I was talking to someone from UniFrance and told them, "I'm going to shoot *Une vieille maitresse* [*The Last Mistress*, 2007] with her." She was, in fact, still too young for the part. But in French, *vieille maitresse* has a different meaning than "old mistress." It's rather a mistress that one can't leave, can't break up with, so it's not a question of the age.

Otherwise, I invent the actors. I see a lot of unknowns, meet two hundred unknowns and choose the first one who's going to give me what I need. I never rehearse with the actors, but we block out scenes extremely carefully. There's the choreography of the actors' bodies and the camera movements. I used a lot of rails for *Bluebeard* (2009), because there were a lot of traveling shots in the film. That was all prepared minutely, but the actors never act the parts before the cameras are in place. I never discuss the characters with them either. I choose them because they are the characters, and I never tell them what to do beforehand. If I choose actors, it's because I want them to surprise me, and if they don't manage to surprise me, telling them what to do will not lead them to do that. Rather, you always direct actors by telling them what not to do.

4

Cinematic Rhythm and Structure

Cinema's ability to defy ordinary limits of time and space means that a film's structure can be as complex as an architectural space, with various angles of entry and points of view, hidden rooms, and twisting, turning passageways. Some films are labyrinths in which the viewer searches for resolution, a way out, while other films are like big, empty rooms in which everything is visible. The viewer enters through the front door, looks and listens for a while, and then exits through the back door, often promptly forgetting whatever he or she has experienced.

Rhythm, what some filmmakers refer to as a film's music, greatly influences a film's structure, and vice versa. Rhythm gives flow to a film that can carry the viewer throughout, even when the film's structure is labyrinthine, dispensing with exposition and neat resolutions and creating an apparent discontinuity in order to invite viewers to enter the film and fill in from their own experiences whatever is "missing." Together, structure and rhythm contribute to a film's meaning, emotion, and fluidity.

A film's structure and rhythm can be written into the script and/or come from many elements within shots—machinery, animals, the movement and language of humans, passing shadows, light flashing through objects, and diegetic music, that is, music present in the scene, such as when a character listens to a car radio. A film can also draw rhythms from nondiegetic music on the sound track or from the natural tempos of the culture in which the film is set. Of course, a film's rhythms often emerge from the continuity (or discontinuity) of the scenes and sequences that constitute the story. The rushes, the daily shots, are usually out of

sequence due to shooting schedules organized by location rather than by story sequence, although some filmmakers prefer shooting in sequence so that cast and crew can develop a keener sense of the story. In any case, the film often takes on a certain rhythm from the continuity (or discontinuity, if that is the desired effect) and the lengths of various shots as the film-maker works with the rushes during the edit. Most filmmakers agree that, as a powerful yet ineffable cinematic element, rhythm is more a matter of instinct than intellect, so a filmmaker often finds his or her way to a film's rhythms intuitively.

Some contemporary movies are influenced by the kinetic pace and busy structures of music videos and television commercials, with their short takes and many sharp edits. Shooting commercials and music videos teaches filmmakers and viewers a kind of cinematic shorthand—how to say something quickly and vividly and sell a product or a story in fifteen seconds or so—an experience that can sharpen directors and audiences. However, when that style is used in a limited way—for example, just to tell the story and ensure audience attention—the result is a superficial film that might as well be a commercial advertisement.

The filmmakers here rely on the more subtle agency of a film's rhythms, knowing that if the rhythms of a film coalesce and work with its entire expressive complex, viewers can be launched straight into the messy life of a film's subject and become involved, even if they enter in the middle of the narrative or if they are confronted with the element of unreality in a fantasy film. They will follow along, again injecting personal experiences that echo the filmic experience in order to help themselves identify more with the characters. Finding a film's true rhythms is so crucial that, for many filmmakers, it really means that they've arrived at the final edit.

Lance Hammer

Everything about *Ballast* (2008) was subservient to conveying accurately the feeling of being in the Delta. The pace of the Deep South is different from the pace in cities. The rhythms are slow and people have time, so I wanted the rhythms of the editing to reflect that. It's funny because there is a lot of jump-cutting in *Ballast,* but I was trying to make that seem not frenetic, so the jump cuts occur within an entire piece that is languid.

Breaking the Waves (Lars von Trier, 1996) changed my life because I realized what is allowable in film language, what people would accept,

and I felt liberated as a filmmaker by seeing Lars von Trier totally and purposely defy continuity. Dogma has liberated filmmakers from the tyranny of Hollywood and preciousness, and I'm a big fan of reduction and stripping away everything that's not essential. Mark Hollis, a musician, says if you can use one note to say something, why use three? Why not let that one note reverberate and resonate across space and time and truly understand its subtleties? Robert Bresson, my true hero, also insisted on economizing—showing something in the simplest form and leaving space for it to exist so you have time to consider it. If you have fourteen things happening, that one thing will be lost or diluted. But if you just focus on that one thing, it has the potential to be very powerful. Dogma basically says we don't need all this noise. Let's talk about the essence of the story, the essence of the shot. Let's not put all this other shit in between that expression and this expression. Let's cut out every frame in between and show just those two things. You move faster in time, and you don't waste so much eye space watching all these unnecessary frames. Even though continuity and editing techniques tell you that you should put all that in, you don't need it. It's unimportant; people will understand, because that's the way life is.

Pablo Larrain

I hate when I see a film and can tell what's going to happen. If you always follow what you should do, it kills the film because you don't let it fly away on its own wings. Although *Tony Manero* (2008) has a classic, Aristotelian structure with three acts—a beginning, middle, and end—the film doesn't look classic in any sense, because every time you think something is going in a particular direction, it twists and goes elsewhere. I didn't do that to manipulate but because I felt that's the way it should be.

Kiyoshi Kurosawa

The truth is, I didn't place a lot of weight on the concept of sonata for *Tokyo Sonata* (2008). It takes place in Tokyo, there's piano music at the end, and "Tokyo sonata" had a super nice ring to it. But I did look up what "sonata" means. It's three or four pieces of music combined into a single, coherent whole. My film has four central characters, and their dramas unfold independently in the world. From time to time the characters come together to share a meal, so I had to think a lot about the ideal way to structure this. It

wasn't as if one story was more important than another or one came first, so I had to figure out the best combination for telling the individual stories within the context of all four. It did make a difference in the way I cut the film, in that I took fewer liberties in scene transitions and I stitched the various scenes together meticulously. For example, I didn't cut to scene B until I was confident that scene A would be fully digested by the audience. I didn't want to leave a mystery about what was going on in scene A before moving on to scene B, which would have been a rough editing style, just moving along and pushing the film and leaving people wondering what they had just seen. So I took my time to make sure that the audience understood exactly what was going on in each scene.

I had always planned to end *Tokyo Sonata* with the piano recital, but in my screenplay the boy just stops playing. So the real conundrum was what to do after the music stops. I knew there wouldn't be a standing ovation, but people wouldn't ignore the performance and walk out either. Right before shooting, I couldn't figure out what came in between. So the film's ending, where the boy and his family leave and the audience stays in the room, is an abstract representation of watching over whatever will happen to this family in the future because no problems have been resolved. To me, it felt like the most honest position we are in as an audience, which is that we just have to hold our breaths as we watch what we imagine will unfold later.

Lucrecia Martel

Of course, everything in my films is planned, it's artificial, but I believe that everything goes through the body. There's this idea that thoughts are intellectual, but in my opinion, they're not. They're shaped by our perceptions of time, rhythm, and tone, and so they're really physical by nature. I believe it's naïve to say that this film is intellectual and that film is not intellectual. In fact, there's nothing more intellectual than commercial Hollywood films, in the sense that they are like chess games, a series of thoughts that predict what's going to happen next.

Bette Gordon

You find the rhythm more in the editing room. In the writing, there's a text, but the pages are a blueprint for something else. It's not really the thing itself. For me, shooting is gathering information, everything I'm going to

need. Getting into the editing room means construction and reconstruction, so rhythm plays when we're there.

It's hard to teach. People have taught filmmaking using an analytical projector, looking at each scene, each frame, and at the rhythm. But that's an analytical process used only by people who analyze films. As a director, I never think about that. I use my instinct in the editing room to feel the rhythm, and the more you watch it, the more you feel it.

I don't think you can teach rhythm. You either have it or you don't. It's something you have to feel and understand. Another way you feel it is with an audience. That's why people do the good kind of test screenings, where you invite friends or random people into a screening room. It's not about "Did you like this or that," but sensing how they respond to the way in which the story's told, to the rhythm, the timing. When they lose focus, you can feel it in the room. When they're sitting up and paying attention, you can feel that too. As in oral storytelling, if I'm telling you a story, I know when I'm losing your attention. You can feel that between people, so a director has to feel that with the audience. That's why you have to test it with people. Even if you have only one person in the editing room, you are now experiencing it through that person's eyes, and you see where things lose steam, where they gain momentum, and where they're too long or short.

Ivo Trajkov

I especially find the rhythm in the editing. Actually, sometimes I work as an editor, as a doctor in the editing room for other films. I love that profession because I love that period in making a film. Sometimes you actually shoot something that you didn't realize you shot, because so many circumstances hit that frame during that moment. Suddenly, something is happening in front of that camera, and often you're not aware of it. So you need time after the shooting and before the edit to forget about being the director, just as you have to forget you are a writer after you've written the script (if you're the auteur) and before the shooting to avoid the danger of becoming stuck in that first idea of it.

I'm saying this because I need a longer time to forget what I have in my mind in order to discover what's really there. Sometimes I need to listen to that material—"Oh, this is interesting"—because it offers me a particular direction and I start to follow that way. Of course, you need time for that.

With genre films, though, it's almost impossible because the rules are so strict that you can't play with the rhythm. It's four weeks to edit and that's it. In auteur films, there's time to listen and feel shots, to realize what's there and then try to go a different way, even if it's different from what you originally thought during the shooting.

Céline Sciamma

Rhythm matters most. I told my actors in *Water Lilies* (2007) to say the dialogue in a flat way because that's not a matter of tone but of rhythm. To me, it's all a matter of rhythm, and even tone is a matter of rhythm. For example, if you speak fast, you tend to sing a little. I was shooting moments, and I used a lot of long takes from a single angle, so I needed the rhythm to be true in the shoot because I wasn't going to create the rhythm in the editing room. That's why I was always telling my young actors things like "Lift your head," "Look right"—really coordinating their movements, especially with Pauline, who played Marie. She has a lot of scenes where she's alone and doesn't talk, so I created a rhythm with her as she acted. It was a kind of choreography. Cinema is very much about the rhythm, and that's what makes the difference.

I contrasted the rhythm of the actors with the rhythms of the sound track music, the electronica and the music that accompanied the girls' synchronized swimming, as well as with the rhythm of the editing. I wanted the movie to go fast, one hour and a half in all, a kind of pop thing. I didn't want any useless scenes so that the film would be fluid and no one would get bored. The film features a character faced by obstacles, which gives the viewer a sense of classical drama, and I combined that overall rhythm with the rhythm of each of the scenes. A good example of combining two rhythms is the scene in the locker room where Marie says to Florianne, "I'm going to do what you asked me to do"—deflower her. The scene is long, there's a lot of silence; but after she says "I'm going to do it," there's a cut, and then the viewer is in the bedroom as they're doing it.

Anne Le Ny

Rhythm is almost everything in a film, and it's an element where you feel the director most because it's one of the most organic elements of a film. I was impressed by François Truffaut's *La peau douce* (*Soft Skin*, 1964), where

there are lots of shots of doors opening and closing and keys turning—let's say, shots that are not of extraordinary interest but that make you feel the rhythm of the director's heartbeat.

I didn't know about editing at all when I made *Those Who Remain* (2007), because actors are not invited to the edit. Maybe that's one reason there are not many shots in my film, but it's also my reaction against this fashion of editing films with shots that last no more than five seconds. And it was also my way to control the rhythm. So although I could say I don't think of the rhythm, it's intuitive. Right or wrong, you have the feeling when you are right with the shot.

Mia Hansen-Love

Film is about the language of acting, like theater, but the incarnation comes not only from how the actor performs the dialogue and action but also from the way you are looking at the actor—how you filmed him, how you cut the scene—and the wardrobe. And it's not only that, it's the whole film. So film language is special, and it also has to do with some kind of invisible music. When I talk about the truth of a film, I don't mean the truth in terms of right or wrong, but the feeling that it's true, which has to do with this invisible music. This music results from the work with actors, with editing, and with music itself.

The music or rhythm of a film is hard to explain in words because it's so intuitive and therefore has to do with personal feelings. You see the film after you've done the first cut, and you try to sense if it's the right rhythm, if it goes too quickly or too slowly. But because the rhythm is an ensemble of different things, it's hard to describe. So although I tried to find a rhythm with *All Is Forgiven* (2007), I didn't want to insist on that, because for me, when the style of a film is obvious, it's too emphatic.

Teona Strugar Mitevska

Rhythm is essential, one of the most important things in film. It's the music of a film in a way, how the film breathes. As much as we need to breathe, the film also needs to breathe, and the rhythm is its breathing. I really find that in the screenplay. Sometimes I make a mistake and have to fix it in the editing, but I create this rhythm, this breathing, when I read the final version of the script. I imagine everything about the film in my head, so I edit the film long before I get into the editing room.

Olivier Assayas

It's difficult to describe the actual pace of a film because, obviously, when you make a film, you have an instinct for these things. It's like music—it feels right—and it's hard to elaborate on that. I write basic screenplays: I have a structure and dialogue, and I know where each scene is taking me. Some scenes can evolve—I add things, actors add things. Some parts shrink—because you have to follow your instincts on the shoot. I am constantly reinventing the film on the shoot and also reinventing it in the editing room.

Agnès Jaoui

Rhythm is everywhere. First, it's in the script. Jean-Pierre Bacri and I write the script like a musical score—a play of dialogue and silence. This is absolutely concise, and we are very conscious of it. That's why the text is exactly what we want, and no actor improvises, including Jean and I when we act on set. Eugène Marin Labiche [1815–1888], a comedy dramatist, wrote musical notations under the dialogue lines for the actors to follow. Of course, that was crazy, but it was also a little like slapstick or vaudeville. You have to be a genius actor to play that, and if you notice, all male actors who are comics are also musicians—it's a question of rhythm.

Sergei Dvortsevoy

If you are able to discover uniqueness in life, and you are able to show this, you should, even if it's a simple uniqueness. Then you can relate something without telling; you show it, and it goes directly to the soul and heart of the audience without need for explanations. One reason I shot such long takes for *Tulpan* (2008) was so people would feel the atmosphere, a precious, important thing, because when they feel the atmosphere and the story—everything you are relating to them—that goes straight to their hearts. They not only feel the director's brain but they feel the breathing of the characters and the breathing of nature. Catching this breathing, the rhythms of nature and people's inner breathing, was very important.

Claire Denis

Of course, I feel the rhythm of a film in the screenwriting. The reason is inside. For me, *White Material* (2009) was shaped like a spiral or when you smoke a cigarette, and the rhythm was like when the smoke drifts up. Of

course, the editing is important, but I never expect editing to shape or give rhythm to the film. It's too late then for me.

Jia Zhangke

I try not to have any prescribed rhythm or tempo with my films. Everything depends on the space and the individuals I'm shooting, so I want to capture those rhythms. But of course, at the end, during the editing process, I take into consideration two aspects. One is the objective subject matter I'm dealing with, and I will somehow select a rhythm for that. But at the same time, I somehow incorporate my own subjective rhythm. So it's a combination during the editing process of the subject matter and my own preference as a filmmaker.

In my films it's most important to get a sense of the accumulation of time. I try to express that theme, the sense of time passing, through the shots and rhythms of all my films. I chose to use only a single camera for my interviews in *24 Hour City* (2009), instead of having two or three cameras running at the same time, which would have been easier to edit; but I wanted the limitation of a single camera to convey that sense, again, of the weight of time passing. The portrait shots are also about the accumulation of time. You can see time passing in front of you during these shots, and your emotions accumulate along with it.

Spaces have become an increasingly important part of my movies, and I want to capture each space's character and rhythm, for example, the Beijing train station. Depending on when you are there, you see totally different characters and feel different rhythms. In the morning you see a highly dense population, with everybody rushing around trying to get to their destinations. In the afternoon, you see people enjoying the sun and the day, just casual and leisurely. In the evening, there's a sense of loneliness as a lot of people from Russia and Mongolia are waiting for their trains to go back home, so the space becomes surreal and lonely. Again, not only are individuals and characters important to set the tone and the pace of a film, but space is another component of the movie's rhythm and tone.

Pedro Costa

Most of the actors in my films are not professionals, so they move differently. I'm not saying they are closer to real life or that they are naturalistic. But I have to respect their rhythms. Some guys are slow and they speak slowly,

and I tend to see if they go together and let it happen more or less. Then
there's my rhythm that's constructed, and I have to think about that a lot,
mainly when I'm editing the film.

This world creates more and more dispersion or fragmentation, so
everything is partial, and some artists work toward that. The work I'm doing
is slow and small in a way, and it's about very small things. The ambition
is big, but it's really about things that happen between when you wake up
and turn on your coffee machine—there's an explosion, there's despera-
tion, there's joy—and how can you do that? I do it over this long time that
stretches a bit. I let the words come from the actors and don't impose my
thing. I bring less imagination into the thing and let her or his imagination
be the tone, the rhythm of the film. They give me the direction.

Brillante Mendoza

Rhythm or velocity in terms of direction or editing is of key importance and
even more so in the writing process of the screenplay. I work consciously to
ensure my films have a rhythm, even if the camera lingers on one angle for
two or three minutes or there's a series of rapid cuts lasting only seconds in
the editing. At the end of the day, rhythm should be dictated by the material
or concept so the filmmaker can translate his or her story effectively.

Shamim Sarif

I'm conscious of rhythm when I'm writing because that's an important part
of my writing as a novelist and, now, as a screenwriter. There's the rhythm
of the story, how you build the elements of the story and move it forward.
You want to intersperse moments of languor and artistry for their own sake
with scenes that move the plot forward. There's also the underlying rhythm
of the story. It also has to do with the rhythm of the culture in which a film
is set. With *The World Unseen* (2007), we all got into the sense that we were
living in that time of the past and things moved a lot more slowly.

Tomas Alfredson

I edit myself, and for *Let the Right One In* (2008) I worked with another editor.
When I was young, I played drums for ten years and dreamed of a career
as a pop artist. It was a one-way love affair with the drums, but it helps a
lot when I edit. Playing with the rhythm is about when and where to put
the cut and where not to put the cut. Rhythm is all around us, everywhere

in our lives and in our way of talking. Also, the Scandinavian culture has a specific way of communicating in silence, so silence is important when you talk about rhythm. Camera movements and editing are the same thing to me—this rhythm of how long a track should be, when the tracking starts and when it ends. You could say it's a part of the same rhythmical body, and it's totally instinctive. I wouldn't want to intellectualize that.

Paul Schrader

There are two approaches to shooting a scene: one is mise-en-scène and the other is montage. Mise-en-scène is the sense of blocking, and montage is the sense of editing, but both affect a film's rhythms. A guy like Orson Welles was a master of mise-en-scène, and Sergei Eisenstein was a master of montage. Mise-en-scène is stage craft, not just the physical look of a film. Take that famous scene in the motel room in Welles's *Touch of Evil* (1958), where the camera goes up and down a track as the actors keep reblocking themselves. You get your overhead shots, your single shots, your insert shots—that to me is mise-en-scène.

Mishima (1985) and *Adam Resurrected* (2008) are designed, and neither is terribly real. The minute you see that hospital in *Adam* in the middle of the desert, you know this is not quite real and it's a kind of metaphorical hospital. The fact that it doesn't feel entirely real helps the film because a lot of the action is not entirely real either. In *Mishima*, the Tokyo University riots with the kids throwing stuff around was the only pre-existing footage in the film. That film has a character with a sense of the hidden, so you have to let the architecture of the film express that. He can't really come out at you—he's too hidden, too contradictory—so you try to make the architecture emotional. That's hard, because architecture by nature isn't an emotional art. But that's what you try to do through the juxtaposition of elements, in the same way that elements in certain graphic arts interact with each other. Every artist from Piet Mondrian to David Salle deals with how objects exist in a space together as a way to create emotion, awareness, and insight, through the juxtaposition of elements, rather than through more traditional and powerful tools of empathy and identification. It's always easier to do empathy and identification: "Those poor parents; they just lost their child." You can hammer somebody over the head with that. But with *Mishima*, there's no real empathy. It's all about ideas, and so it's a much harder road to navigate.

Özcan Alper

The rhythm of a film is its own flow. You construct the story, and then it starts to find its own rhythm. Rhythm is not really about intellect; it's about how you approach the visuals, the daily routines. It's about how you want to portray that world, which has its own rhythms. Also, *Autumn* (2008) has many layers, not just one. I borrowed that from Akira Kurosawa, whose films have this amazing sense of rhythm. So someone from the Black Sea region who sees *Autumn* enjoys it, while someone who lives in America can also relate to it by sensing another layer. That means rhythm is an integral part of the narrative tools.

The mise-en-scène was definitely the major part of this film in that it has this continuous feel, and the cuts didn't feel like cuts. I maintained that flow through mise-en-scène, so there's definitely a relationship between the editing and the mise-en-scène. I maintained the feeling of continuity and flow in the way we shot the location.

Andrew Bujalski

When I was in college, you could "shop" classes before deciding whether or not to take one. I went to a class that sounded interesting, but the professor's delivery was totally monotone and interspersed with "um's." So he'd go "duh, duh, duh, duh" and then he'd say, "um." I'm sure he was brilliant, but I couldn't take it because all I could hear was the rhythm of the "um's."

Rhythm is the most important thing in a film. I don't have musical scores in my films, but I've realized that the score is the dialogue and sound design, which are not just a series of events, so that music directs you like an opera. The rhythms of the dialogue have to direct everything, and that's hard to articulate because it's intuitive.

The challenge of putting *Beeswax* (2009) together was that so much exposition and information are delivered in every scene. We shot a couple of days of pickups on this film, which I had never done before. We managed to get through the two previous films with just the footage we had from the shoot. But I ran into a little exposition problem during the *Beeswax* editing with the footage we had, and I just needed to get this one piece of information across. I was so nervous about getting this information across during those two days of pickups that we shot about five different ideas on how to convey this so I could mix and match pieces and get it done.

My instinct about the best way to do it was the one that crammed in the most information. So I cut it into the film and showed it to someone. But it didn't work—the person still didn't get what I was looking for him to get, even though I felt like, "Well, she just said it!" Then I tried another option, which worked fine. There was less information there, but it made so much more sense rhythmically. That was an interesting lesson. I felt stupid for not realizing it at first, but it's hard to calculate that.

5

The Process

Pre-Production, Production, and Post-Production

Many of us enter a movie theater, look at the screen, hear the sound, and experience a single impact. If you ask us a few days later, "What did you see?" we'll tell you the story of the film as if we had lived it with the characters. So we tend to assume that the filmmaker's choices relate mostly to content, that is, story and characters.

But this apparent simplicity belies a complicated and collaborative process that differs naturally from filmmaker to filmmaker and from project to project. We've discussed cinematography, sound, actors, and rhythm and structure in separate chapters; but, of course, these elements are not really distinct from each other in filmmaking, where everything counts and it all counts together. Performances, camera work, lighting, sets, whatever's in the foreground and background, whatever was planned before the shoot, whatever happened during the shoot, and whatever happened to the images and sounds after the shoot—all these and other elements work in unison to amplify their individual expressive powers in service to the composite whole. Deconstructing that complexity through words is impossible. Only the films themselves can offer up whatever one can get from them. Yet this chapter attempts to further dissect the illusion by describing the overall process of making a film—from pre-production to production to post-production—with a collage of these thirty-nine film-makers' accounts of the various means by which their films began with an idea or even just a feeling and eventually wound up as cinematic experiences. It is left to the reader to piece everything together and arrive at a sense of the possibilities.

It could be said that there are as many ways of using cinema's language—that is, cinematic styles—as there are personal filmmakers. The final result of an art or personal film always comes down to a single person, no matter how many people were on the creative team, no matter how discrete the filmmaker is with his or her style, especially when everyone involved shared the filmmaker's vision and worked within that context.

Generally speaking, a film begins in development, where an initial concept is turned in a script that is written and rewritten into a blueprint for making the film. During pre-production, cast and crew are hired, locations scouted and selected, and sets built, at the same time that the director, producer(s), director of photography, and production designer collaborate on planning the look of the film and the director possibly rehearses with the cast. The raw materials of the film—its images and sounds—are recorded during production, also known as "the shoot." The shots are then cut together into the film's visual arrangement during the edit, which is married to the sound track created by the sound designer and mixer. Any special effects are also added during the edit.

A film producer can have so many possible functions that the role is difficult to define. Usually, he or she is a key figure who mediates between the creative and business worlds to ensure that the filmmaker's inspiration becomes reality. But a producer's role can be as small as bringing in a key actor or as enormous as organizing and supervising the entire project, as well as offering creative input, particularly if he or she has directorial experience. In the independent international filmmaking world, the ideal producer is present from the beginning of the concept until the final distribution and exhibition deal. He or she smoothes the way for the director, arranges financing, irons out interpersonal conflicts, and resolves the numerous logistical problems that crop up. Like the director, the producer must always have the big picture in mind at the same time that he or she confronts an endless stream of minutia, all the while keeping an eye on the budget, the bottom line. Some independent producers are even involved before anyone else, including the director, developing the film project from its inception, buying rights to a novel or a property in another medium, or starting with a concept and writing or co-writing a screenplay that will attract the right director, cast, crew, and financing. However, this is rarely the case with the personal filmmakers here, who are almost always the

source of the initial idea and write or co-write the screenplays and shoot, edit, and sometimes even produce their films themselves.

The director usually meets with the director of photography, production designer, location scout, and camera people during pre-production, when the shoot is planned, as well as before each day's shooting in order to discuss the location, how much of it they want to cover and from what angles, and what sort of informational and emotional content they want to communicate. They usually follow their pre-production plan in a general way, but by the time of the shoot, the director and other key crew members may have accumulated many ideas that serve the film better than whatever was in the screenplay. This is one reason why, in commercial American films, the involvement of the screenwriter usually ends as soon as the director is hired. Once that director is on board, the film literally belongs to him or her, and other writers may be brought in to make further changes.

When the filmmaker writes, directs, and edits, the challenge can be to remain open to the possibility of change. Although some filmmakers see and hear the entire finished film in their heads as they write the script and follow that vision throughout production and post-production, at the opposite extreme are those who hold on to only the thread that is the film's driving concept. They prefer to respond to whatever happens during the production that might lead to a fuller realization of that initial vision. For the latter, the script is just a guide to build and furnish sets, work out schedules, design wardrobe, and give actors enough information about their characters to begin exploring them. Some refer to the script rarely, if at all, during the shoot. Still others plan only the story and dialogue in advance because they enjoy balancing rational creative elements like story and dialogue with what they consider more intuitive creative elements, such as camera movements. Perhaps a special lighting element or a particular shot the filmmaker knows he or she needs is planned in advance, but the rest of the process can be improvised because the filmmaker may not know exactly what the actors are going to do or how the scene is going to turn.

Few films conform to their original plans. Most viewers would be surprised to learn how much a film can change from script to shoot to edit, because the process inevitably involves adapting to changing circumstances. And, as with so many decisions made during the filmmaking process, a trim budget can dictate a tight shooting schedule that leaves

little room for experimentation or even necessitates dropping pages of the script. However, some independent filmmakers working at the low end of the financial spectrum, but with no studio bosses to answer to, can make up for lack of money by taking more time.

Even if the thread of the film's original intention seems to have been lost during the shoot, it may be possible to restore it in the editing. If that original concept survives intact, other missing elements have a way of returning, in that their sense and meaning somehow remain present. Or the filmmaker may have what seems like a gratuitous scene that was filmed for its sheer beauty. Later on in the edit, though, that scene can become the film's final shot, so that two final sequences emerge—one planned and one discovered. As he or she continues reshuffling the order of shots, scenes, and sequences, the filmmaker may realize that one of those final sequences would be better as the film's opening sequence; so the original first sequence becomes the second sequence and no longer carries the same meaning, because film has a cumulative effect. All the scenes that follow carry not only their own meanings but also many possible other meanings that accumulate from scenes that went before. So the editing process can be exhilarating as well as despairing because there are so many points at which multiple possibilities present themselves, and it can be difficult to choose. A director can easily ruin a film in the editing but not always save it, so most filmmakers try to control the loss of control.

Serge Bozon

My ex-girlfriend wrote the screenplays for all my films, and I hope she will still work with me, but I have been quite delayed by our breakup. I thought I was going to shoot a project we had quite quickly after *La France* (2007), but that won't be the case.

I've never written a script, and I don't want to. I'm the only one in France who doesn't write or even co-write. Everybody else who does art house movies in France writes or co-writes. We have commercial movies and art house movies, and each type has different producers, distributors, and theaters. It's a shame, but the boundaries between them have become completely separate.

The best filmmakers to my taste were those directors who never wrote the scripts, and I would even say that Jacques Tourneau, Edgar G. Ulmer, and Allan Dwan—forties and fifties Hollywood B movie directors—accepted

every script the producer gave them. They never refused a single one.
The relationship to what is personal in a movie is often deeper when the
director did not write the film. You don't belabor yourself with issues of
intention, with what was meant. I'm not trying to create a myth about the
American studios of the forties and fifties, especially the work of B movie
directors. But I wanted to say something in *La France* related to my ambi-
tion to become a commissioned director for art house films, in the sense
that I don't write them.

I don't do a lot of takes when I shoot because I don't have the money
or time. And I change a lot in the editing process. It's not a policy, but
that's the way it's been since my first movie. When I edit, I'm no longer in
this childlike state of discovery, so the film really constructs itself in the
editing. I work with an editor, and I'm there all the time. It took a while
to find *La France* in the editing. The first version of the movie was two
hours and forty minutes, more than one hour longer than it is now, and I
also didn't respect the script's scene order, so I changed everything. The
movie is not really a narrative, just a series of scenes where they're singing,
eating, traveling, so there were many possibilities of change.

I'm happy with the final results, but I was quite anxious for the first
few months. I thought, "It doesn't work, it's too theoretical, kind of dry." I
wasn't able to find an underlying flux. Maybe I'm mistaken, but I imagine
now that in the first forty minutes there's little tension and narrative, and
we seem to be far from war. The film lifts after the monologue during the
raft building, and the nature of the men and the film becomes progres-
sively more destructive, darker.

Eric Guirado

I like paintings and photography, so I'm concerned about all the elements
of my films. I have imagined my film so many times that it's a pleasure to
choose the jacket and shoes for a character and to create everything. I still
take life drawing lessons at the École Nationale Supérieure des Beaux-Arts
in Paris, which teaches me how to deal with the whole as well as the details.
So although I don't have time to rule over everything, I'm concerned about
everything, and I definitely look through the viewfinder, because lighting
and frame composition are important. I didn't storyboard *Grocer's Son* (2007)
because I wanted somewhat of a documentary look, so I didn't want to guide
my cameraman too much. But I'm working on a project now where I'm

making storyboards because that will win us some time. Of course, we can make changes later, but we will start out knowing what we want to do.

When you get to the editing, it's always a big shock. First, you realize the film can't be exactly what you imagined. Whether you're a poor or rich filmmaker doesn't matter. It's always the same, that's part of the process. For *Grocer's Son*, it was quite hard for me not to rehearse the actors, so I didn't have the kind of work that makes for confidence, and my confidence was put to the test. I went through great moments of solitude. Some things were far from what I'd wanted.

For example, when the two young people paint the grocery van and first make love, I had imagined something sweet, in the dark but hot, because they are young and we'd see them in a nice shadow against the truck's curtain. But they didn't want to do that, and we lacked confidence and trust together. Nicholas Cazale, who played Antoine, had gotten married a month before. He told me, "I can't imagine myself kissing her." And I think they wanted to give me a little shit, because they knew it was important to me. It was hard for me to say okay, because I don't like it when you have two people beginning to kiss and then you cut to the day after. In the end, though, you work with what you have. Okay, you have all this on the table now, just do the film. I don't like to complain, so you eat your shit, and then you work a lot with your editor with what you've got to find the best film.

Each stage of the process makes me like the next one. Now that I've finished the film and I'm talking about it, I miss writing. And I know when I write, I will miss shooting, and when I'm shooting with so many people bothering me, I'll say to myself, "Thank god I'll be doing the editing, where there will be only two of us."

Lucia Puenzo

Working with everyone on the film is more a matter of mutual enthusiasm than control. Maybe you have an important scene to shoot, but your DP has a personal problem, and that will cause your scene not to turn out as well as you imagined. So, it is important to care about the people that you work with, and I didn't expect that. I had never imagined how important it is.

I thought thoroughly about every person who came onto the team, and we worked intensely—not for lot of time, because we only had five weeks of pre-production for *XXY* (2007)—but a lot of work in little time. By the time

we reached the shooting period, the team was already like a single body. When a team works in such a connected way, it's powerful and magical, especially if you come from a writing experience, where sometimes you are lost and don't know where you should go with your script or your novel and you are alone. When you are writing, you don't have ten other voices moving in the same direction with you. In filmmaking, you can say, "I have ten people who understand."

Of course, there were many moments when we didn't have that sense of working as one. We had a lot of unexpected weather filming outdoors in Uruguay, even storms that destroyed our sets. Cinema can be a series of happy accidents, so you have to be flexible and ready for surprises, but those surprises can also be bad. You need to deal with the bad surprises and stay calm, not let the anxiety eat you up, and you have to be flexible enough to adapt to the good surprises, even if they weren't part of your original idea.

The actors also proposed ideas, and sometimes I had to find a way to say no, while other times I recognized that their ideas were better than mine. For example, at the end of the film, the embrace between the father and Alex was supposed to include the mother. Valeria Bertuccelli, the actress playing the mother, was six months pregnant, and the day we shot that scene, she began having contractions and we had to call an ambulance. Also, a huge storm was brewing and Ricardo Darin had to leave. So if I didn't get the scene right then and there, I wouldn't get it. Valeria kept yelling from the ambulance, "Go ahead, do it without me!" We shot it without her, and by the end of the take you can see drops of rain coming down as the storm started. When we viewed the rushes of that scene with the storm raging outside, we realized that it was wonderful, better than what I'd planned. Those surprises literally happened every day.

However, I think I like the two extremes best—the writing and editing. I enjoyed the shoot, but it brought anxiety and all kinds of problems. You enjoy it, but at the same time, the clock's ticking and it's a lot of stress. In the editing, after everything has been filmed, you just have to make the best of it, and the writing, when you have no limits, is for me the best.

Shamim Sarif

When you're moving from novel to screenplay, the first step is to forget about the novel. Because I wrote the novel *The World Unseen* (2007), I knew

it intimately, so it was about the themes and being more severe about iden-
tifying the story arc. *I Can't Think Straight* (2007) and *World Unseen* aren't
meant to be traditional art house or experimental films, so I was definitely
looking for strong story arcs and characterizations.

Pre-production was great. I loved moving into the collaboration of
directing, especially on *The World Unseen,* and getting input from people
who were better than me in so many fields. They often came up with things
I never would have thought of and even took me in different directions.
That's exhilarating because then you're building, really opening up the
story, the characters, the whole feel of the thing.

Sometimes I had to insist on my decision because nobody else is
looking at it from start to finish. The cinematographer likes that location
because he can shoot the light from there; the production designer wants
you to do the long shot so you can include her beautiful shop. Everyone's
got their own agenda, and you're the only one with the full agenda.

The director is like the keeper of the vision, as well as the manager.
That doesn't sound glamorous, but if you're not good with people, you will
have a tougher time. You're trying to get people to do things for you to
the best of their abilities, and you need skills that allow you to do that. I
don't like a tense atmosphere when I'm working. It kills creativity. Maybe
some people thrive on that, but not me. I won't hesitate to clamp down if
somebody's being difficult for no reason, but I like to keep communication
open with heads of the departments and everybody else.

During the last week of shooting *I Can't Think Straight,* the financier told
us we were losing three days of shooting. That's a lot of story that suddenly
disappears before your eyes, so you're scrambling to get it together. Or a
location gets shut down and you lose half a day's shoot. You've lost not
only several shots but probably a scene or two, especially when your shoot
is twenty-five or thirty days. I loved the shoot, but it's a huge anxiety,
probably the most traumatic fun I've ever had. It was exhilarating, a pure
adrenaline rush, because you're spinning plates, and if you're not on top
of your game, something's going to crash. When it was over, though, I was
happy to get back to sitting in my room with my computer.

I had an editor, but I was there the entire time because that's the
next magical time of filmmaking—where you can make or break, change,
or influence the film. I learned to cover myself with cutaway shots because
we were so pressured just to cover the main action. Even on *I Can't Think*

Straight we stayed away from that wide shot and two close-ups formula—that generic, low-budget thing. The DP was amazing on that movie, and we tried to cover action in a single shot so we would have fluidity and movement. But then you give yourself an editing issue because you can't always cut out of it. So with *World Unseen,* we tried to do the same thing, give some interesting, flowing movement, but I always had cutaways.

Mia Hansen-Love

It was unimaginable that I wouldn't direct *All Is Forgiven* (2007) myself, because I've always associated writing and directing. They are indivisible to me. I know other people work that way, but for me, at least at this point, they're entirely complementary, and I can't conceive of compartmentalizing them. Perhaps later I'll be able to write something for someone else, but now it seems that the writing is only one stage of the project—in fact, it's rudimentary—because in directing, I take it a lot further.

I owe the existence of this film to a huge miracle. That's how it always is when you're starting out. You're either very lucky, or things are extremely difficult. I was totally unknown. I'd made a couple of low-budget shorts that no one had seen, but Humbert Balsan, a great French producer, had seen one. He'd risked working with a lot of young directors and making many auteur films, and he took me under his wing and looked after the film for a year. He also started out as an actor, working for Robert Bresson in *Lancelot du Lac* (1974), and I love Bresson deeply as a filmmaker, so we got along very well. Then Humbert committed suicide, and I was lucky enough to meet another producer. Interestingly, in the first draft of *All Is Forgiven,* it wasn't clear at all whether Victor died of an accident or committed suicide, but that became clear after Humbert died—there's no doubt in the film now. The film would not have been made if it weren't for Humbert Balsan. The fact that he took me under his wing inspired my confidence, and also, thanks to him, I won a number of prizes for smaller films.

As a young filmmaker, it's most important to find that right producer who wants to work on your project. Then it's that person's task to convince others to invest in the film. Fortunately, we still have a system in France that allows first-time filmmakers to make films with state funding and work with actors who are not box-office draws. The film's budget was one million Euros, extremely low, but just enough to make it. I couldn't use a lot of takes when shooting *All Is Forgiven* because I didn't have a lot of money. It

wasn't that bad not to have so many possibilities because it gives a strong intensity to the scene when you know that you can do only seven takes. You have to be concentrated, and the actors know that. And although I don't like improvisation in film, where you feel the director allowed the actors to do anything with no control or direction, improvisation can be interesting when there's a consistent, solid grounding or frame. So the improvisation in my film occurred within a rigorous ambience, a precise frame, especially in the scenes with the children, and I wrote those scenes to be quite open. We also followed the story sequence during the shoot as much possible. The scene where Pamela sees her father in the kitchen for the first time since she was a child was actually the actress's first day of shooting. She was touched, and you feel that because she's so shy in the scene.

During the shoot you do lose control, and that's actually the great thing about it. With television, there's a program or series and a script, and when you shoot, you have to fit to the program. But in cinema, you want to bring in thousands of additional new dimensions that weren't in the script. So the script is a starting point and should point to other directions. I tried to write *All Is Forgiven* in a way to allow for finding life during the shoot. It's most important that the shoot is alive.

The editing is another way of writing, but the difficulty is being economical, making choices. You have to make sacrifices. Sometimes you see beautiful things and want to keep them, but the essential thing about editing may be to get rid of things you like, to have the courage to exclude those moments and give precedence instead to the main line of the story and hold to its direction.

So when I shoot a scene, I have to forget the script, forget what's before and forget what comes after. Just think about the present and try to get life from the scene. And after having shot the film in a way to give it as much life as possible, when I cut it, I always have to remember what came before and what comes after. I can't forget the overall direction, the film's construction, as well as the question of rhythm, which is so essential. So the shoot and the edit require different ways of working, and the filmmaker's relationship to the scenes becomes different.

Bette Gordon

I've always had the luxury of driving my own films in the sense that I was never working for somebody. I was always working for myself, so the

decisions I made were always based on my gut, which is a hard thing to learn. You have to listen to that little voice inside you, and you don't have to answer to five execs who want A, B, or C. I've never had that experience, even in the little television work I've done.

I am not absolutely consistent on directing exactly what I write. If I find material I love, I'll get it to the stage where it needs to be, or I'll work alone or, most often, with writers. I collect images that speak to me about the story. Maybe it's a starting point for me, so I go back to painting, photography, and sometimes sculpture—to my roots—and pull colors and images even if they're not about the story. It's a visual notebook. Once I do that, I start to get closer to what I'm going for visually. When I started making short films, I was coming from a more experimental approach to filmmaking that approached storytelling as visualization. Having studied the arts, I have a strong sense of color and composition, so I approach the image carefully and specifically, focusing on what's in the frame, what's not in the frame, and aspects of composition—diagonals, color, shape, form, and texture.

People have said *Handsome Harry* (2009) is a character-driven film, but the location for all my films is also a defining factor of character and story. *Harry* is a male story seen from female eyes, so how much of that world is my camera and how much is observational? It's both, and I was looking for specific environments in which the story could unfold. Brian De Palma says that for him story comes from location. I relate to that, so the first person on board once I have the money to make the film is the location scout, and that's my first real relationship, aside from the producer. Location is a part of production design, and the production designer is as important in creating the look of each place as is, of course, the cinematographer. I've always had great experiences with DPs. I love the technical aspect, and as I learned to shoot, I learned everything I could about film stock, the developing process, and how and why you light. Sometimes people come to filmmaking from theater or writing, and they don't have the technical background, so it scares them. It doesn't scare me at all.

I love that pre-production time, when everything is still possible and you're realizing the dream, reaching out to this entire palette for your world and creating it from scratch. After that, you begin making compromises, whether on budget, who you can get, or who you work with.

The early team is a great way of exploring a lot of different ideas—with actors, producers, writers, designers—and you get so much creative energy from putting your ideas together and creating something new. I really enjoy the collaborative process, and that's why I love directing. You have to be a great collaborator, cheerleader, and organizer, because there are nonstop questions and interactions with other people. As a director, you must know how to bring people over to your side and get them to want to do exactly what you want, whereas a writer can exist in a room alone and not need that interaction.

Editors often say they love working with directors who are not also writers because they have less attachment to every single word, phrase, and pause, and the film hasn't existed in their head from day one. If the film has become a part of you, you can be resistant to letting go of shots. Some people can do both, but people whose work I admire, from Martin Scorsese to Jonathan Demme to others, are those whose works were written by one person and directed by somebody else. My directing students are often freer when they have not written the script. Some people are strong directors but they can't write, and some people are great writers but they don't have a great sense of visual storytelling and so they are not great directors.

Yet we all write, as the auteur theory says. We can write with our cameras, and that's a valid form of writing. So there are three drafts of a film—the writing, directing, and editing—and each time you go from one aspect of the production spectrum to the next, in a way, you are constantly rewriting.

Céline Sciamma

In France, unlike the United States, it's rare to write a screenplay that another person directs. Even if it's a big commercial comedy, the director originates the project, so there's no such thing in France as a screenplay market. When a producer finds a good script, he's embarrassed if the screenwriter doesn't want to direct. He feels as if they are in trouble—"How are we going to do this?" So it wasn't surprising that the producers of *Water Lilies* (2007) wanted me to direct, even though I never intended to become a director. I picked these producers because they had the right skills and were young, poor, and really wanted to do it, so that the film would have the right milieu and I would feel we were making the same movie.

I was scared I would make a screenwriter's movie, because screenwriters sometimes make very literary movies. But I totally became a director. I have this visual obsession about films, and I knew exactly what I wanted, even the movie's sound design. When we were editing the sound, I was there every day, and I knew precisely what I wanted. Some directors, especially in France, don't care about the sound; they think it's just a matter of the viewer hearing what people say. But I discovered how obsessive and confident I was while doing it.

I loved all aspects of making the film—the writing, the shoot, and the editing—and I discovered a lot of it as I went along. I can't say there's one part of the process that I loved more than the others because I was trying to kill the screenwriter in me when I was directing. I didn't want to be indulgent with what I had written. I had to take stuff away if it wasn't right.

Making cinema is killing your darling at each step. When I was in the editing room, I tried not to have feelings for the rushes, because if it's not good or doesn't fit, it has to go. With each phase of making the movie, you're in a new position, but for me, it's always writing, a new way of writing the story, first with words, then another way on set, and yet another way of writing in the editing room.

Because filmmaking is such a long process and you do it with other people, there are many ways to get lost. I don't like to work in conflict, so I was in control, but peacefully. We had a young cast, so my direction was kind of soft. But I am a total control freak. I picked every curtain, every costume, and I gradually came to be in control. Sometimes the DP and I had arguments, but I never had the feeling that I'd lost control. When you prepare the movie in writing and pre-production, one day you make a decision, the second day you make three decisions, and by the end of two months' preparation you've made two hundred decisions. So the shooting is like the romantic event of the film, the moment when those two hundred decisions are present and immediate.

Making cinema is not glamorous; it's only glamorous at the end because it's also a matter of the weather, of what we've been eating at the crafts service table, and you have to put so much of your will and faith in the process so that a little lasts to the end. I was most concerned about that. At each step, I had to come further along in my original intention—further, always further, and not get lost along the way.

Anne Le Ny

As the writer-director, you make the decisions, but you also do that with the creative team. If you want to be the only one, don't do cinema. Write or paint instead, where you're alone. Filmmaking is something you work on with your collaborators, and that's great. When I'm shooting, I prefer a great idea from somebody else than one of my bad ideas. One of my best memories from shooting *Those Who Remain* (2007) concerns a shot of small importance, when Vincent goes into a bus and gets out after a few moments because he's decided not to leave. Normally, we would do that sequence with three shots, but it was the end of the day, and we had no more time because we were outside and the light was going. So I said, "My god, we have to do it in one shot," but it didn't fit my idea, which actually would have been normal and boring. Suddenly, the photographer said, "I can put my camera 'here,'" and the script person said, "Yes, and maybe if we have the bus coming this way, it will work." Even Emmanuelle Devos, who was still on the set, said, "Yes, and Vincent could do 'this.'" Viewers don't expect him to enter the bus and then, after the camera holds on the bus for a few moments, to exit out the rear. It changed the rhythm, and that's actually what I wanted, a different rhythm. This is also why I didn't have too many close-ups. Because I think good actors can say so many things with their bodies, even from certain distances.

That scene wound up in the style I had in my head. I thought, "That's it! We are all doing the same movie." It wasn't a moment when I had a marvelous idea, but a moment where I thought, "We really are a team and no one is trying to take the power. That's great!"

Jihan El-Tahri

For me, it's more difficult to direct a documentary than it is to do fiction. You have to write anyway for a documentary, constantly write and research, and you have characters. Then you take all this and confront the reality of your subject, which sometimes is a bitch because it doesn't correspond to your plans or to whatever your research gave you. So you're in a constant struggle of adapting and giving up. You have to be willing to throw your entire budget down the tube and start anew, and I've done that several times. And you need to go the extra mile; otherwise it's boring as hell. All the topics I deal with are big, dry, and boring, so I always have a research file filled with anecdotes.

I think that's more difficult than fiction, where you write it, you know it, you spend as much time as you want, but at some point, you get up and do your film. In documentary, people die on you, and reality that is going this way suddenly goes that way. You're not going to change it, so you're constantly juggling with a million things, and within this juggle you also need visual harmony. You can't let the flow of wherever the film is taking you disturb the harmony you need for a visually coherent film. You could be working with six different formats in a documentary—8 mm film, 35 mm film, VHS, etc. I'm talking about visuals; I'll get to sound in a minute. So you're cobbling together a mish-mash of stuff and you have to know the visual thread of harmony that allows for a visually coherent discourse.

That's just in terms of mise-en-scène, and it's a specific decision one must make in advance. So lighting the spaces is absolutely essential for me. Someone asked about my Cuban film, "Did you interview everyone in the same place?" They were in Africa and in Cuba, so that wasn't possible. But if you have an idea of how harmonious the light and visual spaces can be, you can bring those locations together. A good cinematographer knows how to light. Exteriors are as problematic as everything else, because when you move from all the structured and archival stuff to the present day and exteriors, it just doesn't work unless you film it while keeping in mind the material you already have. There are so many visual factors you have to take into account before you even start your edit. I've had to reshoot locations differently, especially exteriors, because they didn't match and flow in the same aesthetic as everything else.

As for content, I can have a brilliant idea, but it just doesn't work because it takes away from the actual raison d'être of the documentary. I've said, "I really want to use this, I spent so much time filming it." But you have to make a choice at some point. What is the backbone of your story? Is it the narrative, the visuals, or the sound? They are all factors, but you have to choose one to become the backbone, and the others become supportive.

Sound is also fundamentally essential, and I do a lot of sound research. You need to associate sound not just with the visuals but also with the message that's coming across. A lot of the emotion, the feeling of where I'm taking people is connected to the sound rather than to what people say on-screen or the visuals. Sound is the film's rudder.

I know other people can make a film in a year or a year and a half, but maybe I'm just slow. Usually toward the end of shooting one film, I've started research for the following film. I sleep very little, only three to four hours. I don't know how I would have done it otherwise. I don't do commission films, so it's about what grabs me, and I start researching out of my own curiosity. The films are about looking at the topics and wanting to know about them. By the end of one production, I have some sort of synopsis written for the next film. I send it out, and producers start trying to find money.

So for me, the important phase is pre-production because that's when I research and play around with ideas. I'm not under any pressure—no one's giving me money, no one has asked me to do anything—so that's the phase where I find my own territory. I'm finding what intrigues me, the questions I want to respond to. And whatever one doesn't get in money, one needs in time.

From the day I start a project, I put it on my computer in folders. One is "Personalities," another "Anecdotes," another "Chronology," and another "Archival." I have six or seven folders, and anything I find I just throw in these folders. It's a huge hodgepodge of information, and when I sit down to think of the film, I have the chronology—a very important element—so I organize the chronology. Through that chronology, all my questions—the causes and effects, what happened before what, connections I didn't see—suddenly connect themselves. If they don't connect, the question of why they don't connect is staring at me. That pre-production phase keeps me from getting lost.

The production phase is fun and a lot of hard work, but you need to get it done. For me, a film is really done in the cutting room, but if you didn't have a pre-production phase, you couldn't conceive of the film visually, which I do by the end of the pre-production phase. I see the colors, the flavors, where the accents are in the film. And my choice of places, lighting, where to do the interviews, and how to do them are imposed on me. The story imposes itself on me, rather than me on it, so it's a matter of finding it.

The editing process is vital, because the editor is my first audience. I treat him as spectator number one. If there's anything he doesn't understand and we need to stop for a week until we find why he doesn't understand this, I will do so. I never leave my cutting room. I don't give

space; I try to shut up, which isn't easy, but I do. The way you organize the bins of film clips according to themes is crucial because you're going to get stuck. Everyone knows that at every phase of the production you get stuck somewhere. The only way you get unstuck is by organizing everything thematically in a way that is coherent with what you want to say. Then you sit there and watch everything go through. I also remember the time code of the cuts. If you can't watch the whole thing as a mess, you won't get any ideas. I already have the structure, an outline, from the beginning, so every sequence you see in the final film had eight to ten alternatives, all saying the same thing but differing visually and in terms of content.

Claire Denis

Each film is different. The film is already secretly dictating something you know, even when the script is not written. And the film is not your child. I hate when people say, "Oh, your films are like your children, yah yah yah." It's not at all the same process. The process of creation is completely different. Sometimes I feel for a long time that I'm the only one who knows, I'm the only one who can follow the track of the film. And sometimes the film comes through a hint, and it's as if my process is about looking for the trace of something that will crystallize and convince me I'm not wrong.

So each process is different. When the film is over, I can describe it artificially and separate each moment, but when I'm doing it, I am in the film or the film is dictating the law of the moment. When I say "artificial," it's artificial, yes, because I am describing from a distance the difficulties, the drawbacks. I can describe what happened during the editing, what happened during location scouting, and what I describe of this process is true. On the other hand, I know it isn't true because when I do location scouting for a film, I'm not sure the film will exist. I'm not sure I am right or wrong to believe that I'm searching in the right way. Sometimes when it's a location that isn't exactly what I was looking for, that explains to me what I was looking for. Sometimes location scouting reveals that I was wrong in the first place, and it can reveal an aspect of the film I had not been able to describe in the script. Other times, the scriptwriting is, in a way, escaping the film. It's like writing around things, describing the void or something that I don't want to see, and I keep telling the producer, "Something is wrong in the script, I don't know what." Then, suddenly, I realize that the script is okay, but I did not believe I was going to make

the film. Sometimes I enter the process of writing the script with 30 percent of my belief in the script, and the rest is only doubt about the film. And sometimes it's the reverse: 80 percent of me believes in the film when I'm working on the script with my colleagues, and I'm so convinced that I convince everyone.

I think the film has a shape that I ignore when I start, and the script-writing is the best way to search for it. Some answers come when the script is finished, and there's the moment where I see all the flow in the script or all the incoherence. But sometimes the flow and the incoherence convince a producer or convince someone who is going to give me money, so it's not cheating. It's what really happens. I do believe in something, but the film is not going. The film is refusing something. In fact—and I think I'm not the only one—when I start shooting, give me three, four days of shooting, and suddenly I finally know this is real. Now I'm really confronting the film. And then I realize whether I was right or wrong to write the script this way. Or sometimes after three, four days of shooting, I realize that I forgot something while writing the script. Or the opposite, I foresaw something that was not clear in the scriptwriting, but I knew it was there. It means the film sometimes appears very awkwardly.

The mise-en-scène is established during writing the script. That's why it's so important while writing the script that I more or less see the space, even when I shoot on location. I see an abstract space. Normally when I'm writing the script, I know which lens I'm going to use. It's always like that. So when the script is finished, I can sort of describe the image, and therefore, when I do location scouting, even though some locations are great, I know they are wrong because they don't match the space I have seen while I was writing.

Writing the script is very physical, so there is a lot already in the script that actors and the technicians can grab when they read it. People believe that when a script is full of dialogue, it's solid, serious. Because my scripts are not full of dialogue, people believe my films are not scripted. The scripts I write with Jean-Pol Fargeau—except for *White Material* (2009), which I wrote with Marie N'Diaye—are not full of dialogue, but they are full of shapes.

There are always moments where the film is gone and lost during the shooting, script writing, and editing, almost every day for a moment. And sometimes it's lost for good.

I think I would jump out the window if this happened to me. I wouldn't survive losing a film, and I'm honest—I think it's a question of life. It's a question of reason to live. Sometimes the film seems lost, I don't know where it is; but if I definitely was losing a film, I think I would jump through the window or take sleeping pills or jump under the subway. I would not survive that.

Pedro Costa

Each film is different, and more and more I try to advance or do something else, and in the case of *Ne change rien* (2009), it was something about music. My idea was to do something around music I like. And something else—I became critical, disillusioned, and disappointed with the way films are produced and managed now, even by some young guys.

It's all in the way you do the film. Everything begins with the way you organize the film. I'm talking about budget, economics, and human relations we don't see anymore, like Rainer Werner Fassbinder's group or even a tyrant like Jean-Luc Godard. At least it's something and not what I see more and more, where nobody really believes in what they are doing, even short films. I've seen short films where the credit roll is longer than the film because the filmmaker had to include this producer and that producer. In Europe now, you have to get this fake co-production system. It's really fake. The first thing a producer says to a director is, "We don't have money," but they just go for something from Belgium, then from France, then from a television source and Germany; but it's never just the money. You also have to place people and certain elements in the production that take a lot of the budget. Some realities take a lot of the money; post-production takes a lot of the money. Everybody's doing video, and they say it's easy—just take a small camera and go make a film. That's the biggest lie because if you want to do a print so you can show the film, you have to do a sound mix. You have to do certain technical things that take money. And then technicians' salaries are sometimes absurd.

It started with the producer of my second film; it always starts like that. The problems always begin with the producer, and I resolved this historical cliché by turning that against me. I boycotted the film. I thought, "I will not boycott the producer, that's a cliché. Everybody has done it." At the same time I thought, "I must find a way to boycott the film and do the film I want without destroying it." I had this impulse not to shoot the actors

I'd brought to the set, so I began filming everything else. I was already thinking of some other way of organizing a film, and the only way to do it at that moment was by literally grabbing the camera and a few guys from the crew. I couldn't understand what those other thirty-five guys were doing. It wasn't a union production like here, but it happens the same way in Europe. You have to have an assistant to the assistant, just because it's not serious if you don't have that. It's absurd. So I grabbed the camera myself and told the DP, "Come help me do close-ups of people in the village. Let's do what I feel like doing, not this love scene." It had become ridiculous.

My last film shot in 35 mm was a long time ago, and I don't even try to get some DPs or lighting technicians to work with me for, let's say, one and a half years, because that's how long I take to make a film. But that's not new. Everybody did it. Fassbinder did it in another way; he did a lot of films where everyone was connected. Or like Chaplin, a hundred years ago. *Gold Rush* (1925) was a four-year shoot, every day. I like shooting every day, like a carpenter working. It's not different from the real world. But when I made that other kind of production, there was this system where I was picked up by a car every morning and driven to the set. And they would say to me, "Are you okay? Today is a fine day and we'll have this magnificent scene." You get to the set, and they ask if you want chicken or fish for lunch, and then another guy comes and says, "Do you want to place the camera?" It didn't feel right to me; it felt like a moment outside time, outside reality.

François Truffaut said Roberto Rossellini didn't have the stupidity in him that you need to make films. You have to be a little bit of an idiot to believe in this machine for seven, eight, nine weeks. I mean to believe in the love scenes, to keep on going, "Yeah, it's fine. Let's do it again." Even before the shoot, when writing the script. Rossellini made one, two films, and by the third you can feel him going. Truffaut said you see that Rossellini began with a village; then he filmed a country, Italy; and then it became an island, Stromboli; and then a continent, India; and then his ideas were far, far out. He was into Europe, Socrates, and those ideas. That's my feeling when I see a shoot in the street. It's ridiculous. You have to be strong to believe in that thing. I had that, and I lost it. Of course, I have all the films I've seen and made with me, as you have, but I lost a lot.

For me, life is taking the bus, paying my rent; it's about common things, and the cinema I like doesn't exist anymore because Hollywood doesn't exist anymore. I like Hollywood of the forties, the fifties. Even with

the bad parts, there was something else. Fox in the forties was not like today. It's not the same. So I had to find something else, this one film for a year. I have friends, so somebody can do the camera, but how can I get an actor or DP to be with me for one year? They can't. They spend their lives in planes, hotels. They like variety, they need that.

So, I'm going to keep doing what I'm doing, and *Ne change rien* is a little like this. It was made in between other films. There was no contract. Jeanne Balibar is my friend. She began singing, I like her voice, and I admire her a lot. She's one of the great actresses today, and I thought, "She's my friend. I should film her." I like the architecture of her face; she reminds me, of course, of other people I saw on-screen, and that shows.

I'm not fascinated with what still fascinates my colleagues; that magic is no longer there for me. I cannot put myself in this machine again. I even felt I was betraying all those people—Godard, [Jean-Marie] Straub—those guys who tried to renew the form a little bit. Cinema for me is something else. Bertolt Brecht's work was in theater, but it's close to cinema. He said it took him much more time, effort, concentration, passion, and love to organize the work than to do the actual artistic work itself. The artistic work doesn't come naturally from that, but it comes easier. It's a result of good economic, political, and moral working relations. That for me is essential, and it really produces the films I've been making, even this film I made with Jeanne Balibar. There's not one paper, not one signature, no contract between us, between me and the musicians or the guy who did the sound.

A lot of the film comes from a little organization that I managed, all the preparation we do before the shooting. For *Ne change rien,* because I shot on video with small cameras, we shot a lot. The difference between the real takes and the rehearsal ones is negligible because of that preparation, and sometimes it's the rehearsal take that goes into the film. There's really no difference. I wound up with four hundred hours of footage.

I was a bit scared, but it's about time and work. People do that. They've done it in the past, and we keep on doing it, like building a house. It has to fit together. If not, it will crumble. It has to stand up. The places, objects, lights, and mainly the people give me direction more and more. Before, I thought I was too slow and had no ideas for writing the script. Now I know that's not true. I'm not slow, and I have ideas. I just don't want to impose them.

Scott Hicks

Although I've written a lot of the material I've shot, I write only in order to direct, and I find collaborating with writers stimulating. I admire those who sit down on their own, month after month, with only a computer screen for friendship, and devise magic out of that. I have to force myself. I prefer feeding off people who bring a lot to the table and sensing input and ideas whether they're about design or cinematography or whatever. I love having choices, although I make the decisions—that's called directing. You have to be the arbiter and say, "No, that's a great idea, but it doesn't belong because of this or that reason," or "I love that! That's perfect. That's just what we need for the scene."

Shine (1996) was an independent project I'd carried for ten years before I got to make it. I read the script and brought another writer into the project. It's much more of an auteur process when you develop the project yourself and have a driving passion that ultimately gets it made. When you make a studio film, obviously you bring your vision to the story you're telling, but there are other forces in play that are also part of the process. That's a different kind of filmmaking, and the choices you make about key collaborators on the film become important.

I don't do many takes, not as a point of pride, but because I find that performance seldom improves with repetition or only up to a point. In my experience it's more likely to lose its spark, juice, and spontaneity. And you don't have the same time when you shoot a film as you do in theater, where you rehearse for three weeks and find your way back into the spontaneity.

Doing *Glass: A Portrait of Philip in Twelve Parts* (2007) was interesting because of its hands-on nature. After ten years of making studio films with significant budgets, to take up the camera myself with just a sound recordist accompanying me was liberating. It's all down to you, and the technology is so available and accessible. I'm also a still photographer, so I understand the dynamics of a shot, and I'm involved in the visual side of all my films; so to assume the responsibility of shooting this film was exciting. I could find shots that I probably wouldn't be able to direct somebody else to find. For instance, I was shooting Chuck Close over his shoulder, and suddenly I saw in his eyeglasses a postage-sized image of the enormous self-portrait that was on the far side of his studio. For a moment you feel you're looking through Chuck's eyes. How would you direct a cameraman to find that? You couldn't. It means that when

you shoot yourself, you're that much more attuned to the immediacy of what's going on. I've certainly worked well in the documentary sphere with cameramen. My eyes would scan the horizon while his eyes were focused through the lens. Because I understand the lenses, I can look at the millimeters on the zoom and know what shot he's got, so I can also direct him toward whatever I can see that he can't. There is that advantage to working with someone else. On the other hand, the intimacy afforded by it being just me and a sound person was such a great asset in making the *Glass* film.

In the editing process, you sculpt the film, and I've come to view the process of shooting—whether it's documentary or fiction—as gathering all the raw material. The raw material is more specified in a fiction film. You have a script, and you shoot the scenes; but it is raw material nonetheless, because you won't know until you sculpt it all together just what you need and don't need. We always have to refine scripts to a high degree, but I think there's over-refinement. Sometimes I'd rather shoot more than whatever is in the script so I have something to cut into rather than wind up running so tight that I can't afford to take scenes out.

When I looked at the first cut of *Shine,* what was evident and had been during the shoot was that Geoffrey Rush had not located the character adequately during that first week in London. We were all worried because every time the film returned to the London time frame, the performance sagged. I decided to remove every piece of this poor performance from the film. The editor said, "But it's the beginning and the middle and end." Structurally, we began the film in London, went back there in the middle, and the film ended in London. I said, "I don't care; take it out." So she asked, "How are we going to start? How are we going to finish?" I said, "I don't know. I have to see what we have and then I'll tell you."

We reshaped the raw film using the structure designated by the script, and I found a beginning and an end. It's not hard to do if you're not precious about it. Preciousness about the material you shot is your worst enemy. It doesn't matter how difficult it was to get the shot or how early you had to get up to catch the sunrise to do it; if that shot doesn't fit the story, it doesn't belong in the film. It's wrenching, but it's gone as if it never happened.

Editing is such an enjoyable process for that reason. Shooting is tremendously exhilarating—exciting, agitating, frustrating—but you're

alive, the energy is fantastic. Then it stops, and the editing becomes a much more contemplative process because you review what you've done. So each stage has its own dynamic.

The editing process for *Glass* was extraordinary. I'd shot on a digital HD camera, stored everything in a vault in South Australia, then upgraded to higher definition when I was ready to edit. Steve Gess, an editor I've worked with on commercials in New York, gave up his day job for seven months, a colossal contribution. He'd never edited long form before, but I loved his eye and sense of rhythm, and a 130-minute film is made up of thirty- and sixty-second scenes.

I barely had a budget for this film, so he was a gift from heaven, but we were separated by 12,000 miles, a little obstacle. We couldn't have done this a few years ago, but we edited a large part of this film over the Internet. I'd get up early in the morning when it was the end of Steve's day in New York City. I'd download the cuts he'd made for that day, and then we'd lock our computers together with a special piece of software created by a special effects company in Adelaide, Australia, that enabled us to view material precisely in synch. We watched the exact same frame at the exact same time, and either one of us could stop on a particular frame or back it up four or so frames. We talked through Skype, so everything happened through our computers. We could even see each other through an eye cam if we wanted.

I created the script as we went along. I pored through transcripts of interviews, isolating statements I wanted, and we wove them together with each other. I'd look at the scenes he was editing visually and say, "Okay, I think I need that." Then I'd fax or scan an e-mail with written material, so he had a script to edit to. It was a unique, challenging, and interesting way of editing. Of course, I also came to New York City for other work and spent time in person with Steve. And I brought him to Adelaide for a month to do the final cut. But an awful lot was edited at a huge remove from each other.

Nothing will replace working in the same space because of the way ideas sometimes morph out of an unspoken exchange. You get to one of those moments where it's, "Yeah, I know." "I know . . . listen, I've got . . ." That's less likely to happen across electronic media than it is in person. On the other hand, this new language found a way for us to make it work, and I could afford it.

Teona Strugar Mitevksa

My favorite part used to be shooting, then it was editing, and now it's writing, because I have the most creativity and freedom to hear everything that's actually possible.

The house in *I Am from Titov Veles* (2007) is a museum, the former home of a great Macedonian revolutionary, so we re-created the interior in the studio and matched it to the real exterior. The factory was actually there, but we didn't use the real factory entrance. We built the wall that Afrodita walks on in the beginning because I needed something graphic to magnify the monster factory's effect on the population and the three sisters. The huge black hill made from the factory's waste, where the two sisters fall asleep overnight, actually exists. It's polluted and was uncomfortable for the actresses. When I saw the barbershop, I thought, "Wow, this is a dream!" so it's the existing location modified to get the best out of it. Veles is a wonderful town of five hills—very cinematic with amazing passages—so we looked at it carefully. I worked closely with my brother, the production designer and my visual right hand, and with a very good director of photography, Virginie Saint-Martin. For her, light is emotion. My sister was a producer and an actress, but during the shoot, of course, she was not a producer because her role was so emotionally demanding.

I edited on the Avid with Jacques Witta, an older gentleman. He doesn't get up or have a glass of water for six or seven hours. I kept saying, "But Jacques, I don't need to be here." He said, "No, no, no. This is not a film where you have shots like this and this. You have to be here because I have to feel everything about you. I have to know it's you who makes the decisions because it's such a personal film. I can give you my vision of the film, but that's not the point. I'm here to help you to find your vision." I learned so much from this man, and he really helped me find the film. I edited the film in six weeks, but the sound design took nine weeks, plus mixing took four, so that was fifteen weeks, double what it took to edit the visuals.

Catherine Breillat

I always say there are different creations of the film; it is created at different stages. First, there's the casting, where the die is cast in terms of choice of actors, and then the shooting, where everything is created. Finally, the editing is the last cauldron of reality. I never decide on the shots beforehand.

It's always the morning of the day's shoot. We go over a scene shot by shot and invent it on the spot.

Of course, the editing is another stage in creating the film. The editor has an incredibly important role. I'm not there at all because creation is always a solitary process. I'm there only when she needs me because of the twinness of creation, so then she can call on me. But I let her work alone so the image can be precise and she can develop her rhythm. I've worked with the same editor since *Fat Girl* (2001), ever since my previous editor, Agnès Guillemot, died. She was one of the great editors. In fact, she said if the director comes into the editing room, then the editor is simply a cover. Editing is instinctive, so you have to leave the editor to do it on her own as precisely as possible. If you're happy with the edit, if you're not aware of anything missing, then the editor obviously made the right choices. But if you have the sense of something missing, the editor hasn't used the right things.

Sometimes it happens that my editor cuts out an entire scene. *Bluebeard* (2009) was long, so we had to shorten it; and since my approach to filmmaking is to use very long takes, that's the rhythm, and they cannot be cut into. I told my producer that even after we'd shortened the film as much as we could, we'd had to cut out certain entire scenes in order to respect my style and my way of creating and building up to a scene.

Charles Burnett

Each stage of the game modifies the film. You have a certain idea of the rhythm in the writing, but when you shoot, it doesn't work. You can't shoot the script exactly, without changing anything. You have to fine-tune it—take stuff out and make language changes. Shooting is a different ball game. People who do everything from writing to editing the end product usually write a skeleton script. My scripts are not like a writer's script, with all this exposition, blocking indications, and other stuff that won't be used.

As a director, you often get scripts where the writer has blocked the action in this imaginary location—how actors come on the scene and relate to one another. Then you get to the set and wonder, "How is the actor going to do this?" It always kills me when a guy turns around in a scene and, all of a sudden, another guy has a gun on him because, generally speaking, people don't creep up on you like that. I remember one scene where I argued with the producer about this guy suddenly appearing in a

girl's house. She's been talking with her neighbor across the street who's flirting with her, and she's getting married to another guy. She leaves the neighbor, comes into her house, and finds her fiancé in the bedroom. I said, "How is he going to get there? If he comes to the house, he's going to see her talking to the neighbor across the street. Because we've already established how the street is constructed, this can't work." "Well, it's television," he said. "You can do anything." People accept that in television, even if it has no logic and makes no sense. That's where you can get into arguments with producers and sometimes with writers. They imagine that this is their world and it can happen like that. The actor will ask, "How did I get here?" "I don't know, the writer wrote that!" So you have to come up with some answer.

I was working with a famous acting couple, and I couldn't get the writer to see that I couldn't understand the scene. "Oh, you'll understand it, just do it and you'll understand." I was getting butterflies, and sure enough, the actors came up to me before we shot the scene: "Charles, we don't understand this scene." And so I had to make up something to get them to do it. I can understand that some things can't be explained and you just have to do them. But this was a case of some strange logic, so we ended up cutting the scene. You don't get into a shooting match because it will probably end up on the editing room floor anyway.

Ivo Trajkov

I love different things about the entire process. The preparation phase of working with creative crew members is always full of joy because all the ideas come out. During the shoot, you add up the pluses and minuses for each day. The minuses are: "We don't have that impression" or "We don't have what we needed or expected or hoped for." The pluses are: "This was beautifully done." So success is having more pluses than minuses, not pluses all the way, because that's not how it works. You have to be prepared to create enough material, enough shots, to do the editing work differently than you imagined, because you won't have "that" moment in a shot for many possible reasons. You need to have different strategies for shooting the scenes, so you still have enough. Everything counts.

I love shooting because there's a lot of space for improvising, to discover what you haven't found out yet, but I prefer the editing. I work for a long period with an editor. I always ask for five or six months because I love that

period. The real creation of the film is in the editing, because we re-create the time of the film. It's a world, and the definition and characteristics of that world are in the re-creation of time and space from 0 to 100 percent, as well as in presenting your characters. This all happens in the editing room. You can even erase a character that existed in the script, in the prep, and in the shooting so he is not in the film. They totally removed Gerard Depardieu in the final version of Mel Gibson's *Hamlet* (1990) because it was four hours long and they needed it to be two hours. That's the power of the editing room. I love to use that power to create the film's world, and that's why I always ask for that time there.

Lucrecia Martel

Things start in an enigmatic way for me. First of all, whenever I finish a film project, I think that I'm never going to get another good idea or I'll never feel like starting the whole process again. So when I find myself starting a new research process, I'm surprised.

I start by collecting different inspiration points or ideas, based on a number of things I'm working on and exposed to. I always carry a little notebook in which I take random notes, make drawings, charts, jot down ideas about characters, sounds, my perception of time—whatever strikes my fancy or imagination. I record all kinds of stuff, not necessarily a story as such, and when I get to the stage of drawing a chart, I'm far advanced in my process of structuring the story. I base it all on sounds—people's dialogue, certain situations—and they allow me to organize a narrative structure. When I say dialogue, I don't mean the actual sentences that go into the movie, more a form that people have of talking with each other, where they don't necessarily stick to a subject but talk about all kinds of issues, go off on tangents, or go back and forth in time. That's what inspires me and provides a frame from which to start elaborating an idea.

At the end of the process, I write a formal script. So I collect ideas for months and months, and sometimes it takes up to a year to elaborate a complete story. When I actually sit down to write a screenplay, I don't do many versions of it. I tend to stick to one. There are some corrections here and there, but it's not totally reworked. My films are structured in layers, so I don't think of the layers as a succession of chronological scenes. I think of the film as simultaneous layers that go down to the core.

I also believe casting radically transforms the movie, not in terms of dialogue and scenes, but in terms of its feel, because what was just a character on paper takes on the form of the body and emotions of a real person. The casting stage is delicate because I need to see how those bodies and feelings match with what I have on paper.

And whenever we choose our cast and crew for a project, we pay a lot of attention to finding people who will get along and work well together. The crews from my three films are still seeing each other as friends, and in *Headless Woman* (2008) a lot of women were in key acting roles, although the crew was mixed. Having a lot of women in my films is fun because I like to chat, and with women it's so much easier. We'd spend hours just chatting about anything and everything, and I adore that. Also, when there's so much talking going on, there are fewer conflicts because they're sort of handled by that talking and other connections that are created.

Nothing changed from the *Headless Woman* script, because when something is so layered, there's no room for improvisation. It's very constructed, but I don't storyboard. I set all the frames, because it's important to be involved in that as well as know who is shooting. I identify with different people involved in making the film at different times, but I tend to think of myself as a ten-year-old who's looking on, a person with a lot of curiosity and no moral judgment.

For *Headless Woman,* the art director and I went to Salta, my hometown in northern Argentina, so we would be on the same page in terms of the way we shot it. For example, we could describe a certain provincial atmosphere, a certain feel the area has in terms of decoration, which is a mix of bad taste and a taste that's peculiar to Salta. The art director suggested that we shoot in a seventies house designed in a more modern style than the area's usual neo-classical colonials. The DP for *Headless Woman* joined my crew a few weeks after shooting started, after I had already set out what I wanted to do, but we clicked right away. I had decided to shoot that house in an enlarged format because its architecture had a lot of vertical lines and straight lines, and I wanted to break that. So I used a format for the interiors that's traditionally used for landscapes, and it allowed me to have the feeling of hiding and spying on the characters' lives. I also did many wide shots with a lot of movement inside the frame because I wanted to see the main character always surrounded by a lot of people to show that she's constantly protected and loved in her own world.

I worked with one editor for the first two films, and for *Headless Woman* I chose a different one. I always find editing difficult. First of all, you're going from a fun time, when you're shooting with a lot of people around you—sort of a partylike atmosphere—to a more solitary time when you're choosing to cut out stuff.

The sound mix was expensive because we did it in Paris. The post-production part involving sound is as tiring for me as shooting the whole film because it's almost like making a second film. When I'm done with the sound mix, I'm dead, and that's when I say, "I'm never going to make a film again."

Olivier Assayas

Movies are alive, so you have to keep them alive and in constant transformation. It goes back to the notion of time, which is another reason movies are so good at capturing this notion of time passing.

To me, screenwriting itself is not interesting. The important thing is real writing. The process of real writing in cinema starts the moment you have an idea and it begins evolving within you. All of a sudden it's so present that you have to get rid of it by putting it on paper, somehow freezing it in what we call a screenplay, which basically is the tool you will use to make it happen, get it financed, and explain to your crew and your actors in which basic direction you are all heading. To me, separating that part of the writing is like a freeze frame because the writing process goes on all the time I make a film—when I choose my actors, my locations, the morning of the shoot when I design my shots, when shot after shot I kind of re-elaborate the first shot, rewrite the dialogue, change this, change that—from one day to the other, not even from one shot to another or one day to another. For *Summer Hours* (2008) we would do twelve takes of each specific shot, and not one take was the same. I was constantly changing and adapting it. It's the same thing when I'm editing, all the way to the final print. I think making a film is one continuous process of writing, erasing, adding, and moving.

Agnès Jaoui

Of course, the first part, the writing itself, is the most important, especially with what we [Jaoui and co-writer/actor Jean-Pierre Bacri] write. I'm not talking about cinema in general; I'm speaking specifically about us. And

editing, my favorite moment, is rewriting. The hardest parts are already created: writing and shooting. Now you have the materials and there you are, ready to give life again. It's also depressing, especially at the beginning with the first edit, because there is no life. It's like a nightmare, all you dreamed but without life. Every director is used to this. But then it's wonderful because when you add things like the music, you give life again to your characters.

Paul Schrader

I'm writing a script now that I will direct. I wrote a script earlier this year that I'm not going to direct but I just sold it. There is no difference. When you write, you write as a writer, not as a director. You're concerned with story structure, character, theme, dialogue. That's all you think about. The last thing you want to think about is the visuals. That's not what writers do because it's about literary logic, not visual logic. You write with storyteller logic, and then in the shoot you dress it with visual logic, which is a different form of thinking. Literary logic is "paper cup"—two words. The phrase "paper cup" is a literary trope. The actual object is something else—it is not "paper cup." The object is what it is. Everything in a room is visual ideas, not literary ideas. So you look at the finished script and say, "How can I turn this into visual ideas?"

The script always changes. It changes during pre-production, especially during rehearsals, so you leave yourself a few hours every day during rehearsals to do rewrites. The whole script gets rewritten before production because there is little improvisation in movies. What people tend to think of as improvisation actually happens during rehearsals, when the film gets recodified and people are playing. They say, "Oh, let's do it this way. What if this happens?" And you change the scenes. Or you're sitting down while the actors are reading it, and you think, "That's kind of dead, isn't it?" Or they look at you and, all of a sudden, you're writing a new scene while they're reading.

Mishima (1985) is probably the greatest exception to this, where there was little opportunity for conventional storytelling in that the film was designed at the writing stage to a far greater degree than anything else I had written. *Taxi Driver* (Martin Scorsese, 1976, written by Paul Schrader) was about suicidal glory, and I was thinking of working that subject again. I had written a script on Hank Williams, but we couldn't get the music rights

to that, so it fell apart, and besides, Hank would have been like Travis Bickle, just another ignorant kid singing himself to death. I thought, "If you really want to go to the other end of the bookcase on this theme, go to the East, to someone who is highly successful, famous, talented, intellectual, homosexual, and, yet, in the grip of this same pathology. That would be interesting." Some people had accused me of writing down to the character in *Taxi Driver*, of being more intelligent than the character, but I thought this pathology isn't limited to the unintelligent.

People tend to talk about inspiration as if it's some mystical, unknowable force, but it's not. Inspiration is directly related to defining a problem and then solving it. If you define your problem correctly, inspiration comes. With *Mishima*, the problem was how to tell the story of this schizophrenic life, this man who lived in all these different boxes, so people from one box were never allowed to communicate with those in other boxes. If you were a gay friend, you couldn't meet with his literary friends, his political friends, or his military friends. But he unified all these boxes through his fantasies, so I knew I had to get into the novels.

I was always frustrated by biopics of writers because a writer's real life is inside his work, so how can you ever tell the story of a writer's life unless you get inside his work? I came up with the scheme of seeing the progress his thinking made over his lifetime, finding three books that reflected that, and then synopsizing them into little snippets of stories and crosshatching them with the drama of the final day of his life and with traditional biopic memories. Then I said to Philip Glass, "I'm going to make the boats, but you're going to make the river, because I'm not sure all these boats are going to be in synch with each other unless there's a powerful river carrying them downstream." I saw that the film needed an operatic score and Phil had done a number of biographical operas—*Einstein on the Beach* (1976), *Satyagraha* (1980), *Akhnaten* (1984). So I approached him to do this as a biographical opera. He composed the score before seeing the film, based on seeing the script and reading the novels and the autobiography. Then he gave me a temporary score. I cut that together, repeating things and trimming things so I could edit the film to the score.

I said to Phil, "Look, I kind of ruined your score, but it now works with the film." I played it for him, and he rewrote it. Our goal was that it be a piece of music with integrity apart from the film but also serve the needs of the film. For Phil and me, it wasn't so much inspiration as figuring exactly

what the problem was. Once you know what the problem is, you start to see the solution.

Obviously, you have a limited number of choices in the editing regarding what you can change. You can do some writing in the editing in terms of ADR [automated or automatic dialogue replacement], voice-overs, and stuff like that, but you can't really rewrite your scenes anymore. You can reorder and reprioritize scenes, give a different dynamic to scenes—make a scene frenetic that was meant to be stately. There are always things that don't work quite the way you thought they'd work, so you create juxtapositions.

Matteo Garrone

For *Gomorrah* (2008), we wanted to give the audience the incredible emotional experience I lived through while staying on the location [Naples]. So I wanted the audience to feel they are inside of the film, to hear and smell the people. It's as if the movie and the material told me how to shoot, and it was necessary to disappear as director, to become invisible, as if it were a documentary. Of course, that's just an idea of direction, because it was completely controlled. I shot it like a documentary, but there were many people behind the camera, and it was all done on set. But I wanted the audience thinking it was a documentary, which many people did, so that means I've done good work. I have done documentaries, and my work has always mixed the two genres.

First I write the script, then I go to the location, and in this case it was amazing to discover that, just two hours from where I was born, a territory is at war in Italy of 2008. I met a lot of people in this system because there is no precise division there between good and bad. It's all a big gray zone, a jungle where everyone is fighting like animals to survive, and I tried to include that in the film.

When you make a movie, you're blind, so it's like making a painting—I was a painter—and it's difficult to know what the rhythm will be. I can talk about how we decided to work from the book, which is a kind of reportage with hundreds of stories. So it was hundreds of movies in one, and everyone thought it would be impossible to make a movie from it. For me, though, it was a strength to be able to develop the characters' dramaturgy with freedom. We decided to do five stories with five themes, which was hard because there were so many interesting ones, but the five had to be not only local but also universal.

The movie was not against the Camorra, but about Camorra. It is not a thesis where I want to say who is good and who is bad. I didn't want to judge, I wanted to show this from faces, the light, the locations, so every person and location could give me new inspiration.

I sometimes changed the script we wrote because many things happened during the shoot. Also, behind the camera could be very interesting and a lot of fun. There were always about fifty, sixty people from the area who were living through this war experience standing behind the monitor. They were the first audience, and it was important to see their reactions. I think this movie was made by many, many people, and sometimes I was completely overwhelmed when they'd discuss it together—for instance, the scene of the brother's marriage, with the drug dealer and the young boys looking on. Some people looking at the monitor said it was impossible to have the drug dealers on a hill while there is a marriage below because they have too much respect for marriage, but others said, "No, I saw drug dealers at marriages many times." Everything was in dispute.

I love the editing period very much. I reinvent, and I also have a particular way of working. During pre-production I put a part of the budget aside so I can go back and reshoot after editing. I shot for three months, and I edited the movie for four months. Then I saw the movie with the screenwriter, my troupe, and people who didn't know it, so we could discover what we liked and what we could improve. Then I went back on set with a tape of the movie, leaving blank the parts I was going to reshoot. I reshot for two weeks, two or three days for each story. I could do this because I had saved money from other parts of the production. Everybody has his own way of working. There are no rules.

Sergei Dvortsevoy

I wrote a regular script for *Tulpan* (2008), but at the same time, I realize that a script is one thing and my film language is a little strange. I wanted to show something that cannot be written, so the script was just a step. When I started preparation, I began by shooting video, not simply of scenes I had written, but also to discover whether or not I could find the atmosphere of the steppe, to see if I could feel the people and catch the breathing of the reality I created. That was important.

And when I shot video, I realized I needed to change things. First of all, we shot the key scene of the ewe giving birth, and it was ten minutes long.

It was so fantastic, so powerful, that I didn't know what to do. If I cut this scene to have a standard two-minute or so scene, I would lose the scene's beauty and power. I had to make a choice—to cut or not. But if I didn't cut, I needed to rebuild the entire story because if one scene is ten minutes long without a cut, it's hard to keep the same story. I decided to save the scene. It was awful to change the script during the shoot, but I was forced to, and it changed a lot. By the end of the shoot, I was down to 20 percent of the original script.

I edited the film myself. I used a guy from Serbia at the end, just for consulting. I am used to working myself with an Apple MacIntosh because of my documentary past.

Jia Zhangke

I had two friends in school. One turned out to be a thief and the other a prison guard, and the thief was in prison where the other friend was a guard. I asked the guard if they met, and he said, "Yeah, sure, and we have philosophical talks about things like the meaning of life."

Because of the rapid changes in China, even a thief asks about the meaning of life and his purpose! After I heard his story, I got so excited. I thought this was great material, and I started a script for a short that would be called *Pickpocket* (1997). I finished in three weeks, and I handed it in to my Hong Kong producer. But then I told him I'd changed my mind. I would take it back and make a feature-length film with the exact same budget. But because of the budget, I would use 16 mm instead of 35 mm film. I faxed the longer script to the producers, and they loved it.

As a first-time feature filmmaker, my passion and desire were totally outrageous. I would definitely say I was crazy. I shot the film in nineteen days, shooting all day, drinking with my crew nonstop at night, and working again the next day on little sleep. But my mind was clear the entire time; this supernatural power just took me over. *Pickpocket* screened at the Berlin Film Festival (where it won two awards) and paved the way for my later creations.

The conception of my movies usually starts with an outline. It's loose and primitive, just what the story is about, nothing in detail, and I take this outline when I look at the actual locations. The sense of the spaces is important to the scriptwriting process. A huge part of finalizing the script happens while I'm on location, checking out where I'll shoot. I see a lot

of traces of human activity in those spaces, and that starts me imagining, so I use that in my story. The space could be a dance club or a park's table tennis area or a bus stop in a rural area of China. Not only will that space itself give inspiration because of the traces people left behind but, at the same time, how the people who live there behave within that space becomes another source of inspiration for finalizing my script.

Then I start a brainstorming process, using all my imagination to write the final script. The next part is auditioning actors, and based on the actors we've chosen, I will rewrite and revise the script again. When I'm shooting, I usually change the script as well because the shooting process shows me other changes I have to make. There's a lot of rewriting. Maybe that's why it's hard for me to work in the United States because the process is not the same.

Editing is a constant challenge because there are few professional editors in the Chinese filmmaking environment who can see the process through from beginning to end. There's no editing field in film education here, so the people who work in editing are usually young and just know about computers and software. So I do most of the editing, and I must create a distance between myself and my film during the editing to be more objective about it and more rational about giving up things. I guess that's unique to China and unique about my editing process. I don't know if it's good or bad, but when I face a dilemma of deciding whether or not to keep an important plot point that's not well shot, I would rather give up the plot line and capture only the perfect atmospheres, feelings, emotions, and states of mind that I want to create. You might call me a perfectionist, but I really think that's more important than the story line itself. So I will cut out parts that could ruin the rhythm, emotion, state of mind, or atmosphere of the film.

Gerardo Naranjo

For *Drama/Mex* (2006), certain situations had to have a clear outcome. I didn't always know what would happen within the scene—in the beginning or middle—but I knew how I wanted it to finish so I could take it to the next scene. The crew and cast were my friends, and they were brave. I think they believed we were doing something silly, not important, and no one would see it, so that gave everyone a sense of freedom. They were willing to take risks and make fools of themselves.

We only did two or three takes for *Drama/Mex*. The rule was not to repeat. I also gave no direction to the actors, and we didn't have the right to stop and make them do it again. So they would do it two or three times for us, and we caught it as we could. The highest number of takes I'll do for a shot is three and only when we have serious problems. I feel there's something in the honesty and truthfulness of the first takes.

I'm Gonna Explode (2009) used an equal mix of professional and nonprofessional actors, which was another equation. A film mixes certain things, and the outcome of that is the idea, so the equation for *Drama/Mex* resulted in a concept about interaction, the chaos in a relationship, and that film went where it had to go.

Shooting is actually easy for me. I've been training, imagining, and living for that moment all my life. The hardest part for me is to conceive the idea and be clear about what I'm saying—the cultural identifications and other subtexts. That's where I struggle and fight myself because I really don't want to say something that I don't intend. This may sound silly and simple, but the biggest tendency of these times is making films where we're not aware of the subtext we communicate. I admire Darren Aronofsky, but when I saw *Requiem for a Dream* (2000), I felt he wasn't aware of his subtext. It was almost as if he delivered a puritanical message preaching on responsibility about drugs. It's always better to open possibilities than to close them. Closure and conclusions are too precise, so how people perceive my movie worries me a lot. The essence of *Explode* is that it's an absurd film about how absurd life is, and there is no message being preached. Artists shouldn't take shortcuts to conclusions or definitions that do not open the possibility for people to think for themselves.

Because it's hard for me to write and I only know the root of the film, I think I really write in the editing room. I admire Bresson and pure cinema, and I do crazy things with the camera regarding dynamics and movement. So I finally write the movie in the edit, when I understand its entire form. Up through writing and shooting, it's all feelings and ideas but nothing precise. In the editing, I give shape to whatever mess I have and finally start to understand what I've been trying to make. I start to know my intentions because I feel pretty much lost in the previous two phases. I trust my instincts, but I don't understand things very well.

When I shoot, it's hard for me to understand exactly what it is. I think of a movie as having a spring, summer, fall, and winter. Obviously, the

winter is the darkest time, when I feel I didn't get what I needed. I have regrets and wish I were wiser, more energetic, or another person. But then I finish it, and I can recognize the film, why I did certain things, and the initial impulse that made me want to make the movie. It's something that obviously comes with age. I'm thirty-five, but when I was young, I was arrogant, and now I understand that you can see imperfection in your film but not judge. I am more patient with my work, and I try to understand the nature of the medium. I trust in the nobility of our understanding of human narration, in our ability to tell stories, and that a subconscious hand will take us through the story.

Kiyoshi Kurosawa

I prefer less dialogue, so when I'm writing, I never write more than one or two lines of dialogue for any character. Even a few lines are too long. I'm not trying to make them sound rude or inexpressive; it's simply my preference for dialogue.

My screenplay is the opposite from final. It's a starting point, so I have many unexpected discoveries as I shoot on location, as well as in the editing room. Since I write my own screenplays, I have the luxury to pronounce my screenplay finally finished only when the edit is finished. For example, the role of the thief in *Tokyo Sonata* (2008) was taken from the screenplay, but the actor brought such intensity that he inspired the actress playing the wife to deliver a much more vivid and intense performance. Ironically, she almost took the leading role in the last portion of the film, which definitely wasn't my original intention. But I felt that intensity while we were filming those scenes, and I liked them a lot, so I used them a great deal in the editing, including a scene of her walking by herself on the beach at dawn that I'd certainly felt was a throwaway moment when I wrote the screenplay.

During the shoot, I don't look through the viewfinder, and this time we shot on film with no monitor, so no one other than the DP saw it. It was very much up to the strength of the DP. The production designer is also important, but I pick the locations, and I give a lot of weight to that. I decide on the space, the camera angle, and how the actors will move within that space, and then I leave the rest to the DP.

This is because I have experience, but also because the first and most important part of my job as director is to find people I can trust, whether

it's a cameraman or an actor, and then trust them 100 percent, whether it's my first time working with them or the tenth. So, I scrutinize my choices carefully, and then it's totally up to them. I work only in Japan, but I've found that if I trust someone 100 percent and leave it in their hands, they almost always rise to the occasion and deliver what I want. That's my job. When I was younger, I was more nervous and micromanaging, but at some point I realized that the way to get the best from someone is to leave it up to them so they're inspired.

Jerzy Skolimowski

It always depends on who you're working with. I had a good writing partner for *Four Nights with Anna* (2008), Eva Piaskowska, a young woman with brilliant ideas, so that part of the work was pleasant. The shooting is hard work. You have to get up at five, six o'clock in the morning, which I hate, and you have to do physical work and deal with so many people. Unfortunately, you have to manipulate them a little, which is not pleasant. You have to push them one way or the other. Sometimes the true explanation is not enough, so you have to invent some other reason, and you have to play the carrot and stick thing. I don't like it, but it is part of the job because people have a natural resistance to being pushed into something. But I never yell, and we kept a great sense of humor on the set. One way was by speaking to the crew over the loudspeaker in pidgin versions of different languages, which relaxed them. Even if I was commanding them, I commanded in primitive Russian, German, French, Italian, Czech, and they understood. So it was harmonious. Some directors execute their egos; they're like little Napoleons on the set. I don't care for that. I do it in a gentle way.

I'm an experienced filmmaker and I know my tools, so I was planning certain things even while writing the script, and I was fully aware of whatever means I had to create each scene. Obviously, on the set something more comes. There's a bit of improvisation, accidental things, but I'm always ready for that. When something happens and it's good, I'm ready to accept it. But basically, it was planned, a kind of strategic *partiture* [musical score], not only for sound but also for image.

I was a bit unfortunate in the editing because the editor wasn't my choice. I hadn't worked in Poland for many years, so I didn't know who was good or bad and I was advised to use this guy. But he did not have my temperament. So I used an emergency device: I did the editing with him

during the day, and then I took what we did and worked with Eva and my friend André at night. We'd think, "What to do with this material?" I took notes about where to cut and where to add, and the next morning I would go back to the cutting room with the notes and say, "Okay, cut here and add there." At the end of each day I got another video of the new cuts to work with at night, and the process repeated. It was a lot of work, but that was the only way.

Brillante Mendoza

I'm involved with the entire process of making my films. I'm one of the producers, and I have a small production house. I'm also a production designer, so I know the dirty jobs, and it helps a lot to know what you want to do. It lessens the preparation because everything is quite clear, especially to me, in terms of logistics and production design. I think the preparation sometimes slows down the process with other directors. But when I see a location, I know exactly what I'm going to do and what I want, and that's it.

Still, the longest stage is the preparation, which includes research, because even during the research process I try to involve not only my actors but also some members of the staff. I want their input, and I want them to feel the experience as I gather material and pull together the story. So the research and doing the script with the writer take the most time.

I had worked with the cinematographer for *Serbis* (2008) on my other films. We discussed the scenes and what I wanted to articulate in them. We did a lot of rehearsals, not necessarily with the actors. I had only one camera, and I did the blocking and camera movement while the DP lighted it. In *Slingshot* (2007) I did the cinematography myself, so the cinematographer takes credit in a different way. In *Serbis* the cinematography itself is supposed to tell the story, not just capture the characters. It also tells the story in a different way, and I wanted to make it more personal. I'm not saying I didn't trust my cinematographer, but the people who do that best are the director and storywriter, and I had to capture some moments within the characters that only the director could do. The cinematographer might have interpreted it in a different way, so I asked permission to take the camera at some points in that film, although it was a heavy camera and there was a lot of moving up and down the stairs.

Normally, I shoot chronologically from the start of the film, because it helps me as a director and the actors to develop their characters slowly

because they're involved as you go along with the film. There's also editing going on while I'm shooting, as the editor puts everything together and I watch it after each day's shoot. So I always know more or less whether I'm lacking shots or on the right track.

I'm also involved in the editing, and I ask my editor and others in the post-production process to be on set several times so they can feel the environment and become part of the whole thing. They have to understand and feel it themselves because it's not just putting it together. They're also helping to tell a story, and I'm trying to build a certain emotion.

Pablo Larrain

Filmmaking is probably the best job in the world because you can have an idea about anything and start working on it. You write it during the script process, through which you create characters, situations, dialogue, emotions, whatever, and then somehow with a lot of work—in this case with my brother, who produces my films—you get the money, which is never enough. Then you rehearse with the actors and see the places, and all the images you created while writing start to become real. Then there's the shoot with the camera, where you have to show it to others. You know that it's eventually going to be shown on a huge screen and that it's going to turn out somewhat differently from whatever you did.

Everything is important: the way people speak, dress, and move, the light, the way the camera moves, the colors, the sound design. Everything should be going in the same direction, of course. There's something beautiful and hard to explain about filmmaking, and that's tone. I'm sure even the masters don't really know exactly how the tone of a film will be. So you try to move your pieces with the intention of getting somewhere, but you don't know exactly where, like tuning a piano so when it's played, it sounds good. But along comes the player of the piano, and it sounds different. You never know how it's going to sound, but you try. Filmmaking is also like cooking, where you put together a lot of ingredients—a little more of this or that. You think you know how it's going to taste, but when you serve it, it's different. With filmmaking, you don't know exactly, but you try to handle everything, and everything is important to building mood.

Sidney Pollack said that the best way to know your character is from how he relates to others because relationships tell a lot, even more than actions. So I work on how my characters relate to each other, look at each

other, talk to each other, and I find ways to manipulate it a little bit. For one scene in *Tony Manero* (2008) with four or five actors, we rehearsed and I gave directions to all of them. But I also gave each one conflicting motivations, so no one really knew what was going on. Every shot was different as well because the camera was never in the same position. The actors never knew when they were going to be shot or how. The conventional way is to say, "We're going with Peter. Peter, sit down here." And then you position the camera, the makeup person comes in, special lighting is arranged, the microphone is placed, and then you call "action," so the actor starts "acting." That's dangerous.

To prevent that, I did long shots with ten-minute takes, the longest ones possible for a 16 mm camera, and I asked the cinematographer to light everywhere so we could see everything. No one was on the set, just the camera and actors, so there was nothing behind the camera—no chairs or monitors. I shared camera work with the cinematographer, and I would say I filmed 60–75 percent of the footage we used. He shot more than I did, but in the editing we used more of what I shot. The camera was always handheld, because you get into it that way and the actors were all over. Everything and everywhere was the set, and 360 degrees of it was lit. It was a headache for the cinematographer, who is such a talented guy, but the actors never knew when they'd be on camera. On the first day, everybody was confused, and by the eighth take, no one cared, they were into it. They weren't expecting to look good, and sometimes the lead actor didn't even wait for his lines. He knew what his character was doing and followed him. So if somebody else said something that wasn't in the script, he would just answer because he knew how the character felt.

We didn't do a lot of improvisation; most of the scenes were written, but some were improvised because the actors were really there. It's almost a cliché, but the actors absorbed it, especially Alfredo Castro, the main actor. In some takes I didn't even tell him what to do. I'd start to give direction and then say, "You know what? Do whatever you want. You know what the scene is about?" "Yes." "Okay. Camera! Action!" He would do it, and we would film it. Then I might say, "Why don't you try to do this?" "Okay." I told him to forget about the camera, and he didn't have to step on certain marks because of the lighting. Everyone was going crazy—the camera assistant, the focus puller. They hated me because they couldn't do their work properly, but the result was fresh and real. You can say you

like it or not, but I think you can't say that what you see in the film didn't happen.

The most beautiful part is the editing. Sergei Eisenstein said the deep meaning of things is not in what you shoot but in what you end up doing in the editing process. A shot means one thing when placed before one element, but if you change that order, the meaning becomes completely different. And that's true not only about editing. You build that with many elements and techniques. Ultimately, that's direction, because if you make a mistake with one element, it will mean something entirely different from what you intended. And that is dangerous.

Making *Tony Manero* was a different experience from my first film [*Fugue*, 1996], where I was worried about unimportant things—what people would think about it, having beautiful shots and dialogue, how the characters would look. I spent a lot of time on that, and it stressed me out. I tried to make one hundred films in that single film, the best film ever. I like that film because it's my first, and every achievement and mistake helped me understand many things and learn. But for *Tony Manero,* my second film, I was concerned about just three things: the character, the character, the character. Where is he? What is he feeling? What is he thinking? How is he going to move? There were also secondary things that were important, but I didn't really care what people would think about it. That freedom is so important for a filmmaker. If you're shooting, you just want to make sure you and the whole team like it, and that means you're probably making a nice film people will like. If you try to be smart while you're making the film, people see the string manipulating the puppets, and that's not good.

Courtney Hunt

You seem to have complete control in the writing, but you really don't, because once you set your characters in motion, you have to honor whatever you set in motion. You can't have the film end "this way" because you decided on that way back when, so it's all about letting go. I knew that from the short-film version of *Frozen River* (2003), because little gifts kept arriving and you wouldn't see them coming. We had so little time. On the other hand, I didn't have Hollywood moguls calling me and shouting, "You gotta shoot her better, goddamn it!" I just had me, the crew, the actors, and the producers, so I could take it wherever I wanted in the shooting. I was open

to being disappointed and surprised because I knew the editing would be a whole other phase, a big transformation.

I'm not super madly in love with my own vision. When I got done with writing the script it was, "Okay, I'm done with that now." And when we talked on set about the writer of the script, we talked about "her" in the third person, as if I weren't standing right there. Sometimes we said mean things about her if some small stuff wasn't logical, like "What the hell was she thinking when she wrote that?" But the script was in good enough shape that I didn't have to worry. I didn't have my ego caught up in it, so we let that go, and the actors brought their gifts. They give you all this great stuff, and you have to accept those gifts. It's really spiritual. Somebody gives you a piece of their soul, and you have to accept, honor, and work with it—collaborate. I have complete respect for actors.

Then you just fall apart in the editing. You take your little movie that's shattered into a thousand million pieces and give it to your editor so she can put it back together as you both sit there and work it all through. It becomes something totally new. I came to Kate Williams in pieces, and she literally put me back together again. Every day, she'd say in her Australian accent, "It's great, it's great," over and over. I thought, "She's probably crazy and doesn't know anything." But she kept saying, "It's all here, the emotional beats are all here. Courtney, you're fine." You turn on yourself after you've finished a movie, and all you can think of is the smell of your own footage—ugh. As I looked at the footage, I kept thinking, "Oh, this is the day that happened." Kate just listened and finally, when I stopped hating it, there it was. It was fine. Actually, the editing is really fun because you're not sleep-deprived. The writing is difficult and soul-searching, and the production is frantic yet wonderful. So in the editing you're all healed up.

Tomas Alfredson

A friend gave me the book *Låt den rätte komma in* (*Let the Right One In*) many years ago. I usually hate when people give me books because I want to pick my own books to film in my own pace. But I was struck by the bullied boy theme and the blending of the supernatural with a super-realistic environment. That was really original and made the idea of a film possible. I'm not so interested in stories where anything could happen. If anything can happen, it loses tension.

I tried to call the author, but there were thirty people before me, trying to get the rights. Finally we met. He had seen some of my work, and he'd liked *Four Shades of Brown* (2004). We're the same age, so we have the same references from the time the book was set, 1982. We also found each other to be direct, and making a film is all about good or interesting relationships. It's important to have a DP who composes well and has a good sense of color and lighting. But it's also important that you can be close for a long period of time. You don't have to be the same kind of person, but you have to share the same values about life in general. That way you can have different personalities and tempos, and it's interesting to work alongside a person who surprises you. I also like women in key positions in order to have the female point of view. There is so much of importance that the male eye doesn't see. I've been working with a female editor for over twenty years. She sees things I don't see, and that's important for me.

I have to begin by creating a sort of inner vision about how this film should feel, sound, and look, and what kind of emotions I want to achieve when people watch it. Then I have to deconstruct it into one million different decisions, decisions that you have to give to people, because it's hard to give them the total vision beforehand. It's almost impossible through the language of the eyes at least, but deconstructing the vision into decisions is much easier to explain—like the color of a wall, what kind of fabric you want in a certain building, or a certain kind of music.

It's about weather, wind, time, lightning, and so on. For instance, a scene written for a sunny day turns out to be filmed in pouring rain, and it's much better, so you are thankful the weather had a better fantasy than you. I'm happy for what I haven't planned or for people giving suggestions and leading me to places I didn't go by myself.

So I hold on to this vision while the deconstructed decisions are all being put together in the actual film, but the process of deconstructing it—filming it—is the most boring part. The happiest moments are before and after shooting, when I reconstruct it on the editing table. Maybe it's my editing background, but I edit on the set in my head. I know that I plan to take "this" part from "that" shot in take 1, and then I'll use the other part of the shot from take 2. I don't take notes; I remember everything.

Ari Folman

I began work on *Waltz with Bashir* (2008) by advertising on the Internet for stories from the first Lebanon-Israel war. More than one hundred people had been waiting for someone to hear their stories, so the research took time. Then I wrote a feature-length screenplay, mostly based on my personal story, not on the research. We shot the whole thing in a sound studio, including the interviews. Then we edited everything into a feature-length video film with some sketches in between. This was the main reference for the film, but we didn't draw over the video. We drew the animation from scratch, so the video and sound were just references. First, we storyboarded the video and then we moved the storyboards to big screens to see that the drama was working.

Waltz with Bashir couldn't have been shot as a regular documentary. Having participated in a war, I can say it's like going through a very bad acid trip. For example, in the opening scene with the dogs, I wanted to put the audience through this bad dream from the very beginning of the film and have them go through a new film language. If you look at it from one story line, opening with those dogs and ending with the real documentary footage at the end, hopefully, I succeeded in putting on the screen something of the torture that war can be. This could be done only with animation.

We have three kinds of colors and designs. I was obsessed with doing the characters as realistically as possible, as my main concern when I started was that the audience might not become attached to the main characters because they are drawn. So we made them realistic with more details in the faces, but the more details you have, the more complicated it is to animate and move the characters. Second, was the design of the dreams and hallucinations, which is much freer in terms of color, proportion, and they were done by different illustrators. Finally, when you go toward the massacre at the end, we kept to a strict line of monochromatic colors, between orange and black—no other colors at all. I wanted it as melancholic and depressing as possible, so the last eighteen minutes of the film strictly adhere to that.

The archival, non-animated footage was always meant to be there at the end. I wanted to prevent a situation where someone, somewhere, anywhere, would walk out of a theater and think this was just a cool antiwar movie with great drawings and cool music. It was important to show that on that weekend thousands of people were killed in the Saba and Shatila Palestinian

refugee camps outside Beirut, mostly children, women, and old people. It was essential to show that, and it gives the whole film proportion and perspective.

Just four months before the première, we dropped a great eleven-minute scene about an Israeli Defense Force soldier whose unit was bombed. He became fed up and just left. He traveled in Lebanon with a Phalangist Harley Davidson gang and met a girl obsessed with visiting Jerusalem. He wanted a bike, so he told her, "I'll marry you and bring you to Jerusalem, but you have to bring your bike." But they wouldn't let the bike in, so he was stuck with her in Jerusalem. It was such an amazing, weird story, but it didn't work out with the ending of the film.

Most of the work the editor did was microscopic, frame by frame. She's the only one I really trust, and we've worked for many years together. She can fight me, and I listen to her. It's always a personal relationship between directors and editors because it's an intimate thing to sit with someone for a year in your room.

Gary Winick

A director is clearly the one who's telling the story, from a conceptual and practical standpoint, so it's the nuts and bolts as well as the bigger picture. That means directing is about making hundreds and thousands of decisions that deal with a lot of people. Making decisions is important, whether or not you're sure. Not making decisions stops the momentum of telling the story. If you can delay some decisions, great, but a lot of times you just can't. So you have to be open and know that the film evolves from where you started. Any editor will tell you that where they started and where they ended up are completely different. But if you know what the film is about, the premise of the film—love is stronger than addiction, friendship defies ego—it works out.

Sweet Nothing (1996) began when a friend who ran a housing project in the Bronx found notebook diaries that recorded eleven months of this guy's life on crack, with two little kids and a wife. I thought, "Finally, a way to make a movie about drugs, because addiction is about the feelings." I started a five-year journey to make this movie. I tracked down the guy to get the rights to his story. He was living on the streets, dealing at 145th Street and Adam Clayton Powell Boulevard, in front of a Wendy's. I could go on forever about this amazing journey. I got some money from Partnership for

a Drug Free America because a lot of people said, "Gary, we don't want to give you money for this one. It's not commercial, and we need a big star to do it."

We tried to make this film with Tom Sizemore, Dermott McRooney, and other actors who could have gotten me the money, but finally Mark Ross, who was helping finance and produce the film, gave me half a million dollars, and I decided to cast the best actors I could find, Michael Imperioli, who had done *Good Fellas* (Martin Scorsese, 1990), and Mira Sorvino, who had just done one or two films.

We shot in the South Bronx. I'd driven around with the narcotics squad for research, so I knew the world. We edited it and re-edited it, and finally we got the film and applied to Sundance. We got great reviews, but no one would distribute it. Then Film Forum called, and Karen Cooper ran it for two weeks. Janet Maslin of the *New York Times* gave us an unbelievable review, Siskel and Ebert gave it two thumbs way up, and Warner Bros. bought it, so we got some money. That's the life of that film, and it got me a better agent.

Jean-Marie Téno

For me, all the stages of filmmaking are part of the same process. So it's fun in the sense that I don't really know where I'm going or what I'm going to have as a finished product. I just go in looking, writing, changing, moving, and at a certain point I say it's done; then the next phase is meeting the people who see the film and having conversations. Gradually, I start to think of another project because this one is done. I don't know if there's a moment in the entire process that I could say, "I like this moment more." For me, it has become a way to play around with image and sound, and when it works, that's fine.

The director is the one with the vision who makes the artistic and creative decisions, but it's difficult for me to define "director," because sometimes I'm also the producer, distributor, and I write. And when I shoot, there are two of us—the sound recordist and the cameraman—so when I take the camera, sometimes the cameraman does the sound.

Özcan Alper

Autumn (2008) took four years to make because I had to make a living as an assistant director, and I was waiting to feel that sense of completion.

While I was writing, I was also interviewing prison inmates and people who had gone through the hunger strike in Turkey's prisons. I also read about the psychological conditions of political prisoners and people in isolation for years. They were not necessarily a part of my script, but I needed to know more about that to develop my main character, and the film has that ethnographic quality. I was also raising money—that's very important.

The scriptwriting process has a different level of excitement because you put it on paper for the first time. It's tough, but at the same time, when you create something, you feel happy, and you're still alone. It's just you and what you put on paper, and that's exciting. The pre-production is about convincing other people, and you're still flexible, so I would say it's the most fun. You're explaining what you have in your mind to other people, and it starts making sense. Even with other films I work on, I always enjoy that most. You go around location scouting, drinking at night—you have this rhythm.

The shoot is not as exciting because it's very stressful. I've learned from my mentor—a well-known Turkish screenwriter who never directed—that if you lose the big picture, that one sentence you had in the first place, you lose it all. So for *Autumn* I always had in mind this Russian poem by Pedougher about a young man's life span and how his life went by for a cause he believed in so much. That poem in the back of my mind carried me through the shooting—that was the film's sentence. If you use a building metaphor, it's really about placing a window here, a door there—constructing it at the same time that you're imagining how the finished building will look. So it's about the details and the whole at the same time.

Nature was particularly difficult in the sense of controlling the *Autumn* shoot, but we were lucky. When we shot the highland scenes, we weren't sure we could do it that day if it kept snowing; but if we couldn't shoot that day, we wouldn't be able to go again because the roads would be blocked later on. And with the seaside village scene, I knew that in that season waves can reach the huge height we wanted, but you never know. What if they don't? We just waited, and with the snow and waves, it worked out.

The word for the editing is "difficulty." We ran out of money, and also I'm a bit technophobic. I still use my computer as a typewriter, and now everything is done on computer; so when you're working with editors, they usually tell you, "Oh, this is impossible!" They are always negative and tell you what is not possible instead of what is possible. It slips out of my

control, and I just don't feel the same. It's my least favorite part of the filmmaking process. A German editor who had worked on my documentary helped me work on the *Autumn* script because he has a drama background. It took three to four months, and I was there the whole time. If he came up with an idea, he'd ask me about it, and if I approved, we'd move forward. But since he knew the script and this world I'd constructed really well, he came up with solutions similar to mine. It's most important to work with people who understand you—the editor, the art director, the DP—people with a similar sensibility. It's all about the crew.

Mary Harron

I write with my husband, John C. Walsh, who's written and directed two movies himself, but I think a film rises or falls based on what you do in pre-production. That includes casting, as well as casting all the right heads of departments. Writing is fun and different because it's spread out over a long time.

The production designer and I talk conceptually. We bring in photographs, paintings, and we talk about certain films. The DP and I look at certain films, not trying to copy their looks but searching for certain aspects and qualities that seem right, that give us a language to discuss the look we're putting together. For instance, on *Bettie Page* (2005) I'd talked about Weegee's photographs, and W. Mott Hupfel III, the DP, said what I was looking for was the B movie auteurs. I had mentioned Sam Fuller, and he mentioned *Pickup on South Street* (1953) and *Underworld U.S.A.* (1961). He said, "It's not B movies exactly, and it's not noir," which was right, because noir is formal, composed and stylized, and our film was messier, more documentary, more like the B movies of Orson Welles, like *Touch of Evil* (1956) or *The Stranger* (1946) or Samuel Fuller's films, which were pulpy and arty at the same time. I thought that was right. Gideon Ponte, the production designer, also didn't want me to make it too formal and noir. He brought in a book of beautiful black-and-white photographs of James Dean taken by another actor in the fifties. I looked at one of James Dean in a coffee shop and said, "Yes!" It was a little more documentary and loose than I'd been thinking, and that helped define the style we would go for.

The two most time-consuming things are casting and locations. You spend half your time on a bus or walking around being shown locations

that aren't right, while the DP complains that he doesn't like this or that and everyone else is trying to sign off on a location that you and the DP or the production designer don't think is right. And there's usually one location you can't find even though it's very simple. The new movie I'm doing is set in one location, a school, but we still have to find that. Then there are the thousand and one small decisions on props, art department, and extras, which are important. You have to choose the right people.

The director-DP relationship really varies on different shoots. It's a tricky relationship because they do know more about their domain than you and they run their crews. They have to answer to you, though. You have the final say, and you will edit out their favorite shots. I try to work with people with whom I don't need to have a great battle of wills. I have certainly had that with a couple of people in the past. It won't stop the film from being good, but it's very wearing. Most important is that someone can do what you need in a style that is right for you, so it's worth putting up with a little crap to get that. I think they can have a problem with a woman director, depending on who the DP is—his background and how old he is. It would certainly be a factor in your choice of someone to work with. Generally, the younger crew members are more open to a woman director. Mott and I have a great relationship, and I don't feel that.

I came out of documentary, which is all about editing, basically the art of editing. I like editing because filming is sort of agonizing. "Am I making the right decision? Am I getting the maximum out of this moment? Have I shot enough? Is that performance good enough? Does that look right? Is that lighting right?" Basically, once you're in the editing room, what's done is done. You just make the best of what you have, which is a much calmer state of mind. Editing is like cooking, which to me is the art of saving your mistakes. Someone once said, "There are no mistakes—only a change of plan." So I think editing is the art of rescuing. I'm definitely a big-picture person, not detail-oriented at all. So I keep hold of the game plan, and I think I'm flexible. When we were doing *American Psycho* (2000), Andrew Marcus, the editor, took part of one nightclub scene and moved it into another nightclub scene. I said, "But Andy, they're wearing different clothes." He said, "No, they're not, they just have different ties, and no one will ever notice." Today you could fix that in the DI [digital

intermediary], but no one ever spotted that the tie changed from red to blue. Andy made some radical structural suggestions, and it was exciting. First you think "No," and then you think "Yes!" And I like that.

Melvin Van Peebles

I make films the way I cook, which means I put in whatever I like in case no one else likes it, so I can eat it for the rest of the week. I sit and watch my films and laugh and have a good old time. The fact that they're successful—that's nice. But I enjoy them. There's nothing worse than doing something you really don't like because then no one else likes it either. Then you're really in deep doody. But if you like it anyhow—hello, you're okay. There are usually two groups of people: the stupid ones who don't agree with me and the brilliant ones who do.

You have to go through that formula of writing the script, doing pre-production, production, and editing, but for *Confessions of an Ex-Doofas Itchy Footed Mutha* (2008), I shot in episodes. It took me two or three years, what with shooting in Zanzibar, then Kenya and Europe. Fortunately, I could do that because I know every aspect of the thing. I don't have to have a huge crew. Sometimes I might have up to six people on a crew, but I get the crew I need for that day's shoot. I take input from them all the time—or I pretend to. Then I decide everything, tell them what I want to do, and if it ain't right, they can do it again. I shoot a ratio of about one and a half to one. I get it right. I'm not winging it at all. If I'm shooting someone else's story and they want it a specific way, then I get them that specific way. Sometimes there's things I can't change. Then there's times the script says, "The guy drops down from the green tree." Well, there's no tree around, so you get to call it the purple car. Okay. I always keep the meaning of the action that was in the script in what you see on screen.

I have a technician now when I edit, so it's faster. It's disconcerting to realize that in the edit you have to come down from that space of production to the technical space and hold just to that. But I'm the chief editor. I make not only the final call but the first call.

The editing for *Mutha* took about six months, on and off, but in between I would go to Europe or someplace to shoot because I had to wait for things to make the situation as good as possible. Some situations were flexible, and so I handled the least flexible items and the must-do items

in a certain way. Then I did the more flexible items later because I could change them from this to that. So for this film, I was editing and shooting at the same time.

Lance Hammer

For *Ballast* (2008), I would find a location and start writing narrative for the location—that was a lot of the writing process. I storyboarded two-thirds of the film because I was being cautious. I wanted to accomplish this, so I thought I'd better have it figured out. I spent a lot of time storyboarding, and when [cinematographer] Lol Crawley got to Mississippi, we went over the storyboards so he got a sense of what I was trying to do, and we also went out to the locations with a video camera and mocked up these compositions. Then we realized that rigidity was not what we were after. We wanted to turn off the intellect and fly by intuition. Since we required this of the actors, we needed to do the same. We also wanted to respond to climactic conditions, locations, and an actor who did something spontaneously—that's where the magic happens. So after the second day of shooting, we looked at each other and said, "This isn't how we should do it, is it?" I also didn't know that Lol was going to be so talented, and he was nailing it. He gave me the confidence to throw away the storyboards.

I don't see any distinction among the phases of making a film. They obviously have physical differences. I write a script and it's woefully incomplete and makes me yearn for the next step to give it more flesh, and that's production. Production is just recording a bunch of raw material that bears some semblance to what I wrote, which I was enthusiastic to let go because the script is purely a skeleton, designed that way because I thought I needed structure. The writing is artificial. I didn't want to be specific with the script, although I was. I always knew, though, that I wouldn't pay a lot of attention to it, and I wasn't going to let the cast see it. I just needed the parameters of the script to know what to shoot and the range of things I'd need to record. That way I wouldn't record everything possible. So the script delimits the field of possibilities to something manageable. It also gives me room to explore new things in totally unknown directions at the moment, but ones that I can tell will fit within the existing structure. It's like a cage in which you allow chaos to exist, but you don't let it out. When you record the script, you get into reality—real people, real places, real climatic events happening in the sky—and you record it forever on film

and hard drive. You have to respond to these things instantly—without intellect, through emotion and intuition—and just do it. Lol responded in exactly the same way and thrived on that freedom. The actors also thrived and responded with great passion to being given such an authorial voice. If the project stood any chance of having a life, it had to come from real people being the authors.

Then you take the structure, the tissue, and all the new stuff you've recorded—without really knowing what it is, just knowing you had to record it because it felt important and relevant—and look for the ultimate story. It's the completion of the process and the reward.

I edited the film for two years. I have a lot of insecurity and self-doubt, and I often feel everything I do is horrible. I'm thirty-eight years old, so I know how to deal with that. But I had to edit by myself because it's hard to deal with those issues with other people around. It took me a long time to find the film and work through it. Most of the time I thought it was pretty bad, and it doesn't help that most of what you record in the film isn't good. We shot about a thirteen to one ratio, and that means that twelve out of thirteen shots were horrible. But all you need is one that's good.

I've been singing the praises of improvisation, but that has a really ugly twin. When you try to improvise, most of the time it's not working at all and is embarrassingly bad. That's okay, though, because that's what editorial is: choosing only the best moments and fitting them together in a string so that, over time, they accumulate a kind of power. It's also important that no single element becomes so powerful that it calls attention to itself. You have to have faith in the whole string of these things that will have power in their community. That's straight out of Bresson.

Constantin Costa-Gavras

Each stage of making a film is completely different, but it depends on how you take them. For me, they're all exciting. Of course, the writing is difficult. You spend time writing, and sometimes you're disappointed. Things don't come up; or they do, and two days later you hate them. Finally, you get to where you want, and it can be exciting. In the preparation, you have to foresee the whole thing without having any precise elements—the actors, location, and so forth. Then there's the shooting, which is very tiring. When I was an assistant director to René Claire, he asked me, "You want to be a director?" I said, "Yes, sir, I would like to try." He said, "Do you have good

health and energy? If you do, go ahead. If not, look for another job." So it's very, very tiring, not only physically but also mentally.

It's important to have everything in your mind; and when you go to the real thing, which means the locations, the actors, and so forth, you probably have to redo everything. It's there in the details, which are extremely important. The actors are one part of the film's characters; the other characters are the mise-en-scène and the sound.

I never storyboard. Some outdoor scenes have to be planned, like when you shoot in a car. But even then, when you get there, you don't do it exactly as planned because the elements change everything. I work closely with my DP, and I work with collaborators, not with enemies, so we treat each other nicely and, of course, the director has the last word, every time. That's the idea. The ambience creates itself. I don't believe in screaming and trying to impose my authority. I never have drama when I'm shooting.

The editing, an apparently relaxed period, is where you have all the material and try to see. It's the moment where you finally write the story. The writing is there but you're always missing something. It's the most exciting yet the most difficult period. You know everything, but you have to be fresh every time you put images together, because the director is the first viewer.

Andrew Bujalski

Every step of the way is horrible. I'm a person laden with many anxieties. *Beeswax* (2009) is just too big, but it obviously had to be done cheaply. I shot it on Super 16 mm, and I cut it in 16 mm. But shooting in 16 mm seems increasingly perverse to me, just because I've gotten older. Just cutting *Mutual Appreciation* (2006) took me a year and a half, and *Beeswax* took a year and a half from the shoot to the edit, which also included the sound mix and everything else. It's a long time, and on *Mutual* that didn't bother me. There was less in my life, and now there's more in my life, more distractions, so the convenience is more attractive. I still love cutting on film, and I certainly feel out of step with the world.

I'd worked with all the producers before. As I got through drafts of the script, I'd talk to them, and we'd figure out how we were going to do it. For *Beeswax,* I'd already started to cast beyond the sisters before we knew where we were going to shoot, and it came together to shoot in Austin. I got in my car to go down there on April 1, 2007, and we started shooting in

mid-July. I was alone there for April and May, and sometime in June one producer came to town. A couple of weeks later, another one came, and we geared up to shoot. So for the first couple of months it was just me, looking for locations everywhere; ultimately I have to see and connect to every location. A film like this comes together on favors because we didn't have money to buy everything we dreamed of, so we had to find out what's available. During those months I felt like a politician because I went to every social event I was invited to. I needed to make as many friends as possible so I could exploit these friends and get favors from them. You ask around, and you write a lot of mass e-mails to people with a long wish list of what you need. And slowly things come together. That's one great thing about shooting in a city like Austin, which is so incredibly friendly—friendly in general and absolutely filmmaker-friendly.

I edit alone. That's fun, scary, and painful. My little bit of documentary background was valuable because documentary absolutely teaches that you work with the material you've got, not the material you went out thinking you were going to get. Every narrative filmmaker needs to learn that. It can be difficult with a narrative film because you can think, "I've got the script and the script says this." So it's harder to let go when it's been all worked out on the page. But you try to see what you actually made.

Once I have a cut of the film, I start bringing whatever friends I can pull in whose opinion I value for whatever reason. They look at it, and we go through that painful process of everybody telling me it doesn't work. All the producers see it at various stages since it's not on a computer. I was cutting *Beeswax* in Austin, and none of them live there.

The cooperation can be frustrating and difficult, but the joy of making films is that these people take an idea from my head and bring it to life in ways that I never could have predicted, that have to be richer than where it started. The worst films manage somehow to be less rich than the first idea. That's the weird anti-miracle of cinema, that it's even possible to make films as bad as the worst films are. The medium is so good, and every image is so unique, so how can you make a movie that consists of boring, soul-sucking images? It wouldn't seem possible, and yet it's a science that's been perfected.

6

■━■━■━■━■━■━■━■━■━■━■━■━■━■

The Business

Financing, Distribution, and Exhibition

Making a film may be a creative process, but getting the film to viewers involves many non-art functions as well as issues of control. In most ways, the business of filmmaking is just like any other. Mismatched as they may be, art and business are longtime bedfellows; but profit, or at least breaking even, is particularly crucial for film, because making one requires so much money. Of course, one can borrow a camera and a computer editing setup and ask friends to volunteer their knowledge and help on the shoot. More and more independent films are being made today for a million dollars and far less, with cast and crew forfeiting salaries for "back-end deals," that is, participation in a film's profits, usually after distribution and/or production costs have been recouped.

But if a film is to be seen by enough people to recover its costs and fund the next project, money must be spent. How else will viewers discover and see the film? The costs of marketing a film can outstrip its entire production budget, and distribution is increasingly challenging. As Geoffrey Gilmore, chief creative officer of Tribeca Enterprises and former director of the Sundance Film Festival, observed during a 2009 Tribeca Film Festival panel, "I've been hearing this joke for the last several years now, and it's not very funny. The good news is that more films have been distributed in the theatrical marketplace than at any time since the 1950s. And what's the bad news? That more films have been distributed than at any time since the 1950s. The marketplace is cutthroat and

crowded, and all the truths that used to make independent film work are going away."[1]

Smaller theaters that showcase independent, personal cinema are struggling to compete with nationwide multiplexes (often owned by the same companies that control the movie studios), and major Hollywood studios have turned away from producing and distributing low- and mid-budget films. Internet movie downloading, easily accomplished for free by any computer-savvy viewer, is cutting into DVD sales profits, so pre-sales to DVD companies, along with pre-sales to foreign markets—traditionally important revenue sources, as well as a means of financing independent cinema—have shrunk dramatically. Equity financing is also scarce, owing to the current global economic crisis, although that source will never dry up completely because people who love films will always want to invest in them. One growing, albeit limited source of financing in the United States is tax rebates from various state governments, but this support does not compare with the state funding filmmakers receive abroad.

Independent distributors, cable television stations, and even Internet companies such as iTunes are brainstorming for new ways to promote films and provide viewing platforms for smaller movies that do not necessarily draw massive audiences. IFC Entertainment, a theatrical film distributor, also owns two cable television stations and has been releasing films via national video-on-demand simultaneously with limited theatrical releases. The company's "Festival Direct" program sends other films straight to video-on-demand without a theatrical release, and both programs have proved successful. However, a theatrical release that attracts reviews and public interest invariably drives the success of a film's DVD sales or pay-per-view showings, so filmmakers and distributors often try to book their films in select art house cinemas in cities such as New York, Los Angeles, and San Francisco, if only for a week or two.

In the past, a film would spend a few weeks in limited release before rolling out, that is, moving on to a greater number of theaters nationwide. A year or so later, the DVD would release, followed some time later by pay-per-view showings on cable television. That process has telescoped as more

[1] Geoffrey Gilmore, "Tools of the Trade: Alternative Distribution: Marketing 2.0 and Beyond," School of Visual Arts, Tribeca Film Festival, New York, April 28, 2009.

and more films become available on multiple, simultaneous, and often unconventional platforms. Steven Soderbergh's *The Girlfriend Experience* (2009), shot in high-definition digital, released simultaneously in theaters, on DVD, and on pay-per-view cable television. Of course, multiple-platform releasing can confuse consumers, and marketing becomes an issue because viewers need to learn of a film's presence in order to decide whether they want to watch it. IFC also brought five films to the 2009 South by Southwest Film Festival at the same time that the company made them available via video-on-demand. *Alexander the Last* (Joe Swanberg, 2009) was one of the first films marketed in this way, and it was reviewed by the *New York Times* and *The New Yorker* magazine, print venues that traditionally review films only upon their theatrical release.

In June 2008, YouTube launched "YouTube Screening Room" to promote and market features and short films that screened on the festival circuit but were not picked up for theatrical distribution. According to YouTube, those films have been viewed more than thirty million times and counting,[2] which proves there's a potential feature film audience online. YouTube has announced further plans to showcase feature films. In the case of Wayne Wang's *A Thousand Years of Good Prayers* and *The Princess of Nebraska*, which were picked up for distribution by Magnolia Pictures at the 2007 Toronto Film Festival, a theatrical release was planned for *A Thousand Years*, while *Princess*, a Chinese-language, nonlinear digital film, was released on "YouTube Screening Room" and viewed 150,000 times on opening weekend. Again, it was reviewed in the *New York Times* despite the lack of a theatrical release, and it also generated attention for *Thousand Years*, which was in theaters at the same time. However, YouTube content conventionally consists of brief clips, and many feature films may ultimately prove unsuited to this type of viewing format. In any case, the real issue is that a business model for Internet viewing of feature films has yet to be proven because, other than selling online advertisements, there seems to be no way to make a profit.

Some filmmakers choose to cultivate audiences themselves, investing as much time or more in reaching out to potential viewers via online diary-like blogs featuring footage posted from the set as in the film's actual production. Lance Hammer refused IFC Entertainment's offer to distribute

[2] Sara Pollack, "Tools of the Trade: Alternative Distribution: Marketing 2.0 and Beyond," School of Visual Arts, Tribeca Film Festival, New York, April 28, 2009.

Ballast, his Sundance Festival award-winning debut feature, opting instead to team with former independent film executive Steven Raphael, who is part of a new, fast-growing "do it yourself" movement that has sprung up to cope with the lack of distributors. Hammer created the poster artwork and the trailer, and his team held press screenings and booked the film at theaters, universities, film clubs, and art centers around the country.

Paul Schrader

An independent filmmaker is like a scavenger dog, scouring the planet for scraps that fall off various financial tables. I was hoping to get a 35 mm print of *Mishima: A Life in Four Chapters* (1985) for its theatrical re-release, but Criterion didn't want to spring for it, so they gave me the distribution rights instead. Now I'm redistributing the film myself, one film with one print, and hopefully I can get my money back by spring 2009.

Blue Collar (1978) was written to get me a chance to direct. So I wrote a script in which I could cast three middle-range actors who together would equal one star, and then I put in a lot of plot. It was designed that way, and then I went to Norman Lear to get it done. I've been putting films together now for over thirty years. I started making films for the studios, and then the studios changed and stopped making those films. They became independent films, so for the last twenty years I've been doing independent films, and I've managed to get quite a few of them made.

Now it is harder than I've ever seen it. The landscape is absolutely barren, and, as a result, I am writing a cross-cultural film set in India that hopefully will be financed by Bollywood. *Adam Resurrected* (2008) was co-financed with Israeli and German money. *The Walker* (2007) was financed with Isle of Man money. *Affliction* (1997) was out of Japan, and *Touch* (1997) was out of France.

We really screwed up the independent film movement here. First, we made too many independent films, turned off our audiences, and shot ourselves in the foot. Then the economy came in to shoot us in the head. So we don't have an audience, we don't have money, and therefore, we don't have distribution.

Catherine Breillat

For the moment I have a faithful ally in ARTE, a French-German television station that allows me to do what I want. Unfortunately, it's also the poorest

television station. Claire Denis also works with ARTE; she shot *Beau Travail* (1999) for them and with a very tight budget. But I don't think it's the lack of money that impedes you from making good films. A small budget does not mean the film won't be any good. The problem comes when you forfeit your freedom in order to have a larger budget.

Bette Gordon

In my experience most independent filmmakers who are starting out have about half a million dollars to make their films. I have a friend who just shot a feature on $250,000. He's a young filmmaker, and that's all he could get. And he's going to work as hard as he can until he finishes, in order to ensure that every image is as beautiful and as strong as possible while keeping the costs down. You probably can do that. Even though the differential may be small, when you're talking about really low budgets, you've got to make some hard decisions, and you can save money. It's all about your budget and your aesthetic being friends.

In some ways, ironically, the less money you have, the more flexible and creative you can be because you're writing your own rules. When you have more money, the rest of the world comes in to tell you how that money gets spent.

Lucia Puenzo

In Argentine filmmaking, you are always so aware of the budget and time passing that you're forced to make choices. That's terrible, because so many things are left out. So many times people ask me why I did certain things, and the real answer is, "I just didn't have the money or the time." It's no excuse, but it's the truth. That's so different from making literature, where you have infinite time and the only thing cutting you down is your own talent. In cinema, daylight is running out, and you don't have enough money or material, so you choose another way to express what you wanted.

For example, right now [early April 2008] Argentina is in the middle of a strike and the country's paralyzed. The cinema institute has collapsed and has no president, so there are no subsidies for filmmakers. Everyone in Argentine cinema who depends on that government subsidy had to stop. I stopped pre-production on my second feature [*The Fish Child*, 2008], and if I don't get everything together within the next two or three weeks, I'll lose my team; we have many Europeans and Americans

who will have to leave since they don't depend on Argentine money from the institute.

Eric Guirado

It was hard getting financing for *Grocer's Son* (2007). I'm just one of thousands, but it's hard. I'm going to be forty in September, and I still don't really live from cinema. I do documentaries for television. The business people of cinema always think they know society's central interests, but they make a lot of mistakes. If I were not absolutely convinced of the necessity of my subjects, and if other directors weren't equally convinced, then they would kow-tow to their producers' desires, and that would be a huge error. I like my producer, yet we are always fighting.

Of course, when you've done ten films, it's completely different. I hope people begin to listen and trust you at that point, but for the moment, I see that nobody trusts me exactly. Even now that I had this success in France, people still tell me what kind of film I should do next. It's normal. They think I had this success just by chance. But I work with conviction because of where I come from, a modest, poor family, and where I am now. This is what I've done the best, so I trust myself.

I'm involved in the distribution of *Grocer's Son* because it's my second feature. I feel like a craftsman, and I know what it feels like to have a film that doesn't go anywhere, like my first film, which I like a lot. This is my first success, and I enjoy that and want to be part of it. I even cut the trailer for the film because I want to help the people who want to put it everywhere around the world. So I'm involved with my French distributor and try to go wherever people ask me to be. I'm a good soldier. Maybe after this film's success in France it's going to be a little easier for me.

Charles Burnett

I never thought I would make a living at film; none of us people of color thought so. There was no outlet for us; you couldn't get through the studio system. What really helped was that the Europeans came out for me: Catherine Reulle from France, people in Amsterdam, and the Berlin Film Festival. Each country's festivals had a section of black independent films, and that was really a shot in the arm. *Killer of Sheep* (1977) won a prize at the Berlin Film Festival in 1981. German television bought the film and wanted to produce another one, as did a man from Channel Four in the

United Kingdom, so I got money from those two sources to do *My Brother's Wedding* (1983).

Critical accolades for my films never did translate into money. A lot of filmmakers are in the same boat if their films aren't commercial, with certain formal elements. You find a lot of black directors making studio films and directing television now, and you don't know what their race is, which wasn't the case when I was starting, so things are good in that sense. The doors kind of opened. But if you ask, can you make your own films, it's a different situation. If you're happy making studio films, then fine, do what you want. But for those who want to do more personal films, it's difficult.

Even Europeans have come to want the same commercial elements they do here. And then a lot depends on getting distribution here first before you can get distribution over there, and they want the name stars. It's hard to get distributed these days. So you can get to make the film, but you can't get your money back. I'm lucky to some extent because I've scratched out a living, but barely. People are calling me left and right, asking me for jobs—"Can I do this, can I do that?" A lot of talented people can't get work.

Olivier Assayas

I've always had problems getting financed, but I've managed to make the movies I wanted. I feel privileged that I've been able to make the movies I wanted to make, and if it were too easy, it would not be fun. So it's part of filmmaking that it's going to be difficult. Sometimes it's a nightmare, and you hate it; but it's basically what keeps your energy going.

Once in a while I've received screenplays from Hollywood studios, but I love to write my own stuff and the freedom in that. I don't think I can transport to Hollywood that kind of relationship to cinema; and even if I wanted to make a movie that fits within the framework of the movies people want to see here, I'm sure I would be much happier being financed in Europe. Somehow in Europe you can do things cheaper, with much more liberty and control.

Agnès Jaoui

I must admit that financing has been easy for us because we just made successes. That's also why I don't want to shoot in America. A lot of American

producers ask me to direct here, but I would have no freedom, not what I have in France.

Sergei Dvortsevoy

It was difficult getting *Tulpan* (2008) financed. I had a German producer and, at first, he found money with German foundations. We also had a Russian co-producer and money from some other countries, but the film went over budget, and we found good producers in Kazakhstan, rich people who invested quite a lot of private money because they loved the story. They like the film very much, and they're happy they invested.

Jia Zhangke

I get nothing from the Chinese government, but the economy is doing well, so there are a lot of private companies interested in investing in films. Most of the independent filmmakers, including myself, use these investors along with investors from abroad, from France, Japan, and Hong Kong. It's actually arbitrary, because *Still Life* and *Dong* (both 2006) were financed by a private person, someone who collects painting and photography. You never know what kind of investors you're going to get, not the traditional ones.

Gerardo Naranjo

I struggled for a long time to get financing, but the biggest struggle is finding what I want to say. I'm not saying this in an arrogant way; but after finding what needs to be said, I think making films is easy. It will provoke something in you that will make people believe they should invest and help you. I'm completely sick of the complaining, whining filmmaker who says there is no support. A lot of them in Mexico say, "The government is not helping me make my movie." But nobody helps someone who is not convincing. People are ready to make movies for people who are convincing and who they believe have something to say. I struggled, but I knew that I wasn't sure of what I was doing. And ever since I found the determination in myself, it's been easy. I don't know if it will be easy in the future; I hope so, but I don't think movies are about money. I think it's about something much different—energy, will, and inspiration. If you get properly inspired, you will inspire others and they will follow you. As shallow or ridiculous as is *Field of Dreams* (Phil Alden Robinson, 1989), I do believe that if you build it, you'll get the money. So the biggest obstacle is to convince yourself, and

once you've done that, you will do as much as it takes to make the movie. If you are completely convinced of what you have to do, nothing will seem like a sacrifice.

Shamim Sarif

My first two films were not supposed to release at the same time (2007). We shot *I Can't Think Straight* in 2006, and our so-called investor turned out to be a con man. Nobody had been paid, so the film went into legal limbo. I still had the rights to the script, but he had the negative. The court process took about a year, and in that time we set up *The World Unseen* and shot it in South Africa. While we were in post-production for *World Unseen*, we got back the negative for *I Can't Think Straight* and raised more money to finish it. So we were finished with post-production on both films simultaneously. They sold at the same time, and the American distributor thought it might be a good idea to market them together.

With *World Unseen*, we spent a lot of time going the more standard routes—trying to cobble together co-productions, like you do in Europe, and tax funds. If you watch any French or English movie, you have seven different production companies that all worked together. But they often want a name director and cast, and it's difficult to attach names to a movie about Indians in South Africa. Lisa Ray has a name, but it wasn't enough for a lot of the bigger players. In the end, we cut our budget right down to where we shouldn't have been able to shoot on 35 mm film, but we did. And we raised private equity through a couple of savvy businesswomen who loved the novel.

Tomas Alfredson

You have to run around a lot to raise money. I hate it because, in some way, you have to be dishonest with what you really want to say and you have to know the right time to shut up. You have to let people talk a lot so you can get this money. As a director you have to be involved in that process because people want to meet you: "I'm going to give away one million so I want to talk to this guy who's going to be responsible for everything." You can't run away from it. In Sweden we have to run around to a lot of funds, companies, DVD distributors, and other people. We have to go to a lot of wallets. You could be a poor salesman but a good director, and it sort of disqualifies a lot of good directors.

Gary Winick

I thought I could do a New York production company with digital video, a Dogma New York thing. I brought the idea to my attorney, John Sloss: "Let's make ten films for a million dollars; everyone will own a piece of the film, and everyone will be paid a hundred dollars each a day. What do you think?" He wasn't sure, but I told him, "Here in New York I'm friendly with Fisher Stevens, Ron Rifkin, Laura Linney, Phil Hoffman." So he said, "Okay, if you can get those names."

We approached IFC Entertainment and Sundance Films, and we got them going after each other. They knew that digital was a big word, but they didn't believe that we could make the films this cheaply or that we could get these people. They said, "Try one, just to show us." Fisher Stevens had been getting together with Annabella Sciorra and Griffin Dunne to write a piece by improvising, somewhat the way Mike Leigh works. We did a reading at the Nuyorican Café, and friends like Matt Dillon said, "Gary, don't do this movie; it's going to be awful." We had to shoot in two or three weeks, so I said, "If I make it, though, I can have a company."

We called the film *Sam the Man* (2000), and I got $150,000 from a lawyer friend who wanted to get into the film business, although it only cost $60,000 to shoot. Fisher got his friends; we filmed at his house and at locations where he knew the owners. One of my selling points was that digital is so location friendly and user friendly because you don't need lights. You just go in and say, "Hey, here's twenty bucks. Can I come in and use the back of the store here for an hour?" All of a sudden, you're making a movie. At that time, there was no Final Cut Pro editing software, no Avid. It was the beginning of digital, so we edited on a Media 100 that I bought. I went to IFC Entertainment and said, "We're not done with it, but here are the dailies." They said, "Great. You have a deal." They announced in *Variety* in August 1999 that they were going to do a ten-picture digital slate called InDigEnt, for Independent Digital Entertainment.

I hired people to run it, and we worked out with IFC that seventy-five points would go to cast and crew. But I wanted to do the sound at Sound One, and the films to be blown up in Kodak because I wanted the professional quality of a real film. So I went to these people and said, "I'll give you a small part of your usual fee, but you'll own a piece of the film. It's gross participation, so you'll be paid back from dollar one." A year and a

half later, Bill Nisselson of Sound One started receiving checks when Ethan Hawke's *Chelsea Walls* was sold at Cannes to Lionsgate.

InDigEnt was a moment in time when the right people came together. The first year, we produced six films: Richard Linklater's *Tape* (2001), Campbell Scott's *Final* (2001), Ethan Hawke's *Chelsea Walls* (2001), Bruce Wagner's *Women in Film* (2001), Rodrigo Garcia's *Ten Tiny Love Stories* (2001), and Michael Rauch's *Wake Up and Smell the Coffee* (2001). We went to Sundance seven years in a row with nine films. After we'd sold six films, we got Niels Mueller and Heather McGowan to write *Tadpole* (2002), and I directed. I knew the low-budget tricks—not a lot of continuity days, exterior locations—and all that digital brings you. I called myself the "KOD," King of Digital, because I spoke on all the panels and helped as many people as I could.

Each year, we'd get a new budget from IFC, and we were getting more equipment, so I let people use the old equipment for projects they were trying to get off the ground. It was the best thing in my life, and then *Tadpole* happened, this film I directed in twelve days with tiny cameras while producing other films like a little studio executive, not being on set. Part of the InDigEnt idea was that you do your own thing, it's totally your final cut, and I'll tell you what I think only if you ask.

I won the directing award at Sundance for *Tadpole*. There was a bidding war; we sold it for $5 million, and everyone got this huge payout. For the seventeen movies we made, we gave out $16 million to all these crew people. But there was no marketplace for the last four or five movies, including Steve Buscemi's *Lonesome Jim* (2005), Wim Wenders's *Land of Plenty* (2004), and Andrew Wagner's *Starting Out in the Evening* (2007). They were sold but never made money, even though we were at Sundance for *Starting Out in the Evening* and *Puccini for Beginners* (Maria Maggenti, 2006) and got great reviews.

I lost money on *Evening* because InDigEnt was finished by then. It was such a beautiful movie that I put in money I'd earned from directing *Charlotte's Web* (2006). So after films eleven and twelve, we were still going strong but not able to sell the films because we were with IFC for only ten years.

Right now, even with the economic downturn, the movie business this year has been profitable. But the movies that are working are studio "tent pole" or "exploding movies," and they are probably going to fill the theaters

because they have to be on the big screen in order to be experienced. This is not a good thing, but we're heading toward that economic reality.

IFC has a new distribution model for a certain type of viewership. The people who subscribe to their cable channels create a level of audience so that independent filmmakers can say, "Wow, it may get out there because someone might see it, then actually make a phone call or help us in a way." The ultimate goal is for our films to get out there and make money, and sometimes other people recognize that as well. IFC's two video-on-demand channels are actually returning money on some of the films InDigEnt did with them. Because everyone who worked on the films gets paid back from "dollar one," it will take forever for IFC to get their money back, but we keep getting money. The average low-budget film works by paying back the investors first. They get 25 percent of their money, and then it goes to a 50–50 split. But with our deal, IFC Entertainment gets 25 percent, and then the rest goes to everyone else until they're fully paid.

As for downloading movies from the Internet, that's what the writers' strike was all about. When the strike was coming up, a big part of the negotiations for the writers and the directors was based on the projections for profits from downloading movies. It was nowhere near the money that DVDs and all the pay television stuff get us. Obviously, from a filmmaker's point of view it's "Great, another place where people can see my movies," but we need to be paid. Distribution and exhibition are stopping some movies from being made now. Hopefully, these new models of exhibition and distribution are going to save us.

Jean-Marie Téno

One of the points of *Sacred Places* (2009) is that Africans can't afford to see their own films. They see mostly bootlegged American films; yet Africans really want to see themselves reflected on the screen. That's the paradox that drove me to make this film. So are we going to be like fifty years ago, when there were hardly any African films made, when there were no Africans doing that? Now you have the possibility of many African films being made; yet people in African neighborhoods are still in the same situation—they cannot afford to see our films—so it's a paradox I tried to address.

We are trying to set up alternative distribution, but it's a lengthy and hard process, and actually the question is: Who are you distributing the films for? My films are seen in the United States more than on the African

continent because people see them on many college campuses here, but not in universities in Europe or Africa, because people there have not integrated film as a medium into studies. Even in France it's not there yet.

Jihan El-Tahri

I financed *Behind the Rainbow* (2008), which took four and a half years to make, solely by mainstream television money from all over the planet. But I think there's an interesting question that lies between culture and economics, and that's where the whole problem lies. Culturally, we on the African continent are not as advanced as elsewhere. French cinema was not advanced after World War I, so the government subsidized it because it was a cultural issue, and then it slowly became an industry, and as an industry, French cinema developed its own sustainable mechanisms. We in Africa enter into the equation at the stage where we should be subsidized and culturally acknowledged, but we also need to become a self-sustaining industry immediately. But it isn't. It can't be. I think that's where the real chasm is. I've reached a stage where I honestly think that what I do is not viable anymore because it is cultural and historic and doesn't sell. I'm competing with Hollywood films. I know I'm actually not competing with them because we're not on the same level, yet I need the same money to be able to do that, and it's coming from nowhere.

Lance Hammer

I refused a distribution deal from IFC Entertainment [for *Ballast,* 2008], mostly over the question of rights and because so many people were distributing their own films successfully. I didn't know anything about it, so the first step was frustration over ongoing negotiations with IFC. With IFC or any other distributor in this current market, it's unrealistic. You're offered nothing, just pennies on the dollar, so basically you're giving away your film for free.

When it started becoming clear that it wasn't going to work out, I called filmmakers who had done it before, like Ali Selim, who did *Sweet Land* (2005). He had tremendously successful self-distribution with Jeff Lipsky (former head of October Films), and it was a lot of work, which was the bottom line for everybody I talked to. I'm happy I did it, but it took my whole life. It was extremely difficult, like production all over again. I worked with Steven Raphael of Required Viewing, who used to be head of marketing at Gramercy

USA—he's a big player in the industry who does awards campaigns for films like *La vie en rose* (Olivier Dahan, 2007), which won an Academy Award. I met Steven at Sundance; he responded passionately to my film and had great ideas about how to present it to the market. Susan Norget, my Sundance publicist, is single-handedly responsible for creating awareness about the film there. She was the first person I called, and I got her on the project while we were negotiating with IFC as well. M. J. Peckos, who used to run Target Films USA and First Look, booked our film. They're all close to each other, so I realized I could assemble a team of people who are professionals in the industry and of the same caliber as any existing distribution company, and they would focus on this one title only. Celluloid Dreams became involved in selling foreign rights very early because we learned we got into competition at Berlin right after we got into Sundance. I thought about distributing worldwide for about four seconds, and then I realized that I could probably distribute the film with this team in the United States and Canada but not in every other country in the world.

Courtney Hunt

You have to get creative and be willing to say, "This is a rich country. There's money out there. I'm going to find it. I'm going to respect the people who give it to me, take care of them, and do the best film I can." We went to private equity, which means going to private investors in the world and asking, "Would you like to invest in a movie?" You go to people who can afford it; you don't go to grandma who's living on a pension. You don't try to rip people off. You tell them the truth about what the chances are that they'll ever see a return. You think of people you know, of people who know other people, and approach rich people by letter. Blanketing the world with prospectuses is a waste of paper. You have to be smart about it.

My husband and I made a list of people we knew who might be interested in financing *Frozen River* (2008). We took it one step at a time, and we didn't go to the whole world. Some of those people are happy now, and they would be happy to work with me again. If you don't respect your investors the first time around, you can forget about getting their backing the second time. You have to be fair and honest, take care of their money, and try to make the film a commercial success. You owe that to them. I think that going off and being artistic is indulgent and ridiculous. Those dollars are as good as any other dollars, and you have to honor your investors.

Mary Harron

A film is hard to get made if it's outside the studio system or not a formula film. My new one is a vampire film about teenage girls, but it's within that genre without being a genre film. What you really want for your film is to be able to finance the next one.

We have problems we didn't have before; you used to be able to finance your movie on foreign sales and DVDs, and both sources have suddenly evaporated. Creatively, I feel as optimistic as I ever did and in some ways more, because I tell myself, "I can always take my camera and shoot." My husband and I are going to shoot a short next month with my camera.

But you can't just make films on your own. You want to make a film with resources, and if it's anything that involves special effects and large groups of people, it's difficult. If you can make a movie under half a million dollars, then you can get your movie made, and there's loads of first-time people who will go out and get great movies made. After that, it's going to be more difficult because you can't pull the same favors the second time around.

The $5–10 or $15 million movie is the hardest one to make, or it may even be the $1–15 million movie. Just in the last two years, little is being bought for over a million dollars. If you can make small, personal movies with your own camera and five people, you can keep doing that. The industry has gone off independent film until a new paradigm appears that they feel they can make money from. They'd rather make romantic comedies for $50 million.

I'm working now with Ed Pressman, who financed *American Psycho* (2000), and my first and third films were both with Killer Films, run by Christine Vachon and Pamela Koffler. In some ways, you go for the producers most likely to get the film made. Ed Pressman has done a lot of horror and art house films, so he was a good fit. But you can't just sit back and let the producer do everything; you always have to be active, like in finding your own crew and helping to get it financed. When we did *American Psycho*, Ed and I went around to many studios and financiers, pitching the film together. We're still in the process of financing this new film, even though we're casting. We're going to shoot in Canada. I'm Canadian, so we're able to get some tax breaks, and I'm talking to four or five possibilities to piece together the rest of the financing. You want to do a film where you get tax breaks.

My last film, *The Notorious Bettie Page* (2005), was made for HBO Films, which was nice because you knew they didn't care that much about the theatrical release. They always have a place to put a film. They give you that window.

In the last few years films have gained a whole secondary life that they wouldn't have had beyond the release. The bad thing is, you no longer have a slow release. We used to go from one theater to another, and word of mouth built up. It's a different dynamic now, but your film isn't over if it didn't get a good theatrical release. A lot of smaller films make little in theatrical, but that doesn't necessarily mean they will fail.

Eventually, everything's going to be digital and downloaded. I don't know how money will be made from that because if people can pirate things, they will. Anyone who has any computer expertise can download. My nephew downloads all the movies for free, and he's not the only one. That's why I'll starve in my old age. I don't know what you do about that. We could probably do with getting just a small percentage of this money because it has to be used as a way of financing movies. It has to replace the deals we used to make for DVDs. Until that becomes a viable source of financing, people will be in limbo.

In terms of the gloomy or not-so-gloomy future, I don't know how people will make money off films. But you can also make a film much more cheaply now than you ever could before, so there's some corrective in that. I'm sure even Martin Scorsese has trouble financing some films. Maybe Steven Spielberg can do whatever he wants, but the rest of us can't. After a point, you want a more ambitious budget, so you're always frustrated. But this is a particularly difficult period that we have to get through, and we have to wait until the dust settles. It's like wartime—bombs going off in the air—and out of that there may be great opportunities. But there's also the uncertainty, fear, and danger of not being able to get it done.

Melvin Van Peebles

There was a whole slew of independent black filmmakers like Oscar Micheaux and others very early on, and then they went out of business. I made a documentary called *Classified X* (1998) about them. *Sweet Sweetback's Baadasssss Song* (1971) changed everything because I reached a lot of people. Independent films had never made a penny before, for John Cassavetes,

Shirley Clarke, or others, but they made their films because they had axes to grind. I just wanted to talk to people.

I start a film when I get an idea, and then I decide if I can get away with making it. I know I can't get the money. That's not even a question. I had no partners, no distributors for *Confessions of an Ex-Doofas Itchy Footed Mutha* (2008). I produced and paid for it myself. If you have traveled enough and seen enough people, you know whether or not you can see the universality in it, and I'm technically and financially astute enough to do it myself. Most people don't have all those weapons. I just use my money or find incentives for people to help. I lie, cheat, swindle—but don't tell anyone.

Constantin Costa-Gavras

Getting finances depends on the project and so many things. It depends on the actors you have in the movie. It was not always easy, but it was not always difficult either. The fact is that the movies have been made. In France, there's no interference for economic reasons. Even in Hollywood, I made the films with my French crews and did post-production in Paris. It absolutely had to be that way or I wouldn't have done the movies. And of course, I had to have the final cut and final say on the script.

Andrew Bujalski

When I travel to international festivals, I always sit down with local film-makers. From the conversations I've had, it seems that some of them feel the same way about this government money they get as Americans feel about the studios, that it's equally impenetrable for some who are just starting out. It's a different obstacle, and much as the studios have led to stagnation, it's a different stagnation from what results from bureaucratic funding. But I'll take the average French movie over the average Hollywood movie.

7

Cinema, Art, and Reality

Cinema's apparent reflection of physical reality inclines it toward portraying our interactions within our environment. It has also led to a commonly held myth that cinema's continuous, two-dimensional images do not lie. Documentaries, in particular, often seem to offer views of our world as it really is; but, of course, a film is always constructed from whatever the filmmaker believes is happening in a particular situation. No one can avoid the influence of his or her personality or see beyond the limits of the self. Simply selecting a subject on which to focus and placing the camera so as to reveal a particular view as opposed to any other is an imposition of vision and taste that automatically molds the actual event into something bigger. This description applies, in a general way, to the process of creating any art. In the case of cinema, if the filmmaker could not manipulate the entire complex of images, spaces, sound, time, and causality, why would he or she be interested in making films?

Whether documentary or fiction, all films inevitably explore and transform reality through various means, including camera lenses and positions, lighting, locations, sound design, editing, and the presence of actors, whether professionals or nonprofessionals, who are living their lives but nonetheless aware of a camera's presence. A documentarian may not give a literally true image of reality, but he or she can at least try to lend reality, in the sense of truth, to an image. Moreover, it's clear in the case of certain films that fiction can be truer than documentary because a filmmaker's subjective perception of reality can be more interesting and honest than any attempt to capture an objective reality that does not exist.

In fact, the most successful films deliberately penetrate reality with a unique and artful force, rendering apparent reality less banal, so that the film's images and sounds become symbols of something behind it. Yet the ties between cinematic image and physical reality are so strong that a filmmaker who shows something that the viewer does not recognize as at least analogous to physical reality risks confusion rather than engagement. Literature, painting, photography, and theater seem freer to depart from recognizable reflections of physical reality, whereas the notion persists that cinema is supposed to be simpler and resemble our world as we know it. Films constructed from pure forms with little reference to our visual and aural experience are usually referred to as experimental, and they do not draw a mass audience.

Most of the filmmakers here practice reality-based cinema because the kind of cinema that attracts substantial audiences resists too much manipulation of physical forms, especially the living forms it depicts. Instead, they work with the material of raw reality by manipulating time, causality, and, to a lesser degree, space in order to serve a film's content or governing concept. Watching a story in real time would be like watching paint dry, although there are notable exceptions to this axiom, such as Chantal Akerman's *Jeanne Dielman, 23 Quai du Commerce, 1080 Bruxelles* (1975). So films usually attempt to reflect our psychological processing of time, narrative logic, and space in order to be truthful, if not strictly real.

Cinema can be practiced as an epic form in the sense of using classical dramatic elements of story and character. Yet viewers can be equally persuaded to suspend their disbelief by the diegesis—the film's entire created internal world—of modernist and postmodernist films, in which the cinematic style is more apparent and the classic rules of drama may not be followed. In fact, viewers conventionally suspend belief from the outset of any film, as a condition of watching it, whether its diegetic world is science fiction, fantasy, mimetic realism, or psychological realism, and in spite of how much the narrative, camera, and editing call attention to themselves and ignore the real-life limits of time, space, and continuity.

So what makes a film feel real or genuine? It comes down to our sense of its governing intention, whether the film's maker intends to corrupt us or save us. A film often strikes us as real when it was created out of a director's desire to be as honest as possible when confronting whatever he or she was writing, shooting, or editing. Everyone has his or her reasons

for making a film, as Jean Renoir famously said, which implies that a film-
maker must be as clear as possible about those reasons.

Films that are truthful and affect audiences on deep levels tend to
cultivate a sense of ambiguity that leaves space for the viewer's critical
participation. Rather than stuff their films into genre cubbyholes—"this" is a
comedy, and "that" is a melodrama, a thriller, or an action-adventure—and
stick to predictable, superficial plot lines, the filmmakers here prefer to
layer their films with contradictory elements, including an admixture of
genres, such as comedy with tragedy. Real life is certainly not as predictable
and easy as portrayed in conventional genre films because we feel different
emotions all the time. We elide from tears to laughter, from contentment
to fear; so, despite the widespread use of movies as vehicles of escape from
the complexity and anxiety of day-to-day life, why not show that complexity
in a film? The desire to forget while being entertained is legitimate, and
film entertainment can provide comfort and even happiness, however
fleeting. But it's also true that the stylistic unity of conventional genre
films often serves our most deluded illusions—that the boy and girl always
walk off into the sunset and live happily ever after or that the criminal is
always caught and brought to justice.

Many of the filmmakers here want to break these illusions. They know
that doing so can amplify the viewer's longing to return to the comfort
of illusions and thereby immerse the viewer more deeply in the film. At
the same time, these disruptions render more apparent the untruthful-
ness of simplistic approaches to human experience and make for more
exhilarating and emotionally and intellectually rewarding film experiences,
as the viewer's personal reality wells up to meet the film's reality.

The viewer may not be consciously aware of the filmmaker's initiating
concept, symbol, or archetype, but the filmmaker trusts that it will be
present in the film somehow and therefore sensed on some level. The more
questions a filmmaker raises in a film, the less constrained both filmmaker
and viewer feel to follow a single direction, and the more real—in the sense
of true—becomes the film's relationship to the complexity and uncertainty
of genuine human experience.

Céline Sciamma

To me, cinema is never reality. Even a Ken Loach movie is not reality.
That's why film is political and also art. When I was making *Water Lilies*

(2007), I always kept in mind that I was shooting in a real town, so that part was absolutely real, and I had a real approach to it. Yet it's also totally stylized, not obviously, but in the sense that I re-created that city and tried to assemble it in a beautiful and meaningful way. That's a total intervention on reality. Even a documentary that is edited is a lie that tells the truth, as Jean Cocteau said. And Picasso said it's a lie that tells the truth about lies.

Melvin Van Peebles

Years ago, someone asked a kid, "What do you like best, radio or television?" The kid said, "I like radio." "Why?" "The pictures are better." I thought that was profound, so I do the pictures I see in my head. If you're telling someone your stories about when you were a child or they're telling you their stories, I don't imagine them as a little girl or boy. I just see them smaller. So I thought it would be funny and nice for me to play myself at age fourteen in *Confessions of an Ex-Doofus Itchy Footed Mutha* (2008). Here I was playing myself at fourteen with this gray beard.

In another scene I have a great time tricking the audience, because if people like me, they usually try to go along. The guy is fighting with this blow-up plastic shark that didn't look much like a shark. "Jesus, this is a cheap film!" It is, but it's great. Once they realize that's it's not incompetence on your part, just the way you're telling the story, they get it and go right along.

Anne Le Ny

I don't believe in a realistic style as an absolute value, but the topic of *Those Who Remain* (2007) demanded this type of treatment, so I thought more about the realism of British directors. For that film, it was important to be realistic.

When the woman goes to the hospital every day to see her boyfriend, she wears the same jeans and shoes, but when the relationship with Bertrand starts and there's sexual tension, she begins to care a little more and dress carefully. And it was important that his apartment and car be affordable for him as a teacher. Sometimes I see a character on the screen who is supposed to be a schoolteacher, and I think, "Oh my god, they put a year's salary into the way she's dressed. I understand why this woman is so thin; she never eats because she has no money for food." My

concern was to try to be true. There isn't any single truth, of course, so some people can say it's too much, but at least it's my truth. Some might say there are too many scenes taking place in her car, but there was no reason why they should get out of the car to be in a more pleasant place. I even had an oncologist read the screenplay to check all the treatments, and I changed a number of things based on what he told me. Each time I face reality, I think it's so much more rich and interesting than whatever my imagination could have produced.

Serge Bozon

I love a lot of American film directors from the late forties and fifties, and even if *La France* (2007) is not a classical film and doesn't look at all like those movies, trying to be inspired by them gave me more freedom than trying to be inspired by Jean-Marie Straub or Robert Bresson because those modernists often have a subtractive methodology. They exclude many things—particular styles of dramaturgy, lighting, or acting—so that, little by little, you reach a rarified point where there's little margin for inspiration that differs from the limitations they've set. Classical cinema was not a subtractive form of cinema, so there's more room in which to move. From my point of view as a viewer who also writes about cinema, I find too many modernist clichés in the world of art movies. For example, there is this deep Michelangelo Antonionian influence in today's Asian movies—silent, sad, and about sexual loneliness in cities. That modernist influence flattens out and devitalizes things. I want to create films that have a certain energy and narrative vitality that distinguishes them from this contemplative style with long takes and deep focus.

Also, the auteur in modern cinema often lends an infective signature to the work. If you watch a Federico Fellini movie, you know the women are going to have big breasts—I'm oversimplifying, of course—but in classical cinema you never have these signatures. The work is more subtle and secretly hidden within the global structure of the movie—in the way the actors are directed and the lights are set, for example. But modern films are more often guided by the director's signature effect than by the possibility of the viewer being moved or enchanted or upset.

I didn't invent the war movie without battlefield scenes for *La France*. It's an American B movie tradition that arose because they didn't have money to get the tanks, planes, and everything else. So they had perhaps

twenty men alone in the wilderness, traveling from one point to another in order to save somebody or prepare for the landing of something. I like those movies very much, even if they were made for economic reasons. I think they are much more beautiful than big war movies by David Lean, like *The Longest Day* (1962), a very boring movie. These traveling war movies that almost infringe on the adventure genre are the best because you never can anticipate when there's going to be action or violence, where the enemy is, if or when he'll show up. There's something much freer in the way the narrative takes place in the movie. It's always the same: the small tribe of soldiers traveling around in the landscape, and we stay with them and almost never see anyone else. Even the enemies—like the Germans or the Japanese—are just shadowy figures moving from one place to another, but you never hear them speak.

My soldiers in *La France* occasionally stop and sing songs, apparently from a woman's point of view. I wanted them to be vulnerable because I was afraid the initial romantic feminine dynamic that launched the film would be completely overwhelmed by that masculine military trajectory. I wanted this feminine track to remain, but underneath, and the songs help this feminine dimension emerge. I wrote the songs quickly, and I used them to get humor into those scenes. I wanted to have the maximum change of registers in the movie, to be able to go from a war movie to something completely unexpected.

There are a lot of songs in classic U.S. movies of the forties and fifties, like the ones in *La France* that are never historically accurate. In Howard Hawks's *Rio Bravo* (1959) Ricky Nelson sings a song from the 1959 hit parade even though he's in an Old West jail. From my producer's view, the only reason I should insert historically inaccurate songs in my films would be so the film could make more money. But the songs in my movie are inspired not by today's popular French songs but by American and English songs of the mid-sixties. The French actors in my film who sing live in English are not professional singers, and they play homemade acoustic instruments. I thought this contrast between the initial sophisticated pop influence and the amateurish way of singing, playing, and recording would create a tension. The songs would emerge from the tension to surprise and startle, yet viewers would have the sense that they were not laid on top of the film but were somehow part of it.

Ivo Trajkov

Film seems close to reality, but I will not agree that it is reality in fact. As a consumer, I prefer literature, but I'm not able to write. Maybe that's why I make films. Film definitely creates a close relationship to reality, and it hits the audience more directly. To open a book by, say, Albert Camus, you have to have courage because of the myth that you have to be intellectual in order to understand him. So regular people won't open that book, not because they wouldn't understand, but because someone told them they couldn't. In a way, film looks so much easier to consume. So film is probably the easiest way to relate something important, because viewers expect the same things—a story, a protagonist who struggles, and he will succeed in the end while learning something, finding something, and so on. Yeah, fine. You can base any film on this structure, but all the way through you also can say important things, which is fine. Maybe that's why cinema is so powerful. I don't know, though; these days, probably the most powerful thing is the Internet.

Bette Gordon

A truthful performance happens when the actor reaches deep down in order to stay true to something that feels raw and real. But I teach my students that film is a construction. A film or a painting gets people to see the world in a different way than they see reality. Film is a representation.

The surrealists believed film was the closest experience you could get to surrealism because time and space are so altered and constructed. So Luis Buñuel, a favorite director of mine, never overarched or reached into the unbelievable but always stayed close to the believable in order to get to the surreal world he was so good at creating.

In a way, films with the Aristotelian structure of drama are the most satisfying. There's an arc, a rise and fall and dénouement, and that sense of learning something. Films that deviate from that can be interesting, even when they don't resolve and leave you open at the end, left with the questions. As we all know, sometimes the questions are more important than the answers.

Teona Strugar Mitevska

With cinema, we create another reality, a sort of a parallel reality to what and where we are. There is cinema that copies reality exactly—these reality

shows—but I can speak only for myself and my films, where I create another reality that I give the viewer: "This is my world, come live in it." Yes, it is about reality, but it's also about the experience of reality and offering whatever it is through beauty, emotion, love.

And what is reality? Yes, there's physical reality, but imagination is also reality—dreaming and expressing yourself. With cinema we create another reality, a sort of a parallel reality to what and where we are.

With each film, I like to see how far I can go in different ways. I think also it's a matter of the times as well. There are certain times when people are ready to accept the experimental and imaginative and other times when the audience wants reality. So I'm not quite sure of where the line is, but of one thing I am certain: so long as any experimental material is connected on an emotional level to a character, it can work. As long as the audience connects to the characters or understands them or enters the world you are trying to present, you can serve them anything because it is part of a world they've already accepted.

We can talk about content and message, but for me, form is part of the content. And of course, mise-en-scène, for example, the way I chose to present the town of Veles in *I Am from Titov Veles* (2007). It's about detailed work, and it takes me six months minimum to prepare a film visually after the script is ready. For this film, nothing was left to chance; everything was there for a reason—every color, every movement of character, lighting. Everything served the emotions of Afrodita and her sisters. It was like building a cathedral piece by piece. I wanted to create a piece of art where each scene could stand on its own, meaning each scene could be a painting on its own, as well as exist within all the creation and the construction around it.

Catherine Breillat

I'm not a realist, not at all, but I film the truth. The truth lies within, it's interior. For example, when Bluebeard's bride lifts the key up to her face, it's shot in close-up, and that's a surreal, expressionist shot. I feel deeply inspired by silent cinema. It's not realism. When we were shooting that scene, I got angry with the actress: "Slow down, much slower!" Because when you're shooting a scene like that in close-up, you have to do it far slower than you normally would.

Charles Burnett

The distinction between documentary and feature films is phony; you try to make it look like a documentary, but in so many ways it isn't. There are a lot of reenactments and interpretations made in editing and selection of the subject. For me, a documentary involves a lot of research that is more or less external, whereas a fiction film is based on some reality, but it's mine, in terms of my imagination. I can put the pieces together and not be handcuffed to a chronology of events that's separate from my narrative. There are differences between them, but one good thing about UCLA Film School was that they said, "Here's a camera; go out and make a film." They never made a clear distinction or cared about a distinction. It's really about whether the subject requires a documentary or a fiction film. *Namibia: The Struggle for Liberation* (2007) is based on actual events, but we gave voice to the people, and, rather than use a narration, we dramatized it. To some extent it was done like a documentary with reenactments. When we did *Nat Turner: A Troublesome Property* (2003), we had to turn all this material into a narrative. So to make it interesting we reenacted some of the events, and the film is a hybrid. Sometimes it's not black and white. I find when I'm doing a documentary, I wish it were a fiction film, and when I'm doing a fiction film, I wish it were a documentary.

Olivier Assayas

Movies are about time and space. There's basically not much more at work, because that's what it boils down to. Time is our experience of life, the world, how society changes, how we change, and the world in constant mutation. So art is about capturing some of that process.

Movies deal with observing the world, awareness of the world, and awareness of its changes. In that sense I'm an anti-cinephile, because I believe that movies as an art should be about reproducing perception, our experience of the world, not reproducing whatever we have experienced by watching other movies. Art and modern filmmaking are about dealing with the complexity of the world, about the contradictions—there's not good and bad—and even reality is hard to grasp. We struggle with this, and, ultimately, films are the best way we have found to grab the terms of the problem, never the answer, never the solution, because I don't think

movies have answers. Movies are about being able to formulate questions and get as close, as right as possible, to formulating the elements that put the question up there on-screen.

To make movies, you have to reinvent cinema. I think every filmmaker reinvents cinema, reinvents a way of looking at the world and of using the medium, and adapts it to whoever he is, with his qualities and shortcomings. You somehow have to be extremely pragmatic about it, and you end up twisting the medium, making it evolve within your work in ways that basically deal with whatever person you are, whatever are your dreams, ambitions, and obsessions, good and bad.

That's why style is everything, but it's not really acknowledged in modern film theory. I think the ethics of your cinematic writing, the morals and the way they allow you to deal with the visible and invisible, is ultimately the most authentic thing that cinema is able to touch and grab. That's why I'm ultimately indifferent to movies that just happen on the surface. Movies like that are like academic painting in that they believe that the truth of the artwork is in its subject: "I'm dealing with this issue; I'm representing this issue, so this is what my film is about." The problem is, movies are much more complex than that. And audiences are much smarter than that. Ultimately, movies are about what is behind the surface, not about the surface itself. If you're happy with what's happening on the surface, you're getting it all wrong, because what is basically going on is the mystery of fiction and art, and it's something that has to be absorbed and explored by your audience.

I have this deep belief that everything you do in cinema, in one way or another, has to be unfinished, in the sense that there has to be an open space for your audience to finish the sentence, to finish the scene, to invest the experience of watching the film with their own experiences of the world, their own experiences of the emotions that are going on. This is true of both documentary and fiction film. For example, the seminal documentarian Jean Rouch is a great artist, and he made amazing movies that no one else could have made. Give someone else the same camera and sound man and put him in the same situation, and he would not make the same movies Jean Rouch made because documentaries are about the eye of the documentarian, the eye of the filmmaker. Documentaries reconstruct and restructure reality in the same way that fiction does.

Jia Zhangke

The change from my first to second film is in the narratives. When I first wrote *Platform* (2000), I had worked out characters and continuity, and it was clear how the plot would evolve. For example, one female performer got together with an old love in her hometown. The script explained the sequence of events and motivations for that clearly. But ten years after shooting the film, I've come to realize there is something wrong with this way of telling the story. I thought about a neighbor who was in junior high school. Once, I saw her at about ten in the morning on the street, and I realized that she wasn't in school. A few days later, I saw her standing in the post office in uniform. By observing all this, I knew she had quit school and had a job in the post office. Later on, I saw her biking on the street with a boy following her. Then I knew she was in love or someone was after her. Not long after that, I heard firecrackers at my neighbor's home, and I realized that she had gotten married. The thing is, I had no idea why she quit school, why she got a job in the post office, why she fell in love with this boy, and why she got married. But by not being clear about everything, by not saying everything you can say, you give the audience more room for their imaginations to come up with their own conclusions.

Most of my films capture the reality of China right now, but there's no transformation in using realism just to reflect reality as it is. As filmmakers, we have to bring an aesthetic sense to reality, so it's not just reflecting reality but using the filmmaking process and aesthetics to somehow capture reality. It's a representation of aesthetic feelings about reality. There are two important considerations. At the core of it, as a filmmaker you have to create an approach and an angle from which to examine social reality. That's first, but it's not enough. Unlike a journalist or documentarian, we filmmakers have a particular task, which is to cultivate a sense of aesthetics, to prepare ourselves to tell a story and reflect reality in a unique way. I think that is especially important within my particular cultural context.

I wanted to make *24 Hour City* (2009) in order to reflect on the experience of China's transition into a market economy and the impact it has on workers. I actually started with a documentary and interviews, but the more I interviewed, the more I realized there should also be a component of fictional characters that could reflect on this particular era. That's how I conceptualized the structure of the movie. I cast actors to play "real" actors

within the same format that I used for the real workers in the interviews. I used this type of narrative because that's how I see history. History is a mix of reality and imagination, and by using these two different types of formats, I somehow implied that this is how I see history. I also needed the fictional component to tell the stories of the thirty people I actually interviewed. Without these fictional characters, I couldn't get out all that information. For example, the character played by Joan Chen is actually a concentrated character that combines stories from all the middle-aged female workers I'd interviewed. If you look back at classical novels in Chinese history, they use fictional structures and characters to create the imagination and history of the time. I used fictional characters to build a bridge between reality and imagination.

The biggest decision was to make language, narration, the focus of the movie. A lot of mainstream movies tend to rely on action and movement too much. When you're dealing with the subject of memories and recollection of memories, language should play an important role. This is also a movie about trusting—trusting the narration, trusting the language people use when they're recollecting memories.

On the other hand, the different shots and media I used in this movie are a way to show that memory is complicated, and diversity is necessary to represent that. So even though the focus is language itself, the portrait shots are a great way to make up for language's limitations. When you look at these long takes of portrait shots, you can imagine or empathize with the person's process of recalling his or her painful or lovely memories. I used other elements as well, such as poetry, music, and the black screens, and that's just a way to showcase the freedom of film's vocabulary and how with this complex and diverse vocabulary I can create a complex of memories. I also invoked the tradition of Sergei Eisenstein—the feeling of montage but not the technique of montage. Within these different techniques, shots, and frames, I wanted to invoke the collective mentality of the past with a movie about individual stories.

Lucrecia Martel

When I talk about the grammar of cinema, I find it interesting how close narrative elements are to the way memory works, or at least, to the way my memory works—what I've observed happens to me. Memory is an emotional narrative process, so when people remember something, they

don't remember any transitional elements, they don't remember estab-
lishing shots. They just remember the issue itself. So in the type of films
I make, I believe I have no need to explain where characters come from,
where they're going, or how time flows. I just need to convey what they're
feeling. I know there are other styles of filmmaking that require those other
devices, but mine does not.

There's a medical aspect in my filmmaking in that I try to get as close
as possible to my subject in an almost microscopic way and from that draw
more general reflections. The set of a film can be similar to an office where
x-rays or CAT scans are made of the body. All these technical aspects allow
us to come closer and closer to discovering and putting out into the world
the mystery of something that is by nature secret and mysterious, and that's
the mind itself. So both film and medicine use technical devices in order to
bring into the light something that deep down is still mysterious.

Mia Hansen-Love

I don't like overly emphatic films, and a heavy style has to do with emphasis.
There is no message or moral, but I would like viewers to have the feeling
that they have experienced something as real as their real lives. I want
the sense of infinity—that sounds pretentious, but that's what I'm looking
for—because in real life you have a feeling of mystery, of open-endedness,
the sense that everything can be questioned. I make films because I have
this sense of the mystery of life, so I want people to get this same feeling
when they see my films.

All Is Forgiven (2007) may initially seem to be a literary film because
writing and words are so important in it. Writing is important in my life
and relationship to art. Also, the lead character is a poet, and in the end,
when he dies, all he leaves the daughter is a poem. So writing is important,
not only to the words but also to the question of one's relationship to the
world, to discovering your vision of the world. Writing is always about how
you describe the world.

One of the many other subjects of the film is the passing of time. When
I first wrote it, I would say it was about the passing of time, which is a
more common subject in novels. In general, films today describe a short
period of time, whereas classic American films often followed a character
until he died. Today that's unusual, but it's never been at all unusual in
novels, where years pass as you follow an entire life. I didn't want to make

a film that looked literary, but my uncle's story was the inspiration. I didn't choose it; it was the story I had to tell. Of course, now I describe the film differently, because you always change the way you talk about a film.

Gerardo Naranjo

Simply composing the frame and leaving out things is an aesthetic decision and a corruption of purity. It's completely partial and a complete manipulation, so I don't believe it's possible to be impartial in any way. Noel Burge said that the important part of the frame is what is left out, so I like to fragment a lot. Since the greatest painters, fragmentation has been used as a way to provoke imagination, and if we're conscious of all the spaces of the frame—Abbas Kiarostami does it better than anybody—if we are conscious of the right, left, up, down, and behind spaces and of wherever the spectator is, then we can use the off-frame space in the best way, and imaginations start to work. Things take on more value when we don't see them fully, when the mind works. There are two sides to this—imagination and memory. Mexican filmmaker Carlos Reygadas Castillo says that if you look at something for enough time, you start removing whatever circumstances surround that object and begin to see its true nature, and then you connect through your senses to whatever it truly is. This is one of the few gifts that only cinema has—to resemble, to provoke feelings in you, to provoke a memory, for instance, of sitting under a table as a child. So if you shoot under a table and stay there long enough, it takes viewers to a moment when they were young and sitting under a table. If your film is done properly, it's even possible to allow the viewer to make up his or her own film.

Jerzy Skolimowski

I use physical reality, obviously, but I always work to give it more meaning. If the film worked only on that physical level, it would be too pedestrian, so I always try to create something significant, not obvious, but something. In the third or fourth sequence of *Four Nights with Anna* (2008), when he's walking with the axe, I have guys pushing a car in the background. It doesn't mean much, but the fact that they are kind of awkward and against that background signifies something beyond words. Again that's the power of film: it gives you the image, and you don't interpret it exactly with words. It's there to give atmosphere and allude to something you don't name precisely with words.

Brillante Mendoza

My greatest fulfillment as a filmmaker is when people ask, "Was there any script? Are these actors? How did they do it?" I feel fulfilled deep in my heart because I made them believe that everything was real and there was no setup at all. But there was. When you work hard and people don't recognize the boundaries any more between documentary and fiction, you are so fulfilled as a director.

The aesthetic of my films tries to capture physical reality and maximize the truthfulness and honesty of human emotions. For me, the only mediating factors in telling the truth are the camera and the actors. Otherwise, everything you see is physical truth that is transformed by film. I derive my concepts from real stories I call "found stories," and I shoot on real locations, "found locations." I call this method or style "real time." The best way to capture audience interest is to be honest with your film.

I know exactly what I want. When I say I want this kind of red, they know this is the kind of red. I'm very particular, even with the texture of the clothes, the cut of the dress—I'm particular with everything I want to show, each detail. I'll ask the actors not to cut their nails for a week before the shoot or not to shampoo their hair for four days, because I don't want to see glossy, clean hair. For *Serbis* (2008), I had all the actors tan, because I wanted their skin to be that kind of brown color, and we dyed the mother's hair several times to achieve that particular white. I didn't want it to look like it was dyed for the movie but look real.

This is because mise-en-scène is crucial. I've asked some journalists and critics who review my films if they've been to Asia or any part of Asia because some wouldn't understand the Asian culture, especially where I come from, and the Third World sensibility and economy. If you understand it, you understand my films and where I am coming from. This is why there's a lot of chaos in *Serbis*, a bunch of seemingly small stories and a lot else—noise and dirt. The moral issues of the film I'm trying to express are represented not only by this family but also by the crumbling decay of their cinema house. You have to involve the audience so that they're part of the film, not just watching the film, but involved in the situation. At the end of *Serbis* I burn the celluloid because that in itself is an experience, which makes the film a three-dimensional rather than a two-dimensional experience. Watching a film is usually a two-dimensional

experience; you're in the audience and you watch a story. But my film is like watching a real-life story. So it's important to draw the audience into the chaos of that film.

Because of *Serbis*'s subject, the rent boys, and everything else, some journalists asked, "What will you not show in a film?" I answered, "I will show anything I believe in as truthfully as I can. I'm not going to stop myself from showing anything I really believe in." It was assumed by everyone that in the sex scene there was real penetration. The actors knew how I work, and if they were on a different level of their profession, they probably would have had real sex. But since this was the girl's first film and she's from a conservative family, she had done enough, so there is no penetration. But I wanted people to believe there was actual sexual intercourse, and it was so realistic that people believe that's what happened. That was one reason the film was controversial in Cannes over the issue of exploitation. They thought, "Why do you have to do this?" But I knew I did the right thing because I made them believe it. I don't even think of it as an issue. I treat such a scene the same way I would treat an ordinary scene, say, of a boy eating. Why would I treat it differently?

Pablo Larrain

Cinema doesn't necessarily have to assume that a film must be close to reality because that's a documentary. You have to assume that you must find your own poetic way to get close to reality, because a film is always an interpretation of reality, whether you like it or not, even if you use non-professional actors and real places, as do many filmmakers, like Robert Bresson and Carlos Reygadas Castillo. Many people don't use actors and try to be close to reality, but they're also manipulating everything. So don't tell me that's more realistic than a film made with actors on a set.

You have to try to create something that could be real for the audience, and if that reality handles human situations we all feel close to, maybe we can tolerate and understand our own reality through something that is not real. It's as if film shows something not real, but it is a way to get more reality. I think about this when people say "*Tony Manero* is horrible" in terms of the world it shows. That's so because you think about it and feel its subject. So the film achieves something real, even though we're showing something not real. The film achieves something as strong as reality and makes you feel that its reality is strong and violent.

So, like *Tony Manero* or not, most people who have seen it pay attention to it and feel it's close to them.

Courtney Hunt

You have to work so your production designer doesn't make things look too pretty. There is a feeling that things have to look good, and when somebody "does a room," they're going the "do the room" and put all the details in there. I had a wonderful production designer for *Frozen River* (2008), and we got a trailer that was in perfect shape, a wreck. We paid the kids who actually lived there to move out, and we just moved in. When my production designer went in, I kept saying, "No, don't touch it. Leave it alone. Leave it alone." It wasn't too hard to make it look awful in that particular part of the world, but it was important to keep it looking awful. At one point, this gorgeous light streamed in and I was saying, "Curtains! Get rid of that light, put the curtains down!"

This was important for me, and Melissa Leo really got it. She didn't have even skin tone, and there were sadness and lines on her face. These are real things that happen in the world; all of us have lines on our faces or will have lines on our faces. She was committed to the truth of her character in that moment and couldn't give a crap about whether or not she would be sufficiently luminous. The truth is, her performance is luminous, and so is her face.

Tomas Alfredson

It's interesting to create a scene that describes boredom, but making a boring scene is completely different. You want to make a scene that gives out the feeling of boredom by playing with those elements film uses to affect people. For instance, in making a scary film, it's easy to make an audience feel bad. You just show upsetting images. But to get the audience to become scared through their own imaginations is different and much harder.

This is connected to the relationship between film and physical reality because *Let the Right One In* (2008) is not reality at all from a filmmaker's point of view. It contains a lot of visual effects that we worked hard to look not like visual effects or obvious visual effects. Giving the film a strong taste of reality is a lot of work, and it's interesting to explore what gives you that realistic feeling. You cannot just put up a camera in front

of reality, and then the scene will be realistic. You have to pinpoint those elements that give you that flavor, the inner visions of reality.

Jean-Marie Téno

When I do a shot, I always come to the same questions: Where do I put my camera? What do I want people to do? And then, when I finish capturing all the shots, I need to organize them in a certain way, work on my sound track and with musicians to give some space for emotions. When you go back to the first cinéma vérité, the nouvelle vague films, for instance, when they started taking the camera outside to shoot, that was cinema, and yet there was mise-en-scène. And when I ask someone to redo what he normally does every day, I'm not capturing exactly what he's doing, because he's redoing it, playing his role, and sometimes it's even harder for him, like the djembe player in *Sacred Places* (2009) who was making his djembe. I asked if I could film, and, of course, when there's a camera filming, nobody acts exactly the same.

When I make a documentary film, I'm not showing reality. I'm showing reality through the filter of my own eyes. When you have television reportage, for instance, they capture the reality and give it back, or maybe just in the way they capture reality; but they may have a point of view and make their point from that reality. But when I capture reality, I create a narration on that reality, and I give it a completely different meaning. It's a question of point of view. In my films, I always keep saying "I." It's not an "I," where I'm saying everyone is me, Jean-Marie Téno. I'm sure if others were filming the same thing, they wouldn't come to the same conclusions. It's really a personal journey toward these people that I'm part of, and it's a single vision that can be complemented by various other visions. So a documentary, for me, is almost like being an artist. When someone writes an essay, it's not reality. The whole notion of reality is so complex.

Whether fiction or documentary, both are films, both are visions of the people behind them who had something to convey. The difference is that someone can create the whole story and have actors enact some of the elements, and instead I capture something. Sometimes I have reenactments, but most of the time I just capture the living image or have someone playing his own life on the screen. From where I'm standing, we are doing exactly the same thing as fiction. I made one fiction film a long

time ago, but the idea was to have fiction that looks almost like documentary. When the first African films came out, the West thought, "These films are almost documentaries." And yet they were not documentaries. People were simply being shown a reality they were not used to seeing.

Jihan El-Tahri

Often people say about my films, "Oh, it's so factual, so objective." I totally disagree. There's nothing objective about what I do. I choose the subject, I choose who to interview, what to cut out, the tone I give it—everything about my films is subjective. I do stick to facts as tools in order to express my own subjectivity, and that's the message. I start with a question, and I think that documentaries are usually answers to questions. The film shows my process of answering the question and the answer I come up with or lead the viewer to. If someone else filmed the same exact subject, his process of answering, his film would be entirely different. So it's very subjective.

Documentaries are attempting more and more to break the barrier between fiction and documentary, so more often than not these days, a film with commentary and talking heads is quite rare. Mathieu Kassovitz's *La haine* (*The Hate*, 1995) is interesting because it plays with both genres. That's one reason my aesthetic choice is always to use commentary and talking heads. A lot of people criticize that choice, and that's fine. But I see documentary and fiction as different forms of expression, even though they're both films.

Özcan Alper

No matter how real a film looks, I think it creates its own reality, and mise-en-scène is the means of creating that reality. When I was constructing *Autumn* (2008), I always thought of the script in its relation to other arts, like painting or poetry, but not as an assemblage of other arts, as a whole. A painter who saw the film in Israel asked if I paint. I'm not talented in that area. But I tried to create in the film a melancholic kind of painting through a psychological sense of time and the lead character's world. So in a way, the context determined the poem, the film. I would say my film is nurtured by other arts, especially poetry, because they have similar dramatic structures. I used them as inspiration points, but I don't see my film as bringing other arts together.

Mary Harron

All three of my feature films were historically based, particularly *I Shot Andy Warhol* (1996) and *The Notorious Bettie Page* (2005). They were rooted in actual events. I'm historically minded and came out of documentary, so I like researching, and I do a lot of it when I'm writing a script as well. I don't like Hollywood movies that treat historical subjects by filling them with essentially modern people—women with bold modern makeup who talk about sex in Victorian England in a completely modern way, who are feminists in a manner that's completely ludicrous, or people who are racially tolerant in a way that would be inconceivable at that time. It's completely ahistorical.

Obviously, all documentary is a construction on its own, and I guess fictional films have the advantage of being obviously made up and an interpretation. With documentary it's a bit subtler. On the other hand, with documentary you are capturing the messiness of our lives.

Ivo Trajkov

What I like about filmmaking is that you can still understand something from the background. You show a character speaking, but what you're really relating is something in the background of the shot, what you can't see or hear but is there and transforms the audience's emotion. As a filmmaker, you have tools to express this and create the audience's experience. So, one of cinema's unique tools is definitely the mise-en-scène.

I grew up on Eastern European films from Czechoslovakia, Hungary, Russia—Miklós Jancsó and Andrei Tarkovsky—and they all play with the mise-en-scène. It's one of their most powerful tools, and I learned that from them. Mise-en-scène expresses the uniqueness of cinema that distinguishes it from the other arts. For example, the author of the novel *The Great Water* could express what he wanted with 30 kids. But we had 250 kids for the film (2004) because the film gets power from that, and you need to deal with the mise-en-scène, the huge scenes with a lot of kids inside the frame. We made it cinematic. You can express the same things with 30 kids in the book because you are using different tools. Adapting that book to film was extraordinarily tough because the novel is specific, with a specific structure, and it's not at all linear. So that's why we multiplied the number of the kids.

Of course, we needed a huge location, so we created the entire location space from three different locations in different parts of Macedonia. The lake is in one place, the gate and the exterior courtyard are somewhere else, and the factory interiors are in a third location. We needed that huge location to get power, and we created one film space from those different places.

Shamim Sarif

I don't like things that make themselves obvious. If you can see the film-making and the look and feel too much, things draw attention to themselves and away from the story and the characters, unless it's a conscious decision, as in a Wong Kar Wai film, a poetic movement where mise-en-scène is everything. Again, that's there for a reason. But oftentimes it intrudes. Filmmaking is a tough business. People are trying to get noticed, and if they do something that they think will show off their direction, they feel they're going to be noticed.

Ari Folman

We had to make decisions about how much detail to include in the character animations for every shot of the interviewees for *Waltz with Bashir* (2008). My main concern was that viewers should feel attached to the characters even though they were drawn. The more flat they would have been, the less you would feel attached to them, so we needed as many details as we could have, meaning everything—contours, wrinkles, shades—that gives your face the sensibility of what you are.

I thought from the beginning that people would go with the language of the film, that they wouldn't mind that the characters were drawn. The most common remark I hear is, "After ten minutes I forgot the characters were animated." I take that as a compliment.

I don't know why people are so obsessed with why this film was done in animation. This is the film. Would you ask the people who made *Toy Story* (John Lasseter, 1995) why it's an animated film? But *Bashir* would also work as a book, because when you read a book, building the characters and everything else is up to you. You create them in your mind and give them shape and color. You even read the names as you want to read them, and there is something in this kind of animation that also creates the gap

between the real person and the drawing that leaves room for your imagination. *Waltz with Bashir* was done to leave room for your imagination to complete all the other details.

And why is drawing less real than a camera that filters everything you film? This is a philosophical question. But is the camera's image that you see on the screen any more real? It's made of pixels. And every decision the director makes on the set, even when the film pretends to be a real documentary, is completely subjective. Where he puts the camera, the lights, and everything else is maneuvered and manipulated by the craft of filmmaking. So what's the difference between filming with lights and camera in a particular place and drawing a character?

8

The Viewer

Like jazz or pop music, cinema is a popular art form meant to communicate with many people, often at once. Just as a film's illusion is a complicated thing, made up of various and sundry parts that somehow draw together into an integrated whole, the audience is a composite that ranges from the wide-eyed and rapt to the distracted and preoccupied.

So some films are like roller-coasters, in that the director attempts to mold viewers into a single-minded audience and takes that audience for a ride, controlling its experience in whichever way he or she desires. That's fair enough. After all, viewers paid to climb onboard and know more or less what to expect. Although the filmmakers here avoid roller-coaster film-making that forces viewers into single-track, superficial, reflexive reactions to their films, in a sense, all is fair in love and cinema, and a filmmaker should be able to use any cinematic tool to his or her advantage.

Genre films—westerns, thrillers, romantic comedies, and horror films—might be outrageous and stretch the limits of credulity, but their finest examples are venerated by such masterful filmmakers as Robert Rodriguez and Quentin Tarantino. Orson Welles's *Citizen Kane* (1941), one of the great films of American cinema, leads the viewer around by a ring in the nose, but the viewer is not aware of being manipulated. And that's the point. The viewer should not feel manipulated, of being made to wheel this way and that as a single body in response to the film's messages of fear, longing, sadness, or delight. So even a roller-coaster film can provoke the viewer to sift out any deeper meanings. If the viewer is enticed with familiar film structures and elements, the film can take off in unexpected

and surprising directions, not all of which have to be immediately clear. In fact, some filmmakers prefer involving viewers through their emotions, because intellectual understanding can result from emotional experience, even if the intellectual information arrives long after the viewer saw the film or fails to arrive at all.

This often is the case in real life: we glimpse situations that elicit our emotions even when we don't fully understand what's going on. The experience can provoke one person to make up some story about what's going on and what will happen in the future, whereas others may pass by the same scene, note what is happening, react briefly, and promptly forget it. Still others may not be moved at all.

Many films, even great films, draw the same range of responses. And the best films leave room for viewers to relate individually, even to the point of questioning their lives or refusing to engage in the film at all because they may not be prepared for what they believe will be that filmic experience. In creating a film that affects people as deeply or almost as deeply as their real lives—that is, in succeeding—a filmmaker inevitably alienates part of the audience. Of course, this is true of all art—music, painting, sculpture, architecture, mathematics, literature, and poetry.

So, where does the film take place—in the mind of the viewer or the mind of the filmmaker? The only way to determine how much to tell or not to tell viewers and how to say it is to put one's self in their place. So the filmmaker is the first viewer, and it could be said that filmmakers wind up making films for themselves, sometimes with help from colleagues and audiences at test screenings. They can only hope that viewers' tastes will correspond to their own. And that's just a hope, after all, and one that is not shared by all filmmakers, because if a film is truly worthwhile, it continues its creative work by inspiring viewers to draw from the film whatever they may, rather than whatever someone intended, even if that someone is its creator. A film's final maker is the audience, and the finer the film, the more it opens itself to all kinds of readings.

This is why the filmmakers here believe that art filmmakers should work deeply and, to a degree, ambiguously, despite mass interest in conventional roller-coaster cinema. This issue also relates to the reason most filmmakers prefer that audiences see their films in movie theaters, where they are surrounded by sound and where images loom above them on a giant screen, as opposed to what some view as the worst-case scenario,

viewing films on a handheld device. Although these filmmakers recognize that DVDs, cable and pay-per-view television, computers, and mobile devices allow more people than ever before to see their films and that new ways of creating material for these formats are imminent, they want us to remember that one of the most delightful conditions of watching movies is to forget where we are, even that we're seeing images on a screen. The ideal cinematic experience is like a handshake, an agreement to allow the movie to do something to us, and we comply more readily with that illusion in a darkened theater where we also experience the communal sense of an involving, bigger-than-life event that's working on everyone at the same time.

Lucia Puenzo

The story of XXY (2007) was at the extreme of the coming-of-age love story, the most atypical imaginable. I liked this idea because I also thought that young people around the world would identify with the film. They don't forget that one of the characters is an intersexual and that the other one is discovering his sexuality, but they can relate to this moment in life where everyone is lost. Adolescence is always a powerful moment in our lives, when we're becoming individuals and cutting ties with our parents. I also think we're open-minded at that age.

Since I hate films that say too much, that are blatant and give too much information, I took an opposite position in XXY. This was my first film, and I was trying to find where I want to stand; so even when we were rehearsing, I told everyone over and over that I wanted this to be a silent film. Even when we improvised, I stopped the actors from saying one word more than necessary. I just don't like films that speak too much about their subjects, so I worked to make XXY a silent film with not one word of extra information. But when I was editing, I often said, "I'm lacking this information or I would have liked to show a bit more of this." I thought, "Maybe I went a bit too far with that." But it is all part of learning the limits. With my second film, I'm a bit more relaxed.

Another discovery was what viewers drew from the film. When I went to festival screenings of XXY all over the world, I had expectations of how viewers would understand it, but when I talked with these people, they had seen things I had never seen. That's the final part—when you meet people and give them that freedom to see your film the way they want. I

hate books and films that give you answers all the time, because they are telling you how you have to read that book and how you have to see that film. When you leave a film with questions and viewers have to find their own answers, it's a richer experience.

Céline Sciamma

Determining how much to tell the viewer and figuring out how much he or she is capable of inferring is mostly done in the writing. In *Water Lilies* (2007), I tried to establish dramaturgy in the writing, such as the sequence where the girl steals the necklace, gives it to the boy, and then the boy gives it to another girl—one of those classic "three times" events. I always think the audience is clever, and I rely on that.

I made the film for the largest audience possible in its tone and humor, and I had a conscious strategy regarding its structure. I wanted to begin with the three characters, each physically different so the viewer could identify them quickly—the blond cheerleader captain, the chubby friend, and so on—so the viewer would think, "The three-girls archetype—yeah, I know, I've seen that movie." Then I wrote in the synchronized swimming—that's the journey. So the viewers are comfortable and embrace that journey willingly. Then I blew the archetypes by making the film more complex and taking the viewers in a radically different direction, but they still go along. That was the strategy I had in mind when I was writing—beginning the movie in a pop way and then drifting it away from that. I took a chance.

I like the fact that, especially with the Internet, more people see movies. It's wonderful, and you can't say that things were better before. It's not that I'm an optimist, but anything that allows more people to see art can't be bad. Yes, it can have side effects on the industry, on the way the work is shown, and these are not the ideal viewing conditions. But the people who download the most music from the Internet are also the people who buy the most CDs. So everything that educates the viewer's way of experiencing films is good. I'm not going to complain if someone in China can download my movie for free, because that's a good thing.

Of course, you can get totally anxious about the way the movie is going to be shown, but we have to find a balance. People were afraid television would kill the movie theaters, and it hasn't. You have to find new ways, and the point is that people will see your work. Some people are going to make great movies for these new venues because filmmakers are going to

be thinking about a specific venue. To me, the best thing that's happened in visual fiction worldwide in the past ten years is HBO and other cable stations with programs like *Six Feet Under* and *The Wire*. They were created for that television format, for people watching at home in their chairs while eating. The people who made those programs thought about all that, so it's an amazing format that has brought such different emotions and so much art to what's happening right now. So, films on mobile phones? As long as an artist thinks about that format and brings emotions—why not?

Serge Bozon

My producer thought I was crazy because, perhaps two minutes after the orphan's death in *La France* (2007), an actor sings comical lyrics, like "I would like Poland to invade France." The producer said that the audience cannot be moved by the death of the orphan if two minutes later someone is singing those lyrics. But I think placing a comical scene after a tragic one does not dilute the emotion that arose with the tragedy or render the comical pleasure useless. For me, one of the main faults of these neo-Antonionian films in contemporary modern cinema is the absence of a variety of emotions. The neo-Antonionians often have this solemn element, never any humor, never space for eccentric monologues that go off, like in Phillipe Garrel's films.

Mia Hansen-Love

You have to tell the viewer as little as possible, explain as little as possible. That's important. But you also have to know exactly what you want to say to the public in your film. I've said there is no message in *All Is Forgiven* (2007), that I just wanted to tell a story as truthfully as possible. But something balances that out. I grew up with this idea that the purpose of art is to trust and give hope. At the same time, I grew up with another, equally important idea, which is that art has to be lucid and tell the truth even if this truth is despairing. So the question for me is how to be lucid and truthful, to show this despair that life can give you and, at the same time, provide confidence and hope. So there is no message, but I tried to do both things in my film, and I work from this obsession.

In fact, I wanted to tell this story because of my cousin. If she were not so generous a spirit, I wouldn't have told the story of *All Is Forgiven*. She's a good example of how one can take on difficult burdens and still be a good

person. When I introduced the film in France, some people asked why that character was so friendly, because she would not have been that way in real life. Many young girls might have been angry and would not have forgiven, but what interested me is not girls in general but this precise girl. I wanted to show this girl because she's so interesting and has this grace. We don't have to show all people.

I wrote another film after *All Is Forgiven,* a different story but also sad and with many things in common with this one, as well as this double question of being truthful to life and at the same time offering hope. I want to show people who have a special grace—that's my purpose in doing films. Life is short, we have little time, and I don't want to spend time filming people I don't like. I prefer filming people I find graceful and inspiring.

Scott Hicks

I don't have an issue with someone watching my film on his or her iPod. You just have to accept that the film you made with one medium in mind is going to be seen in all sorts of other media. I've long resigned myself to the fact that when your film ends up on an aircraft, for example, that's basically the death of it, because it's reduced to the size of a matchbox. It's been reformatted and re-versioned—it's lost its meaning. My heart sinks when people tell me, "I saw your film on the plane!" I think, "Oh dear, what a shame." But what can you do? It's part of the business. Because of Directors Guild of America regulations I am consulted before significant changes are made to some films. But one studio wanted to cut one of my films to eighty minutes—remove half an hour—for some particular version. I wondered, "What's the point? It's not going to make any sense." It's a sale, but it makes a mockery of everybody's work, from the writer to the editor to the cinematographer especially.

I don't mind re-versioning a film for broadcast needs, if it doesn't radically alter the shape or structure or content. In fact, it's interesting when you look at something you thought you couldn't reduce or tell more succinctly, and then you find you could have done that if you'd had more time to contemplate it.

Catherine Breillat

I shot *Bluebeard* (2009) on Super 16 mm, but because television requires a high-definition element, we did the post-production digitally. We can create

35 mm film prints, but for the moment, the film doesn't exist in 35 mm. It's only shown in digital. It's funny because the Americans in Hollywood came up with the idea of broadcasting digital video films by satellite to different theaters. But that impedes smaller-budget films because cinema theaters are under-equipped to project digital films. I prefer the digital version if you know how to use it and it's not too high definition. Young people these days want to see films on their computer and cell phone screens—that was unexpected. Cinema never saw it coming. In fact, the ratio is wrong on wide-screen televisions, so human figures look wrong, whereas the image comes over far better on computer and cell phone screens.

Eric Guirado

We can't fight these new ways of viewing films because it's too big, but what we can do as filmmakers is encourage people to go to cinemas. How to encourage that is a big debate. It's not easy, but because I have no children and I'm not married, I like to spend a lot of time going to cinemas where I meet viewers just to encourage them and say, "We have something different. There's something different happening here between us, so please keep going to the movies." In France I've gone to my own screenings more than one hundred times.

It becomes a communal experience that has to do with the process, the big room, all the people, the lights, and has something to do with sleeping and dreaming. You experience something unconscious when you go to cinema. The Lumière brothers didn't so much invent movies as going to the cinema. We all know that when you watch a DVD at home, the phone can ring; you make a phone call; you think of something, hit "pause," and write it down; or you go for something to drink. You are never as concentrated or captured as in the movie theater. Something else interesting about the movie theater itself is that you enter it and leave it in the same way that you go in and out of the film. So it's important to actually push a door and go outside in the street, and suddenly something is happening inside you, left there by the film.

Charles Burnett

I can see a lot of films on television because I grew up on it, so I can accept it. But I can't imagine watching films on a smaller platform. I watch films on my computer, which is a good-sized screen, but my son watches movies

on smaller screens. I guess if you're just looking for information or to get a glimpse of something, it's okay.

I get videos from the Academy of Motion Picture Arts and Sciences so I can vote for the Oscars, and I have problems watching them. A friend has a digital projector for PlayStation that makes the image about the size of a wall, and he projects films in his bedroom. It's cheaper than HDTV, and if you put surround sound with it, it's like watching movies in a theater. Before that, I didn't want to watch the videos, but when I borrowed that projector, I watched them all the time.

Teona Strugar Mitevska

I always draw from this idea that cinema is a form of expression, as are theater and literature, but cinema is so appealing and challenging because it includes everything in a way—theater, visual arts, literature, and so forth. We also have to be conscious of changing times. Maybe cinema is not the most powerful form today; maybe it is the Internet, and we have to be ready to accept other forms of expression. Today it is cinema, and tomorrow I have to be ready to embark on something else to tell my story.

Even in France, where they are cinephiles, they are at the point of losing audience members like crazy. The cinephilic audience is getting older, and that audience isn't being renewed, so the state is developing more programs to introduce cinema to young people. For example, my six-year-old son sees black-and-white cartoons every Wednesday, and other programs are creating a new cinema audience. Teenagers don't see films in cinemas anymore, so you have to introduce this wonderful form to them at a young age.

Seeing a film on a big screen is a totally different experience from seeing it on other platforms. *I Am from Titov Veles* (2007) was made for the big screen, and you miss so many details on a small screen. Things are changing, and we just have to do the best we can. Peter Greenaway said that cinema is dead, but it's really commercial cinema that is dead. The only cinema that will survive in the future is auteur cinema. It will play as opera does today. At one point opera was a popular form, but it's survived as an artistic form, and Greenaway projects that the same thing will happen to film, so commercial films will be seen via the new technologies. I'm not upset about this; it's a normal development.

Jia Zhangke

At the end of the 1990s in China, new media arrived—CDs, DVDs, and VHS tapes. At the same time, my first film, *Platform* (2000), was released and distributed in Japan and Europe. So a lot of bootleg copies were distributed in China, where it was officially banned. I have mixed feelings about pirated movies. The first time I saw a bootlegged copy of my own film, the shopkeeper asked if I wanted to check out this new film, and of course he took out *Platform*. I had this sense that "Wow, someone stole my baby." But afterward I realized this film had been widely discussed by a lot of people, so then I thought, "I'm so proud of my kid! It's doing well!" Later on, the packaging on a different bootleg DVD of the film stated, "This film has been banned by the Chinese government; therefore we are responsible for distributing it," as if the bootleggers had this obligation. And not only that, they actually reprinted foreign articles and reviews on the packaging. So the role they play and the sense of responsibility they found for themselves is interesting.

In the 1980s we began to have access to translated scripts from Eastern European and Russian films. I wrote an article saying that we could read other films, but we couldn't see those films. We could read translated scripts by Ingmar Bergman, Italian neo-realists, and New Wave filmmakers, but we couldn't actually see those movies until later on, when we finally watched DVDs of the films made from those scripts. There still is no such thing as a free and open forum for foreign films in China. Two entities control how many movies the country can import, and most of them are Hollywood and French movies, so we lack other types from other parts of the world. That's why these bootleg DVDs are so popular in China. They are the only way to see films from different directors.

The end of the 1990s was a difficult time for films; people in China didn't go to the movies, so the cinemas in small cities and towns disappeared. In my hometown, the three cinemas are now a supermarket, a furniture store, and a stockbroker's office. There was a lack of venues to show films, so filmmakers resorted to online access. YouTube is definitely a phenomenon in China, especially with young people.

Constantin Costa-Gavras

It's a little bizarre to see films on a cell phone or even on a computer; the best way to see a movie is in the theater. First of all, the relationship between the viewers and the film is completely different—you're in a big

theater, alone with the film. But a lot of people cannot go to the theater; they are far away or can't pay for it, so it's a commercial as well as an artistic necessity to have DVDs. Still, movies essentially must be seen in a theater. We spend so much money to make everything very nice—the sound, images, good actors—and on a small screen you can see nothing of that. You don't even see the acting.

Bette Gordon

I love the experience of being in a theater. My generation loves the interaction of sitting in a theater for a horror movie, where something is about to happen. I remember seeing *Psycho* (Alfred Hitchcock, 1960) as a kid, and that intake of breath all at the same moment was such a shared experience for the audience. I hope we don't lose that, but we're on the verge of losing it because of the new technology. For me, no telephone or Internet film or anything like that will ever take the place of being in a movie theater when the lights dim just before the movie starts, that feeling of being an invited guest, where your unconscious is able to receive and believe in this fractured information that you make sense of, where time has a different meaning.

Lucrecia Martel

It's okay if my films are viewed in new ways—via an iPhone, DVD, or on a plane. I really like lying on my bed and watching a film on my computer, with just the screen in front of my eyes, so I'm not one to pass judgment on people who watch films on their cell phones. I find that totally understandable. Having said that, however, there's a ritual element in going to a movie theater that will come back because it has a communal aspect that is like a party, where you get together and share something. The problem nowadays is the way we build theaters just to watch a film, and that's it. I like the idea of the cinema as a place where people can get to know each other, discuss films, have a coffee, and do all kinds of things. I went to Kazakhstan recently and saw people talk on the phone during a film and I liked that. I like the idea that people can cry, discuss stuff, even talk to the characters while watching a film.

Gerardo Naranjo

I think I'm respectful of the viewer's feelings, and I try to communicate that. I don't like filmmakers who don't respect viewers, who put you in

the freezer and take you out. They want to make you feel things, and they laugh at the audience. "Look, I made you feel that, and now I'm laughing at you because you're an idiot." I see filmmakers like that as playing with the emotions of the audience and punishing middle-class conformity. It seems to me that they position themselves as gods who try to wake up certain sectors of the audience. That is a narrow vision that doesn't open up possibilities. Those filmmakers are too intellectual, and that leaves me cold. What I admire most is when I am surprised by the juxtaposition and contradiction of feelings. When the message is too clear, when I'm just supposed to feel pity for the character, I'm not interested. I'm interested when I don't know what to feel for the character, when my feelings conflict. I'm not interested in someone in a film who isn't interesting in life. These are not the movies that inspire me.

Cinema at its fullest—like the films of Jean-Luc Godard or Orson Welles—entertains the audience at the same time that it offers complex messages involving culture. At its best, cinema is a poetic medium. Reality is interesting, but it's more interesting when we get a little more than what we see.

Jerzy Skolimowsky

I'm trying to take the viewers by their noses and lead them my way and show them that "No, no, this is not what you think it is," and surprise them, again and again, on every possible occasion. The worst thing to me would be if I felt I was boring—that's the greatest sin the film director can commit. I hope I didn't have a single minute of boredom in *Four Nights with Anna* (2008), that it always leads you to something, always makes you speculate, "What's going on? What's this all about?"

Ivo Trajkov

I prefer films with a message, an idea, with the auteur's point of view that reflects reality and has something to say. Of course, this kind of film is not for the mass audience. If there were no auteurs like that, I wouldn't go to the cinema. What's wrong with doing films for a select audience? Of course, it's hard to say this to the producer. There's that joke about a Hollywood producer who said, "If I need to send a message, I'll go to Western Union."

How far you go into the experimental and non-narrative depends on which type of audience you're talking to. That's the first question. I've

always made different types of films. If you've decided that expressing what you have to say is pushing you to do so without any limitations, without thinking of anybody else, of course you would not be communicating at all. There's a difference between making a film for yourself and making a film because of yourself. If you do it for yourself, that's wrong; but when you make a film because of yourself, because you feel so strongly that there's a pressure within that you have to express, then you have an important message. You need to tell it, and you will find the way to do that. A historian once said that if the artist has something to say, he will always find the way to get it out. That's a motto for me, and it depends always on this.

Claire Denis

I don't think my films are manipulating. And whether or not a film is manipulative is not a question of it being a commercial film. Sometimes commercial films are manipulating the audience and sometimes not. They are honest in a way. "Honest" is not the right word; it's a moral word. They're simply showing what they mean.

Auteur films can be manipulating. It has to do with the sort of person the director is, what he is looking for, and what kind of film he makes. There are great films that are manipulating. Me, I know I'm not. And giving answers is different from manipulating.

Kiyoshi Kurosawa

I never think of myself as manipulating an audience. All I do is make decisions—what to show, what not to show—based on my particular sensibility, and then we find out how the audience reacts to a film based on my sensibility. The great thing about film is that you have no idea how the audience is going to react; people react to the same scene differently. Some are terrified while others laugh right through it, and that's why I love to make movies, because you can in no way predict how an audience is going to react to what you've created.

I didn't set out to make a comedy in any way with *Tokyo Sonata* (2008), but if someone finds certain things funny, please feel free to laugh. I'm sure that if you take a few steps back from the sight of someone intensely engaged with what seems to be an unsolvable problem, it can be humorous, depending especially on the actor and how he or she interprets the situation. It also really depends on the country and the screening situation. In

Japan almost no one laughed during *Tokyo Sonata,* but for some reason, when the film screened at Cannes, some people found it hilarious, which I thought was wildly inappropriate. I would have preferred a sort of sweet chuckle.

Brillante Mendoza

My films are not for people who can't understand or aren't interested in understanding the developing world. My film is not here to be liked; it's probably here more for people who are adventurous and courageous in ways of experiencing and seeing these things without any hypocrisy.

Pablo Larrain

American films have created a great body of work for the history of cinema. Many American directors have made such wonderful films, but they also created huge damage in that they educated the entire world to think films are supposed to entertain rather than make people think or feel certain emotions in a structured way. You could easily say that *Tony Manero* (2008) is depressing, dark. I'm not going to say it's not, but I will say that you could look at it differently. Audiences are different all over, and as a spectator, a film shows you a few things that touch the story, and then you complete whatever you haven't seen with your own biography. So it's really up to the people who are looking at a film.

When the film's creator shows a lot of information, the viewers feel secure because they know everything that's going on, but that's not good. I want the audience to be insecure from a cinematic point of view, because they don't know who this character is and why he relates to others this way.

Nothing is worse for a film than nobody caring about it or everyone loving it. It's dangerous when everybody loves a film, and I am suspicious of it. But when everyone hates it, I want to see that film, because there's always another way of thinking, especially if opinions are all over. That's why you don't have to trust what happens with the film at the time it's released. When you have good reviews, you feel nice, and when you have bad reviews, you feel bad; but a good film will stand the test of time, and that's what matters. When Luis Buñuel's *Los olvidados* (*The Forgotten Ones*) came out in 1950, they destroyed it in Mexico; and a year after that, they took it to Cannes, where it won the Palme d'Or. So they had to re-release

it in Mexico. Today it's a classic and will always be important, so time is always a better judge of a film.

In a way, the new media by which audiences view films are good because they make everything more democratic—now people will get to see almost everything. In other ways, it's bad because the cinema as a place is dying—that place you enter and turn off your cell phone, forget about yourself, and just settle in this dark room and enjoy the film. But you can't fight against the development of technology; you just have to live with it and do the best to suit your purpose.

Courtney Hunt

Film is way more accessible than theater or literature because you get a full-surround emotional and intellectual, aural and visual experience, and so you hit a lot of bases. It can transport you because you surrender to it when you walk into a movie theater. Even when you see a movie on your flat screen at home, you sometimes surrender to it. That certain surrender of the will is what's so powerful in terms of reaching people. You can put down a book, walk away from the television, or your kid can come into the room, crying. With cinema, at least you commit to the two hours. I think I've walked out of only two movies in my entire life; it just doesn't happen. Getting viewers in is tricky, but once they're in, they're going to sit there.

With *Frozen River* (2008), the big question was: Will the audience hate Ray? One of my investors read the script and said, "She's a loser, she's a loser!" I said, "No, she's poor, she's struggling." This idea that being poor is something to be ashamed of in this culture makes me crazy. So to put people in Ray's shoes, where they don't want to be, and then have them walk in those shoes for ninety-seven minutes means they are giving you a lot of power that you have to use with absolute care.

You can reach people in a more profound way, but you also can cause the viewers to shut down. I don't get too much into whatever they walk out of the theater with, because my feeling is that in a way, it's none of my business. I've given it to them, and it's like a gift. They can throw it in the trash if they want to as they walk out of the theater, or they can keep it for the next ten years. My hope is that they understand a little more. I was hoping that the people who work in Walmart would come see the movie and say, "This is my life, this is the shit I deal with." The

sort of smarty-pants art house crowd who are actually seeing the movie asked questions like, "Is this world really out there? Is this really going on?" And I'd answer, "Yeahhh, do you ever leave New York City? Because if you did, you'd find it, right in your very own state." People wear certain blinders, and if the film can take those away a little bit, do anything that causes them to stand in another person's shoes and care about that person, that's going to change those viewers, whether they want it to or not. They're going to understand a little more about these people and stay open to them. Are they going to act differently? I don't know. All I know is, it's going to raise the shade on their understanding the slightest bit, and that's good enough.

Ari Folman

Waltz with Bashir (2008) screened twice in Ramallah. I didn't attend because no one wanted to insure me, but from what I heard, they were good screenings. A woman from our distributor whose husband lives in Lebanon tried to organize screenings in Beirut, but it didn't work out. Apart from that, there were articles and reviews in Saudi Arabia. I was surprised that the film was well received in Israel and just as I'd intended, as a personal story. The only criticism was from the Left, that the film didn't take enough blame for the massacre. The right wing had no problems with the film whatsoever, which was a big surprise for me as well.

We filmmakers tend to underestimate the audience. If you want to work on a personal level, they understand that it's personal, not political. I don't think *Bashir* is a political film, other than when I say "War is bad for you." I put it as simply as I could. There's nothing more in this film in terms of political statements.

Mary Harron

People always get apocalyptic about the audience being coarsened, but I don't think the audience is getting any coarser than they probably were in the seventeenth century when they were watching bear pits and *King Lear*.

One thing you realize, especially in the transition from script to shooting the film, is that you need to get rid of a lot of exposition. But during pre-production or script conferences, producers and the studio are always asking for more clarification, even though you often don't need it

because audiences put two and two together. The audience is obviously flexible and eclectic.

Lance Hammer

Ballast (2008) is a slow film, so how can you engage viewers so they'll stay until the end? You engage viewers by making them work. It's not that I'm trying to make anybody work, but this is the way life is. When you get onto a city bus and you're watching someone across from you, you know nothing about that person. But human beings are naturally curious and want to know about the people they're surrounded by. So you look at whether or not they have a wedding ring, at their ethnicity, at their clothing. Through subtle clues, you start to piece together a life. And if you were then to get off at the same stop as that person and go to his or her apartment, that would say more about that person. Pretty soon, you can piece together a whole narrative from these fragments. That's the way life works, and I wanted this film to be realistic. I wanted it to operate with the rhythms and modulations of real life. When I'm truly moved by something, it's inevitably from real life and often by strangers. I'm driving by and see someone is doing something to somebody else on the corner, either viciously or compassionately, and those are the things that move me. When art incorporates emotionally truthful elements, it resonates with me on the deepest levels, and it's always based on realism.

So it was important that this film reflect the way our lives work. I didn't want artifice, although on a certain level, I wanted a tremendous level of artifice, because *Ballast* is ultimately a personal expression. Yet I wanted to use the language of realism to accomplish that.

Throughout film history, particularly Hollywood's, which has devolved, it's assumed that viewers are stupid and don't want to be engaged in the viewing process, don't want to participate. Certainly that kind of film is important, but I'm not interested. Even, say, *Dark Knight* (Christopher Nolan, 2008), a pretty good film, requires a lot of participation from the audience. You have to think; you can't be lazy, and I believe that's why that film is so successful. It's hugely entertaining and full of spectacle, but you're intellectually engaged.

I definitely put myself in the position of the viewer, and it's hard to do. My girlfriend was involved in every single aspect of this film. I'm the viewer, but I have little objectivity, just enough so I can work my way

through a lot of it, and she gives me a different kind of understanding. My colleagues came in after I'd gathered enough strength and confidence to show it to them, to see if it was working. At first, I didn't want to lead them with questions, so I'd ask if they understood the film in general terms and for specificity if they didn't understand something. Ambiguity is extremely powerful, but you can cross the line. I wanted to bring it to the point just before you cross that line, so it wouldn't be totally mysterious and unintelligible. There were times where I definitely crossed the line, and they would give me specific examples.

But people's ability to understand cinematic language is sophisticated. After only one hundred years of cinema, that people know what a jump cut means—the temporal appreciation of exactly what is happening—is pretty amazing. People don't seem to blink an eye at everything you leave off, whatever's snipped off in between.

I have mixed feelings about new platforms for viewing films. Innovations in technology excite me; so many people having access to creative content—what artist wouldn't be excited about that? But it will change content. A film like *Ballast* does not find a natural home on a cell phone. It doesn't even belong on a DVD in someone's living room. I'm happy that someone would watch even a third of it, rather than none of it; and if it means people will buy a DVD, that's great, but it is an antiquated narrative form for this new technology.

The avant-garde always figures out how to use new technology and exploit it to empower the art form in ways the people who invented and developed the technology never anticipated. Right now, we're at that stage where people are saying, "Let's just force all of our film content down to this new platform, even if it's not really appropriate for it." Nobody's figured out what the new language is yet. We should be excited that a new technology exists that will liberate us from the shackles of this current technology. I want to believe that, but I have no idea what to do for an iPod, except that you have to catch someone's attention every five minutes and the image has to be composed in a completely different way, as the aspect ratio is very different. You don't hear anything on an iPod, so you have to be simple and direct with the sound.

David Lynch, who, ironically, rejects the iPod, is the kind of filmmaker it takes to figure it out and lead the way for the rest of us. It's an exciting but scary time.

Olivier Assayas

Ultimately, the interest today is in boring and conventional cinema. The dullness of most filmmaking is dangerous because it gives an alienated notion of the world to the viewers, and they think that this is what cinema is.

When you make movies, you obviously hope that people will like them and that they will be successful. I don't feel I am being radical in constructing this or that. Basically, I'm trying to be as real as I can. To me, movies are not about other movies; they are about life—about your own emotions and feelings. When I am telling the story of these characters, somehow I consider the spectator is smart enough to escape the trappings of the genre. I don't think that humanity is horrible. If you dig, there is a certain beauty to humanity, so showing the ugly side of people is the easy route. A mature way of envisioning humanity is to try and see some decency.

Movies today are often about numbing the audience with loud music, loud sound tracks, and big objects, and people just take the film in their faces. The whole point is to create a completely passive audience, whereas art is about creating an aware audience. Anything worthwhile in art has to do with the dialogue between yourself and the work of art. You look at a painting, the painting is projected onto you, and you project yourself onto the painting. This is why I care so much about the idea of unfinished filmmaking that leaves open space for the audience to have a dialogue with what's going on. You have to have an active, involved audience. It's also why I say that movies are about questions, because they mean that you are somehow asking your audience questions. You put things there on the screen, but it's not conclusive. You're proposing points of view, conflicting layers of reality, and your audience has to make sense of it. So they're always having a dialogue with what's going on and involved in the complexity of what's going on. That's essential. It's not an issue of making good or bad cinema. It's only this way that cinema can be an art form.

I may be totally mistaken, but I don't believe that the future of cinema is on cell phones. I suppose that for some kids it is because it has novelty value; but hopefully, at some point, the phones will have a bigger screen, maybe one that folds out. Even huge studio spectaculars benefit from a big screen.

Also, when you watch movies on cell phones, it's a tiny screen but the sound is big. You get the full effect of the sound through your ear

phones, so the full space of the film in terms of sound comes through. It's interesting because people wind up being more interested in what's going on in the sound than in the actual images. It's hard to figure out exactly where movies are going, but people will have bigger and bigger screens at home with better and better projection of sound and so on. So you will have a completely decent experience at home.

Still, I trust that people will keep coming to theaters because they don't want to be complete couch potatoes. They need to go out and share experiences. We have so few collective experiences, and if you walk into a theater, people are sitting there whom you've never met, but you experience something together. It's tiny, but at least it's something as opposed to nothing. Somehow you need that, and you feel better.

Sometimes I'm home and want to see a movie. I have the option of watching the millions of DVDs I should be watching but haven't, even though some of them are masterpieces, or getting on my bike and going to watch a bad movie that opened yesterday. I will go out and see the bad movie because it's on a real screen at a cinema. It's incredibly more satisfying, and that's what gives me faith, because even when I watch a masterpiece on my television, I don't love it as much as I should because I know that if I'd seen it in a theater, I would have enjoyed it more, I would have felt its full experience. When I watch it on a smaller screen, I feel I'm spoiling it.

Jihan El-Tahri

I structure my documentaries to speak to three different audiences. The first audience doesn't have a clue of what I'm talking about and needs to watch something from A to Z in order to come to an understanding and find it interesting. The second audience knows enough about the topic to see where any holes might be and say to me, "Hold on, but you didn't say this and didn't say that." I need to have a level of depth so they'll know I'm not skimming. The third and most difficult audience is the academic one. There must be enough subtlety and nuance for them to realize, "Okay, she knows about that; she just decided to not include it."

Andrew Bujalski

If I were making slapstick comedies or thrillers, I would be going for certain specific things—that everybody laughs right here or everybody jumps out of their seats right there. But my films are designed to be a different personal

experience for each person who watches them, so it's harder to synthesize everybody's opinion. And it's harder to perfect this kind of movie because it's not meant to be perfect. You try to strengthen the parts that feel like they want to be stronger and cut the fat, but it's harder to know what's what. You just have to play with what you've got. Any editor can say, "Do this," but what's more valuable is the experience of sitting next to some other consciousnesses watching the film with me and imagining it through their eyes before they even open their mouths to tell me what they thought about the film.

One of the perverse things about making films is that I run and run toward making this magical thing I imagined, and then I never know what it is because I'm the person least qualified to experience this film. I have no idea what it's like for somebody who didn't sit there for four years making it. Ultimately, viewer experiences are the ones that matter. You make this thing and give it away to somebody else, and you'll never know what you gave them.

Tomas Alfredson

One of the biggest problems today with entertainment and filmmaking is that the screen is performing a monologue. But you have to have a dialogue with the audience. You have to talk to the viewers, suggest different things and have them think and sometimes be ahead of the story and sometimes behind, but always active and thinking. The frame is one of the most important ways to do that, framing with sound and framing visually to suggest different possibilities. *Let the Right One In* (2008) is a horrifying story, a story with a lot of tension, so I studied what makes you get scared. It's always your fantasy about what scares you, not the real scary stuff. If someone were to hit you with a baseball bat, you wouldn't be scared, you would be hurt. However, thinking of being hit by a baseball bat—that is scary. That's how our imaginations work, so that was the key to making this film, playing with the audience's fantasies.

You have to be manipulative, because if you didn't have any ideas or visions of how you want the audience to feel in a certain situation, I don't think you would do a film that inspires the audience's taste. You have to have an idea with everything you do, but the idea shouldn't be too easy for the audience to see around or pinpoint—that's the big trick. Of course you have to be a manipulator.

But I'm not interested in being dogmatic. I think if a person came up to me and said, "Wow, this was an interesting film about cars," I would be happy if that person had the impression that *Let the Right One In* was about cars. You should have as much air around the story as possible for viewers to find their own opinions about whatever it is. So, outside of the screen, I don't want to be dogmatic or say, "This film is the truth about bullying" or "This is the best way to . . . whatever." Outside of the screen, I don't want to express that, and I don't think I have that language either. My language is filmmaking, and so the film has to stand for itself.

I can serve it but not chew it. Of course, people who are not educated or sophisticated or have no other references could get the wrong impression from some films, but then you're talking about censorship. I can also see that if you give the audience hamburgers for ten years, they wouldn't want to eat anything else but hamburgers. So that's a big danger, of course, because people get used to a certain input.

Pedro Costa

I think we should adopt some radical measures. The other day I was with a friend, Jean-Pierre Gorin, who made films with Godard. He told me about a marvelous idea they had that I remembered when I took the plane here. I had a small book I planned to read during the seven-hour flight, but I was too tired. I'm lazy like everybody, and I drank whiskey. I found myself watching *The Taking of Pelham 123* (Tony Scott, 2009) with John Travolta, and it was like everybody going through the motions. Then I remembered Jean-Pierre's project with Godard, which was not hijacking a plane per se but hijacking a plane in order to show their films. I thought, what a great idea, if I were in that plane and two guys came and said, "This is a hijack. You're now going to see our film or *La règle du jeu* by Jean Renoir, and that's it. You cannot escape." You have to do things like that. It's the only solution.

DVDs are great because you can go back to the things you like and relax, but you become lazy, so I have to shake myself and go. What I saw from *The Taking of Pelham 123* was, would I go to a theater to see that? No, but in that airplane situation, you don't resist. You know it's not good, not good for you. It's like a big cake. You're going to eat it. You know it's bad for cholesterol, but you eat it anyway. But then you have to do your workout.

Everybody is asking me and a lot of filmmakers like me to do films for museums and galleries, and we're going into this art world, not really

doing installations, because I cannot think of this kind of video art for four months. But I've shown pieces, extracts of my films.

Some of my films were shown at the Tate museum in London, and they also asked me to show some films by Godard and Straub. Then I showed a 1931 film by D. W. Griffith called *The Struggle,* his first and last sound film. One hundred and fifty people in that theater had never seen a Griffith film, and people who should have seen a Griffith film imagined they had because they had seen a book with a photograph of *Broken Blossoms.* At least that's my feeling. They were amazed just that the sound of a door closing was a door closing. Today, in an American or European movie, a door closes in a strange way. It's behind you, it's in surround sound, or it's half or a quarter of a door. It's ridiculous.

I still think the camera is wonderful, and it has to do with our world. It's the tool, and it thinks a little if you put your brain into it. Jacques Rivette, another guy I like a lot, said something that's true for me, that the world seems to be going faster and faster. When we try to do the same thing in a film today that you saw with Frank Capra, John Ford, or Charlie Chaplin, it takes three times more time just to show that emotion. That *Taking of Pelham 123* thing is like a can of something you drink and it's over. But the amount of things in an Ernst Lubitsch or a Frank Capra film is amazing. If you show a Capra film in a theater, some people will be puzzled. What is happening? What is this? Because it presents a huge human spectrum, and I and a lot of my friends feel that it's not easy to do that today. You need time to work out how to do it, how to show joy and sadness in one shot. It's difficult. People will not understand. They used to, but now it's about mimicry.

9

Cinema and Society

Even the most escapist fantasy film cannot help but transport some fragment of its maker's ideology and traces of its parent culture. Whenever an actor is filmed on location, whatever is in the background is captured on camera as well. Even a fabricated film set expresses something of its time, culture, and values. For instance, films from the thirties bear witness to that era through the political and social attitudes of the characters, the style of the clothes and decor, as well as many other cultural signifiers the director may not have been aware of at the time. American westerns from the mid-twentieth century express the dominant culture's attitude toward American Indians.

As an important cultural witness and influence over the decades, cinema has come to hold an increasingly important position in our collective cultural and social life. An example is how American movies have spread the signs and signifiers of that popular culture throughout the world. The possibility exists that films can influence us in ways that progress contemporary society. However, that possibility is undercut by the daily assault of sounds and images from so many different media that gives us a pervasive feeling of déjà vu—of having seen or heard it all before. The personal filmmaker's challenge, therefore, is to win a big enough audience to finance his or her next film without lapsing into the culture's clichéd images and destroying the possibility of saying something dynamic in a fresh, original way that can stand out from the constant noise.

There are no examples of a film's direct political influence, but if a film opens up new possibilities in thinking and feeling to enough individuals,

perhaps it can act politically in the sense of being an agent for broad soci-
etal change. Of course, cinema is only a medium, a conduit that processes
information, so it is capable of displaying "good" and "bad" qualities,
neither of which is absolute. This diametric goes back to the question of
intention, whether the filmmaker intends to corrupt us or save us, and
further, to the necessity for filmmakers to be absolutely clear about their
intentions and fully aware of any subtexts that may be buried within their
films. For example, intentionally or not, the *Star Wars* series illustrates
how films can convey a dangerously simplistic approach to human issues
concerning abuse of power and sexism.

A film can even become an opportunity to free ourselves from the
constraints of our individual circumstances by allowing us to meet people
and visit parts of the world we would otherwise never know, thereby
stretching our imaginations and developing our empathy—crucial values
that enhance society by bridging gaps that result when people cannot
comprehend the Other. On the other hand, vivid portraits of Others
can be pressed into the service of inhuman agendas, and the history of
cinema is rife with examples. Cinema doesn't change the world—people
do. And the finest films help people open their eyes and hearts to that
possibility.

Constantin Costa-Gavras

Films can have a political effect, probably not to change the ideas of people
who definitely believe something but perhaps to reinforce people's belief
in something like justice: "Yes, we are right to believe in that." Also, people
who are floating somewhere in between can probably change their minds. Of
course, when you start to make a movie, you can't say, "Let me do something
to change people." It would be crazy. I make a film because it's a story I
would like to tell, something that touched me deeply, and I would like to
tell you about it, just as I would in life when I want to tell a story at dinner.
Why, I don't know, but I want everyone to know it. It's a human thing to
share the story.

From its beginning, cinema was essential in the world because we
were able to meet people from all over—Chinese, Japanese, French, Ameri-
cans—and today, even more and more, because more people make their
movies. Every country should be able to make their movies, and finally

they're starting to. I was on a plane today with the previous secretary general of the United Nations, Kofi Annan, and I asked him, "Why don't you find money so every country can do its own cinema?"

I think it's essential to meet people through cinema because there's no other way. Music, for example, comes from all over, which is nice, but it doesn't travel as much as movies. Unfortunately, here in the United States and to some extent in France and other countries, the big major companies have all the theaters, and they only contract big, successful movies. There is no room for other movies.

Lots of films are dangerous. We often see movies about the individualist who solves all his problems with a big gun. You see huge guns everywhere in these movies, and that one man saves the world. I think that's very negative for young people because we learn through those images more and more. Probably we'll get to the point one day where we're not reading anymore and we learn everything through images. The facility of killing in the movies and video games—the big splash of blood and so forth—is exciting and scary at the same time. It creates a facility for killing not only in young people but also in cultivated people, and from the show to reality is not a big leap. I don't believe viewers actually become killers, but they can start relating to people in violent rather than human ways.

Roland Barthes said that all movies are political and we can analyze all movies politically. He's completely right, especially because the images are so big. Look, why do we use images to convince people to buy things? And they buy them, so they are influenced and follow you through images. Aren't those violent images, the ease of stealing and killing in movies, being sold too?

Claire Denis

I'm not sure cinema is the best way for cultures to come together because I believe the best terrain for people to come together is life. It's best for me to consider cinema as a sort of magic world where people can group. *White Material* (2009) began with the actors I wanted to work with, not because they are black-skinned actors but because we have something in common that we can share. That's how I figure out a lot. I would be afraid of thinking that films are a way of meeting people I would have no occasion to meet otherwise.

Jia Zhangke

My first three movies were banned in China. I wasn't aware of that until the film bureau called me in while I was a student filmmaker making *Pickpocket* (1997) and said I had violated regulations stating that only state-run studios could make films. I was therefore banned from making more films. My films were also banned from viewing, and equipment and post-production companies were served notices not to work with me. So I started collaborating with a state-run studio for *Platform* (2000). As we were about to shoot, the leader said, "Guess what? We aren't going to make this film because someone at the top said you are only twenty-nine years old, so how are you going to make a film about ten years of history in China? Why not wait until you are older, and then we can talk about it?" It drove me crazy, so I broke from that collaboration and made the film myself.

The policy shifted in 2003 from seeing films as propaganda tools to seeing films as a way to create an industry. Therefore, censorship laws loosened up a bit. The banned filmmakers, including myself, negotiated with the state and were now able to make films. My fourth film, *The World* (2004), was officially seen in China's theaters.

My most difficult times as a filmmaker—from 1989 to 2003— have passed. Even though they banned me from making films after *Pickpocket,* that didn't stop me. I kept going with *Platform, Unknown Pleasures* (2002), and other films, so not compromising can give you more power to negotiate.

I first thought about making *24 Hour City* (2009), about workers, right after *Platform* in 2000. I was thinking I'd focus only on workers being laid off because of this change in China from a planned economy to a market economy. But it didn't work out because I didn't find a lot of exciting material. It wasn't until I learned the fate of Factory 420, where thirty thousand workers disappeared from the industry when it was decided to transform the factory into a luxury high-rise apartment complex, that I thought it was right to record this time in history so it could become part of the nation's memory.

I filmed the female workers singing this particular song, and it got me thinking that these people working for the great factories were part of this planned economy, part of the socialist ideal. They went into these factories with ideals of power and freedom, but in practice there was repression of individual freedoms and a lot of harshness. During the Cultural Revolution,

you didn't even have the freedom to love and have romantic affairs. You had to go to the officials for permission. So through the film's interviews, I revealed the ideas of a system contrasted with its actual practice, of moving from a socialist ideal to the practice of repression and restriction of freedom.

My most important mission as a filmmaker is set against this background of the Chinese cultural context, because I hope people will start respecting and focusing on the individual, rather than seeing society just as a collective. It's the story of individuals who need to be respected and paid more attention when you look at how the economy affects China. So I focus on the individual. A freer market is a good path, but this particular policy change also comes with survival of the fittest, so there will be inevitable casualties, people sacrificed within this process of transformation. And they actually make it justifiable to the point where it's inevitable. This economic transformation has intruded on a lot of individual rights and freedoms, and I want my films to counter that somehow, to challenge and change that cultural reality.

So film is one of many ways through culture that you can have an impact on the political scene. If you look at recent film history, starting in the nineties, all the Chinese independent films were about groups in China that have been neglected or sacrificed during this process of change. Because of these films, suddenly a sense of taking care of these neglected groups has become the mainstream idea the government actually has to respond to or pay lip service to. Independent films can rebel and challenge whatever hasn't been examined before. With this rebellious nature, we can test the boundaries of many different issues, and it's very gratifying. For example, in the eighties, a lot of movies talked about gender issues and empowering the female population. At that time, there was a lot of sex trafficking and prostitution and lack of respect for the female sex. Because of those movies, a strong wave of interest in empowering women surfaced, and it's become the mainstream notion. In the nineties, gay and lesbian issues were unimaginable as topics, but because of movies like *East Palace, West Palace* (Yuan Zhang, 1998) or *The Wedding Banquet* (Ang Lee, 1993) that touch on gay issues, that community has become more visible in China. These are just two examples of how independent filmmakers and other elements of culture can test the boundaries and push the envelope.

Céline Sciamma

Sometimes the movies that are officially nonpolitical are the ones that are politically dangerous, like *Independence Day* (Roland Emmerich, 1996), which is supposed to be just entertainment. Every part of the world is being assaulted by big spaceships. You see the Eiffel Tower and Africa being destroyed; then there's America, and the president of the United States saves the world, and you see all these spaceships crash. The worst part is the African people in their little dresses—they may as well have bones in their noses—celebrating America's rescue of the world. That's politically dangerous, and that movie went around the world. But people say, "It's not political, just total entertainment."

Cinema is always political. It enables you to live experiences you would never otherwise undergo, and it opens your mind and body to other people's feelings. Talking about women from a woman's perspective in *Water Lilies* (2007) is definitely political for me. My movie also has this gay subject, where a girl falls for another girl, and that story has been told very few times with characters of that age. People want to peg it as a gay movie, but I decided to portray this as simply falling in love, and it just happens to be two girls. I also decided the movie shouldn't give any answers as to the sexual identity of these two characters, so the viewers can decide. My opinion is that Marie is going to like women forever, but I decided not to insert my opinion, so everyone can relate to it a different way. To me, that is a better way to be political because it's more generous and talks to more people. Everyone in the audience should want that kiss between the two girls because they've been falling in love for over an hour and a half, and now the audience wants them to have it. I wanted everyone in the room to be gay for just ten seconds and, if not gay, to feel the love. Even as far away as that may be from the viewers' taste, they experience it. It's becomes a journey that's not theirs, but it's familiar. I became kind of angry whenever a gay member of the audience would say, "That's not political or gay enough; you need to give a more positive representation." The film is definitely political because everyone wants that kiss to happen. But movies are not flags.

To me, cinema is a way to live through experiences that you wouldn't ordinarily have. You wouldn't save the world from meteorites, or, if you're a girl, maybe you wouldn't fall in love with another girl. That's the purpose of film, and to me, that's political, that's sharing.

Agnès Jaoui

Family is exactly the same as society. It looks like society, and family is where it's all settled. We wanted to deal with that when we began to write *Let It Rain* (2008). All relationships reveal our positions, and that means politics. So you must be close to the characters in order to avoid clichés. It's the same process when you act; you don't play the results. You have to defend your character as if you have all these reasons to act the way that character does. You can't judge.

Lucia Puenzo

When I was looking at scenes from *XXY* (2007) during editing, the first viewers of the film kept telling me that *XXY* was about freedom of choice. I thought it wasn't about freedom of choice but about desire and how desire can free people. If you can connect with what makes you feel pleasure and desire, that may seem small, but it can actually help you survive and be okay, so desire is vital in that sense. When I finally saw the film with intersexed people—heads of Argentina's intersex society, who could have destroyed the film—they politicized it. They found it incredible that the film makes the central issue for intersexed people not just the liberty to choose their bodies, but the demand to be desired by almost anybody. So we were "speaking" about this in the film without being aware of how the film would be received by those who fight for the right to have their name. Somehow, without realizing it, we were thinking the same way, that sex and desire are most important because they have such an important place in society now. Nestor Perlongher, a great Argentine gay activist poet, always said, "We don't want to be respected; we want to be fucked." That's what *XXY* is saying, and in that sense, it's political. It's about other people telling intersexed people, "Okay, we'll find you a place to live and then decide if you want to be a man or a woman—we'll give you freedom of choice about that." And it's also about, "I could fall in love with you and my world could change because you are coming into it just as you are." So films can be political from an unexpected point of view, maybe not always from the point of view people expect, but perhaps from a place on the margins that most of us are not even aware of.

Pedro Costa

I do my films for the people that I show in those films, and they're doing it for me. We have this body of work, three features and more shorts. I'll

keep on going, and I would like to share this common thing I have with those people with someone else. For me, it's hopeful in the sense that every filmmaker still has that little flame of hope that somebody somewhere will be touched.

Unfortunately, I don't think it changes much. That idea that film can be a revolutionary gun does not exist. Or if it does exist, it failed completely, because the guys that we're talking about, who believed in it, didn't succeed. We're always talking about another legion of guys who were working even in modern cinema, the sixties, seventies, but they are completely forgotten. Nobody sees them. Who was the traitor? Was it us or them?

Yet every time I see the films Jean-Marie Straub made with Danielle Huillet, it's always the same feeling—sometimes it's not even the film itself—but the feeling that this is worth something, that cinema was invented and is worth something. It was worth doing the stuff.

Serge Bozon

It's important to be aware of the power of cinema, of pictures. It's not something safe. You can't make a movie, like that's great, that's fun, and that's all, because films act powerfully on the unconscious. They touch us in places we're not aware of, and when any art touches us—stories, paintings, pictures, and all art—it reaches somewhere deep. Maybe we don't feel it right away, but we do later on. I'm interested in psychology, and I really believe that art in general is very important.

But the problem is that there are so many films, so maybe too many films can kill the power of one film. That's why you have to be aware of the importance of balance in movies. That's why I fight for independent films and for equity in films. I don't want only one kind of film. We need all kinds of films, even if we don't like them all. We need comedy, big spectaculars, and intimate films—we need all that because it's dangerous when we have only one kind.

I hope *La France* (2007) has some political meaning, but I don't have a single clue about what it is, because it wasn't made from a political point of view. I didn't want to say that these deserters were generous, great guys who refused to fight, that they were the ones who made the right choice. No, it's just that they were too weak to keep on fighting, and that's not a condemnation. I mean they were weak like somebody's tall or somebody's

weak. I tried to tell the story from the point of view not of the winners but of those men lost in the shadows of history. It's a historical issue, not from a political angle but to try and see what the history of the weak could be. I can't say more than that. But I would love to try doing a truly political film.

Teona Strugar Mitevska

John Cassavetes said that we filmmakers have this ideological and foolish idea that we can change the world with our films. All that may not be possible, but still, with each film, each piece of art that we create, we try to do exactly that—change the world. I had exactly the same conversation today with John Tintori, the chair of New York University's graduate film program. I said, "We are all aware that art cannot change the world. Politics can change it, but we're still trying." He said, "No, you're wrong there. Maybe film and art don't change the world, but they definitely change our opinions, the ways in which we look at the world and observe it." This is most important.

It's so wonderful that once I have an urge that comes from my brain and stomach to say what I need, to talk about issues that are important for my community, my country, I can get that out there. I always start with a local idea, a local story, but all the stories are human, so different cultures can find themselves in any local story you tell.

Not a day passes where I don't say to myself, "Thank you for this art form that's in my hands." It's wonderful to work in cinema because it's such a powerful medium. It enables you to talk about important issues to so many people of different cultures and nations.

Charles Burnett

In general, film can and should reflect and express a culture. I tried to do it with *Killer of Sheep* (1977) and *To Sleep with Anger* (1990). But I don't know how many films have distorted cultures and people and have been used for propaganda. *The Birth of a Nation* (D. W. Griffith, 1915) created an entire library of negative images of black people that's continued to this day. Today's anti-Arab sentiment is expressed in a television show like *24* and others. A lot of shows have to do with Latino drug lords, that kind of thing. I remember seeing a Japanese film made by Yasujiro Ozu and Akira Kurosawa's films, and I was blown away. Having only seen American portrayals of Japanese people, that experience was amazing. Or watching

the scene in *The Searchers* (John Ford, 1956) where Jeffrey Hunter kicks the Native American woman in the blanket down the hill. I always knew when you saw John Ford movies, where they were killing Native Americans, that the Indians were inherently the bad guys. There was nothing in there about how we stole their land. That opened my eyes about film.

When I was in Africa, I recognized the humor in how film can distort the reality of a culture. Have you ever seen a lion in the wild, a real lion? They are incredibly, magnificently built, unlike zoo lions. You can see the muscles in the chest, and there's no way a man can wrestle a lion and open his mouth, unless that lion is dying. The first time I saw a lion in the wild, I thought of *Tarzan* (*The Ape Man*, 1932, W. S. Van Dyke), and I realized that was the biggest charade of all time. A lion can just swipe and rip off your whole face, so when you look at these things, you think, "What a distorted view!"

Tomas Alfredson

Film language is becoming more and more Americanized, so the American model of making films is setting the standard these days, and it's harder, in fact, to know where films come from. Eastern European films have preserved their own way, their own sound, compared with some other European countries' films, because they underwent the communist years. When I say the "sound" of a film, it's almost like the language. I feel Polish or Czech films have their unique sound and unique pace. Filmmakers throughout history have created conventions so that we understand film, and because America is such a great and dominant film nation, the American film industry has created standards about the visual language, the pace, using music, using the text. The other day I was watching some crap American police show on television, and suddenly, my heart was bumping because there were all those elements in how it was edited and how they put sound on it. You turn into a Pavlovian dog because a filmmaker can push certain buttons. As a filmmaker, I always try to get away from those tricks because they're too easy. So you want to place the cut not where it's supposed to be, not in the obvious place.

Catherine Breillat

It's most important for me as an artist to work by instinct. It took me a long time to realize that when I work instinctively, I am working politically. The

artist always transgresses society's received notions. Through the reactions of the audience, the reactions of society, the political import of the film is revealed, precisely because my films are politically correct. I might have changed censorship laws in France, where they had banned the works of three directors—myself, David Cronenberg, and Nagisa Oshima. It was the same in England and Norway. This all happened with *Romance* (1999), which was a weapon of war against censorship and romance. In France it led to a change in the definition of pornography because I showed that the film was also dealing with ideas and how to express them.

I don't like pornography, but the Louvre is full of paintings of naked women. So whether you're feminist or not, you can shoot naked women in a film, and that has nothing necessarily to do with pornography. And because naked women are shown, but rarely naked men, I also wanted to shoot naked men.

The problem for the artist is how to go beyond the doorway you're not supposed enter, to find a way of crossing the line you can't transgress. I'm not against taboos; I'm in favor of them, but it's the role of the artist to transgress, to go beyond limits. The artistic space is always outside certain social limits, so how do you go beyond them? Take the example of porn films. Taboos have fallen around porn films. Now porn films are coded; laws regulate them. If you look at porn films from the early seventies, they were made in a spirit of freedom, whereas the ones now that are coded by ratings aren't transgressive and are not even films because there's no story, no fiction, just sex. They are audiovisual dildos. Those films don't bother middle-class mores, whereas my films do, which is absolutely unbelievable.

Matteo Garrone

After *Gomorrah* (2008) was released in Naples, there were thousands of pirated DVDs of it, so the Camorra made money and were happy. I'm sure they didn't expect that the movie would be so successful, but it's not a movie that wants to denounce. It wants to be a metaphor for something more global.

In some way this movie provides a way for many people to better understand something that was hidden from them. It's the duty of the politicians, not the filmmakers, to change things. I can give information in this case, but—this is from Jean-Luc Godard—a movie is political by the

language it uses, not with what you are talking about. If the language is pure, it becomes political. The expression is important in a movie, as in painting and writing—not the content.

Gerardo Naranjo

As Godard said, framing, shooting, and cutting are political acts, even if you don't want your film to be political. Even deciding to shoot this way or that way is a political decision. I think my films are political in the sense that I try to make them entertaining, and I also want to speak to those who don't want to hear. Filmmakers have one responsibility—even if I hate the word "responsibility" because I think that's for grown-ups. Like Christians say, it's easy to convert a nun because she already believes.

We live in difficult times where the rule is ignorance and insensibility. So, if anything, we must speak to people who are not interested in what we have to say. And the only way we can do that is to try mixing entertainment with intelligence. I think that's the only requirement for the artist of today.

It's stupid to make elitist entertainment because nobody will see it and it won't change things. I'm speaking as a Mexican, not as a filmmaker, because I haven't a clue what that represents in the world. But as a Mexican filmmaker, I know I have to try provoking some change and motion in the people who see my movies. That's the origin of my films.

Then there is a second reason, the only reason I am a filmmaker. I love films, and I grew up frustrated because the only movies I could see were *Pretty Woman* (Garry Marshall, 1990) on the one hand or soap operas on the other. There was no cinema when I grew up, just Arturo Ripstein or Felipe Cazals—obscure Mexican filmmakers. So my generation of Mexicans has a huge identity crisis; we have no clue what we are because we never saw our streets, our girlfriends, our stories on the big screen. There's a hole we can't fill, and that's schizophrenic. Movies should obviously entertain, but it's something else to make movies people come to see and find out who they are, find a way to construct an identity. Then others will see who we are.

One of the most important consequences of making something personal is that it will communicate the universal, but the film has to be precise, deeply personal, and full of detail. It cannot aim to be universal from the beginning.

Jerzy Skolimowsky

I keep out of politics because I don't have any means to intervene. It's helpless; I can just watch as the disaster unfolds. I cannot do anything. I'm fully aware that film can manipulate people, but I haven't seen such a film recently. I manipulate my audience, but not in that political aspect. However, film definitely does reflect culture. Let's take the example of my British film, *Moonlighting* with Jeremy Irons (1982). Portraying the four Polish workers in London was definitely a cultural statement, but not a political statement because they were ordinary people. Although in a metaphorical sense you could say, "Alright, this leader of the guys could be a leader of Poland," but those are far-out interpretations. I'm aware that some people thought that was the metaphor, but it wasn't. I always try to base the film on reality, and the metaphorical sense can only be on top of that, the icing on the cake.

Brillante Mendoza

Film reflects culture, especially in my country, with a lot of social issues, as it's a third world country. If you notice, though, poverty is never an issue in my films. It's there, already a part of the lives, a fact of life, and these people just do their thing to survive. That is also part of my point in *Serbis* (2008)—that morality is relative, especially in a religious country like the Philippines, the only Catholic country in Southeast Asia. Our religion plays an important role in our lives, particularly because the Philippines is not only religious but also matriarchal. So *Serbis* is about the moral decay of the Filipino family.

I want to relate certain issues without any pretensions or hypocrisy, and reveal that these things really happen in my country. I'm not here to stop them or pretend that they are not happening. The only reason there are not more films dealing with these issues is that Filipinos themselves are often afraid to show what is really happening. Even the audiences are reluctant; they don't want to watch these kinds of films, and the government has problems with my films. They don't have a choice because my films are recognized all over the world, so it's like "we have to support him," and that's what they do now. But I've heard a lot about how they don't like my films. That's not at all surprising; I knew they wouldn't like them. That's why they submitted another film, one that hadn't even gone to any festivals, to the Academy for Oscar consideration in 2008.

Pablo Larrain

Most of the filmmakers in the book *Film Forum* tried to show a certain kind of humanity that is closer to reality in a poetic way. Their films use different emotions, make you feel different and think, and even help you travel somewhere else, and that's very nice. I've never been to Iran, but through the films of Iran I know a lot about it. I've never been to Bosnia, but Emir Kusturica has taught me a lot about Bosnia. I obviously never met Frederico Fellini, but he showed me worlds that will always be there because he captured that time on film, and that's beautiful.

Even though these characters in *Tony Manero* (2008) are people you get to see, know, and be in touch with, nobody takes care of them. Brazilian filmmaker Glauber Rocha said that violence and anger in Latin America in those days resulted from the ideological situation. They're in transit—the place we show in the film was like a cheap hotel where nobody really lives and nobody trusts anybody. They're just surviving, and that is important because the relationships are based on saving your own ass. That selfishness is not an attitude; it's a way of surviving. All that mixed up with this disco music thing makes the film interesting, because it turns out that these people are trying to understand what they're up against. These days, you save money or you care about somebody. These guys are just trying to get through the day, just be there and breathe enough to keep living. There's a dialogue exchange when the blond woman owner of the hotel asks the lead, "What are you going to do after this?"—when the disco phase passes and there's another new musical fashion—and he says, "No, it's not going to pass. Forget it, it's not a fashion. This is life, and it will always be like that." I don't know if he really thinks that, but I know when he says that, it's all he has. It's saving him in a way.

John Travolta's character in *Saturday Night Fever* (John Badham, 1977) is from a Catholic immigrant family, and he wants to succeed, experiment, and live the working-class hero American dream. But he's in the United States, where many things are possible. What's interesting is that my character thinks that reality is also possible for him. But he's wrong; he's in Chile during the Pinochet regime. He doesn't know much about anything. He's thirty years older than the John Travolta character, he doesn't look like John Travolta, and he doesn't dance as well. All these importations bring a natural damage. It's a bit fucked up, and when you put it on the

screen, it sends out weird, funny, dark, and mysterious feelings. In the end, it's allegorical, a metaphor for society, for the country. He's a result of a society; his impunity is the impunity of a government. His behavior is the behavior of a government, and his desires are also the desires of a government. This poor guy is trying to be like John Travolta. His is a tiny story, but a whole country was trying to be like the United States. It wasn't just the capitalist system; it was the words, the language, the television, the food, the way of dressing, the culture—everything was coming from the United States, and people were crazy about it.

The government reflected in this story is one part of it. The other part is that people were being killed because they thought, talked, or behaved differently, in ways the government thought they shouldn't. So the film is an allegory, even though it looks realistic—the time, the tone, the art. It's not an ideological statement though; it's just a point of view. Of course *Tony Manero* is a political film. I'm not trying to get away from that at all. I thought about that and intended it. But what we didn't do was to make any statement. It's not a pamphlet. We're not trying to say what is wrong or right or you should do this or that. We just tried to bring this whole story into a poetic mood and, hopefully, make you think as an audience. Sometimes films want to entertain people; sometimes films want to bother people and make them think. Maybe *Tony Manero* intends to make people think because there's nothing we can do about the Pinochet regime now. It was thirty years ago. So why try making a pamphlet now? If I had lived during those years, maybe; but perhaps we can get you to think about it and understand a little more about us. If the film does just a little in that direction and makes people realize certain things should not happen again, we would have made a great work even if we didn't intend to do that. If it happens, that would be beautiful.

Lucrecia Martel

In my view, Argentina is a classical South American country that was influenced by immigration during the nineteenth and twentieth centuries. That was enriching but created a problem—an upper class connected to Europe—and that created a society where social classes are also separated in terms of race, so social injustices become issues of race or ethnicity. For example, it seems normal in Argentina that white people

are in power positions and black or dark-skinned people are in working-class situations.

I come from a generation of Argentine film directors who are telling stories and making films after a period of dictatorship, and what a dictatorship does to a country is not only to cause more than thirty thousand people to disappear—among them, artists and filmmakers, of course—but also to create degradation in the texture of society itself.

Cinema allows us to reconstruct all that was destroyed. It's a way to refuse forgetting and blanking out things, a way not to accept the black holes created in our history.

Headless Woman (2008) triggered a dialogue in my province on this issue of social injustice. Actually, whenever I set out to make a movie, I have a political intent. I want to reshape the history and the dynamics of the country in which I live, although I am not sure if cinema can be a good tool for making a difference. In a way, cinema is consumed so much by the petite bourgeoisie that it becomes like preaching to the choir.

On the other hand, I have a sense that *The Dark Knight* (Christopher Nolan, 2007) is an intelligent reflection coming from the right. And *The Matrix* (Andy and Larry Wachowski, 1999) is not far from the philosophy that shaped ex-President George W. Bush's politics. There's a huge amount of talent in the United States, and we see it throughout the history of cinema, but little criticism there talks about what it means to act politically. Of course, there have always been directors who were highly enlightened in terms of history and what was going on, but what I do question is if that applies to the industry as such. For example, in 9½ *Weeks* (Adrian Lyne, 1986), which was presented at the time as a corrosive, transgressive movie about the anarchic way desire is handled by a couple, the scene that was viewed as most transgressive was where Mickey Rourke's character forces Kim Bassinger's character to steal something in a shopping center. That crime against private property was seen as something really transgressive, and to me it was naïve.

Cinema and literature need to suture breaks in the integration of the social texture so we can rebuild a community that was lost. In a way, cinema can become our collective memory, because the entire world has undergone degradation, and we need to work at rebuilding.

Ari Folman

I had no intention of making any general statement with *Waltz with Bashir* (2008). This was a completely different war for Israel than any previous one, because we were always attacked before. Sometimes when you confront civilians in big cities, you go home and don't want to talk about it. It's not like battlefield stories that can go to a level of bravery and glory. There's no glory entering a big city like Beirut, so this was a war with no glamour, a war that people don't talk about much.

For me personally, every kind of filmmaking is therapy. Because *Bashir* is so autobiographical, it was a dynamic therapy process. It's not just sitting in front of a shrink twice a week and paying a lot of money. You travel, meet people, talk, dig into research, write a screenplay, shoot, edit. You deal with it all the time for years. But if I had to sum it all up in one line, I'd say that in the end what matters is that, for example, five years ago, when I saw a photograph of myself at nineteen years old, I was completely disconnected to who I was then. But now, if I look at that photograph, I feel I can see this guy in me. In the end, this is what really matters; it's nothing bigger than that.

On a larger scale, since the film was released in Israel four months ago, my life has changed completely, not only because I travel so much, but also because everywhere I go—a wedding, a party—I find myself sitting in a corner with people I don't know who are telling me horrific war stories that suddenly emerged in them after they saw the film. And I have nothing to say to them except, "Go make a video of it." This is it. This film opens all the scars, and they feel the urge to talk about their past.

I don't think films generally can change people's opinions, but maybe, if kids, teenagers see it, they'll say, "I don't want to be a part of this sick thing." And if one or two of them say that, it's enough. Usually, antiwar movies are cool, and the men in the movies are cool guys, so when you watch as a teenager, you might say, "Wow, war sucks, but I want to be in this war because I want to be one of those men." I don't think anybody wants to be one of the guys in *Bashir*.

Courtney Hunt

Film reflects what's going on in the culture, and the culture is affected by film—it goes back and forth. Even the styles of film reflect back and forth with the culture, as with Tarantino's films—what he's saying, the way he's

interpreting and seeing the world and throwing it back at people. They see themselves in that, or they don't. Film is a giant mirror.

I have a problem with documentary because I think it entrenches people. I don't do documentary because I find it offensive to stick a camera in people's faces. I don't like that way of zeroing in on someone and asking for part of their soul. There are ways it can be done well, but I don't believe that the filmmaker can really distance him or herself. I go to see documentaries because they're voyeuristic, and I love that, but I don't want to be part of it.

Documentaries all claim to be objective, and none of them are, although *Trouble the Water* (Carl Deal and Tia Lessin, 2008) is amazing because they took it somewhere else, let it run off the rails. There are certainly documentaries that rise above the form, but I have trouble with the run-of-the-mill documentary, especially if it's with children or people who are severely traumatized. Then you have them sign waivers, and they have even less control. I started a documentary in film school when I discovered this group of about twelve African American and Latino kids from a poor school in Harlem. They used to play on my street, 112th Street, on this crazy apparatus that was two stories tall. They'd jump up and flip, so I called the movie *Flippin'*. It was incredibly dangerous; any mother who saw it would scream "No!" But no one was supervising them, and I made friends with them. They wanted to play with my camera, and I took footage of them. And of course, my Czech documentary teacher was going, "Oh my God, this is so amazing!" Then I realized that this was completely voyeuristic and sick, and I wasn't going to do it because they were six, eight, and nine years old! I had gone to their school, and, of course, they were all in special education. I had said to the teacher, "Hey, I'd love to hang out with you and shoot some footage." She couldn't even find most of their parents to get permission, so I said, "Let me take everyone to the zoo." We went to the zoo, and we were about to go in when she said, "Wait, we can't go into it yet because they can't eat in there. They want to eat their lunches first." It was about 9:30 in the morning. These were children in abject poverty, and they were afraid to go into a place where they couldn't eat for that amount of time. It was scary to them. By the way, the zoo was of no interest to them. Their lives were too traumatized. I wondered, "What am I doing? This is so wrong!" I realized I wasn't going to do the film; these babies were going to have to be their own little sweet

selves. I wasn't going to make a movie about what they had no control over. It was exploitative.

Shamim Sarif

Film can have a big influence. The power of visual images is very strong, especially in the world we live in now. There have been a lot of studies about why black empowerment happened twenty, twenty-five years ago, and why the Rodney King affair was such a huge thing when just the week before another black man was beaten and killed by the police on the streets of Los Angeles. No one remembers his name, but Rodney King's beating was caught on videotape and broadcast, so it had an effect. I see the effect movies and television have on my kids, and people call and e-mail me every day, saying that now they feel they can do this or that. I've walked out of movies feeling a little more empowered, and if that's a by-product, great.

I've also walked out of films feeling disturbed. A good example would be war movies—"Be a man, go to war and fight"—that glorify machismo. I have two young boys, and I don't want them to see this.

Jean-Marie Téno

Films impact culture everywhere. How do we know the dominant American culture all over the planet except through films? They impact the whole world. Kids are dressing like Americans everywhere, and there are all these other American trends. So when I approach a documentary, I not only present reality but I also use this reality to create, to give new meanings and to organize it in a different way in order to meet my own reflections on the state of Africa today. Film for me is always my own thoughts, how I am looking at a society, a culture. When I make a film, it's my vision of the reality that is surrounding me. So how is it impacting the culture? I don't know if it's impacting the culture, but I'm reflecting the effect that the culture I'm living in has on me. I'm putting that in the film, trying to shape that and bring new meanings to things I see. Making films is almost like looking at the world around me and trying to remodel it to my own thoughts and express what is bothering me.

Jihan El-Tahri

The voice you choose is something specific that relates to culture. Up until now, Africa has been seen from the outside in, and something important

about the culture is that we're in a space today where you can actually tell your story in the way that you see it, from inside. That's important because, culturally speaking, it's living up to that culture and seeing it with an emphasis that's very different.

For example, I followed the standard, common reading of the specific topic of *Cuba: An African Odyssey* (2007) at the beginning. The standard interpretation was that the common denominator didn't involve Africa and that the Cubans were fighting this cold war on behalf of the Russians, so African revolutionaries never had a space in the commentary. It was partially a proxy war, and I bought into that. But the more research I did, the more bothered I was. It was as though the Africans didn't exist; the Cubans, the Russians, the Americans, and the Portuguese were there, but not the Africans. I said, "I'm not buying into this. Let me look at it from a different angle." I started asking the questions differently because I was coming from a different space, and I knew that people like Patrice Lumumba existed and did change the nature of the reality. Where you come from and the position from which you choose to approach the topic are very cultural, and that's important. I started doing my research completely differently and, lo and behold, a whole chapter of untold history appeared, not just because I found it but because I asked the questions nobody had asked before.

Paul Schrader

Film has that documentary element. Whatever you're showing is real. Even if it's a set, it's a real set; someone actually built it. It's not imagined. Film has that kind of tactile quality, so when you go into people's lives, you see things. It reminds me of a story about Henri Langois, who believed you should save everything. He saved a lot of pornography and was asked about it later in his life. He said it proved to be a good decision because you need to look into decoration to understand people's lives. They used people's rooms for these films, so all that pornography showed how people of a certain class were living. Whereas, even in the movies, unless they're documentaries, you don't really see how people are living because they've designed and decorated the rooms for the film. So much of early silent film is now of interest purely in a kind of anthropological way. Like that documentary by Paul Strand, *Manhatta* (1921), full of his constructivist angles; but when we look at it today, we are most amazed by what people are wearing on the streets.

Özcan Alper

The 1980 coup d'état in Turkey brought silence there. Everyone just stopped what they were doing and embraced a defeatist attitude, and films became more melodramatic and fatalistic. It was an interesting transition to the nineties, when the spirit of the seventies came back. Today, people choose to tell smaller, more personal stories, and we can also observe a social change, especially in the nineties, in terms of how people perceive their nationality. There had always been an emphasis on the Turkishness of the culture and republic, but with the Kurdish debate in the late eighties, early nineties, people started realizing that so many other ethnicities contribute to what we call being Turkish now.

In 2000 a Turkish state operation called "Return to Life" put imprisoned students in fifty prisons into solitary confinement because they were protesting with hunger strikes that turned into death fests. Afterward, many political prisoners were released. I identified with my character because I was a student in the nineties, watching films with my friends, reading and educating myself about film history and other things, and that's how I encountered Godard, Italian neo-realism, and Russian cinema. Yusef's story in *Autumn* (2008) passes on the story of what student rebels went through in the nineties. He's a student, and although the USSR collapsed, he still believes in the socialist dream.

Cinema has always been political. I see films as a way to communicate with people, especially in terms of our hope for social change. I see cinema not as a propaganda tool but as a field that allows me to combine philosophy, aesthetic views, and political views. If you live in a country like Turkey, it pushes you toward that. To me, a director is one who has his own world and wants to share that world with others. And more than that, communicating this idea with others is a matter of survival. So it's like breathing to me; if I have something in my mind, I have to express it. That's how I live, how I survive.

Ivo Trajkov

We in Europe support cinema because of its cultural importance, not because the films will have a big audience. We are trying to build up our cultural identity, so we have freedom as auteurs to do films the best way that we feel. Right now there is more interest there in pop or mainstream culture—whatever you want to call it. But even if you eat the best fruits all

the time, one day you'll suddenly say, "I don't want any more of these. I will try something else." So that will eventually happen, and it will start a new wave of interest in auteur cinema. Auteur cinema was never for the big audience. Maybe it was lucky that in the sixties and seventies there was a cultural phenomenon that unified audience interest in those films. That definitely was the peak of film as a medium, and it won't repeat itself.

When I picked up the novel *The Great Water,* by Zivko Cingo, it was well known in Macedonia and dealt with the history of what happened there right after World War II. I felt that somehow I was able to respond to that question of history and that I needed to do that film. If we want to look toward a future, first of all, we need to go back to our past and say, "Okay, this was it, we know that, we reflect on that, and then it's a starting point to go forward."

First of all, you discover that people are individuals, and as individuals, people are always the same, through the centuries. They make the same mistakes, have the same traits. They believe in something, what they believe in fails, they are disappointed, but they need to go forward. That's everywhere, there's a universal idea behind all that. It's good when you discover something in your own history that you think is so specific, that nobody else understands. Then you find the lives of individuals and discover the universe inside them and that it's equivalent to any other nation in the world. Somehow you find that we're all connected anyhow. Of course, there are local things, specific things that add up to an entire story, but this basic notion of a universal idea—that's what's important as well. But I wouldn't find that element if I didn't go back to history and work with that period.

I decided the film *The Great Water* (2004) wouldn't just be about a period of communism or Stalinism in Macedonia but more about one man and his memories of his childhood, a personal story that's more than just a part of the history because a part of the history will be there anyhow, as background. It's much more interesting when a human story is in the center. Somehow it becomes a character-centered film more than a historical epic, which had been my starting idea.

Digging deeply, I discovered the responsibility of the individual, because it's the story of a childhood friendship. When the kid found his best friend and then betrayed him, he failed as a human being. He failed within a historical moment, so actually, every human being failed somehow. When

you take them together, you have this historical failure, and everything comes out from there. But there always is an individual, someone with a name, a surname, whom we can actually ask, "Why is this? Why exactly you? What were you feeling when you did this?" That's what I discovered, that there is always the responsibility of one individual, whether or not we say, "There was a war. It was society. There was an ideology." Yeah, that's true, but always you find that one guy with his name and surname who did something, and he needs to feel responsible.

Andrew Bujalski

One of the great frustrations is that one would like to believe that one's film is going to be understood by everyone, and of course, everyone doesn't understand. I'm sure that's something to do with age, and part of being older is joining society more. But you can't control how things are going to play in any culture, and, in a way, I see too many films that don't feel to me like their own kind of coherent work but like salvos in a cultural conversation—"This is what's going on in the culture, and we'll get some attention from it." Those are the films that are easy to market. Those films are getting made because someone has done demographic research that says everyone wants to see them. They're not always right, but the films you're most frustrated by are the ones where they were right. It's easy to get frustrated over worrying about what is and isn't popular. My wife sometimes thinks I'm lying when we see a film and I say, "I didn't get it." She says, "You mean you didn't like it." There are things I just don't like, but, Lord knows, when it comes to a lot of things that are great successes, I don't so much feel I didn't like it as I didn't get it. Not just the appeal, but what was it? So many Hollywood films have morphed into a form I just don't understand anymore.

I don't feel qualified to criticize because it's language I don't speak or know, as is evident in my films. I don't like to criticize for criticism's sake, and I assume everybody has their own perspective. If someone loves some movie I think is nonsense, I don't want to take that away from them unless I know why I'm taking it away, not just because I didn't get it.

Olivier Assayas

Viewers have been taught to think that cinema simplifies and explains the world in basic, Manichean terms. That alienates people because they end up not understanding the world they live in. They think everything

functions in such stupid, simplistic ways. Basically, these films hide the lies the government is telling them. So it kind of dumbs down people, but I can't find a better word than "alienate."

These films are part of the disaster of modern culture and the way people absorb things without even questioning them and do not understand the world we live in, let alone try to get a grasp on it. It is completely depressing, and I think movies are extremely guilty in this process because the rules of conventional narrative are, to me, part of modern oppression. When I discuss screenplays with this or that industry type, they say, "This is a good film," or "It has a problem in the third act," or "There's not enough of this or that, it lacks this or that." To me, it's like talking to media Nazis, because the world is complex, and simplifying the world is criminal. You owe it to your audience and to the world to be truthful in using the tools of your art. Otherwise, what's the point? You're just part of the problem.

I am convinced that movies, including bad movies, are contaminating our unconscious. The unconscious of individuals is affected by the stuff they ingest continuously. You are what you eat, and, sadly, you are what you watch. There are so many reflexes and automatisms we now have that are determined by stuff we've been swallowing subliminally. The dishonesty of modern cinema affects people and fucks up modern society.

Profiles of the Filmmakers

For more complete filmographies for these filmmakers, see the Internet Movie Database (www.imdb.com).

Tomas Alfredson (b. 1965)

© Tomas Alfredson

Swedish stage, television, and film actor/writer/editor/director Tomas Alfredson first drew significant notice with the internationally acclaimed features *Four Shades of Brown* and *Let the Right One In*, the latter a strikingly original take on the romantic horror genre that won numerous prizes, including the "Founders Award for Best Narrative Feature" at the 2008 Tribeca Film Festival and the European Fantastic Film Festival's 2008 Méliès d'Or for the "Best European Fantastic Feature Film," as well as four awards from the Swedish Film Institute.

Right One tells the story of Oskar, a flaxen-haired twelve-year-old tormented by bullies at school and ignored by adults at home, and Eli, who is more or less twelve, more or less a girl, and all vampire. Even before the film's theatrical release, the rights to an English-language remake were

snapped up, and it is slated for release in 2010. It will be a challenge to replicate Alfredson's controlled, ethereal direction, which not only freed the vampire film from overwrought conventions such as gory fangs and trembling bosoms but also infused his *Right One* with a low-key naturalism that proved wonderfully strange and compelling.

"One of my main tasks as an artist is to complicate things," says Alfredson. "If I can complicate things a little more than they were before, I am happy. I love when people ask, 'Where are they going at the end of the film? Is he going to be the new blood provider?' I don't know. It's up to you to decide—you are a grown-up."

Selected Filmography

2010: *The Danish Girl*

2008: *Låt den rätte komma in* (*Let the Right One In*)

2005: *Dear Mr. Barroso*

2004: *Fyra nyanser av brunt* (*Four Shades of Brown*)

2003: *Kontorstid*

2002: *Spermaharen*

Özcan Alper (b. 1975)

© GODLIS

A glowing meditation on love and loss set in the raw beauty of northern Turkey's rugged mountains, *Autumn* (*Sonbahar*, 2008) took "Best Film" and "Special Jury Prize" at Turkey's Adana Film Festival. Among Özcan Alper's achievements in this astonishingly assured debut feature is his poetic use of time and space as the film tracks a student activist just released from a lengthy prison term.

Alper was born in the small town of Artvin in northeastern Turkey, near where his film takes place. He became involved with alternative cinema groups as a university student when his interest shifted from physics to

cultural and political issues, much like his fictional lead character. Alper's first short, *Momi* (2001), received several awards and was the first film to be shot in the Hemshenli dialect spoken in northeastern Turkey, which is also one of three languages spoken in *Autumn*.

Olivier Assayas (b. 1955)

"I need movies," declares multiple-award-winning French auteur Olivier Assayas. "I suppose I would not be the same person if I hadn't found cinema, so I owe my life to it and to powerful movies that impressed me so much when I saw them at seventeen or eighteen, like *Pickpocket* by Robert Bresson (1959), *The Mirror* by Andrei Tarkovsky (1975), and Guy Debord's *We Spin Around the Night Consumed by Fire* (1978). They gave me a sense of the power of cinema, of how important an art form it is in the sense of how deeply you can affect people. They gave me the notion that this art form is worth dedicating your life to."

The son of writer/director Jacques Rémy, Assayas began his film career writing for *Cahiers du cinéma*. After establishing himself as one of contemporary cinema's most imaginative and socially provocative filmmakers, known for dazzlingly fluid storytelling and innovative ways of amplifying his characters' inner realities, Assayas published the book *Conversation avec Bergman* (1990). He was also one of the first European critics to direct attention to emerging Asian filmmakers, in part through his documentary on Taiwanese filmmaker Hou Hsiao-Hsien.

Selected Filmography

2010: *Les temps de venir* (*Times to Come*)
2010: *Carlos the Jackal*
2008: *L'heure d'été* (*Summer Hours*)
2007: *Boarding Gate*

2006: *Noise*

2004: *Clean*

2002: *Demonlover*

2000: *Les destinées sentimentales* (*Sentimental Destinies*)

1998: *Fin août, début septembre* (*Late August, Early September*)

1997: "HHH—Un portrait de Hou Hsiao-Hsien" (an episode of the television series *Cinéma, de notre temps*)

1996: *Irma Vep*

1994: *L'eau froide* (*Cold Water*)

1993: *Une nouvelle vie* (*A New Life*)

1991: *Paris s'éveille* (*Paris Awakens*)

1989: *L'enfant de l'hiver* (*Winter's Child*)

1986: *Désordre* (*Disorder*)

1982: *Laissé inachevé à Tokyo*

1980: *Rectangle—Deux chansons de Jacno*

Serge Bozon (b. 1972)

Like Olivier Assayas, Serge Bozon first became involved in film as a critic, in his case for *Traffic* magazine. He has also acted in many independent French films. *La France* (2007), Bozon's third feature, strikes a precise balance between naturalism and the surreal as it follows a lost company of French soldiers during World War I. Despite winning the prestigious Jean Vigo award at the 2007 Cannes Film Festival and enthusiastic critical reviews, this dark, engaging fable was "released in the United States in a peculiar way," says Bozon. "Someone in Seattle grouped together different theaters and they passed my movie from one theater to another, but there was no real distribution."

Bozon models his approach to filmmaking after classical Hollywood

directors in that he does not write his films' scripts. And like those legends he so admires, Bozon adapts his directorial style so extensively to each of the films he's made thus far that they seem to have been made by three different people. "I want to escape modernist signature effects," he explains. "Of course, there are similarities between my films—not many takes, the camera doesn't move much—but that's also like a classic film."

Selected Filmography

2007: *La France*
2002: *Mods*
1998: *L'amitié*

Catherine Breillat (b. 1948)

The fearless, brilliant actor/writer/director/producer Catherine Breillat confronts discomfiting truths about sexual politics with unmatched depth and an unblinking cool that never lapses into detachment. A few nonbe-lievers may dismiss her work as arty pornography, but Breillat insists on the film artist's natural right to depict nude human bodies, just like any sculptor, painter, or photographer. In fact, the wit and vulnerability in her films make for a kind of anti-porn, in that they are profoundly and intel-lectually provocative, the polar opposite of contemporary pornography's joyless, mechanical couplings.

All of Breillat's films contain a signature motif, the seaside scene, but Breillat's sea is not the traditional symbol of the feminine. "The sea is present but in a different way," she says. "The sea can have masculine elements. It can be brutal, ferocious, unpredictable, and violent, and, at the same time, it can be carnal, feminine, and poetic."

Selected Filmography

2009: *Barbe bleue* (*Bluebeard*)

2007: *Une vielle maîtresse* (*The Last Mistress*)

2004: *Anatomie de l'enfer* (*Anatomy of Hell*)

2002: *Sex Is Comedy*

2001: *Brève traversée* (*Brief Crossing*)

2001: *A ma soeur!* (*Fat Girl*)

1999: *Romance*

1996: *Parfait amour!* (*Perfect Love*)

1991: *Sale comme un ange* (*Dirty Like an Angel*)

1988: *36 fillette* (*Junior Size 36*)

1979: *Tapage nocturne* (*Nocturnal Uproar*)

1976: *Une vraie jeune fille* (*A Real Young Girl*)

Andrew Bujalski (b. 1978)

© Cinema Guild

Andrew Bujalski's low-key narrative films featuring casts plucked from his circle of interesting friends have won him acclaim as the most gifted of the so-called Mumblecore school, a term referring to the understated, naturalistic cinema style practiced by a growing number of American independents. Bujalski, who studied at Harvard University's Department of Visual and Environmental Studies, where Belgian filmmaker Chantal Akerman advised him on his thesis film, rejects this label as "restrictive."

"But all labels seem restrictive," Bujalski qualifies. "To devote my life to making something, I have to trick myself into thinking that I'm inventing cinema, so it's about exploring a new cinematic language for me. Of course, you put it out in the world, and the way the media is designed, people who respond to your film are trying to write something efficiently—'It's kind of like this and not like that.' I'm also a movie nerd, and it's written into the movie nerd's code that you say 'this' film is like 'that' one. I experience that impulse constantly, but it runs counter to what I want for my films."

Selected Filmography

2009: *Beeswax*

2006: *Mutual Appreciation*

2002: *Funny Ha Ha*

Charles Burnett (b. 1944)

© Dan Dennehey for the
Walker Art Center

"Without having any idea of a filmmaker, I always wanted to shoot a camera," says MacArthur grant–winning filmmaker Charles Burnett.

> I knew somehow that moving cameras existed, and I had an urge for that. When I was thirteen, a friend loaned me an 8 mm camera, and I stood under the freeway to shoot a propeller plane flying over my house. I didn't think about it again until one day, my junior high school teacher decided to predict what everyone was going to do. He went down the aisle: "You're not going to be anything." "You're not going to amount to anything." Same thing when he looked at me. It was a horrible experience, and I wanted to say something about that.

Burnett, who was born in Mississippi and raised in Watts, California, may have registered at the University of California, Los Angeles, to avoid fighting in Vietnam, but he soon realized that "everyone in the arts was using it as a means of social change, and that's how I got into film." His thesis film, *Killer of Sheep,* set in Los Angeles's South Central neighborhood, was his delayed but eloquent cinematic response to that junior high school teacher.

The film "presents this life and looks at these problems without telling you what to do," Burnett says. "There was no resolution because it reflects how people dealt with these issues all day long. We hoped it would be shown in the community, as a starting point for discussion." *Killer of Sheep*

was recognized in Europe as a groundbreaking masterpiece after winning
a prize at the 1981 Berlin Film Festival—the first of Burnett's many awards.
In 1990 it was selected by the Library of Congress to be preserved in the
United States Film Registry because of its historical, cultural, and aesthetic
significance.

Yet earning a living as a filmmaker has been a struggle, and Burnett
often takes on "turn-key" television directing jobs. No wonder he dismisses
as "a joke" the phrase often used to describe him: "one of our country's
greatest filmmakers."

Selected Filmography

2007: *Namibia: The Struggle for Liberation*
2003: *Nat Turner: A Troublesome Property*
1996: *Nightjohn*
1995: *When It Rains*
1994: *The Glass Shield*
1991: *America Becoming*
1990: *To Sleep with Anger*
1984: *Bless Their Little Hearts*
1983: *My Brother's Wedding*
1977: *Killer of Sheep*

Pedro Costa (b. 1959)

© GODLIS

Many of the films directed by Portuguese auteur Pedro Costa are set in
the grimy rubble of Fonthainas, Lisbon's poverty-stricken slum, where he
holds its disenfranchised, often drug-addicted inhabitants in tight frames
for interminable takes punctuated by meandering, semi-audible conversa-
tions. Costa's uncompromising style has earned him an unofficial title, the
"Samuel Beckett of cinema," and he is revered by many of his peers for

boldly challenging the limits of his art form in order to achieve a refined level of artistic truth.

Costa's sociopolitical point of view was formed when he was a young man playing in a punk rock band at the same time that his country was going through a political upheaval, and his viewpoint has not altered since. "It was really an important moment, crucial for me because there was a revolution in my country, from '74 through '76, that turned wrong. It was the moment when I began seeing the films that made me, by Straub, Godard, the Japanese, the American classic films, and, at the same time, there was some sort of politics. People were in the streets, I was thirteen. I got everything together in that moment, and everything made sense together. Straub was as fast and furious as the Clash. For me, it was exactly about that, about almost a moral attitude. I still think the same thing actually."

Selected Filmography

2009: *Ne change rien*
2007: *O estado do mundo* (*State of the World*)
2007: *Memories*
2006: *Juventude em marcha* (*Colossal Youth*)
2001: *Où gît votre sourire enfoui?*
2000: *No quarto da Vanda* (*In Vanda's Room*)
1997: *Ossos* (*Bones*)
1994: *Casa de lava* (*Down to Earth*)
1989: *O sangue* (*Blood*)
1984: *E tudo invenço nossa*

Constantin (aka Constantino; Constantine) Costa-Gavras (b. 1933)

© Pathé

"I was in France when I saw *Greed* by Erich von Stroheim (1924), the first movie that made me understand cinema could be different from what I

used to see in Greece," recalls Costa-Gavras. "I understood then that a movie could just follow two characters crossing a desert, have a tragic end, and could last more than two hours."

Born into a poor family in the village of Loutra Iraias, Aracadia, Greece, Costa-Gavras was not allowed to attend university in his country or emigrate to the United States because his father, a member of the left-wing EAM branch of the Greek Resistance, was imprisoned as a suspected communist. So Costa-Gavras studied film in France, apprenticed under Yves Allegret, and became an assistant director for Jean Giono and René Clair.

"The director must be present from the beginning to the end and say what is good, what he likes to do and what he doesn't like to do," he says. "You can't even let great technicians do what they want. At every point, the sound, the acting, the editing must be the director's choice. The director has the last word, every time."

Costa-Gavras's debut film, *Compartiment tueurs,* was the first of this legendary director's distinguished body of work, which has garnered, among many prizes, two Oscars and two British Academy of Film and Television Arts awards (BAFTAs) for screenwriting, the Cannes Film Festival's Palme d'Or, and the Berlin Film Festival's Golden Bear. From 1982 to 1987, Costa-Gavras also served as president of the Cinémathèque Française.

Best known for merging controversial political issues with the entertainment impact of commercial thrillers, Costa-Gavras helped advance cinematic storytelling by trimming away the fat of excess exposition in early masterpieces such as *Z.* Costa-Gavras's films often raise issues of law and justice, oppression, violence, and torture. Even though *State of Siege* and *Missing* were produced by Hollywood studios, Costa-Gavras trained his sights in both films on authoritarian Latin American governments that were supported by the United States during the cold war.

Selected Filmography

2009: *Eden à l'ouest* (*Eden Is West*)

2005: *Le couperet* (*The Ax*)

2003: *Amen*

1997: *Mad City*

1995: *Lumière & Company*

1993: *La petite apocalypse* (*The Little Apocalypse*)

1989: *Music Box*

1988: *Betrayed*

1983: *Hanna K.*

1982: *Missing*

1979: *Clair de femme* (*Womanlight*)

1975: *Section speciale* (*Special Section*)

1972: *État de siège* (*State of Siege*)

1970: *L'aveu* (*The Confession*)

1969: *Z*

1967: *Un homme de trop* (*Shock Troops*)

1965: *Compartiment tueurs* (*The Sleeping Car Murders*)

Claire Denis (b. 1948)

© Film Forum

"It doesn't matter that more women are making films these days," says the celebrated French auteur Claire Denis. "I always keep in mind what Maurice Pialat said, that when women start invading cinema, film will be almost dead, because if it was still precious, men wouldn't let it go. He means the fabulous time of cinema was very short, in the thirties, forties, and fifties, and that's true. People can watch cinema on cell phones now, so in a way, it's because cinema is more open that women can get in."

Denis "got in" with *Chocolat,* her intoxicating debut feature set in French colonial Africa, where she was born and raised. Her subsequent films are more often set in Paris, but they continue to read as vivid reflections of the larger dynamic as they examine, in telling and evocative detail, the ways in which the neocolonial legacy plays out in the intertwined lives and destinies of France and the people of its former colonies.

Selected Filmography

2009: *White Material*

2008: *35 rhums* (*35 Shots of Rum*)

2005: *Vers Mathilde*

2004: *L'intrus* (*The Intruder*)

2002: *Vendredi soir* (*Friday Night*)

2001: *Trouble Every Day*

1999: *Beau travail* (*Good Work*)

1996: *Nénette et Boni* (*Nenette and Boni*)

1994: *J'ai pas sommeil* (*I Can't Sleep*)

1994: *Boom-Boom*

1991: *Keep It for Yourself*

1989: *Man No Run*

1988: *Chocolat* (*Chocolate*)

Sergei (aka Sergey) Dvortsevoy (b. 1962)

© Film Forum

Tulpan, award-winning Kazakh documentarian Sergei Dvortsevoy's rapturous first feature, took the Cannes festival's Un Certain Regard award, then went on to win universal critical superlatives. Yet Dvortsevoy arrived at his vocation "just by chance," after reading a newspaper ad for a Moscow film school while working as an airplane radio engineer. "I decided to make my life more interesting and creative," he recalls. "I joined the documentary department; I didn't even know what that was. I thought maybe I'd taken someone else's place, but step by step, I realized it was right for me."

Set in the vast, land-locked expanse of Kazakhstan's Hunger Steppe, *Tulpan* exemplifies how local, small-scale observational filmmaking at its best can offer far more emotion and fascination than assembly-line Hollywood blockbusters. Asa, a young man just out of the navy, attempts to woo Tulpan, the only unmarried young woman for many miles around, so that he can move from his brother-in-law's yurt and get his own herd of sheep. The film's mise-en-scène—the characters are surrounded by 360 degrees of unbroken horizon—clarifies their isolation, as well as the universality of the

family's daily dramas. Among Dvortsevoy's most notable achievements in this film, which took four years to make, are powerful performances delivered by a distraught mother camel and a ewe that gives birth onscreen in a harrowing ten-minute scene. "The most difficult thing for the actors was to be as strong as the animals," he says, "because all the animals in the film are fantastic, and the actors could not be worse."

Selected Filmography

2008: *Tulpan*

2004: *V temnote* (*In the Dark*)

1999: *Highway*

1998: *Chlebnyy den* (*Bread Day*)

1996: *Schastye* (*Paradise*)

Jihan El-Tahri (b. 1963)

Jihan El-Tahri became a documentary filmmaker after exhausting the challenges of her career as a journalist for such prominent international news outlets as the *Washington Post* and *U.S. News and World Report*, and as the author of two well-received nonfiction books. "I suddenly realized that I could tell you who I was with and what they were doing, but I had no distance," recalls El-Tahri, who was born in Beirut, raised in Egypt, and lives in Paris. "I had a massive identity crisis. I needed to find a way to discover what was important to me about the story, from my perspective and with my aesthetics. I know every trap of journalism, and that's what I was running away from."

El-Tahri went to "film school" by taking any film production job she could get. "I started from the very bottom of the ladder," she recalls. "I was a runner, an assistant. I did every shit job in the business, which was great. I have no problem downgrading if that's the niche I need to learn."

She then began directing and producing documentaries for French television and the BBC, including *The House of Saud,* for which El-Tahri filmed scenes in Osama bin Laden's training camps in Sudan. *Behind the Rainbow,* her latest film, unearths in painstaking detail the roots of the dissension plaguing South Africa's African National Congress Party. In less skilled hands, such material could turn dry and dusty, but El-Jahri's imaginative, bold direction enlivens facts and lends them a gripping urgency.

Selected Filmography

2008: *Behind the Rainbow*

2007: *Cuba, une odyssée africaine* (*Cuba! Africa! Revolution!* and *Cuba: An African Odyssey*)

2005: *House of Saud*

2003: *Les maux de la faim* (*The Price of Aid*)

2001: *L'Afrique en morceaux*

Ari Folman (b. 1963)

© Ari Folman

Gorgeous, terrifying, and heartbreaking, *Waltz with Bashir,* Ari Folman's 2008 Oscar- and Palme d'Or–nominated animated documentary, received international acclaim for its fierce honesty and groundbreaking visual techniques and won the documentary award in 2008 from the Directors Guild of America. Yet Folman, like Sergei Dvortsevoy, never intended to become a filmmaker. After serving in the Israeli army, he traveled with the intention of going "around the world like everybody in Israel," he says.

I was a bad traveler, not good with a backpack, sleeping bags, and dirty guest houses, but too arrogant to go back home to say "I quit." So I

moved from one country to another every month, and I invented the whole trip by sending letters back home relating stories I'd heard from different travelers. I got such a great response—"Wow, you're having so much fun. We envy you"—that I enjoyed the writing much more than the traveling. I decided to go home and do something with storytelling, and that's how I ended up in film school.

Folman also claims to have been "clueless" when he arrived at film school. "I didn't know who Godard and Antonioni were," he says. "Luckily, the history of film was only ninety years, so I could easily watch one video a day and complete everything in two years. From the very first day, I knew this was what I wanted to do."

Folman's graduation thesis, a documentary shot during the first Gulf war, consisted mainly of interviews "with people in their sealed rooms, waiting for an Iraqi missile attack," he says. "It was funny because they're having anxiety attacks, thinking they are about to die, but nothing happened in that war."

Nothing was humorous about the 1982 Israel-Lebanon war explored by *Bashir,* which employs richly atmospheric comic-book noir animation to track Folman's real-life, four-year quest to recover his memories of serving in that war and witnessing the massacre of Palestinian refugees in the Sabra and Shatila camps outside Beirut by Christian Phalangists enraged over the assassination of their leader, Bashir Bemayel. As Folman seeks out army buddies, the film recounts their real-life experiences through fantasies, flashbacks, hallucinations, and dreams.

"I never thought it could be done any way other than as an animated documentary," Folman says, "never as a fiction film or a classic documentary. Before even writing it, I imagined it with drawn characters. The only way to bind together all the film's themes—memory, lost memory, dreams, subconscious, hallucinations, drugs—into one storyline is through animation."

Selected Filmography

2008: *Vals im Bashir* (*Waltz with Bashir*)
2001: *Made in Israel*
1996: *Clara hakedosha* (*Saint Clara*)

Matteo Garrone (b. 1968)

© GODLIS

The son of a theater critic and a photographer, costume designer/writer/ director Matteo Garrone won the 1996 Sacher d'Oro award sponsored by director Nanni Moretti for his short, *Silhouette,* which became one of the three episodes in Garrone's first feature, *Terra di mezzo.* His subsequent films also won prizes, but it was the electrifying organized-crime epic *Gomorrah* that took Garonne to the forefront of international cinema, claiming top awards at Cannes, the European Film Awards, and elsewhere.

Realistic, artful, chilling, and shot through with moments of antic humor, Garrone's film is set in an area of Naples controlled by the Camorra, where human life is little more than disposable garbage. Adapted from Roberto Saviano's best-selling 2006 nonfiction book, *Gomorrah* neither judges nor romanticizes the characters in the film's five interwoven stories. The result presents a vividly persuasive portrait of life under the rule of the mob and also implies how far its influence extends in the world.

"It was important that everyone in the world understand each character's human conflict and the consequence of each one's decisions in a territory at war, governed by that system," says Garrone.

So we decided to tell the story from the bottom, not from the top, the bosses. Instead of talking about Roman emperors, we talk about slaves. We probably disappointed all the real bosses who were waiting for a movie about themselves and thought, "How can the life of these slaves be interesting?" The movie always told us what to do. Sometimes it was as if the movie told me what language to use. I had to be open-minded, and I really don't know what I've done, honestly.

Selected Filmography

2008: *Gomorrah*

2004: *Primo amore* (*First Love*)

2002: *L'imbalsamatore* (*The Embalmer, The Taxidermist*)
2000: *Estate Romana* (*Roman Summer*)
1998: *Oreste Pipolo, fotografo di matrimoni*
1998: *Ospiti* (*Guests*)
1998: *Un caso di forza maggiore*
1996: *Silhouette*
1996: *Terra di mezzo*

Bette Gordon (b. 1950)

© Bette Gordon

During Bette Gordon's college year abroad at the Sorbonne in Paris, a friend suggested they take a film course taught by someone from *Cahiers du cinéma*. "I ended up falling in love with film and politics in Paris, of course," Gordon recalls. Upon returning to the University of Wisconsin, she earned a master's degree in film and another master's in art. After collaborating with an experimental filmmaker, Gordon made her own "mini-feature," *Empty Suitcases*, which drew an offer from German public television station ZDF to fund her first full-length feature, *Variety*, a vividly impressionistic, unflinchingly authentic landmark of American independent cinema.

"The offer spiraled me forward, away from the experimental form to what was becoming New York City independent filmmaking in the 1980s," Gordon recalls. "We all worked together, and it was an organic, natural process. If anyone needed someone to show up to work on a film, they showed up. It wasn't about getting known actors, and you made the film with whatever money you had. We were just happy to be working and enjoying ourselves making art."

Gordon's recent film, *Handsome Harry,* was made with that same collaborative spirit, but "the independent world has changed," she says. "It's been so structured by the distribution companies and exhibition

spaces, that in order to get A, you need B, and in order to get B, you need C. There is such a train of expectations that you have to meet in order to make a film today."

Selected Filmography

2009: *Handsome Harry*
1998: *Luminous Motion*
1983: *Variety*
1980: *Empty Suitcases*

Eric Guirado (b. 1968)

© Unifrance

"I didn't choose the story, it chose me," says French filmmaker Eric Guirado of his second feature, *The Grocer's Son*, a surprise box-office hit in France, in part for its nuanced portrait of a vanishing way of life. Guirado worked for eight years on and off on his script about a thirty-year-old who reluctantly heads home to the country after failing at work and love in Paris in order to take over his family's mobile grocery. The film explores what happens when sons don't follow a father's bidding, "even if it's not a huge heritage but something small, like taking over a village grocery," Guirado says. "I also wanted to talk about those people you only see as a folkloric element in French movies—the country people in deep parts of France, places we never know about."

Guirado's first film, *Quand tu descendras du ciel,* titled after a French Christmas song, is about a reverse journey—a farm boy goes to the city—so it's not surprising to learn that Guirado was raised in France's countryside, the son of a factory worker and a house cleaner. He moved to Lyon at eighteen to study biology and spent every free moment writing, photographing, and experimenting with theater. "I didn't know yet that I wanted to make films because I thought that was another galaxy, something impossible," he says. "But when I went to a short-film festival close to Lyon, I had an

awakening. Even the bad shorts told me I should do that, because I was drawing, painting, playing music, and writing, but not that well. However, I could gather people with my enthusiasm, creativity, and a story in order to make movies."

Selected Filmography

2007: *Le fils de l'épicier* (*The Grocer's Son*)
2003: *Quand tu descendras du ciel*

Lance Hammer (b. 1967)

After graduating from the University of Southern California with a degree in architecture, Lance Hammer stayed employed as a Hollywood art director and musician while working for several years on *Ballast* (2008), his debut feature, which won the awards for best director and cinematography at the 2008 Sundance Film Festival.

Ballast's unhurried rhythms and spare, beautifully composed shots infuse its story about the fall-out from one man's suicide on three people with the sweet dark melancholy of a Delta blues. Hammer brought to life the conflicts and truths that bind these people together through the convincing performances he coaxed from a cast of non-actors.

IFC Entertainment snapped up the film's distribution rights at Sundance, but Hammer pulled out of the deal so that *Ballast*'s own production entity, Alluvial Film Company, along with Steven Raphael's Required Viewing, could release the film. Hammer's decision highlights a harsh reality confronting independent American filmmakers, for whom distribution advances or "minimum guarantees" sometimes barely recoup a film's budget while forcing directors to give up control. Yet independent film distributors are struggling themselves in a market where conventional exhibition platforms and DVD sales are dwindling as digital downloading increases.

Mia Hansen-Love (b. 1981)

© GODLIS

A thirteen-year-old ethereal blond walking down a Parisian street is spotted by Olivier Assayas's casting director. She wins the role of a middle-aged writer's nymphet girlfriend in Assayas's *Late August, Early September* (1998) and another supporting part in his *Sentimental Destinies* (2000). Just seven years later, that young woman, now engaged to Assayas, is awarded France's prestigious Caesar and Louis Delluc prizes for Best First Film of 2007 with her feature debut as a writer/director, *Tout est pardonné* (*All Is Forgiven*), an achingly lovely film about the reconnection of an estranged father and daughter. Hansen-Love's second project, *Le père de mes enfants* (*The Father of My Children*), won the 2009 Un Certain Regard award at Cannes.

"It's been an existential experience," says the director of her meteoric success. Hansen-Love, who also wrote for *Cahiers du cinéma*, describes her teenaged self as depressed. "The experience of acting with Assayas was cathartic," she says.

> But playing someone else wasn't an escape to another reality; it was liberating, because embodying another's physicality somehow reunited me with myself. What was also so determining was that acting established my relationship to fiction. To me, writing is the heart of every artistic undertaking. Whether you're a writer or a painter, writing is still essential. That's how I see things and how I approach art. So I moved on from acting to film criticism.

All Is Forgiven recounts the story of a French writer who retreats from his Austrian wife and their young daughter into heroin addiction. Eleven years later, his daughter begins to reconnect with her long-lost father. The film draws on Hansen-Love's own family legacy of melancholia—her Viennese grandfather committed suicide—as well as the true story of her father's younger brother. "It's not biographical, though it's the most personal film

I could make," she explains. "I grew up with questions about destiny, the meaning of life, and the sadness so prevalent in our family. For me, this story is a question of the transmission of sadness, of how, on the one hand, one wishes to accept and recognize that sadness and how, on the other, one desires to be free of it."

Mary Harron (b. 1953)

© Mary Harron

Mary Harron co-founded *Punk* magazine and was the first writer to interview the Sex Pistols for an American publication—fitting preparation for the edgy blend of cool wit and dark adventure that distinguishes her work in *I Shot Andy Warhol*, based on the true story of feminist fundamentalist Valerie Solanas; *American Psycho*, adapted from Bret Ellis's best-selling novel about a Wall Street yuppie who is a serial killer; and *The Notorious Bettie Page*, a cheeky account of the legendary fifties pinup's life and career.

When not writing and directing feature films, directing episodes for prestigious television series, or teaching student filmmakers at New York University, Harron and her husband, filmmaker John C. Walsh, make short films with her digital camera. "We made a short with our two daughters for 'Creepy Christmas,' a friend's online film festival that's an event calendar with a different film for each day," says the writer/director. "Our day is December 24th, and our film is *The Night before Christmas*. I worked on the script with my older daughter, Ruby, and Ella was the main character. The kids were free, we shot with our digital camera, and John edited it. It was a lot of fun to film something without any great drama about it."

Selected Filmography

2010: *The Moth Diaries*
2005: *The Notorious Bettie Page*
2000: *American Psycho*
1996: *I Shot Andy Warhol*

Scott Hicks (b. 1953)

© Scott Hicks

Shine, Scott Hicks's feature biography about troubled classical pianist David Helfgott, premiered at the 1986 Sundance Film Festival and won the Oscar for Best Actor, as well as Oscar nominations for Best Actor in a Supporting Role, Best Director, Best Film Editing, Best Music—Original Dramatic Score, Best Picture, and Best Writing. Hicks already owned an Emmy for his documentary *Submarines: Sharks of Steel* (1993) and a Peabody Award for *The Great Wall of Iron.* He continues to add to a diverse body of work that balances between Hollywood productions, independent features, and documentaries.

"It's hard to say why certain ideas appeal more than others," says Hicks. "I've never really tried to rationalize why I choose particular subjects for films, because I really don't know. What interested me in Helfgott was the disconnect between his apparent incompetence as a human being and his unbelievable competence at the keyboard. I couldn't understand how the same person could be those two things. As I started to discover his story, the layers peeled back, and it became more and more fascinating." A midnight screening of *Koyaanisqatsi* (Godrey Reggio, 1982), featuring Philip Glass's score, led to Hicks's *Glass: A Portrait of Philip in Twelve Parts,* for which Hicks also acted as camera person.

Not surprisingly, he is sometimes asked, "What's with you and musicians?" During an audience question session following a *Glass* screening at the IFC Center in downtown Manhattan, one fan proposed that Hicks might suffer from "pianist envy." "I'd thought only therapy could answer that," says Hicks, "but now I know—it's pianist envy—and I'm prepared to accept it."

Selected Filmography

2009: *The Boys Are Back in Town*
2007: *Glass: A Portrait of Philip in Twelve Parts*
2007: *No Reservations*
2004: *I'm Only Looking: The Best of INXS*

2001: *Hearts in Atlantis*

1999: *Snow Falling on Cedars*

1996: *Shine*

1990: *Call Me Mr. Brown*

1989: *The Great Wall of Iron*

1988: *Sebastian and the Sparrow*

1985: *The INXS: Swing and Other Stories*

1985: *Family Tree*

1983: *One Last Chance*

1982: *Freedom*

1982: *The Hall of Mirrors: A Festival*

1980: *Assertive Skills Training*

1979: *You Can't Always Tell*

1975: *Down the Wind*

1974: *The Wanderer*

Courtney Hunt (b. 1964)

© Courtney Hunt

Courtney Hunt's mother "was intent on having me see what was around me," says Hunt, who was raised in Memphis during the civil rights movement. "That taught me not to miss people along the way. Just because they work in the dollar store doesn't mean they're not decent."

Althea Faught, Hunt's Columbia University master's of fine arts thesis film, aired on PBS television's *American Playhouse,* and Columbia's faculty awarded it the highest finishing funds of any previous student film. It also won First Prize in Directing from New Line Cinema. Hunt's next project, the bleak, beautiful, uncompromising short film *Frozen River,* premiered at the New York Film Festival in 2004, and the feature-length version of *Frozen River* won the Grand Jury Prize at the 2008 Sundance Film Festival, prompting juror Quentin Tarantino to praise the film as "a wonderful

depiction of poverty in America. It took my breath away and then somewhere around the last hour it put my heart in a vice and proceeded to twist that vice until the last frame."[1] *Frozen River* went on to take numerous other American and international film awards, and received Oscar nominations for Hunt's screenplay and Melissa Leo's lead performance as Ray, an upstate New York mother of two abandoned by her gambler husband, who left with the money she had saved to replace their ramshackle trailer. Desperate, Ray teams with a Mohawk woman to smuggle people across the Canadian border into America.

"I tend to be interested in marginalized people," says Hunt, who holds a law degree from Northeastern University. "I'm an observer, and what's going on in the mainstream is less interesting to me than the issues I've observed. I'm all about writing about location. I go somewhere and I want to know all about that place—who lives there, what grows there, who works there."

Frozen River was shot in near arctic winter conditions at the Canadian border. "We had exactly the amount of time we needed, and if anything had happened to slow us down, we wouldn't have finished the movie," says Hunt. "We just kept going. The camera stopped working for two hours once because of the cold, but we shot twelve-hour days for twenty-four days, and we got it done."

Agnès Jaoui (b. 1964)

One of France's most successful filmmakers, Agnès Jaoui writes, produces, directs, and stars in internationally popular, enthusiastically reviewed films and theatrical plays that artfully blend humor with pathos. She shares writing, producing, and acting credits with her former husband, Jean-Pierre Bacri.

[1] Quoted in Ryan Pearson, "'Frozen River' Best Drama at Sundance," *USA Today*, January 26, 2008; www/usatoday.com/life/movies/2008-01-26-181860732_x.htm (retrieved September 13, 2009).

Janoui met actor/writer Bacri when she was twenty-four years old and "he was already famous." The pair wrote a five-character play in which they planned to play the leads along with a friend. "A big theater wanted our play and Jean-Pierre, but they wanted the other roles filled by stars," says Jaoui. "So we staged it in a little theater. It was such a success that the big theater, which had put on a flop featuring two big stars in the meantime, begged us to come back." From that point, the Bacri-Jaoui partnership has never lacked financing.

Also a trained singer, Jaoui released *Cantata*, a collection of Latin songs, in 2006, and in the summer of 2008, she adopted a brother and sister from Brazil, adding "mother of two" to her impressive résumé.

Selected Filmography

2008: *Parlez-moi de la pluie* (*Let It Rain*)
2004: *Comme une image* (*Look at Me*)
2002: *Le goût des autres* (*The Taste of Others*)

Kiyoshi Kurosawa (b. 1955)

© GODLIS

Kiyoshi Kurosawa is most widely known as the unpredictable, prolific maker of diabolically terrifying horror films and thrillers, but the actor/writer/director demurs. "I love horror films, and I've done a lot of them, but I actually don't consider myself to be a horror specialist," he says. "Like other filmmakers in Japan, I don't feel boxed in by the Japanese audience. I recently made a bunch of horror films in a row, so I wanted to get out of that genre altogether; but the distributor decided to label some of my films as horror that I actually didn't make as horror films because it would be easier to sell them. Frankly, that gives me pause."

The bloodletting is mostly metaphorical in *Tokyo Sonata*, an unfailingly intelligent, emotionally probing family melodrama infused with surreal

touches. When a Tokyo husband and father is laid off from his job, he discovers that he is part of a vast army of unemployed men who wander the streets each workday because they're ashamed to tell their families. As the situation at home unravels, the film speaks to the horrors of modernity in ways that proved to be startlingly prescient, given the violent collapse of the world economy that followed soon after the film's appearance at the 2008 New York Film Festival. "I think it's fair to say that *Tokyo Sonata* anticipatorially reflects reality," says Kurosawa, whose many international film awards include Cannes's Un Certain Regard prize for *Sonata*. "Some of the events you see on-screen haven't taken place yet, but Japan is a heartbeat away from this, including the idea of Japanese youth volunteering for the U.S. military. It could well happen."

Selected Filmography

2008: *Tokyo Sonata*

2006: *Sakebi (Retribution)*

2005: *Rofuto (Loft)*

2005: *Umezu Kazuo: Kyôfu gekijô—Mushi-tachi no ie (Kazuo Umezu's Horror Theater: Bug's House)*

2004: *Ghost Cop*

2003: *Dopperugengâ (Doppelganger)*

2003: *Akarui mirai (Bright Future)*

2001: *Kairo (Pulse)*

2000: *Kôrei (Seance)*

1999: *Oinaru genei (Barren Illusions)*

1999: *Karisuma (Charisma)*

1998: *Ningen gokaku (License to Live)*

1998: *Hebi no michi (Serpent's Path)*

1998: *Kumo no hitomi (Eyes of the Spider)*

1997: *Cure*

1997: *Fukushu the Revenge Kienai Kizuato (The Revenge: A Scar That Never Disappears)*

1996: *Doa 3 (Door 3)*

1992: *Jigoku no keibîn (The Guard from the Underground)*

1989: *Abunai hanashi mugen monogatari*

1989: *Sûîto Homu* (*Sweet Home*)

1985: *Do-re-mi-fa-musume no chi wa sawagu* (*The Excitement of the Do-Re-Mi-Fa Girl*)

1983: *Kanda-gawa inran senso* (*Kandagawa Wars*)

1982: *Tôsô zen'ya*

1980: *Shigarami gakuen*

1977: *Shiroi hada ni kurû kiba*

1975: *Bôryoku kyôshi: Hakushû dai satsuriku*

Pablo Larrain (b. 1976)

© GODLIS

After graduating from film school in his native Santiago, Chile, Pablo Larrain founded Fabula, a company dedicated to audiovisual and communications development, through which he has carried out his two film projects thus far. Larrain's first feature, *Fuga* (*Fugue*, 1996), drew international notice, and among the awards won by *Tony Manero* (2008) were the Best Film and Film Critic's awards at the Turin Film Festival, where lead actor Alfredo Castro also took Best Actor.

Tony Manero, a grim, almost documentary-style "musical," follows a middle-aged psychotic killer obsessed with impersonating John Travolta's character in *Saturday Night Fever* (John Badham, 1977). The result is a gritty, terrifying allegory about the spell cast by American pop culture during the dark years of General Augusto Pinochet's police state.

"What I think I've done, and what I appreciate from other filmmakers, is to tell the story of course, but most important of all, find the tone, the atmosphere," says Larrain. "If you have that, the rest is probably easier. The hardest thing is to find the right atmosphere for a film—the skin, the tone, the mood."

Anne Le Ny (b. 1962)

Anne Le Ny was already well known to international filmgoers as a fine character actress when she wrote two screenplays. Almost immediately, both were made into films and released in 2007. Someone else made *En visite,* while Le Ny directed Emmanuelle Devos and Vincent Lindon in *Ceux qui restent* (*Those Who Remain*), about a love affair between a man and woman who meet in a hospital where their partners are being treated for cancer. By turns poignant and comical, the film is a finely tuned study of a doomed relationship.

As a young girl, Le Ny wanted to be either an actress or a writer, and even after her success as an actress, she continued writing. She says she became an actress out of "narcissism, which is a regular reason, and also because I love stories, which is why it's not so strange to go from acting to writing and directing—they're all ways of telling stories."

"I wrote the first screenplay to prove to myself that I was able to write an entire one, but I didn't want to direct it," Le Ny continues. "I never thought I could become a director because there were no models. You had to be from a very cinematic family, and my parents were scientists."

It wasn't until she wrote her second screenplay, *Those Who Remain,* that Le Ny finally felt ready to direct. "My boyfriend calling me a coward about a hundred times a day helped me decide," she adds. As it happened, both films began shooting on the same day, but *Remain* was far more successful and nominated for three Caesar awards, including Best First Film in 2007, a year in which all the nominees for that category were women.

"We were asked in interviews if this was a kind of new wave," says Le Ny. "I said, 'We can tell it's a new wave when there are five nominations for Best Film, because we all know that first films are the cheapest. So when they're ready to give big budgets to women, then we will see.'"

Lucrecia Martel (b. 1966)

"I did not have that much cinematic culture where I grew up," says Argentine writer/director Lucrecia Martel.

> What drew me to cinema was my grandmother's oral storytelling and the adult conversations I heard as a child when I went with my grandmother to visit her bedridden friends. I observed that when people are really engaged in conversation, the boundaries of time and space fade away as they mix tenses—talking in the future, present, and past at the same time. I've continued to elaborate on this observation, which was the starting point for my filmmaking. Also, if you have the sound of a scene clear in your mind, you will inevitably film in a stricter, more austere and essential way and even film less, which for me in Argentina is important because film stock is very expensive. I like to shoot just what really matters.

After studying animation, experimental filmmaking, and communication science, Martel directed a number of short films between 1988 and 1994. In 2001 her debut feature, *The Swamp*, won awards at the Berlin, Havana, Toulouse, and Sundance film festivals, among others. Her next feature, *The Holy Girl*, was nominated for the Palme d'Or at Cannes, and Martel served on the Cannes Film Festival Feature Films jury in 2006.

Like other young filmmakers grouped together as the Nuevo cinea argentine, who surged to international prominence in the mid-nineties, Martel is fascinated with "the local," those regions, vernacular languages, and social classes typically overlooked by mainstream cinema. The locus of Martel's fascination is Salta, the tropical province in the north of Argentina where she was born and raised and where her films have been set. The region's rich storytelling tradition is another inspiration for Martel's

elliptical, concentrated, yet minimalist narrative style and the complex, nuanced sound tracks that create deeply immersive viewing experiences and have distinguished her as one of modern cinema's most esteemed stylists.

Selected Filmography

2008: *La mujer sin cabeza* (*The Headless Woman*)

2004: *La niña santa* (*The Holy Girl*)

2001: *La ciénaga* (*The Swamp*)

Brillante Mendoza (b. 1960)

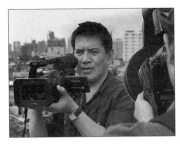

© Brillante Mendoza

"It's hard for a first-time filmmaker to prove himself; especially if he doesn't have any background in productions," says writer/director/cinematographer Brillante Mendoza (aka Dante Mendoza), who was his country's most in-demand production designer before he began making his own films. Born in the Philippines, long home to a thriving popular film culture, Mendoza is the most acclaimed of his nation's new generation of art house directors. This prolific filmmaker—he's made eight international award–winning films in the past four years—won Best Director at Cannes in 2009 for *Kinatay,* which, like his previous films, is so graphically raw and grounded in the minute details of physical reality that it's often mistaken for a documentary.

Mendoza credits his production design experience for enabling him "to differentiate physical truth and commercialism," he says. Mendoza opted for "physical truth" when he started making his own richly atmospheric films, "because that's where I am comfortable practicing my craft. I partly produce my films, and I am lucky to have friends who produce with me and believe in my talent. A film director is the one who has the narrative statement of the film, what the film is about, which encompasses everything that articulates that statement. That includes production design, music,

the story, cinematography, editing, and sound design—everything that articulates the story of what you want to say."

Selected Filmography

2009: *Kinatay* (*The Execution of P*)

2008: *Serbis* (*Service*)

2007: *Tirador* (*Slingshot*)

2007: *Foster Child*

2007: *Pantasya*

2006: *Manoro* (*The Professor*)

2006: *Kaleldo* (*Summer Heat*)

2005: *Masahista* (*The Masseur*)

Teona Strugar Mitevska (b. 1974)

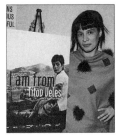

Born to an artistic family in Skopje, Macedonia, Teona Strugar Mitevska was a child actor and then trained as a painter and graphic designer. Together with her cinematographer brother and actress/producer sister, she formed a production company in her present home of Paris, France. Mitevska's brother served as the DP and her sister, Labina Mitevska, played the lead role in Mitevska's second feature, *I Am from Titov Veles,* the story of three sisters struggling to survive in a Macedonian town just after the socialist revolution's failure has left the nation wide open to ruthless profiteers, including the local factory owners who provide work but pollute the village.

Unlike most of her peers, Mitevska plans her entire film down to each final detail during the scriptwriting phase. "Once things are in place, there is a little margin to go left or right, but I shoot long takes, so there isn't too much choice," she says. "Any cutaways are written in the script, so it's fabricated. I like everything to be precise and quiet on the set. I shoot for editing, so my editing room choices are to put things 'here' or 'there,' to

change the order of scenes, but not shots within the scene. I don't give myself much choice. I shoot a small ratio of five to one. I hope one day to shoot two to one."

Selected Filmography

2007: *Jas sum od Titov Veles* (*I Am from Titov Veles*)
2003: *Kako ubiv svetec* (*How I Killed a Saint*)

Gerardo Naranjo (b. 1971)

© Jean Agrave

"My main intention was to make a truthful film about angst against stillness, to capture the moment you discover there's another person like you—a perfect partner in crime," Naranjo says of *Voy a explotar* (*I'm Gonna Explode,* 2009), a feverish, mood-shifting road trip movie about a pair of Mexican teenagers "who find in each other a way to fight against the inertia they feel from their surroundings, the nonsense of living in the comfort of an absurd society." The film evokes the 1960 cinematic earthquake that was Jean-Luc Godard's *Breathless* and follows Naranjo's highly praised *Drama/Mex* (2006). "I think of *Drama/Mex* as a happening, as a planned action. I knew everyone well," he explains.

They weren't actors; they were exuberant, colorful people with precise personalities, and I knew how they would react in certain situations, so I planned *Drama/Mex* as an accident whose outcome I knew. I was struggling to be a filmmaker, coming from a failure called *Malachance* (2004), which was supposed to be my first feature. I was frustrated because I wanted to get ahead of all the other struggling filmmakers and use my own language. So I tried to make this movie as an arrogant gesture, like "I'm better, I can make a movie." I produced it, wrote it—I did everything, and I failed. I found out in the worst way that purity

doesn't come with arrogance. It hurt a lot to pass unnoticed, but now
I think it was a good thing. Everybody is talking about re-launching it,
but I think no one will miss it.

Lucia Puenzo (b. 1976)

The daughter of Argentine director Luis Puenzo, whose *The Official Story*
won the 1985 Academy Award for Best Foreign Film, Lucia Puenzo has been
writing non-stop since the age of eighteen and attended film school. But the
younger Puenzo never thought she would direct films. "I've written literature
and film scripts, and I've done research for documentaries, but always from
the point of view of the world of words."

When Puenzo decided to direct her script for *XXY*, the story of an inter-
sexed adolescent trying to explore her sexuality, she was forced to adjust. "I
realized how different the experiences are, the loneliness and silence of the
writer," she says, "where you write whatever you want, even a Hollywood
super-production, compared with meeting your team and knowing that
each person has to be equally passionate. Aside from learning how to place
the camera, a big lesson was how to work with a team."

Puenzo was also careful to define her boundaries. "I was very strong
about having my space, because it can be overwhelming when your father
is a director," Puenzo explains. "When he came into the project with the
other producers, I was direct. I wanted him involved because his experi-
ence is enormous, but I told him, 'I want you to be a bit on the margins.'
So he never even came to the set in Uruguay, and he never said what he
thought unless I called for advice and until I gave him the edit."

Selected Filmography

2009: *El niño pez* (*The Fish Child*)
2007: *XXY*

Shamim Sarif (b. 1969)

© Shamim Sarif

Born in South Africa to East Indian parents who abandoned apartheid South Africa for England, Shamim Sarif studied directing and film at the Raindance Institute. Before going to South Africa to shoot *The World Unseen* (2007), which she adapted from her award-winning novel, Sarif had refused to go there. "Then my parents started drifting back, using British passports that identified them as 'honorary whites'—a horrifying idea to me. They felt things changing and were happy, whereas I wasn't satisfied with that."

World released the same year as *I Can't Think Straight,* Sarif's first feature, which she novelized after she finished the film. Both Sarif's films follow the stories of women who find love with other women, but sexual preference is largely irrelevant to her films. Sarif's paramount concern is exploring the issue of "finding one's own place within the culture and family that one is born into, something most people grapple with as they mature."

Her account of making *I Can't Think Straight* is the independent filmmaker's worst nightmare, featuring a bogus financier who did not pay the production's vendors and withheld the film's answer print until Enlightenment Productions, the company Sarif runs with her partner, raised enough funds to buy it back. "The shoot's schedule and budget were outside the production team's control, so we couldn't plan the way one should for a film shoot," she recalls. "Locations changed almost on a daily basis, and the schedule was cut by four days with only a week to go. But I would not trade that experience for anything because it kept my creative team focused and working together through challenging circumstances and pushed me to learn how to come in under time and budget without sacrificing story."

Paul Schrader (b. 1946)

© Paul Schrader

Raised in Grand Rapids, Michigan, by parents with strict Calvinist principles, Paul Schrader, one of America's most protean film stylists, is reputed to have never seen a film until he was eighteen years old. After Schrader received his undergraduate degree from Calvin College, with a required minor in theology, his mentor, legendary film critic Pauline Kael, recommended him to the University of California, Los Angeles, Film School, where he earned a master's in film studies. He then launched a remarkable career as film critic, screenwriter, writer/director, and director of others' scripts.

Schrader's first script, co-written with his brother Leonard and set in the Japanese crime world, became Sidney Pollack's *The Yakuza* (1974). He went on to write scripts for Brian De Palma's *Obsession* (1976) and Martin Scorsese's *Taxi Driver* (1976). Schrader was able to leverage the success of those groundbreaking projects into financing for *Blue Collar,* his tour-de-force directorial debut, also co-written with his brother, that follows three Detroit auto workers who steal and blackmail. Among his many other films is the recently re-released *Mishima: A Life in Four Chapters,* widely regarded as one of the most inventive and searching film biographies ever made.

Unfortunately, abundantly gifted and inventive filmmakers, however many times they have proven themselves, seem less in favor these days. Schrader's *Adam Resurrected,* funded by overseas money and set in Israel, has yet to be picked up for distribution in the United States as of this writing. For his subsequent project, Schrader headed to a more welcoming studio system in Bollywood.

Selected Filmography

2008: *Adam Resurrected*

2007: *The Walker*

2005: *Dominion: Prequel to the Exorcist*

2002: *Auto Focus*

1999: *Forever Mine*

1997: *Affliction*

1997: *Touch*

1992: *Witch Hunt*

1992: *Light Sleeper*

1990: *The Comfort of Strangers*

1988: *Patty Hearst*

1987: *Light of Day*

1985: *Mishima: A Life in Four Chapters*

1982: *Cat People*

1980: *American Gigolo*

1979: *Hardcore*

1978: *Blue Collar*

Céline Sciamma (b. 1980)

© Unifrance

No false notes mar the bittersweet charm of *Water Lilies* (*Naissance des pieuvres*, 2007), Céline Sciamma's first feature. Made from her master's thesis screenplay, it was a co-winner of the 2007 Cannes Film Festival's Critics' Prize. This poignant coming-of-age portrait of three fifteen-year-old girls careening between childhood vulnerability and adult sexuality illuminates a stage of life not too distant from the twenty-nine-year-old Sciamma, who passed her own suburban childhood devouring fiction, comic books, and films. After earning master's degrees in literature and film, Sciamma was swarmed by producers eager to take on the *Water Lilies* project and insistent that Sciamma direct.

"I was totally scared," Sciamma recalls. "I had done only one short film and sound for one film and photography for another at school, so I didn't

want to direct *Water Lilies*. Then I thought, 'Am I going to give this film away to another director? No, I can't!' I thought it would take months, maybe years, to gather the financing, and by that time, I could make up my mind about what kind of director I'd be. But in three months we had all the money, so I got into the process of rewriting, casting, and other aspects of pre-production, and then I shot the movie just a few months after I got out of school."

Like Anne Le Ny and Mia Hansen-Love, Sciamma was one of several young women filmmakers, many of them French, who made their feature film debuts in 2008. "I think it's linked in part with how French movies are produced, how we get the money," says Sciamma.

People are looking for stories now, and women have stories that haven't been told much. Nothing in *Water Lilies* is from the perspective of adults or boys, which I hadn't seen before. Women also go to cinemas and they take men. The generations before us had to force their way into filmmaking, make the robbery, but we feel entitled, so maybe it's also about chronology. Female voices haven't been out there for very long or that often, so I'm part of a new generation.

Jerzy Skolimowski (b. 1938)

© GODLIS

One of the most strikingly innovative Eastern European cinema talents, Jerzy Skolimowski is comfortable within a diverse range of film genres. An award winner at the Cannes and Berlin film festivals, he has also directed successfully, albeit not necessarily happily, for Hollywood studios.

Skolimowski entered college in Poland to avoid military service and studied ethnography, history, and literature. In his free time, he boxed (the subject of an early documentary), wrote poetry and short stories, and played jazz in local bands. After meeting legendary Polish filmmaker

Andrzej Wajda, Skolimowski left school to co-write the script for Wajda's *Innocent Sorcerers* (1960). He then enrolled in Poland's legendary film school at Lodz, where he co-wrote the script for classmate Roman Polanski's debut feature, *Knife in the Water* (1962). Four years later, Skolimowski played the leading role in his own first feature, *Identification Marks: None*, based on a script he adapted from several of his short stories.

After living and making films in many countries, Skolimowski took a break from directing upon completing *30 Door Key* in 1991. For nearly twenty years, he acted in other films and created figurative paintings at his home in Malibu, California, and his nineteenth-century hunting lodge nestled deep in a Polish forest.

Skolimowski returned to the forefront of world cinema in 2008 with the spare, suspenseful *Four Nights with Anna*, an enigmatic masterpiece that screened in that year's New York Film Festival. "I've always had the feeling that while I'm painting I use a different side of my brain," he says.

> You are alone against the white canvas, a peaceful atmosphere, no one to push or control you, no one to compromise with. You are a real artist, free. In the movies, that is practically impossible because you have to consider everything around you—the crew, the actors, the producers, and their needs—and you have to find the way around that. I needed that break to rebuild myself as an artist. By becoming a free-spirited artist again through painting, I felt, "Okay, now I'm back to art, now I can make a movie." Before that, I was in a bad way, trying to be commercial, which doesn't suit me at all. I was thinking too much about money and too little about art. When I make art, I'm good. When I'm trying to do something else, I'm not good at all.

Selected Filmography

2008: *Cztery noce z Anna* (*Four Nights with Anna*)

1991: *Ferdydurke* (*30 Door Key*)

1989: *Torrents of Spring*

1985: *The Lightship*

1984: *Success Is the Best Revenge*

1982: *Moonlighting*

1981: *Rece do góry* (*Hands Up!*; completed 1967 but not released until 1981)

1978: *The Shout*

1972: *King, Queen, Knave*

1970: *The Adventures of Gerard*

1970: *Deep End*

1967: *Le Départ*

1966: *Bariera (Barrier)*

1965: *Walkover*

Jean-Marie Téno (b. 1954)

© Jean-Marie Téno

Jean-Marie Téno writes, produces, directs, and even shoots footage for his internationally honored films, which explore Africa's colonial and postcolonial history. Though he was born and raised in Cameroon, Téno lives in France. "But I don't even know if I live in France," Téno qualifies. "I travel to the United States and all over the place." In America, where he says his films are more widely viewed than in either Africa or Europe, Téno has been a guest of the Flaherty Seminar in New York, artist-in-residence at the Pacific Film Archive of the University of California, Berkeley, visiting artist at Amherst College, and lecturer at numerous universities.

Téno first discovered cinema in a "small African cinema house, where I saw a lot of Indian films, not Sajit Ray films but films with dancing and magic," he recalls.

> That was a distraction and enjoyment in our small town. I went regularly, but I never went to film school. I tried to see people like Jean Rouch, because when I started thinking of making films, people said I should meet him, but I couldn't. He was always away. Finally someone said, "Why do you want to meet him; why don't you make your own films?" So I began and gradually I learned on my own.

Selected Filmography

2010: *The Fo and I*

2009: *Lieux saints* (*Sacred Places*)

2005: *Le malentendu colonial* (*The Colonial Misunderstanding*)

2003: *Le mariage d'Alex*

2002: *Vacances au pays* (*A Trip to the Country*)

1999: *Chef!* (*Chief!*)

1996: *Clando* (*Clandestine*)

1994: *La tête dans les nuages* (*Head in the Clouds*)

1993: *Afrique, je te plumerai* (*Africa, I Will Fleece You*)

1988: *L'eau de misère* (*Bikutsi Water Blues*)

1987: *De Ouaga à Douala en passant par Paris*

1987: *La gifle et la caresse*

1985: *Hommage*

Ivo Trajkov (b. 1965)

© Macedonian Film Fund

Born in Skopje, Macedonia, Ivo Trajkov graduated from the Czech National Film School in Prague and then launched a career noted for remarkably original ways of producing, writing, directing, editing, casting, and even acting in a wide range of film genres, including comedies, docu-dramas, experimental, and dramatic features. *The Past*, which Trajkov describes as "a crime story without crime, a drama without conflict, and a love story without love," employs an astonishing multi-tracked sound design—created by individual musicians in response to the film but without hearing the tracks made by their collaborators—as well as handheld camera work and documentary elements. These techniques draw viewers into the world of Frantisek, a deaf man imprisoned for a crime of passion who is trying to make sense of an environment he can't understand. For *The Great Water*, Trajkov cast hundreds of children, including the two leads—none of whom

had acted before. His filmography also includes sixty episodes of the acclaimed documentary series *Unexplained Deaths,* as well as five feature films, for which he's received numerous awards.

Selected Filmography

2009: *Ocas jesterky* (*Tail of Lizard, Wingless*)

2007: *Movie*

2004: *Golemata voda* (*The Great Water*)

1998: *Minulost* (*The Past*)

1993: *Kanarska spojka* (*The Canary Connection*)

Melvin Van Peebles (b. 1932)

© Melvin Van Peebles

"I don't consider myself an artist," says the multi-gifted, maverick artist/ musician/actor/director/writer/Wall Street financier, whose film subjects often borrow liberally from his remarkable life. Melvin Van Peebles's semi-autobiographical 1971 feature, *Sweet Sweetback's Baadasssss Song,* changed the landscape for independent filmmakers and African American directors by becoming the first American independent film to turn a profit. Yet Van Peebles describes himself in an offhand manner by quoting a line from a song he wrote for his latest theatrical piece, *Unmitigated Truth: Life, a Lavatory, Loves and Ladies*: "I'm just an innocent bystanding brother, that's me."

Van Peebles attributes his many and varied achievements in part to his life-changing experience as a twenty-two-year-old U.S. Air Force officer. "Just after they integrated the service, I was on a secret jet, part of a three-man crew where there should have been ten," he recalls.

It was just at the end of the Korean War, when the Strategic Air Command was afraid the Russians would bomb us. We weren't going to get

caught like Pearl Harbor again. So there was always a squadron ready, with each plane carrying an atomic bomb. We flew from our base in Riverside, California, up the coast of California to Alaska, down past Japan and then over the coast of Russia, so if they ever bombed us, we would be able to turn around and bomb them. On this particular flight, an engine caught fire, and everyone who had experienced an emergency before on these planes had died. Suddenly, I heard this black voice saying, "Oh Lord, Lord, please, Lord, just let me make it to my twenty-third birthday, Lord!" There were no black guys on the plane but me. It was me praying! So I'll never complain because I'm still here. I'm ahead of the game.

Selected Filmography

2008: *Confessions of an Ex-Doofus Itchy Footed Mutha*

2000: *Le conte du ventre plein* (*Bellyful*)

1995: *Vrooom Vroom Vrooom*

1989: *Identity Crisis*

1973: *Don't Play Us Cheap*

1971: *Sweet Sweetback's Baadasssss Song*

1970: *Watermelon Man*

1968: *La permission* (*The Story of a Three-Day Pass*)

Gary Winick (b. 1961)

© 2009 Summit Entertainment, LLC.

Although Gary Winick won Best Director for *Tadpole* at the Sundance Film Festival and went on to direct major Hollywood movies, his crowning achievement has to be InDigEnt, the paradigm-shifting digital film company he founded, which produced many of the finest American independent films of the nineties. "I came up with the idea for a Dogma New York type of thing," he recounts.

We pledged to make ten digital films, allocating to each $150,000 for production and another $150,000 for post-production. Each film had to be shot on Mini DV and follow a fifteen-day shooting schedule. Everyone from grips to actors received profit participation, with checks going out as soon as each film was sold for distribution. The model attracted high-caliber crews and casts who wanted to do something different. We were so ahead of our time.

Winick continues to segue smoothly between producing and directing. "As a director, I'm a good storyteller," he says. "I understand story and what a scene is about. As a producer, I want the director to feel he can make his movie because I'm in the trenches with him. Five hundred things can go wrong in a day, and the director shouldn't know about one of them."

Selected Filmography (as director)
2010: *Letters to Juliet*
2009: *Bride Wars*
2006: *Charlotte's Web*
2004: *13 Going on 30*
2002: *Tadpole*
2000: *Sam the Man*
1999: *The Tic Code*
1996: *Sweet Nothing*
1991: *Out of the Rain* (*End of Innocence*)
1989: *Curfew*

Jia Zhangke (b. 1970)

© GODLIS

Jia Zhangke's films explore contemporary Chinese history, the alienation of his country's youth, and the impact of globalization—themes that fly

in the face of older generations of Chinese filmmakers, who offer more idealized portraits of life in the People's Republic of China. His signature style—extended takes, colorful digital video, and a minimalist/realist style that blurs the boundaries between feature and documentary—also speaks to Zhangke's desire to present authentic poetic visions of Chinese life as it evolves.

Zhangke became a filmmaker at the age of twenty-one. "I painted, wrote novels, and so on, but I felt unfulfilled," he recalls, until a viewing of *Yellow Earth* (Chen Kaige, 1984) "shook me to the core." Zhangke entered China's Central Academy of Film at twenty-three and, at twenty-seven, made his first feature, *The Pickpocket*, financed on less than $50,000. "I read a book by French filmmakers talking about independent filmmaking, and that got me going on the idea of doing your own thing outside the system and expressing yourself independently," he says. "We organized a functional production team from our Young Experimental Filmmakers Club and people from the art, recording, and writing clubs."

Despite being banned from filmmaking for four years by his government, Zhangke never stopped making his films, and he is widely regarded as the sixth generation of the Chinese independent film movement's driving force. In 2006 his *Still Life* took the top prize at the Venice Film Festival.

Filmography

2010: *Ciqing shidai* (*The Age of Tattoo*)

2010: *Moving the Arts*

2009: *Er shi si cheng ji* (*24 Hour City*)

2007: *Wuyong* (*Useless*)

2996: *Dong*

2006: *Sanxia haoren* (*Still Life*)

2004: *Shijie* (*The World*)

2002: *Ren xiao yao* (*Unknown Pleasures*)

2001: *Gong gong chang suo* (*In Public*)

2000: *Zhantai* (*Platform*)

1997: *Xiao Wu* (*Pickpocket*)

ABOUT THE AUTHOR

ELENA OUMANO is a music and film journalist whose work has been published in the *New York Times, Spin,* the *Nation,* the *Village Voice,* Amazon.com, *Interview* magazine, *L.A. Weekly, L.A. Times, Image magazine* of the *San Francisco Examiner-Chronicle, GRAMMY* magazine, and other media outlets. She is also the author, co-author, or ghost writer of over twenty books. These include *Film Forum: Thirty-five Top Filmmakers Discuss Their Craft, Movies for a Desert Isle: Forty Well-Known Film Lovers in Search of the Films They Love Most, Paul Newman, Sam Shepard: The Life and Work of an American Dreamer,* and *Elvis: On the Road and On the Town with Elvis Presley.* Elena is the main interviewee in the A&E television cable channel's "Biography" segment on Paul Newman. She also holds a Ph.D. in language and communications from New York University and is a full-time professor of communications at BMCC of the City University of New York. Samples of Elena Oumano's writing can be found at www.elenaoumano.com.